RAUSCHENBERG / ART AND LIFE

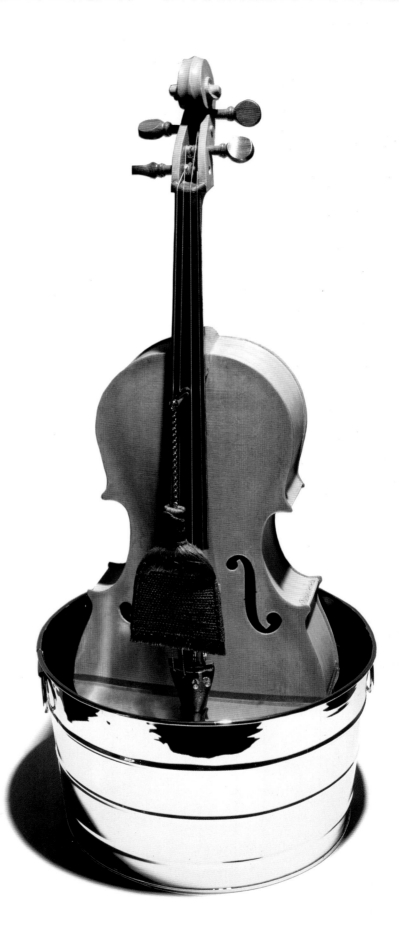

HARRY N. ABRAMS, INC., PUBLISHERS, NEW YORK

RAUSCHENBERG / ART AND LIFE

MARY LYNN KOTZ

Project Director: Robert Morton
Editor: Ruth Peltason
Designer: Elissa Ichiyasu
Photo Research: Neil Ryder Hoos

Page 2: Tibetan Garden Song (ROCI Tibet) 1986. Assembled parts with glycerine, (edition of 35 plus 15 artist's proofs, Graphicstudio U.S.F.), 43 × 18¼" diameter. Rauschenberg noted that in Tibet "people didn't ask 'why is a cello sitting in water?' They were curious to see how many reflections it made."

Page 6: Able Was I Ere I Saw Elba (Japanese Recreational Clay Work). 1983. High-fired ceramic, 106¼ × 91". Collection Otsuka Chemical Company, Japan. Rauschenberg's images of modern Japan interact with Jacques-Louis David's Bonaparte Crossing the Saint-Bernard (1800–1801).

Pages 10–11: Fish Park/Roci Japan 1984. Acrylic and collage on canvas, 78½ × 220¼". Collection the artist. In Japan a carp kite is traditionally flown on Boys' Day.

Epigraph (page 7) by Rauschenberg from the catalogue Sixteen Americans (Museum of Modern Art, New York, 1959).

Library of Congress Cataloging-in-Publication Data
Kotz, Mary Lynn.
Rauschenberg, art and life / by Mary Lynn Kotz.
p. cm.
Includes bibliographical references (p.
ISBN 0-8109-3752-2
1. Rauschenberg, Robert, 1925-
2. Artist—United States—Biography.
I. Title.
N6537.R27K67 1990
700'.92—dc20 90-217
[B] CIP

CONTENTS

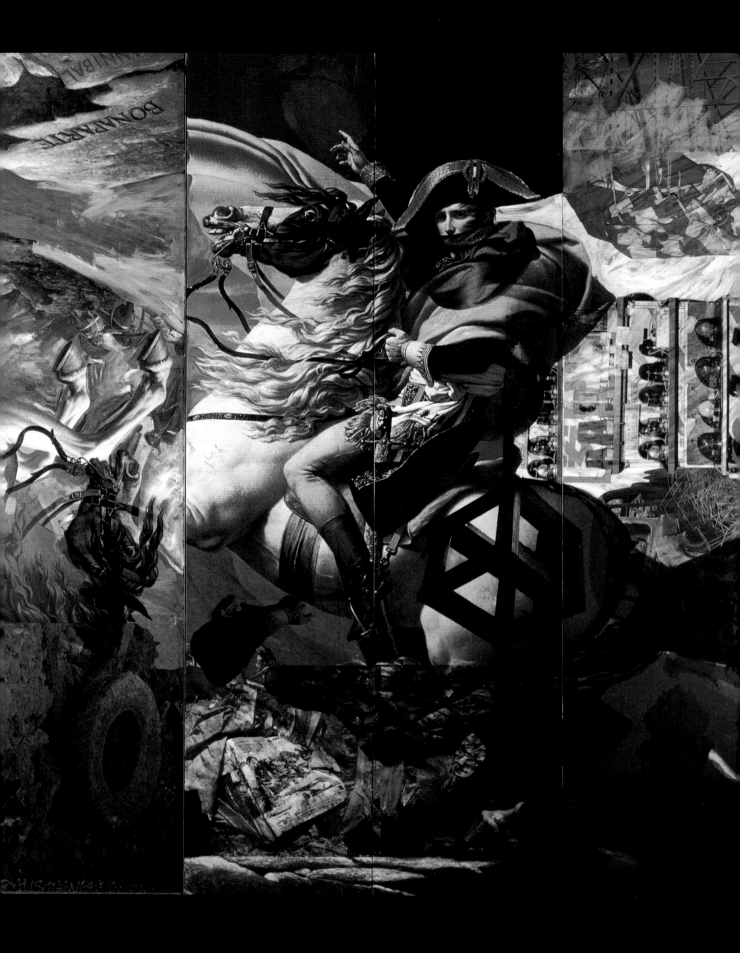

"PAINTING RELATES TO BOTH ART AND LIFE.
NEITHER CAN BE MADE.
(I TRY TO ACT IN THAT GAP BETWEEN THE TWO.)"

ROBERT RAUSCHENBERG

ACKNOWLEDGMENTS

I AM GRATEFUL to Rauschenberg himself, for his time and attention in the numerous interviews he gave for this book, and for opening his studio and archives to a journalist. Rauschenberg's archivist, David White, has been unfailingly conscientious and courteous in providing me with guidance and information. David White's precision and judgment have been invaluable to this project. Other members of his staff who have been especially gracious in providing technical information about the art are Hisachika Takahashi, Nicholas Howey, Michael Moneagle, Lawrence Voytek, Terry Van Brunt, Darryl Pottorf, and the efficient coordinator, Bradley Jeffries. For information about the Rauschenberg Overseas Culture Interchange project, I am especially indebted to Donald Saff and Brenda Woodard, Thomas Buehler and Charles Yoder.

To those who kindly participated in interviews about Rauschenberg and his work, I am deeply indebted. They include John Alexander, Irving Blum, Trisha Brown, John Cage, Leo Castelli, Chun-Wuei su Chien, Merce Cunningham, Jack Cowart, Joan Danzinger, Alice Denney, Michele De Angelus, Mary Nell Dore, Sidney Felsen, Ruth Fine, Leonard Gaspard, Bill Goldston, Rubin Gorewitz, Elyse Grinstein, Stanley Grinstein, Deborah Hay, Joseph Helman, Henry Hopkins, Walter Hopps, Nicholas Howey, Timothy Isham, Richard Koshalek, Billy Klüver, Richard Landry, Dorothy Lichtenstein, Roy Lichtenstein, William Lieberman, Jane Livingston, Roger Mandle, Julie Martin, Rufus Mier, Jane Nathanson, Susan O'Connor, Seiji Oshima, Earl Powell, Jean-Louis Prat, Neil Printz, Christopher Rauschenberg, Steve Reichart, Dorothea Rockburne, Nan Rosenthal, Todd Simmons, Ileana Sonnabend, Yoshiaki Tono, Ted Victoria, Susan Weil, David White, Jonathan Williams. In conversations with many others, including Fredericka Hunter, William Stern, Theodore Kheel, Robert Petersen, Fred Nicholas, Dora Rauschenberg and Janet Begneaud, Patsy and Raymond Nasher, Anne Livet, Fujiko Nakaya, Marcia Weisman, June Colbert, Richard Hiller, Keith Brintzenhofe, and Eugenio Gutierrez, data was amplified and clarified.

In researching the manuscript, I am grateful for assistance from Mary O. Phelan, Beverly Elsen, Linda Burgess, Barbara Cohn and Peggy Schmid, respectively, and to helpful staff at the Library of Congress, National Gallery of Art, National Museum of American Art, Museum of Modern Art, Archives of American Art, and Museum of Contemporary Art, Los Angeles. Among those who have been especially helpful are Andrew Connors at the National Museum of American Art, Kerry Brougher at M.O.C.A., Elyse Topalian at the Metropolitan Museum of Art, James Fisher at the Modern Art Museum of Fort Worth, and Junichi Shioda at the Setagaya Art Museum, Tokyo. Mary Lou Featherston of the Port Arthur Public Library set up interviews in that city and opened up her files to me. David Vaughan, archivist for the Merce Cunningham Dance Company, has been more than kind in providing research and illustrations.

In preparing the manuscript, I was assisted by Sheila Harvill and Helen Cefaretti in transcribing interviews. Barbara Wolfson skillfully edited the manuscript and helped reshape the final copy. During the writing, I was aided in great measure by the loyalty and support of Karen E. Wilson, who administers my office. My assistant, Katie E. Robinson, mastered the computer, transcribed interviews, maintained innumerable files, and prepared the final manuscript. Her enthusiasm and good nature have been invaluable to the project.

In compiling a Rauschenberg bibliography of more than 1500 entries, I found the work of Calvin Tomkins, especially in *Off the Wall: Robert Rauschenberg and the Art World of Our Time*, to be most helpful, as well as the charming *Rauschenberg*, an interview by Barbara Rose (Vintage Books, 1987). At Harry N. Abrams, Inc., I appreciate the editing of Bob Morton and Ruth Peltason, and the assistance of Neil Ryder Hoos, Irene Perez, and Harriet Whelchel. The sensitive design by Elissa Ichiyasu has enhanced this book immeasurably. Over the years I have been enriched by my association with Sterling Lord, for which I shall always be thankful. The wisdom and counsel of Ronald L. Goldfarb, Esquire, has been of great value.

I am grateful to Milton Esterow, publisher of *ARTnews* and originator of the idea for this book, for a dozen years of encouragement in writing about artists; to Jack Kotz for his knowledge of art history and Rauschenberg's work; and to the distinguished journalist Nick Kotz, not only for his loving support, but for his thoughtful editing of this and every other book and article I have written.

M.L.K.

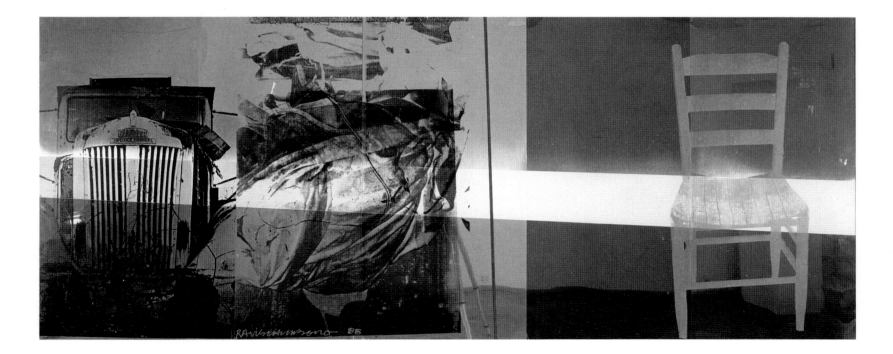

OPEN WINDOW *1988. Acrylic and enamel on mirrored and painted aluminum, 49 × 120¾". Collection Akira Ikeda Gallery, Nagoya, Japan*

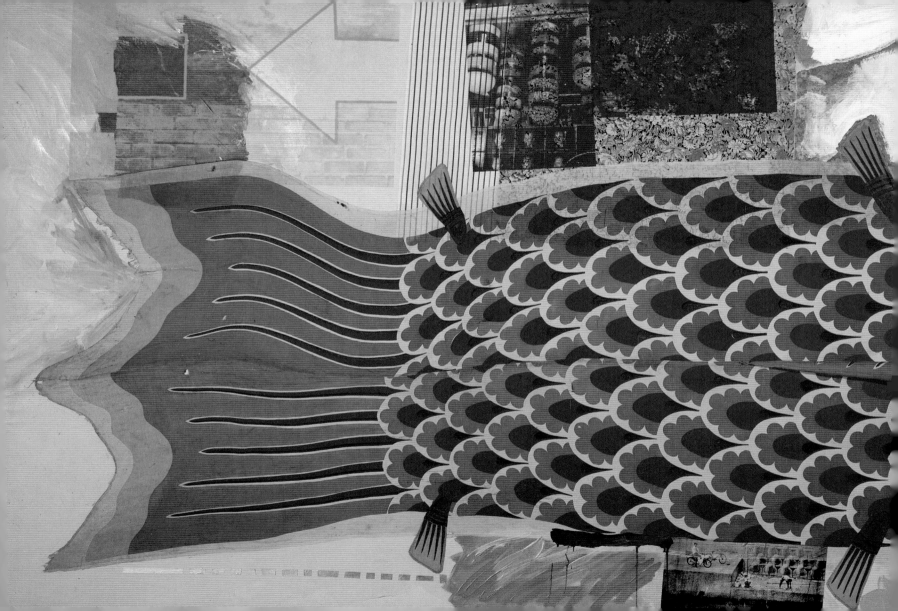

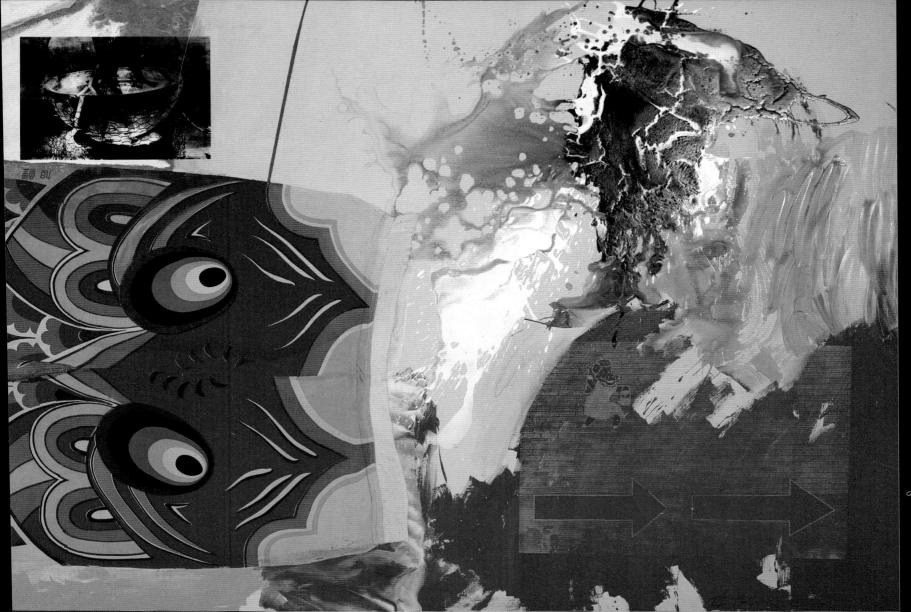

FOREWORD

IN FEBRUARY 1982, on assignment for *ARTnews* magazine at Edison Community College in Fort Myers, Florida, I walked into a room as big as a gymnasium. The first 190 feet of Robert Rauschenberg's *¼ Mile or 2 Furlong Piece*, which he intended to be the largest painting in the world, was spread across the walls. Standing in the center of the room, I felt as though I were in the eye of a hurricane. The diverse shapes, colors, and materials surrounding me swirled in a rhythm all their own.

In the hours I spent there, studying each panel, the *¼ Mile Piece* captured me. I read, as on a scroll, the images that assault and absorb twentieth-century America. Rauschenberg had assembled the stuff of everyday life: the horror, the beauty, and finally, the hope. It was Rauschenberg's State of the Universe message. During subsequent investigations of Rauschenberg's life and his work, I became deeply impressed by the range of this painter's enormous productivity, his continual innovations, and his sheer joy in making art over the course of a career that as of this writing has spanned forty years. I have come to admire his message as well as his art. Robert Rauschenberg is a patriot, a citizen activist, and a humanitarian. This book is an appreciation.

Mary Lynn Kotz
Washington, D.C.

RAUSCHENBERG / ART AND LIFE

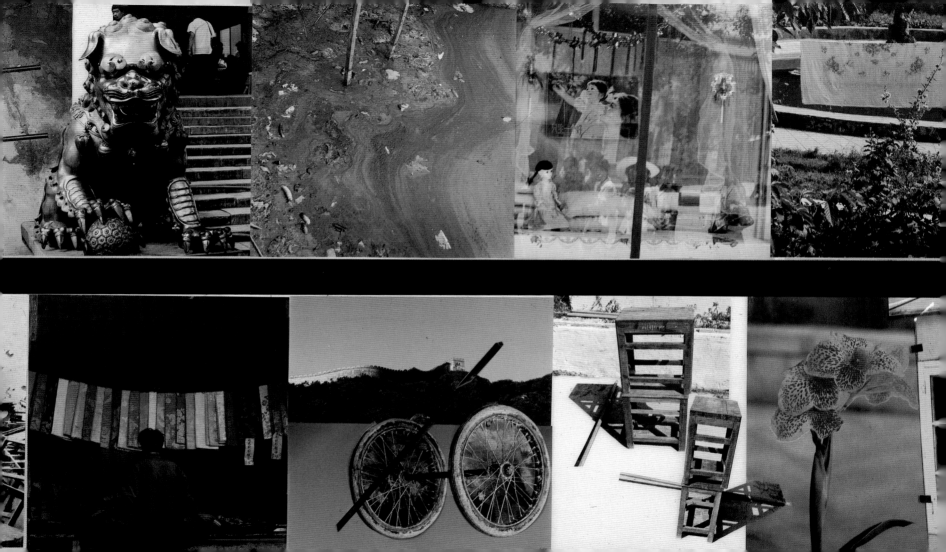

A GLOBAL PALETTE

ON A STEAMY June day in 1982, the American artist Robert Rauschen-berg and a party of friends, advisors, and collaborators stepped off a bus in Jingxian, a remote military town beyond the Yellow Mountains in east central China. They were startled to see mountains surrounding the town covered with what looked like snow. Instead, they found that the snowy substance was white paper pulp, laid out to bleach in the sun. Rauschenberg had come to China as a guest of the Anhui Province Artists' Association to work at the Xuan paper mill in Jingxian. He was excited by the idea of creating art at the world's oldest paper mill, the birthplace of paper.

Rauschenberg had learned about an unusual handmade paper there that was still crafted as it had been for the past fifteen hundred years. The Chinese considered the paper a national treasure, and used it for scrolls, official docu-ments, certificates, and diplomas. It appeared delicate—thin and translucent—but was actually quite strong and supple. Known as "thousand-year paper," Xuan paper was said to last forever.

During his two-week stay in Jingxian, Rauschenberg immersed himself in the traditional papermaking processes, which he adapted to create several hundred collages. *Time* magazine art critic Robert Hughes praised Rauschenberg for producing "some of the best work of his career." The art, and his experience traveling and working in China, became the catalyst for Rauschenberg to launch a unique venture to promote international understanding.

Notwithstanding the results of Rauschenberg's efforts, the Xuan project did not have a smooth beginning. It had taken the artist and his sponsors, Gemini G.E.L., two years to surmount the bureaucratic hurdles in the Chinese govern-ment, and to win permission to work at the mill. For three weeks following his arrival in China, Rauschenberg traveled throughout the country with his party, which included a Chinese host artist and an official guide. He visited museums, cities, villages, and archeological sites, photographing the countryside, collect-ing ideas and materials for art he might make at the Xuan mill. Rauschenberg was astonished at the pervasive control exercised by the government at every level. Even though he had permission from the highest officials of the Chinese culture ministry to work at the paper mill, local officials made him wait for two more weeks in the Yellow Mountains, one hundred miles away from Jingxian, before he was granted a permit to enter the town.

When Rauschenberg and his crew finally arrived, they were greeted with suspicion and treated with icy formality. The group of seven Americans was not permitted to see the secrets of the mill itself. Instead, they were segregated in a mill workers' dormitory where they lived and worked in a makeshift studio, to which the Chinese reluctantly brought their special paper.

Rauschenberg's interpreter was a Baltimore artist, Chun-Wuei su Chien, who had been born in Anhui Province. At first, it seemed impossible to translate an avant-garde Western artist's ideas to Chinese artisans who had never been outside their own province. Through Mrs. Chien, Rauschenberg explained to the workers that he wanted the thinnest, most diaphanous paper possible. They took his specifications into the mill, where they brought in a master scroll-maker. The craftsmen made a split bamboo mold, tied together with horsehair and silk thread. They dipped this mold into a vat of white pulp, comprised of mulberry based fibers floating in water. When they lifted the mold, the water rushed back through the bamboo/horsehair/silk mesh, and the pulp began to bond. With great skill, an artisan shook the frame gently to even out the pulp as it formed a wet sheet beneath the mold's wooden frame, or deckle. In judging the amount of pulp, and in shaking the mold, the skill of the craftsman alone accounted for the thinness of the paper. In this way, the sheets were cast in the Xuan mill, then laid out in the sun to dry. After many efforts, the workers finally had molded paper that met Rauschenberg's exacting standard—which resulted in a paper much thinner than they had thought possible.

The papermakers next were asked by Rauschenberg to create the thickest paper the mill had ever made. Together they devised a method of laminating the thin sheets to each other to create a thick, stiff, but still translucent base for the art. As part of the process, Rauschenberg used a broad scroll-maker's brush to coat each thin sheet with rice paste, gluing it quickly to another sheet. After many efforts, the mill workers finally put together thirty layers of this lamination to achieve the thickness and translucence Rauschenberg wanted. It was a snowy parchment-like paper, as stiff as cardboard.

The prepared sheets were now ready for the use that the chief Chinese papermaker found so puzzling, a Rauschenberg collage. Since the 1950s, Rauschenberg has pioneered collage construction in sculpture, painting, and printmaking. He often appropriates images from the mass media, or includes real objects from everyday life, arranges them in unusual juxtapositions, and transfers them to canvas, fabric, Plexiglas, metal, or paper. "A picture is more like the real world when it is made from the real world," he has said.

In China, Rauschenberg was fascinated by the ubiquitous posters with their vivid colors, idealized pictures, and propaganda messages, which he collected by the armload in Shanghai. While waiting for the paper to be made, he would cut out multiple images from the posters to use in the collages. Working beside him were Stanley Grinstein, cofounder of Gemini G.E.L. in Los Angeles, and Donald Saff, the director of Graphicstudio U.S.F., Elyse Grinstein, Ruth Saff, and Terry Van Brunt, Rauschenberg's chief assistant. Both Gemini, sponsor of this expedition, and Graphicstudio are innovative studios known for their collaboration of fine artists with master printmakers. Rauschenberg and the Gemini crew snipped pictures of children, bicycles, vegetables, and other Chinese scenes from the posters. As they scissored away, producing a small mountain of cutouts, they amused their Chinese collaborators by laughing and singing, showing obvious delight in working. They also showed videotapes of American movies they had brought along. *The Black Stallion*, *The Blues Brothers*, *The Big Bands*, and *Dumbo* introduced the mill workers to Western culture.

The reticent Chinese workers were gradually drawn to this gregarious American artist who laughed easily, worked alongside them without pretense, and showed respect for their craftsmanship. Lean and rangy at fifty-seven, Bob Rauschenberg moved with the quick step of an athlete. Typically wearing faded jeans and a work shirt with the sleeves rolled to his biceps, and with his deeply tanned face and curly hair, Rauschenberg looked more like a carefree ranch hand

INDIVIDUAL *(7 Characters). 1982. Handmade paper with fabric and paper collage (suite of 70 variations, Gemini G.E.L.), 38½ × 26½". In collaboration with Chinese artisans at the birthplace of paper, Rauschenberg modified an ancient handmade papermaking technique. He created 491 collages in seven suites.*

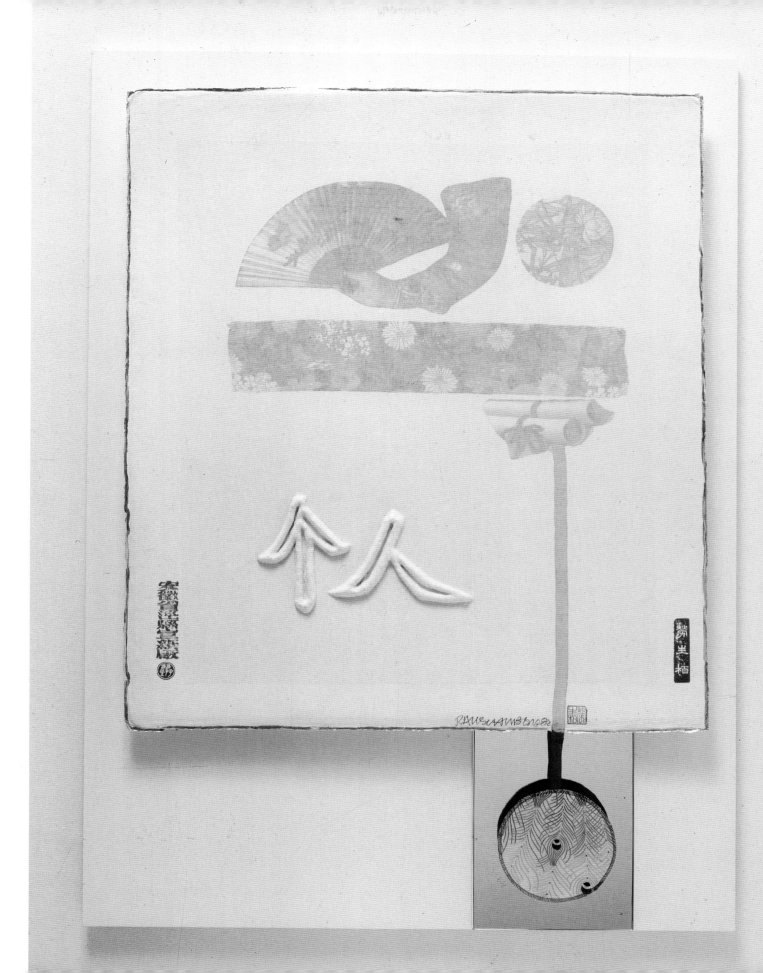

from his native Texas than a world-famous artist. Although the Texas accent had long ago been toned down, the cadence was still there, and so was a Texas-sized warmth and exuberance. The Chinese responded to his playfulness by sharing a joke or a drink, and admired his energy as he worked for long hours in the intense heat. They began to put in extra time on the project, bringing Rauschenberg bowls of soup and watching with fascination as he often worked through the night.

Rauschenberg had decided to make the collages in rectangular shapes, thirty-and-one-half by twenty-six-and-one-half inches. The mill made forms to fit his specifications. Through Mrs. Chien's translation, and by drawing diagrams, Rauschenberg explained to the artisans that he wished to embed the poster cutouts within the sheet of paper so that the collage would be part of the paper itself. Rauschenberg laid the thirty-ply sheets of handmade paper on long work-tables, and positioned the poster cutouts on them: a Chinese fan here, an acrobat there, a child's face, a pig, an athlete jumping.

Round and round the tables he would walk, dropping the images onto the paper and arranging them with his long fingers. Following behind him, his crew applied the cutouts to the pearly parchment-like paper with a dab of clear glue, and then covered each sheet with a sheer panel of white silk.

With the help of a master calligrapher, Rauschenberg had selected seven characters from the Chinese alphabet, meaning "Truth," "Light," "Red Heart," "Individual," "Howl (!)," "Change," and "Trunk." He liked both the meanings of the words and their ideographic shapes. The letters also served as the titles for the artwork.

Rauschenberg then drew the characters on a piece of tissue, as a pattern. A woodcarver took the tissue and carved the characters into a block of cherry-wood. Instructing the incredulous workers to fill the carved blocks with paper pulp, Rauschenberg expanded the possibilities for their use of the paper. The sculptural, high-relief ideograms formed by the woodblocks were then incorporated into the collage. A final, single, diaphanous sheet of Rauschenberg's thinnest Xuan paper was laminated onto the embossed characters, thus sealing them to the surface of the collaged thickest (thirty-ply) sheet. The final touch was a pendant attached by a ribbon of silk to the bottom of each completed piece. Using soup bowls as patterns, his crew cut "medallions" from bolts of fabric that Rauschenberg had bought in Jingxian—richly embroidered brocade which traditionally adorned a bride's wedding pillow.

The elaborate process yielded Rauschenberg's 7 Characters, a Gemini G.E.L. edition of four hundred ninety-one unique collages in seven suites. In the delicate, white, gold-rimmed pictures with their Chinese ideograms and randomly ordered cutouts, Rauschenberg paid homage to China's ancient crafts and presented the iconography of its present culture.

At the mill, Rauschenberg had achieved a collaboration with the workers that was mutually exciting and educational. During every step of the collaboration, however, his freewheeling ideas had clashed with those of the Chinese officials, whose actions were circumscribed by ancient tradition, isolation, and Marxist dogma. Each of Rauschenberg's requests was first deemed impossible by the local bureaucrats before an understanding was reached.

Mill production was carefully controlled for the production of paper supplies for official government needs. Presiding over the mill manager were local, county, and province officials who had to agree on every detail of the operation. One minor clerk could hold up the production. Before materials for a project could enter the mill, or one new step be taken, a tier of bureaucrats had to

consider the proposal and sign a paper indicating their joint approval. The mill workers' enthusiasm for Rauschenberg and their commitment to this extracurricular project was a challenge to the system.

The final confrontation was the use of the Xuan mill's insignia on the work of art. Communist officials had decreed that individual mills, no matter how proud their history, could not "sign" a product. Instead, a generic "made in the People's Republic of China" stamp was mandatory. Throughout the official hierarchy, Rauschenberg pled his case for stamping the art with the mill's own seal—if the project should earn it. The mill workers, enthusiastic about the inventiveness and joy of the collaboration, gave their wholehearted approval. At the last moment, the Chinese government relented and allowed the mill imprint to be placed on the artwork. It was the first time the insignia had been used since the Communists took power in 1949.

When the art was completed, Cui Bao Lai, director of the paper mill, arrived at the studio with a stone signet, or chop, on which was carved an imprint of the mill's insignia. Because of its marbled red and white coloring, the Chinese word for the stone means "chicken blood." With elaborate formality, Cui prepared to stamp each of the paintings with this official seal of approval. Cui explained that the artist's signature seal, which had been made especially for Rauschenberg in Chinese calligraphy, and the mill insignia seal should be perfectly aligned, one above the other. The mill insignia was placed in the right-hand corner of the page. Rauschenberg, however, decided that the stamp should be placed elsewhere to enhance the composition. Furthermore, as the director was making practice imprints of the red-inked seal on a piece of tissue, Rauschenberg discovered that he liked the image as it appeared on the underside of the paper. When Cui gave the stone to Rauschenberg, the artist plunged it into the ink pot, stamped the seal on the paper, and turned it over, producing on the highly translucent paper a muted reverse image within the composition. Shaking his head in stern disapproval, Cui lectured the American about the error of his procedure.

"The character of this stone will live on in my prints," replied Rauschenberg, smiling. "I like the negative image of it on the paper. The positive image is too red—like a woman with too much rouge. She's going to get into trouble!" Cui suddenly grinned, then convulsed into uproarious laughter. The director relented, and gave his approval to this unusual use of his chop. In the final production of the collage, the insignia was printed between layers of paper, which lessened its intensity. Rauschenberg had made a connection.

"There were moments when we felt like Marco Polo," Rauschenberg later said about his experience in China. Even more than the constant surveillance and bureaucratic intransigence, the most frightening aspect for him was the sense of isolation. From one city to another, he said, the Chinese "didn't know what another person was doing." A special pass was required to travel anywhere. No one knew what was happening in the village ten miles away and, what was worse, no one was curious, something Rauschenberg found alarming. "Without curiosity, you can't have individuality," he said. "It just doesn't exist. And without curiosity or individuality, you're not going to be able to adjust to the modern world."

The trip to China stimulated the initiation of a vast collaborative enterprise called the Rauschenberg Overseas Culture Interchange—ROCI. His experience in China convinced Rauschenberg to develop a network for international artistic communication, an idea that he had been formulating for nearly ten years. "I thought it would be terrible," he said, "to live in this world and not know

what another part of the world was like." Art was the transmitter of information, and Rauschenberg, with his exuberance, his American ingenuity, and his belief that anything is possible, set out to construct a vehicle that would bring art across borders, awaken curiosity, and contribute to worldwide peace. Together with a team of similarly dedicated collaborators, Rauschenberg created ROCI.

On December 14, 1984, he invited a group of ambassadors and representatives of the art world to attend the formal announcement of ROCI at the United Nations in New York. The venue was symbolic of the scope of the project. Rauschenberg spoke of his conviction that "one-to-one contact through art contains potent peaceful powers and is the most non-elitist way to share exotic and common information." To the group assembled in the Delegates' Dining Room, he passed around a signed lithograph he had made to celebrate the event, donating a copy to each United Nations member country.

The artworks he makes for ROCI, Rauschenberg has said, are intended as a contribution to peace, an attempt to change the way people see each other. He explained that his initial impulse for the ROCI project came from earlier experiences working in isolated villages in India and Thailand, and realizing that the people there "had no access to the particular taste and feel of other countries. I'm hoping that communication can be excited to the point where the curiosity, at least, is alive. I'm hoping to spread enough information around—if not to make peace, then at least to feed the curiosity."

ROCI is pronounced "Rocky," for Rauschenberg's aged pet turtle who made her own artistic debut in 1969 when she ambled across the stage with twenty-nine other turtles, wearing a flashlight strapped to her back in his New York theater event, *Spring Training*. The turtle, used as the ROCI symbol, is also an Oriental symbol, that, like Atlas in the West, carries the world on its back. Rauschenberg identifies his artistic mission with that of the Oriental turtle. "His goal," according to Donald Saff, is nothing less than "to introduce the world to itself."

Throughout his career, Rauschenberg had been a political activist, supporting movements for peace, social justice, and preservation of the environment. By the 1980s, however, Rauschenberg said he "had given up on the politicians" and decided that "now it's up to the artists to wage peace."

Rauschenberg believed that "if Israel could see India, and Japan could see Mexico, an international chain of artistic understanding might begin" with the power of art to communicate beyond language, and to break down the barriers of isolation. Rauschenberg acted on his long-held belief that "the artist must be engaged in determining the fate of the earth, that the artist cannot stand aloof, as an observer."

He has described his idea of ROCI as going to a country "which may not be familiar with contemporary Western artists, to interact with the artists and artisans there, to learn their aesthetic traditions, to make work in their settings, to talk to students—to touch on every aspect of art. . . ." In short, to foster a dialogue with other nations through the language of art.

ROCI focuses special attention on what Rauschenberg calls "sensitive" areas of the world—developing countries crippled by poverty, countries with totalitarian governments, which have been isolated not only from American art, but from their own artistic traditions, and Communist countries with which the United States has been in a political deadlock. Since 1982, he has traveled across the globe, making art from the artistic materials and everyday artifacts of other cultures. The overall plan for ROCI included twenty-two countries. From the time of the UN announcement through 1990, ROCI has involved twelve coun-

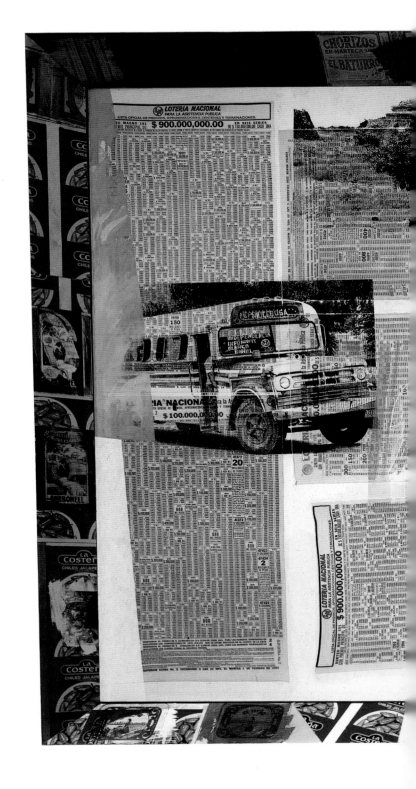

MEXICAN CANARY/ROCI MEXICO *1985. Acrylic and collage on canvas, 80⅓ × 150″ overall. Collection the artist. Colors of the Mexican flag and a canary yellow signal the title.*

tries, including China, Tibet, Chile, Venezuela, Mexico, Cuba, Japan, Malaysia, the German Democratic Republic, and the Soviet Union. ROCI also includes work made in Sri Lanka and Thailand.

The China expedition, as well as a subsequent trip to Japan, helped establish the model for a complicated international cycle of travel, artistic creation, exhibition, homage, and re-creation on a scale never before conceived, let alone accomplished by a single artist. ROCI has taken on a life of its own: it is a constantly changing exhibition that feeds on itself, and a crusade that, having sprung from Rauschenberg's fertile imagination, has taken over and changed his own life and his art.

In each case, when Rauschenberg first goes to a host country, he works with its artists and writers, and travels throughout the country for several weeks taking photographs. He is accompanied by his assistant Terry Van Brunt, who videotapes the artist and everything that he sees. For each country they visit, a major exhibition of more than two hundred works of Rauschenberg's art inspired by his experiences there and in other countries follows within a year or two, and is usually held in that country's premier national museum. Also part of each exhibition is a catalogue with text by a country's leading poets, writers, and journalists. Among them have been Octavio Paz in Mexico, José Donoso in Chile, and Yevgeny Yevtushenko in the U.S.S.R. When the exhibition closes, Rauschenberg leaves behind a work of art as a gift to the people.

As the ROCI road show travels from nation to nation, it brings with it works from each of the preceding venues. Since 1982, when Rauschenberg began on the China ROCI, up to 1989, more than sixteen hundred works of ROCI art have been made. Considering its phenomenal growth, it has become, in effect, an organic body of material, with Rauschenberg as creator. The last stop on ROCI's worldwide odyssey is scheduled as a major exhibition to celebrate the fiftieth anniversary of the National Gallery of Art in Washington, D.C., in 1991.

The first ROCI exhibition, at the Museo de Rufino Tamayo in Mexico City, opened in April 1985 with 250 of Rauschenberg's earlier works and bright, colorful pieces inspired by his travels in Mexico. Next came Chile that fall, followed by exhibitions in Venezuela, China, Tibet, and Japan. In February 1988, the ROCI/Cuba exhibition was simultaneously on display in three major museums in downtown Havana. One year later, ROCI/USSR at the Tretyakov Gallery of Art in Moscow became the first one-man show of a Western Abstractionist in the Soviet Union.

Museum directors have typically reported record-breaking crowds in attendance at each venue. By 1989, more than two million people had seen themselves and their global neighbors through Rauschenberg's idiosyncratic prism of painting, collage, assemblage, printing, video, and performance. To any viewer, it is immediately apparent that communication by this wizard-like artist is not strictly limited to art in the conventional sense: Rauschenberg makes up his own rules for display and so engages his audiences through a variety of mediums, which also may include performances by the Trisha Brown Company (Rauschenberg has designed the sets and costumes over the years), the jazz music of saxophonist Dickie Landry, or public forums where Rauschenberg fields questions from other artists, writers, and students.

In a ROCI exhibition, the installation itself is considered innovative, given that art is conventionally displayed by hanging pictures on wires from the molding. Rauschenberg sends an installation team led by Thomas Buehler to each country. The art is attached directly to the walls, or in the case of some sculptures, placed directly on the floor without pedestals. White paint, a requirement for the

UNTITLED *(Sri Lanka). 1983. Photograph*

installation, is hard to come by in some places. In Cuba and Russia, for instance, the ROCI crew had to bring their own; in China it was made from finely ground seashells.

Alongside Rauschenberg's various works of art are hundreds of his black and white photographs made in different countries, portions of which appear as silk-screened images in some paintings. Van Brunt's videotapes also run simultaneously on as many as ten to fifteen monitors, conveying through perpetual motion what Rauschenberg saw in a given place, what captured his attention. Color tapes of each country are strategically placed near the works from the appropriate countries. In the museums, Rauschenberg is introduced by a biographical film. Some of his earlier works are also exhibited. Via ROCI, Rauschenberg is in the process of revealing a country, and himself too.

THE BUREAUCRATIC obstacles that delayed Rauschenberg's China visit were only a foretaste of the monumental logistical challenges for ROCI.

Orchestrated from a command post in Tampa, Florida, ROCI requires the skills of a diplomat, travel agent, entrepreneur, foreign trader, transportation specialist, historian, and impresario. The organizing mind that makes ROCI go belongs to Donald Saff. In addition to his own work as an artist, professor at the University of South Florida, and director of Graphicstudio U.S.F., Saff is the artistic director of ROCI. Saff makes the initial contacts with a country by actually scouting out a venue, approaches the artists and writers with whom Rauschenberg will work, plots his itinerary, negotiates byzantine arrangements with museum directors and government officials, and designs the installation in each museum. His work is coordinated by assistant director Brenda Woodard. For its advance work and installation, ROCI requires a battalion of collaborators, disciples, and "spear carriers," many of them Rauschenberg staff and volunteers.

Collaboration is Rauschenberg's modus operandi. "If you work alone, then the private ego takes control," he told a Moscow audience at ROCI/USSR. From his joint efforts in the late 1940s with his then-wife Susan Weil, to multimedia performance art with Merce Cunningham and John Cage in the 1960s, and to the prints and sculptures made in such studios as Universal Limited Art Editions (ULAE), Gemini G.E.L., and Graphicstudio U.S.F., he has always worked closely with others. In his own studio in Captiva, Florida, he is surrounded by young artist-assistants.

Donald Saff, the artistic director of ROCI and director of Graphicstudio U.S.F., with Rauschenberg in the artist's studio in Captiva, 1986. Photograph by George Holzer

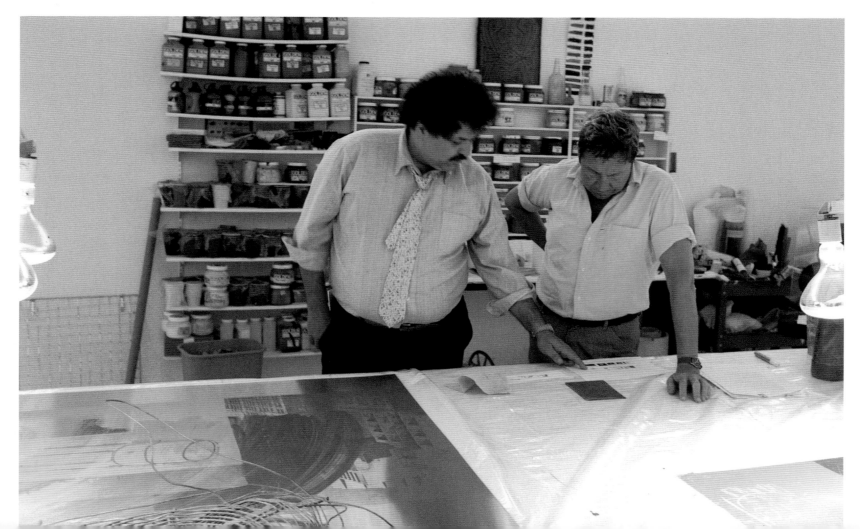

Rauschenberg also expects collaboration from his viewers. Many of his pieces have moving parts; others are activated when a viewer walking by causes a silky scrim or a row of light-as-air Mexican wheat sacks to move gently in the air. Some pieces have mirrors that incorporate the viewer's image into the work. "I want to make you work hard," Rauschenberg told a Tokyo audience at the opening of ROCI/Japan. "I don't want to give you any answers."

The price of Rauschenberg's present campaign to wage peace is enormous, with the seven-year project expected to cost at least eleven million dollars. In order to keep ROCI free of politics, Rauschenberg decided not to seek or accept financial support from the United States government. But finding private financing was not as easy as he had expected. He had originally hoped to solicit support by offering artworks from each country in exchange for funds for travel, installation, materials, and insurance. "I thought collectors and corporations would be rushing to support something concrete like ROCI, which is dedicated to peace," he said. "I even made up a list of contributors I *wouldn't* accept."

When the support was not forthcoming, however, he committed large sums of his own money to sustain the project. He recalled that his exhibition in Beijing in 1985, which brought back to China the art he made there in 1982 including the 7 Characters and a hundred-foot color photograph, made him "nearly bankrupt." The works filled most of the National Museum. The ninety-eight crates took up an entire Boeing 747 cargo jet.

"My pockets are empty," he told a Tokyo audience in 1986, not entirely in jest. Fortunately, the art market has been good to Rauschenberg. Even though he receives nothing from such famous early works as *Rebus* and *Winter Pool* that by the late 1980s resold for millions at auction, he has earned hundreds of thousands of dollars from his energetic production of new work. (In 1989, his new paintings were priced from $100,000 to $550,000.) Rauschenberg lives simply, even austerely, in his Florida island compound. Throughout his career, his major expenditures have been for travel, staff, and his own philanthropy.

ROCI, however, was a daunting outlay even for a wealthy man. After working and exhibiting in eight countries, in 1989 he estimated that ROCI had cost him five million dollars. "I've sold my early Twomblys and Warhols, most of my treasures from other artists, not to mention my own work," he said. "I've mortgaged my property. But I expect to keep on until I totally run out, or until some cosponsors come along."

Rauschenberg has been described as the most American of artists. "By reflecting on society," said Jean-Louis Prat, director of France's Fondation Maeght, "he brought to the rest of the world, in the language of art, absolutely what was America." ROCI—in its scope and ambition, its dedication to democracy and its freewheeling openness, experimentation, and sheer high spirits—is a quintessentially American enterprise.

The ROCI adventure has also represented a period of artistic renewal for Rauschenberg. The enfant terrible of the 1950s and 1960s, who had become a world-recognized master by the 1970s, might well have chosen to spend his later years replicating his earlier triumphs. Instead, he plunged into ROCI, thereby turning his sixties into the most productive period of his life. "I decided that instead of having a mid-life crisis," Rauschenberg said, "I'd do something about the world crisis."

AS PART OF the photography he made in each of the ROCI locations, Rauschenberg searched for common themes of everyday life among the various participating ROCI countries. Traffic signs, graffiti, newspaper ads, vegetables, children at play, even tractor tires were common signs. In his pictures, the twentieth century also rolls by in powered vehicles, many of them military. Visual references to a country's unique traditions in history, religion, and art were likewise documented.

In ROCI/Mexico, for example, the bright combinations of red, orange, magenta, yellow, purple, and green of native fabrics and folk art appear in his art, as do everyday images of lottery tickets, crowded buses, hovels, tequila bottles, and carved statues of saints. An economy in decline found its way to his canvas.

Wherever he went, Rauschenberg challenged his viewers to look beyond their own immediate surroundings. In Venezuela, for example, he chose to go down the Amazon, seeking out native Indian tribes. He ignored the intellectuals in Caracas who questioned his reasons for going there, especially as they felt no connection with the Indians. Rauschenberg went anyway, he said, "because I wanted to meet the people that made up ninety percent of the country."

In the jungles of Venezuela, he found and befriended the Panare Indians, who use pigment from the onoto bean to paint their faces and bodies for tribal rituals. Rauschenberg used this same pigment to reflect his own Amazonian vision. In a painting called *Onoto Snare*, which is primitive in feel and earthy in color, he has silkscreened a sketch of a wild boar which seems to be escaping a collaged net attached to the canvas. Dominating the painting are the rich brown-red colors he made from the onoto bean pigment.

When Rauschenberg decided to go to Chile, his second stop on the ROCI tour, in 1984, his plan met stiff opposition from liberal friends and associates, who felt that he would be aiding and abetting dictator Augusto Pinochet. Rauschenberg disagreed. To work with Chilean artists and writers, and to display art in their country would encourage Chileans struggling to restore basic human rights and a democratic government.

The countries he has visited in his ROCI tour were chosen carefully. Like his choice of Chile, his decisions to go to Tibet in 1982, to Cuba in 1988, and to the Soviet Union in 1989 were governed by artistic and political considerations. Although he has been to countries under democratic rule, the greater challenge has been working with repressive regimes, troubled countries.

When he arrived in Santiago in the summer of 1985, Rauschenberg was startled by the sound of gunfire in the streets. "The situation was volatile," he recalled. "Armed soldiers were everywhere. When we met students, they were nervous. They told us about their friends being 'disappeared.' They didn't know who would be next." The Catholic churches were the only places where students, artists, and political activists felt they could safely meet with him. But even in a church sanctuary, the students were wary, and wondered why he had come to Chile. "Why not?" he asked them. "I am happier to be [exhibiting] here than in the Louvre." Chile, he felt, *needed* his window on the outside world.

In the churches, Rauschenberg photographed the rich details in the statues of saints, crucifixes, and priests' vestments. Then he took his cameras and video equipment and disappeared for two or three days. "All of the art patrons, mostly well-to-do people who lived in Santiago, thought he was crazy," recalled Mario Stein, whose Chilean company later shipped Rauschenberg's art. "His equipment would be stolen. He would be attacked. But he wanted to go out among the people, to see the other side."

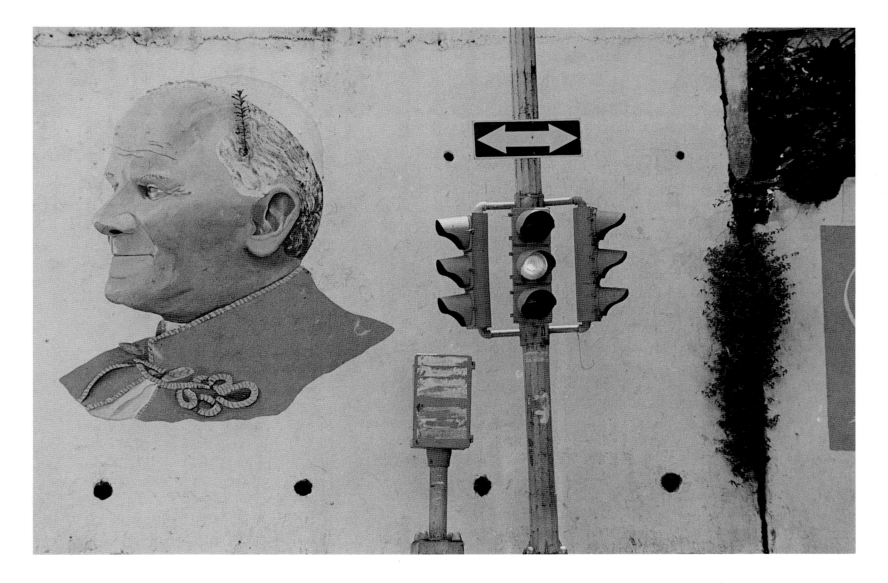

UNTITLED *(Venezuela). 1985. Photograph. The drawing on the wall is of Pope John Paul II.*

The power of the images he saw moved him, as did his experiences with the students and his view of the churches, the landscape, and scenes of everyday life. He documented the streets of Santiago—vendors, soldiers, bus jams, walls lined with political slogans. And as he did in all poor countries, he photographed the hovels where millions of people live out their lives.

Out in the countryside near Antofagasta are the copper mines, a mainstay of the Chilean economy. These, too, Rauschenberg visited, including a descent into a smelter, where he photographed cascading sheets of molten copper ore. From this experience he devised his Copperheads, the series of works for ROCI Chile. On gleaming eight-foot sheets of copper, he silkscreened a medley of images from his photographs. The double-edged title Copperhead refers to the name of a poisonous snake and to the danger coiled and ready to strike in Chile. Rauschenberg said he made the copper works after "smelling the politics" there.

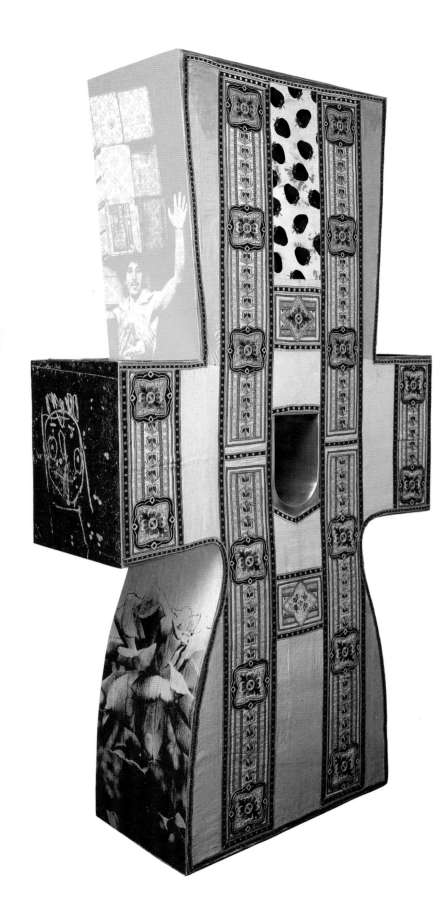

ALTAR PEACE CHILE/ROCI CHILE *1985. Sculpture of acrylic and collage on aluminum, with light bulb and fan, 79½ × 44½ × 15¼". Collection the artist. The most dramatic piece of this crucifix-shaped sculpture is a priest's white satin vestment filled with glowing light. Here Rauschenberg pays homage to the Catholic Church as a refuge in a totalitarian regime.*

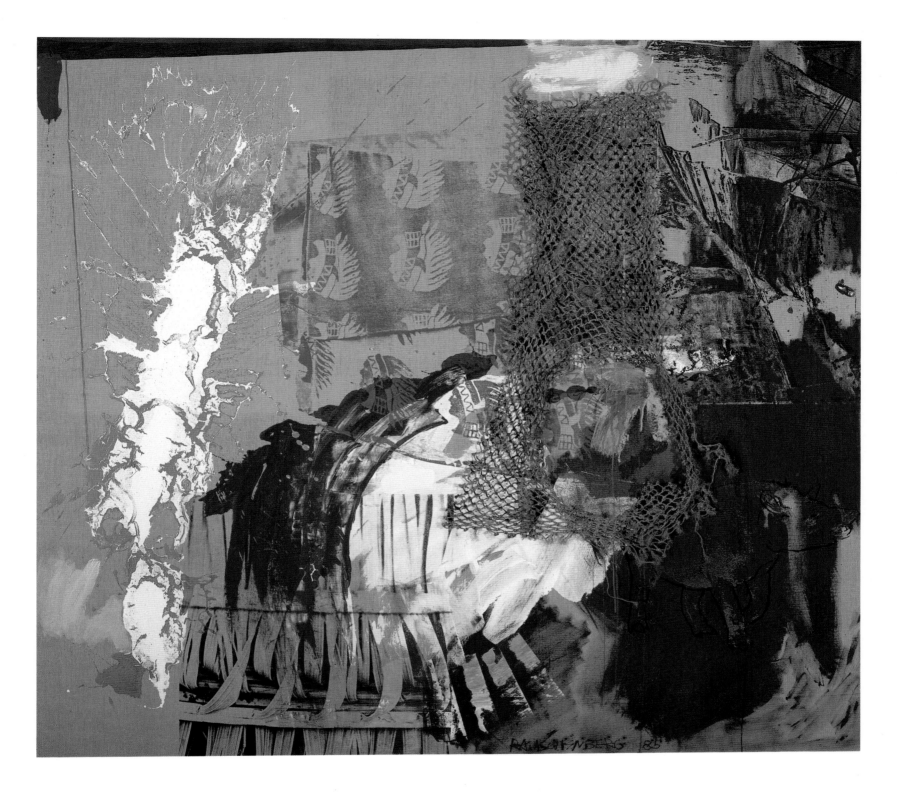

ONOTO SNARE/ROCI VENEZUELA *1985. Acrylic and collage on canvas, 69¾ × 78⅜″. Collection the artist. Rauschenberg used pigment made from the berries of the onoto plant to convey the color of the Amazon. The "snare," a net affixed to the painting's surface, is used by the Panare Indians to trap wild boar.*

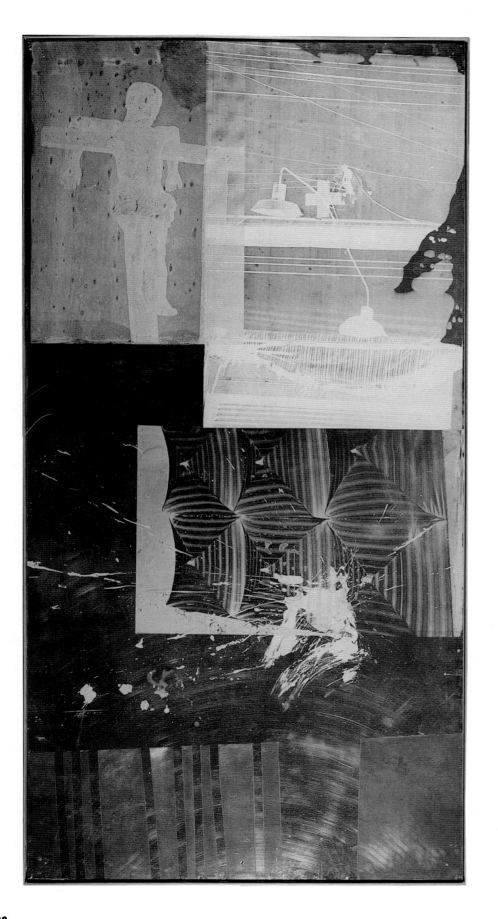

COPPERHEAD BITE V/ROCI CHILE *1985. Acrylic with corrosives and polishes on copper sheets, 97×51¼". Collection the artist. The Chilean dictatorship of Augusto Pinochet, which Rauschenberg found "poisonous," inspired the double entendre in the series title.*

ARAUCAN MASTABA *(ROCI Chile). 1986. Paint and screen-printing on mirrored aluminum object with sterling silver and lapis lazuli (edition of 25, Graphicstudio U.S.F.), 20⅝ × 22 × 22". With its depiction of the Chilean madonna, the ancient flat-topped "mastaba" pyramid juxtaposes the religious strains in Latin American culture.*

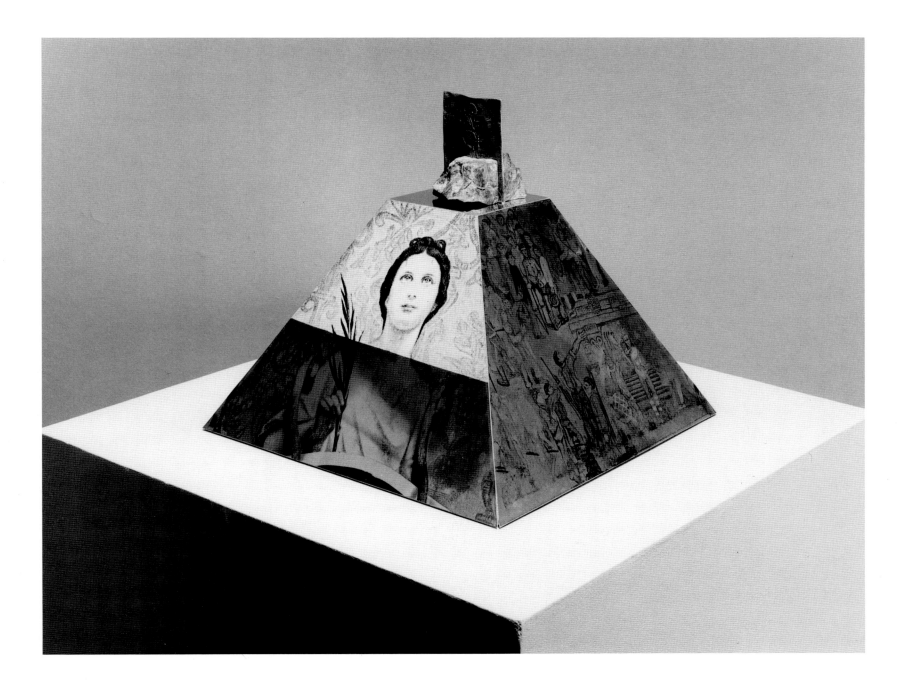

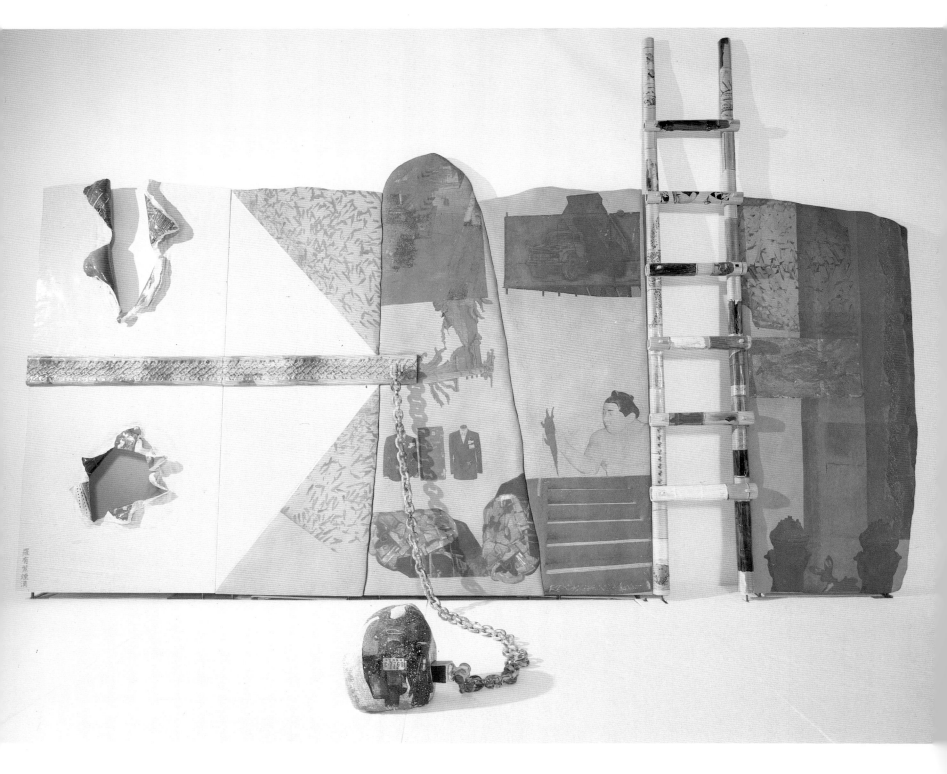

NOTHING about ROCI is more important to Rauschenberg than his collaboration with artists and artisans in the various countries he visits. International cooperation has been his aim, and a satisfaction he has enjoyed. It has also opened the prospect of using new materials for his art, especially so in Japan.

Even though Japan did not fit the ROCI model of either an isolated or a developing country, Rauschenberg was intrigued by this modern power with its unique cultural tradition largely maintained. Part of ancient Japanese tradition in the arts was ceramics, a medium he had used only once before, in an edition of clay boxes at Graphicstudio U.S.F.

He had learned of a new process, developed by the Otsuka Chemical Company, to make large-format ceramic tiles in bright colors that were said to be able to hold their hues, even in extreme outdoor weather, for three thousand years. He traveled to the Otsuka plant in Shigaraki, near Osaka. Known as Potter's Valley, the land there is endowed with a special kind of powdery "peach-blossom red" clay, with which Japan's finest pottery makers have worked for more than seven hundred years. In the late summer rainy season of 1982, Rauschenberg moved to the village to collaborate with the chemists who had perfected a way to transfer photographed images onto the clay.

Rauschenberg lived in a traditional, bamboo-roofed Japanese house, sleeping on a tatami floor and bathing in a steaming cast-iron tub heated by a live fire underneath. Shoji screen doors opened onto a courtyard with a bamboo garden. Every morning he and Terry Van Brunt would bicycle down to the factory to collaborate with the thirty Japanese technicians working with the clay.

The mud fascinated Rauschenberg. He explained to the workers that he wanted a ceramic surface that looked like the dirt of the local area. Once the color and texture were achieved, he helped the chemists make unusual shapes from the soupy clay, including an exceptionally large panel with a hole in it. Using the time while the clay pieces baked in the kiln, Rauschenberg and Van Brunt bicycled through the countryside, making the photographs that Rauschenberg would affix as silkscreen decals to the ceramic tiles.

What emerged from this effort was *Dirt Shrine*, a three-dimensional ceramic sculpture, a celebration of traditional Japanese culture and twentieth-century technology. On the back of *Dirt Shrine*, Rauschenberg listed the names of the Otsuka chemists and ceramists who helped invent the process. "Shigaraki is a great place," Rauschenberg exulted. "No telephone, no movies—but great mud!" When he finally left, eighty workers lined up in the rain to pay him their farewell respects.

DIRT SHRINE: SOUTH *(Japanese Clay Work). 1982. High-fired ceramic, 120 × 179½ × 75". Collection the artist. Made at the Otsuka Chemical Company's ceramic works in Japan's "Potter's Valley,"* Dirt Shrine *is named for the region's red dirt. References to Rauschenberg's artistic past—a ceramic tire track from* Automobile Tire Print *(1951) and ladder from* Winter Pool *(1959)—intersect with imagery from ancient and modern Japan printed on photographic decals and fired into the glaze.*

PNEUMONIA LISA *1982. (Japanese Recreational Clay Work). High-fired ceramic, 32¼ × 86½". Collection the artist. Working with chemists at the Otsuka Chemical Company, Rauschenberg drew with glazes to produce playful renderings on Old Master paintings, which the technicians had copied in tough, high-fired (at 800°) ceramics.*

Rauschenberg and technicians screen-printing on ceramics at Otsuka Chemical Company, Shigaraki, Japan, 1982. Photograph by Terry Van Brunt

RAUSCHENBERG has been adamant about being portrayed as an independent artist, and not as an official representative of his country. Nevertheless, he has found himself in situations in which his art and ROCI did have a diplomatic function. Such was the case with ROCI/Cuba. At a time of hostile relations between the United States and Cuba, with trade and cultural exchanges virtually nonexistent, Fidel Castro went out of his way to provide Rauschenberg with a showcase, even sending a Cuban ship to bring the American artist's exhibition from Japan.

Rauschenberg's art made in Cuba conveyed his very mixed impressions of the place. The grayness which he said he saw in Cuba was portrayed through his use of dull gray anodized sheet metal as canvases for his serigraphed pictures and paintings. The bright primary colors he used on the metal were inspired by the frequently painted, pre-1959 American cars still proudly running in Havana, tail fins and all. His imagery included crumbling colonial architecture, huge Russian trucks hauling building materials, posters depicting the dead hero Ché Guevara, sugarcane fields, and a skull-in-chains religious relic.

The deepest message of Rauschenberg's ROCI art concerns freedom of expression, freedom of the individual, and basic human rights, which he found in short supply in Cuba. Propaganda in particular distresses him. During the opening-day festivities of ROCI/Cuba, one student complained that "the works you have made in Cuba do not show our whole progress." "To break down barriers," replied Rauschenberg, "I think you need to see as an alien does—to get lost in the city, or in the country, to see things in Cuba that maybe you are blind to."

In a country where huge billboards depict Uncle Sam as a growling menace, and the equality of poverty is the most visible sign of the revolution, Rauschenberg spoke for individuality. "Control is the enemy of art," he told the Cuban students. "I've always been for the eccentric. It's our uniquenesses that are important, that make all of us have respect for each other." He criticized Communist billboard art for its "exaggerated focus on propaganda" rather than a "universal response to life itself."

On the night before the exhibition opened, Fidel Castro greeted Rauschenberg at an official dinner held in the Palace of the Revolution. The two men got on well together. Rauschenberg agreed with Castro that the official United States cold war policy toward Cuba should end. Castro invited Rauschenberg and his party to spend the weekend at his personal beach house. When Rauschenberg reciprocated with a similar invitation, Castro roared with laughter. "This is the first time in twenty-nine years I have been invited to the United States," he said. Through his interpeter, he asked, "But if I were to vacation on your island in Florida, what would I do there? Are there not tires and refrigerators and automobiles on the bottom of the ocean?" "No, there are fish and I will cook for you," Rauschenberg replied.

He showed Castro *Hibiscus Fever*, the painting he was presenting to the people of Cuba. It is a vivid red square on two panels of galvanized metal, with acrylic silkscreened images of Rauschenberg's Cuban photographs. Among the imagery is a "microbrigade" worker, taking time off from his factory job to rebuild a house for a day-care center. The microbrigades and day-care centers, as it turned out, were Castro's favorite projects.

HIBISCUS FEVER/ROCI CUBA *1988. Enamel and acrylic on galvanized steel, 72¾×84¾". Collection Museo Nacional de Bellas Artes, Havana. Contemporary Cuban imagery is printed in the vivid colors of hand-painted old American cars that Rauschenberg observed in Havana's streets.*

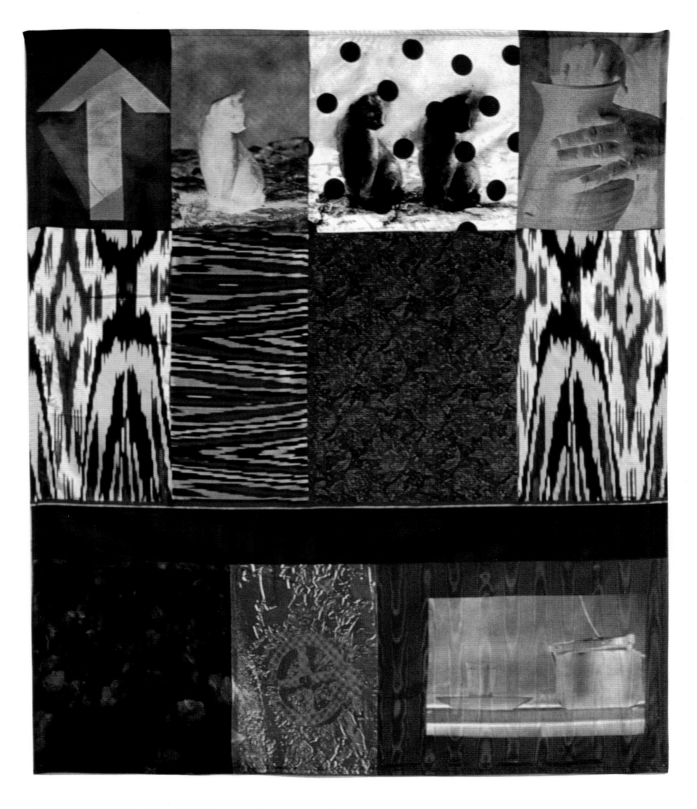

SAMARKAND STITCHES *#5 (ROCI USSR). 1988. Unique fabric collage with screen-printing (edition of 50 unique variations, Gemini G.E.L.), 56×46". In the Soviet Union, Rauschenberg was impressed by the patterned silks woven by the nomads of Samarkand.*

WHETHER THE ROCI exhibitions have contributed, even in a small way, to the cause of world peace will be difficult to assess. There is no doubt, however, that Rauschenberg has reached an enormous new audience, and that he has sparked interest not only in his work, but also in contemporary art.

At the Moscow opening on February 5, 1989, the poet Yevgeny Yevtushenko spoke to the crowd jammed into the Tretyakov Gallery's new Central House of Culture. "I believe no more Iron Curtains will divide U.S. and Russian artists," he announced to the twelve hundred artists, diplomats, and professors gathered to open ROCI/USSR. For the first time, an American Abstractionist had been honored with a one-man show in the Soviet Union. Robert Rauschenberg, wearing a colorful silk vest from Samarkand, stood between his new friend Yevtushenko and Andrei Voznesensky, the poet with whom he had collaborated on a series of prints many years earlier.

On the gallery floor, composer Dickie Landry played an abstract jazz improvisation on his saxophone. At the Palace of Culture, in the automobile district, the Trisha Brown Company, of which Rauschenberg is chairman, performed the world premiere of *Astral Convertible*. Rauschenberg financed the company's performances and had the sets flown in from New York. He had designed the sets for the new work—freestanding, derrick-like towers containing the lights and music for the stage, which were powered by automobile batteries and activated by the movement of the dancers. The audience, unused to the freedom of modern dance, sat in stunned silence during the final curtain.

Even though the Soviets did little to advertise the exhibition, word of the new ROCI show quickly spread around Moscow. The first day, a half-mile-long queue of mostly young people waited outside the museum for hours. By the end of the month, 145,000 people had purchased tickets for the exhibition, in addition to Communist Party members, who were admitted free.

In the week following the Moscow opening, Rauschenberg assistant Darryl Pottorf observed that many of the same groups of young artists returned day after day, studying the pictures, barraging him with detailed questions about techniques and materials. "The show is very important for Soviet artists—emotionally, spiritually, and socially," said Soviet painter and critic Leonid Bazhanov. "Never before have they seen works of such scale and quality. To us, the show symbolized freedom." Macia Shashkino, Twentieth Century coordinator for the Tretyakov, said, "this was the most important art exhibition to come to the Soviet Union in our lifetime."

In China, nine thousand people came to the National Museum of Art in Beijing on opening day, November 15, 1985; before the show ended one month later, more than three hundred thousand people had seen ROCI. Clearly, it was an audience hungry for information about the West. But Rauschenberg's art is not for everyone. Many foreigners, like many Americans, are puzzled or offended by it. Some Chinese viewers, according to press accounts, were critical of the notion that cardboard boxes were "art."

Yet one Chinese university brought its entire art department to Beijing for a month to study the exhibit. "Rauschenberg brought an impetus so that Chinese artists can look forward with full force," wrote artist Yao Qing-Zan. "They can walk out of the threshold of old ideas and forms, so as to face the world." And critic Zheng Sheng-tian wrote, "Rauschenberg takes Chinese audiences across a hundred years of art. It is very important to know who our neighbors are, what their faces look like."

At the ROCI opening in Lhasa in December 1985, fireworks popped and exploded into starbursts in the sky as the Tibetan flag-banners Rauschenberg

had made for the museum fluttered in the freezing wind. Rauschenberg tossed a bit of sand, Tibetan custom, to inaugurate the exhibition. Inside, fur-hatted Tibetans wandered among the art, sometimes anointing the odd, intricate works with *ghee*, the rancid yak butter they carry around in a jar to mark holy places. On the floor, a little dog headed straight for *Narcissus' Father*, a piece consisting of a yellow fireplug mounted on a mirror. After the opening, Rauschenberg taught a swift jitterbug to Tibetan folk dancers in brightly colored costumes. He felt, he said, that the Tibetans were free spirits like himself. Less than a year later, however, after demonstrations for the right to worship, free expression in Tibet was suppressed, and foreigners expelled. Reflecting recently on Tibet and China, where his art had produced such curiosity and hope, Rauschenberg was outraged when the Marxist political machinery crushed the demand for democracy in Beijing's Tienanmen Square. He remained optimistic, however. The door had been opened.

CRITICS, among them Robert Hughes, have praised ROCI for its artistic breakthroughs, such as the Japanese clay sculptures and the delicate Chinese paper works, as well as for Rauschenberg's efforts on behalf of communication, freedom, and peace.

Jack Cowart, curator of twentieth-century art at the National Gallery of Art in Washington, D.C., who visited ROCI exhibitions in Moscow and Havana, believes that the ROCI shows tell international audiences "about Rauschenberg— and by inference about the freedom of activity and expression that is allowed to flourish on the American scene. To foreign audiences—especially those in which freedom of information is unknown, the exhibition makes a powerful statement about America itself."

Hughes, however, questioned the notion that ROCI could actually "cause nations to shelve their mutual distrust" and to adopt Rauschenberg's call for freedom and peace. Yet he has written that Rauschenberg may succeed in other ways, inspiring individuals much like a great historical novelist does with a utopian vision. "In the ROCI project," Hughes wrote in *Time* magazine, "one may eventually see the flowering of Rauschenberg's mature identity: the arcadian as utopian, spinning a poetry of affirmation out of an opaque and hideously conflicted time."

Rauschenberg himself found that as he looked closely at life in very different parts of the world, his own artistic vision was affected. He told an audience in Japan that "the function of art is to make you look somewhere else—like into your own life—and see the secrets that are in the shadows, or in the way the light falls somewhere." As he made art in country after country, his found objects became more exotic, the colors more vivid and jewel-like. His firsthand observation in many lands sharpened the humor, irony, and social commentary that have always characterized his work.

Even after the physical and financial drain of seven years of almost continual travel for ROCI, Rauschenberg still was driven to create more art for the project and to seek wider audiences for its message. His sense of mission fueled a protean energy. "Bob once wanted to be a preacher," said Leo Castelli, his longtime dealer. "He is a preacher still."

Although he gave up the idea of a religious calling while still a teenager, Rauschenberg's life and work have been shaped by the values and experiences deeply rooted in his Texas childhood. The key to understanding his art is to be found there.

TWIN BLOOM/ROCI TIBET *1985. Assembled parts with acrylic paint,*
17 × 28½ × 14". Collection the artist

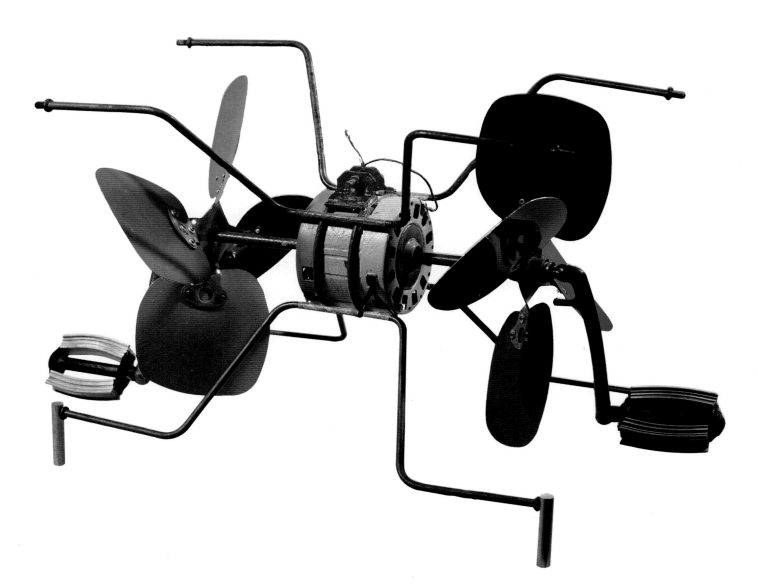

THAI XIV *1983. Solvent-transfer, acrylic, and gold leaf on rag board, 10¾ × 9½". Collection the artist*

SRI LANKA VIII *1983. Solvent transfer, watercolor, and acrylic on rag board, 21½ × 15". Collection the artist*

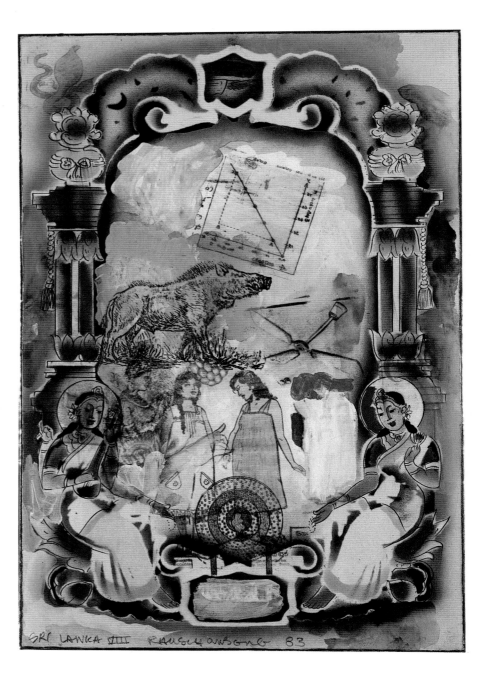

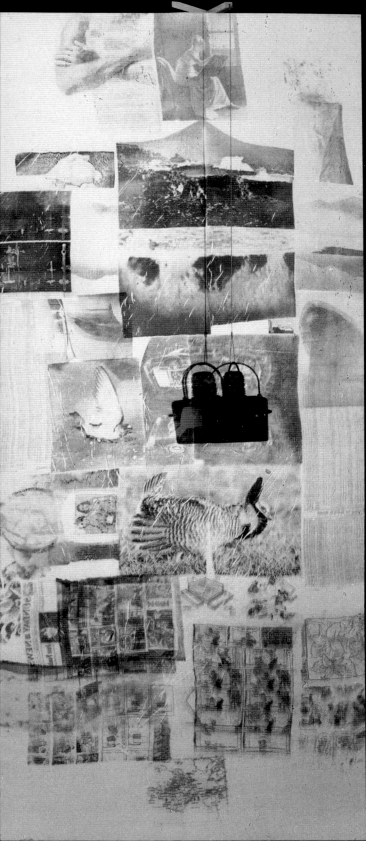

WHISTLE STOP

RAUSCHENBERG'S *Whistle Stop* (1977), a five-paneled painting from his Spreads series, evokes a particular time and place in the American past. Cowboys traditionally long for "spreads"—wide open stretches of range they can call their own. In *Whistle Stop*, an old pair of screen doors hinged on the center panel opens onto imagery that spreads across the entire fifteen-foot expanse of the painting. Pictures of marshland and wild birds are interspersed with scenes of the Southwest. The array of images, clipped from magazines and newspapers and printed on the panels, also celebrates the lives of ordinary people.

A picture in a newspaper resembles the artist's mother as a young woman. Other imagery includes a 1930s-vintage blue Lincoln coupe, a prairie chicken, Indian arrowheads, and the yellow rose of Texas. Faded comic strips of Dick Tracy and Blondie, and a Coca-Cola bottle suggest the commonplace; a ship with *GULF* emblazoned on it sets the locale. In the center panel, behind the screen doors, is an architectural diagram of a very modest house, one room directly behind the other, with plain doors echoing the real screen doors attached to the painting.

The painting, commissioned by the Fort Worth Art Museum, is dedicated to the artist's father, who grew up in a small frame house, like the one pictured in *Whistle Stop*. In the South, these were called "shotgun" houses because if you shot a gun through the front screen door, the shot would pass straight through the house and out the back door.

The dominant object in *Whistle Stop* is a small red lantern, similar to ones on the caboose of Port Arthur–to–Beaumont trains in use long ago. It hangs from the top of the picture by a piece of thin, silvery cable. Battery powered, it blinks continuously, casting a red glow across the painting. The small unpretentious railroad lantern indicates that this is, after all, just a whistle stop: a little place where the train passes through.

WHISTLE STOP (Spread). 1977. Solvent transfer and collage on plywood panels with objects, 84×180×9″. Collection Modern Art Museum of Fort Worth

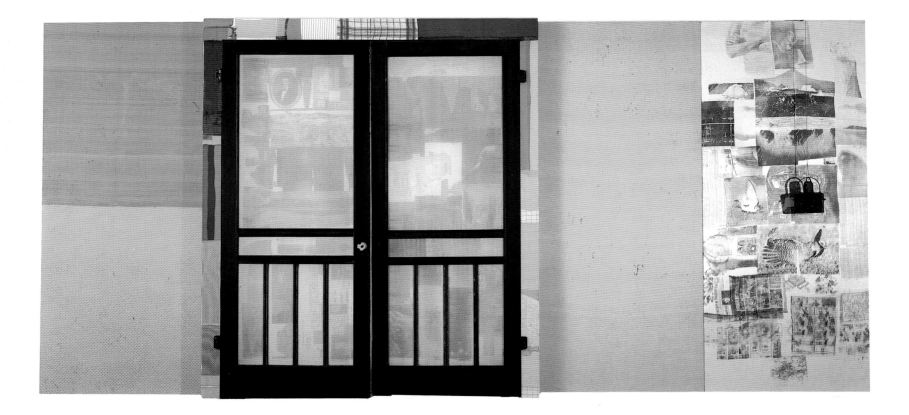

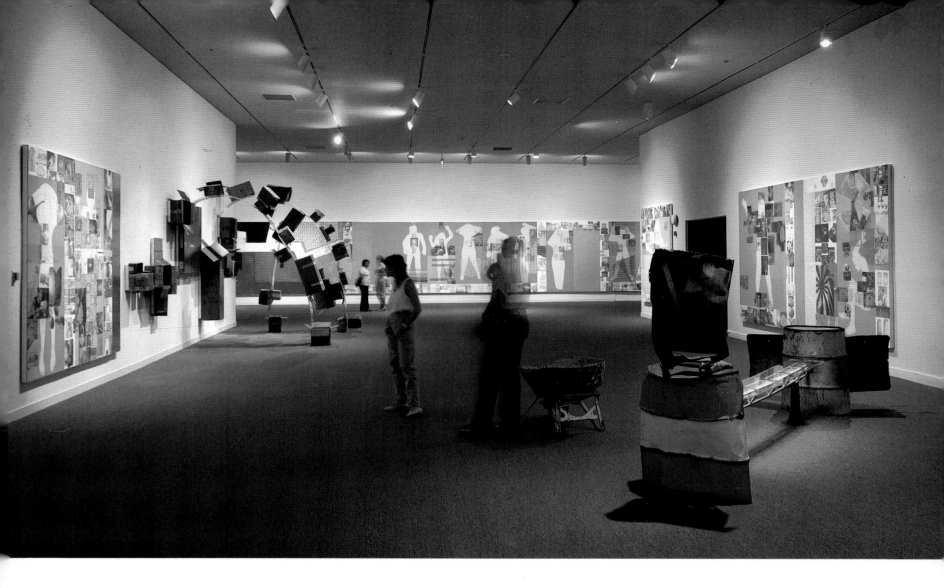

THE ¼ MILE OR 2 FURLONG PIECE *1981–present. Mixed medium, work in progress. Collection the artist. Throughout Rauschenberg's career, homespun images and objects such as this oil drum refer back to Port Arthur.*

FOR A YOUNG boy growing up in Port Arthur, Texas, the heavy aroma of petroleum was a fact of life, and though it was always in the air, it was never easy to tolerate. Rauschenberg recalls that at night the smell permeated his dreams. Even years later, the artist says that an open can of motor oil still reminds him of Port Arthur.

The huge Gulf and Texas Company oil refineries supported the seaport city, which developed along the salt marshes and bayous of southeast Texas. Like a giant erector set on four thousand acres, the girders and struts of the refineries dominated the skyline. During Port Arthur's heyday in the 1930s, the refineries processed thousands of barrels of crude oil daily, and provided jobs for most of the area's fifty thousand residents. Port Arthur was and is a blue-collar town, its neat one-story wooden bungalows laid out on a grid of streets cut through the flatland and surrounded by palmettos, pampas grass, and magnolias. In the summer, the mosquitoes were gigantic, and the humidity so pervasive that the bed sheets in Rauschenberg's house were always damp.

The Gulf of Mexico was eleven miles away, connected by the Intercoastal Canal to Port Arthur. With its ocean-like waves and huge tankers, the Gulf was an invitation to a larger world. Ernest Rauschenberg, the artist's father, worked for Gulf States Utilities, the power company.

Ernest Rauschenberg, power company lineman with Gulf States Utilities, c. 1940.

Rauschenberg at eighteen months in front of the bandstand in Gates Memorial Park, with Port Arthur Library in background.

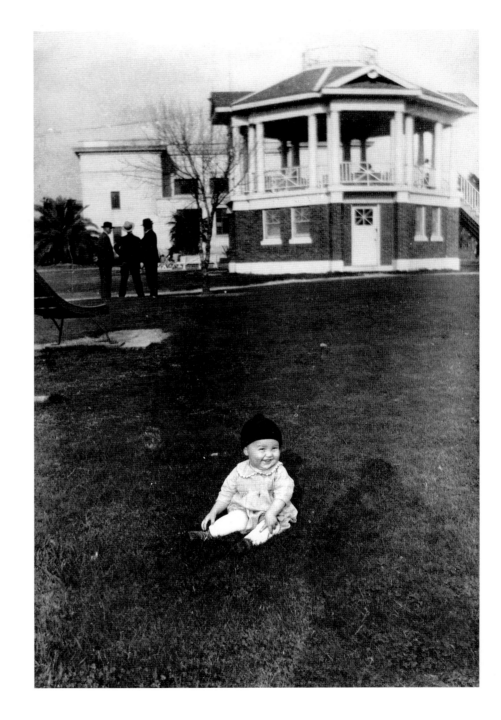

Ernest was the son of a German doctor, Robert Rauschenberg, who emigrated in the nineteenth century from Berlin to the little town of Cameron, Texas, where he married a Cherokee woman. His mother died of tuberculosis before Ernest was seven, and his father, not long afterward. The boy was taken out of school and worked as a farm hand for relatives until 1921, when, at the age of seventeen, he took a job as a grunt—a maintenance man's helper—for the trolley line owned by East Texas Electric, later to become Gulf States.

The next year Ernest Rauschenberg won the heart of a Texas beauty, Miss Dora Carolina Matson from Galveston, a telephone operator in Port Arthur, and they soon married. On October 22, 1925, their son, Milton Ernest (later self-named Robert), was born in the Mary A. Gates Hospital.

Although he never got to own a spread of land, Ernest Rauschenberg was grateful for his job with the power company. "Gulf States was his whole life," says Rufus Mier, who worked on his line gang. "Bully Rooshenberg," as they called him (short for "Bullshevik," the Texas nickname for someone with a foreign-sounding surname in the 1920s), was a slender, serious man who always wore his high-laced lineman's boots. The men who worked alongside Ernest Rauschenberg—digging postholes, shinnying up to the top of the poles, stringing wire—respected his dedication. "He was very businesslike, didn't joke around a whole lot," recalled Leonard Gaspard, who came to work as a grunt in the 1940s when Ernest Rauschenberg was commanding a crew of eight.

Ernest's son Milton, as Bob Rauschenberg was called then, was a cherubic "sweet child," according to his mother. The family often went on outings to the Gulf beaches and walked along the sea wall on the Intercoastal Canal to see the huge barges and tankers. They spent time with their kinfolk in the country, took picnics to the city park behind the Gates Memorial Library, and listened to the performers in the bandstand. The family was poor, but so was almost everybody in Port Arthur during the Depression. Texans are especially proud people. "I'm just as good as you are" is bred in the bone. They believed in the American Dream: you can go as far as you want, so long as you believe in God and yourself, and work twice as hard as the next fellow. Like most of their neighbors, the Rauschenbergs had rural roots, and felt connected to the land. Education, Ernest Rauschenberg believed, was the key to a better life.

Making do was a proud accomplishment. Nothing was ever thrown away, but to be used at some time, in some way or another. Dora Rauschenberg, who had learned to sew because as a girl she'd had to wear too many hand-me-downs, made everyone's clothes. Bob Rauschenberg remembers that she was famous in Port Arthur for arranging her paper patterns on the fabric so tightly that not an inch of cloth was wasted. "That's where I learned collage," he said.

As a child he was torn between embarrassment at having to wear homemade shirts when everybody else wore store-bought, and appreciation that his mother had spent all that time and effort making something for him. Dora Rauschenberg scrubbed her clothes on a washboard, she planted vegetables and canned them in the summer to feed her family in the winter, raised chickens in the backyard for Sunday dinner, and occasionally sewed for the neighbors as well as for her family.

The Rauschenbergs' little rented shotgun home is no longer there, but the adjacent bungalows still stand on 17th Street in Port Arthur, some with automobile tires filled with flowers in the front yard. Their wooden screen doors are like those in *Whistle Stop*. The Rauschenbergs' kitchen had linoleum on the floor, straight wooden chairs, and on the wall a dreary Dürer reproduction, even though they didn't know anything about the artist. "We were ordinary working people," Dora Rauschenberg said. "Art was not in our world."

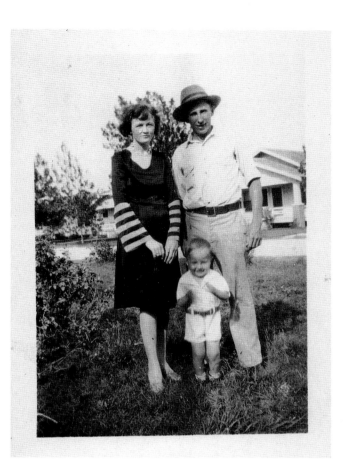

Dora, Ernest, and Milton Rauschenberg in front of their home, Port Arthur, Texas, 1928.

That Milton could draw was a talent not especially valued. He copied the funny papers—Mickey Mouse, Dick Tracy, Blondie, Popeye, and Betty Boop—in the margins of his notebooks. When he was about ten, he painted fleur-de-lis all over his room, only to receive threats of a severe whipping from his father.

Ernest Rauschenberg's passion was hunting. In and around Port Arthur, he was renowned for his duck-hunting prowess. Out before dawn in his boat among the marshes, he would shoot and bring home a brace of wild ducks every time for Dora to dress and cook. He was a bass fisherman, too. In the game-rich bayous and lowlands of Lake Sabine, "Bully" Rauschenberg took his young son out in the boat, taught him to cast, reel in, and scale and clean a fish.

Bob Rauschenberg loved the fishing, and still does to this day, dipping into the Gulf of Mexico from his home on the Florida shore to reel in his dinner. But he hated the hunting, even though the hunting dogs, Queenie and Rex, were his pets. He could not understand how anyone could kill animals for sport, when in his own backyard he had a number of pets—ducks, rabbits, frogs, a goat. And he was terrified of his father, a strict disciplinarian who did not spare the rod.

THE ¼ MILE OR 2 FURLONG PIECE *(Detail). 1981. Mixed media, work in progress. Collection the artist. The homemade shirts of Rauschenberg's past now used in his art.*

ORPHIC DITTY *(Salvage). 1984. Acrylic on canvas, 81⅛ × 110″. Collection Bernard and Sally Sirkin Lewis*

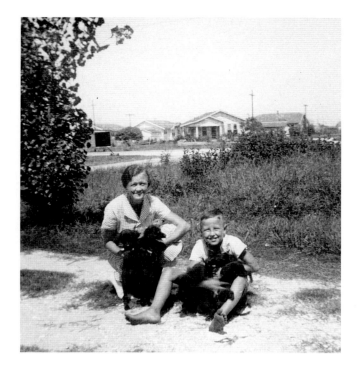

Dora and Milton Rauschenberg with a litter of puppies, by Queenie, his father's hunting dog, in 1937. Their home is in the background.

Chickens, like this white Plymouth Rock rooster, the crowning bird of Odalisk *(1959), were a common sight in the Rauschenbergs' backyard. This photograph documents the first stage of* Odalisk, *at Rauschenberg's Fulton Street studio, c. 1954.*

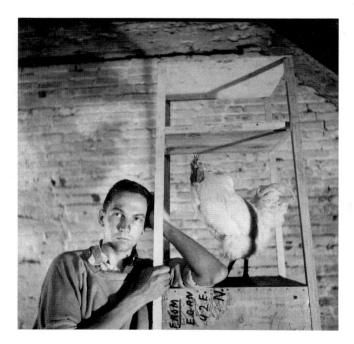

Dora Rauschenberg's passion was the church. The Sixth Street Church of Christ had enough activities to occupy the most devout family. Young Milton was steeped in Bible stories, memorized Bible verses every week, and was baptized as a believer when he was eight. The fundamentalist Church of Christ frowned on drinking, movies, any kind of gambling, even card-playing for fun, kissing—before marriage—and dancing. Pleasure Pier on Lake Sabine, with its dance pavilion, was definitely off limits.

Dora Rauschenberg was a gentle and merry person who emphasized the Thou Shalts more than the Thou Shalt Nots. By the time his sister, Janet, was born when he was ten, Milton had also been steeped in "God is Love" and the precept to love thy neighbor. He took to heart the teachings of Jesus, particularly the words blessed are the meek . . . blessed are the poor. . . .Those ideas structured a value system that would inform his life, and his art.

As a child, he was religious, and he was shy. At grade school he hid during recess, mortified that he would be noticed. At home he climbed trees to avoid being seen, or scooted underneath his house to play with his live insect collection. Yet his impishness would pop out. In the same spirit in which he decorated his room, he swam across the church baptistry after he had been immersed.

He rode his treasured bicycle, wheeled big automobile tires along the gravel streets, floated in the canal in inner tubes, built go-carts out of wooden boxes, learned to whittle, spun an intricate life of daydreams, and somehow knew he was special. Around the age of thirteen, Milton Rauschenberg felt the call to preach. To a young boy in backwater Texas, the minister was the next thing to the Lord Himself. He would be a minister, with the power to reach people, to counsel the needy and console the grieving, and to save souls. He entered adolescence at the beginning of World War II. Like everybody else, the young Rauschenberg collected scrap metal for the war effort. He said a prayer for the boys overseas, and worried about the killing.

He had a talent for dancing and drawing. Drawing was nothing special, he thought. But dancing was. Milton Rauschenberg could dance up a storm, and every girl in Port Arthur knew it. It was love of dancing that led to a clash with his beloved church. "You weren't supposed to dance, or go to movies, or rock in a rocking chair on Sunday," he said. "Everything you did, if it could possibly be interpreted as an indulgence, was evil."

When his minister forbade him to dance, Rauschenberg said he "gave up that ambition to be a minister, because I just wasn't that interested in sin. I don't like negative input."

The teenaged Rauschenberg, who spent his Friday evenings swinging to Glenn Miller and Tommy Dorsey records—even doing the Texas One-Step to Roy Acuff—found a new outlet for his creative impulses in the theater. The Thomas Jefferson High School 1943 yearbook shows the clean-cut, smiling Milton in the Drama Club. He was costume designer for the Repertoire Players, often drawing antebellum costumes (*Gone with the Wind* was enormously popular at the time) whether they were appropriate or not, recalled one of his drama club friends, Mary Nell Dore. "He was a handsome boy, with a clear, fair complexion. But he was not full of himself. He was humble within himself, and kind to everyone," she said. "He was very gentle then, soft-spoken, almost bordering on shy."

He remembers himself as a misfit in Port Arthur, even though he was regarded by others at the time as a model student and a leader. He was an officer on the student council as well as other organizations. "He was a *definite* leader," said Mrs. Mary Evelyn Dunn Hayes, who taught social studies at Jefferson for fifty years. "He was an above-average student, gregarious, an extrovert, but with

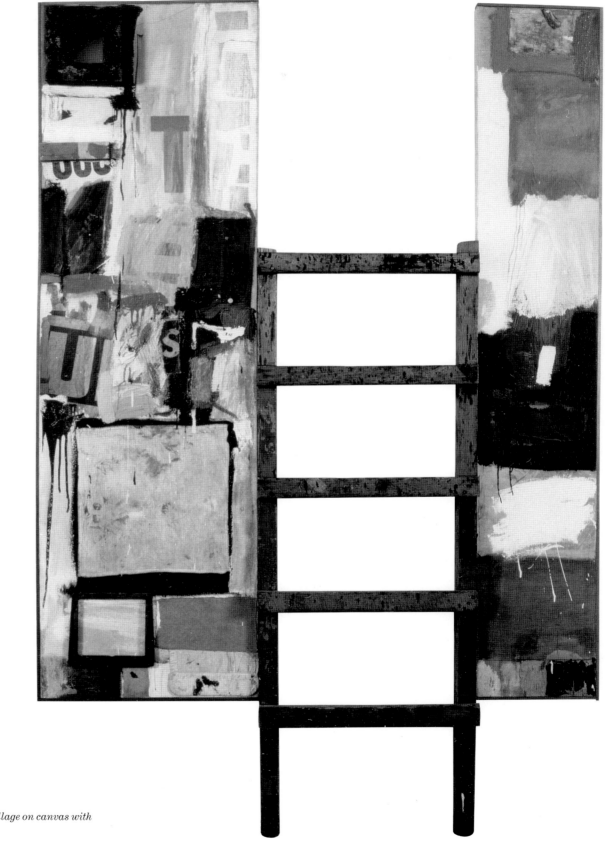

WINTER POOL *1959. Combine painting: oil and collage on canvas with object, 88½ × 58½ × 4″. Private collection*

HOG HEAVEN *(Scale). 1978. Solvent transfer, acrylic, and collage on plywood panels with objects, 84 × 133¼ × 92″. Collection Mr. and Mrs. Richard S. Lane. For Rauschenberg, a tire symbolized the means "for getting from one place to another in a state that covers such vast spaces, and for getting out of Port Arthur."*

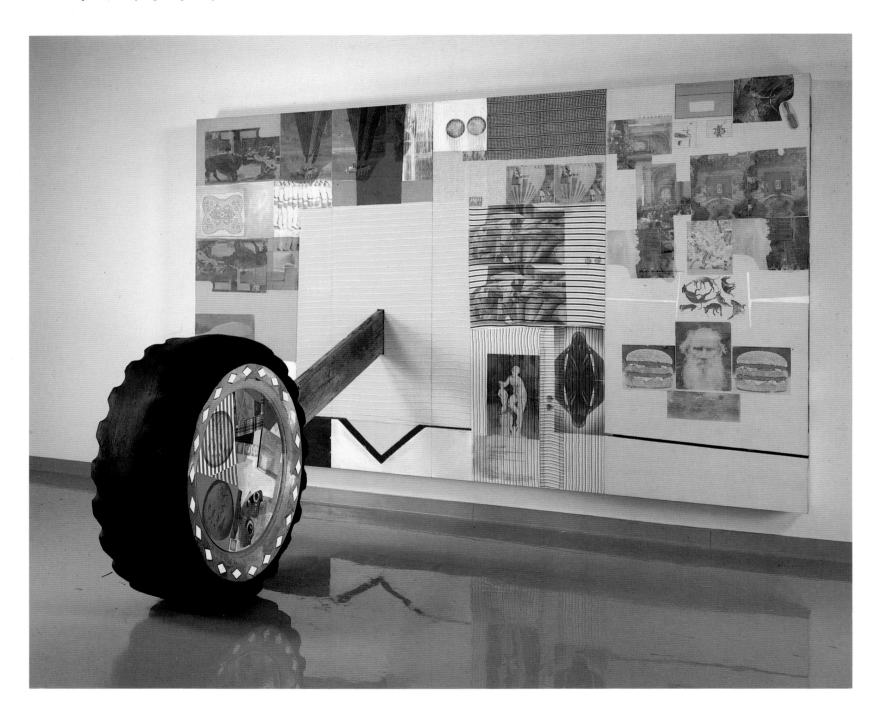

such good manners," she recalled. "Whenever he saw you, anywhere, he 'helloed' you just like he was so glad to see you. He didn't take art until his senior year. But he always had ideas: Milton always had some solution to suggest. You knew he was going to go someplace, but you didn't know *where*."

When Rauschenberg graduated from high school in 1943, no one was happier than he. He hated the conformity imposed by a small southern city. "There was no room for the exception," he said. He imagined a wide world beyond Port Arthur, even in wartime. His dreams were vivid—he sketched and doodled them even when sketching was not a known advantage. That summer he worked in the lakeside pavilion where sailors and their girls came to dance.

In the fall, he enrolled at the University of Texas at Austin. Ernest Rauschenberg, denied schooling himself, was determined that his son would go to college. Milton agreed to study pharmacy, his parents' choice, but the schoolwork was hard. Reading was difficult—sometimes he saw double, sometimes he saw words backwards and upside down. He didn't know then that he was dyslexic. (Even today, he reads slowly and his spelling is idiosyncratic.) The University of Texas would have been fine if he could have handled the reading load, and if it hadn't been for the frog in anatomy class. Underneath the skin of the well-mannered student was a nonconformist who *would* assert himself. One day in anatomy class he argued with the teacher about dissecting a frog, and then proceeded to help the frog escape through an open window. Before he had gone very far into freshman year, he was expelled.

The terror of facing his father was almost as bad as the letter from the draft board that saved him from coming home in shame. "Greetings. . ." it began. The draft notice was Milton Rauschenberg's ticket out of Port Arthur. Once he left, except for the occasional visit, he never went back. "The isolation," he has said, "was not romantic."

Rauschenberg has often talked about how being southern, and from Texas in particular, has affected his life and his work. Like many southerners, he is endowed with a strong sense of place, with irony, and with a gift for storytelling in the self-deprecating southern tradition. And despite his clash with fundamentalism, the religion that is so much a part of the South remained with him, in his search for a spiritual context. Although he physically resembles his German grandfather, it is the Cherokee grandmother whose ancestry he most often claims. He ascribes his reverence for nature and the mystical to his Indian blood.

The boyhood dichotomy in his personality remains. He is shy still, yet his exuberance—even his flamboyance—are often cited by both friends and art critics. Among those in the art world, Bob Rauschenberg is known as an extrovert. "It's a certain uninhibited, almost uncensored, quality that certain Texas artists have all their lives," says Jane Livingston, formerly chief curator of the Corcoran Gallery of Art in Washington, D.C. "He has that big-spirited, funny, crazy, fearless quality that Texans have."

Rauschenberg has suggested that the *size* of Texas has influenced the size of his work. "Maybe that's why I have no respect for scale," he told journalist Wendy Lin in *Art and Antiques*. "Also typically Texan is the tall tale," he said. "But there's an extraordinary amount of truth in exaggeration. It's a way of dealing with the truth. That's my idea in art, too."

The southern accent in Rauschenberg's work is easily recognized by other southerners. The homely objects such as screen doors, tires, buckets, wooden ladders, old straight chairs, the goats and chickens, tell the story of his beginnings. "Having grown up in a very plain environment," he said, "if I was going to survive, I had to appreciate the most common aspects of life."

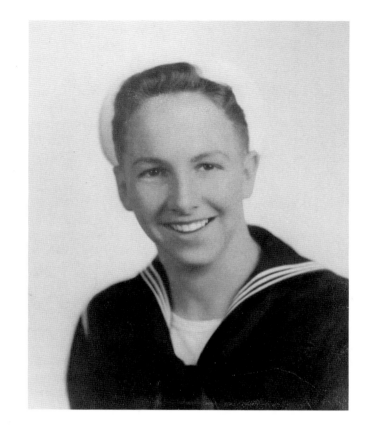

Navy portrait of Rauschenberg, 18, in San Diego, 1943.

THE 1943 ITEM beside his picture in the *Port Arthur News* reflects Rauschenberg's hometown pride in his wartime service:

Milton E. Rauschenberg, 18, son of Mr. and Mrs. Ernest Rauschenberg, 2721 17th Street, was recently named honor man of his recruit company of Camp Scott, one of five training areas at the U.S. Naval Training Station of Farragut, Idaho. The honor was given Rauschenberg on the basis of his proficiency in all phases of recruit training. He is a former University of Texas student. . . .

The honor recruit's reaction to the war would last a lifetime. Rauschenberg's antiwar sentiments and feelings about the suffering caused by fighting are reflected in his art. One particular work is *Rudy's House.* Painted in black, white, and gray, *Rudy's House* is filled with silkscreened images of mangled wrought iron chairs, fences, and wire mesh set against a wall of crumbling concrete. The scene, photographed in Venezuela for ROCI, looks like a once-fine place gone to ruin.

In the center of the painting, hanging upside down, is a real black metal chair, like those depicted in the background. Its seat is a black mirror. Imprisoned by the chair is the silkscreen image of a larger-than-life boxer dog. In the distortion of the mirrored chair seat, the dog's reflection looks like a helmeted warrior. He has the battered face of a fighter who has lost too many battles. The dog is Rudy.

Rudy had been a Venezuelan fighting dog, bred to perform in the bloody Caracas arena. His jaw had been crushed, and he had been thrown in the gutter to die. "A couple of hippies nursed him back to life," Rauschenberg said. "He is one of the sweetest dogs I've ever met—and forced to fight!" The thought of dogs—or men—being trained to kill is abhorrent to Rauschenberg. "It doesn't take armies to give you an appetite against violence," he said.

When Rauschenberg was drafted at the age of eighteen, he told the Navy recruiters that he didn't want to kill anyone. A sympathetic captain posted him to hospital duty, where his first job, in a tuberculosis ward, was to bathe and wrap corpses. Next, he was sent to a rehabilitation camp for maimed and crippled servicemen. Later, he worked with combat survivors. "No, I was not forced to fight," he said. "What I witnessed was much worse. I got to see, every day, what war did to the young men who barely survived it. I was in the repair business."

He was trained at San Diego Naval Hospital as a neuropsychiatric technician and then assigned to Camp Pendleton in California to work with sailors and marines with brain damage—or whose minds had been blown apart by the shock of the killing. "Every day your heart was torn until you couldn't stand it," he said. "And then the next day it was torn up all over again. And you knew that nothing could help. These young boys had been destroyed."

To escape the pain of the wards Rauschenberg would lie on the beaches or dance in the evenings at the USO. And he drew pictures. His fellow sailors liked what they saw, and asked him to sketch their portraits. To the young Rauschenberg, drawing was still just something he did. He did not imagine it had value to anyone except himself.

On his leave days, he hitchhiked up and down the coastal highways, exploring California as far as he could go and still return to Pendleton by curfew. On one hitchhiking trip, Rauschenberg went to see the cactus gardens in San Marino. He wandered into the Henry E. Huntington Library next door, where he saw two paintings—Sir Thomas Lawrence's *Pinkie* and Thomas Gainsborough's *The*

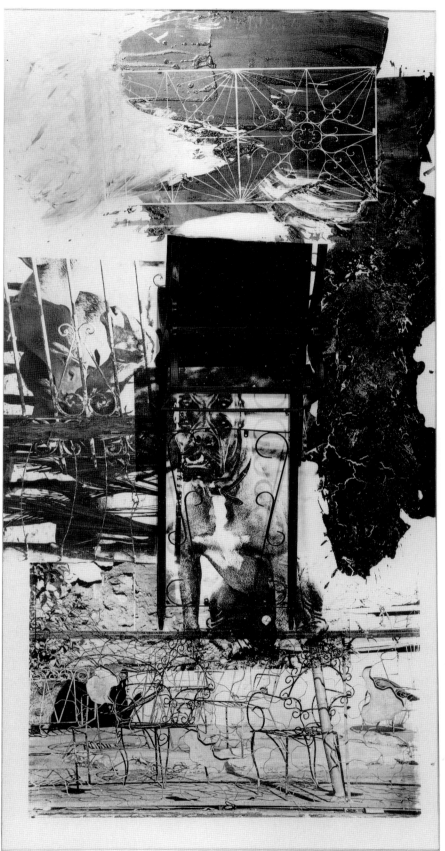

RUDY'S HOUSE/ROCI VENEZUELA *1985. Acrylic and objects on plywood panel, 98⅝×49½×21¼". Collection the artist*

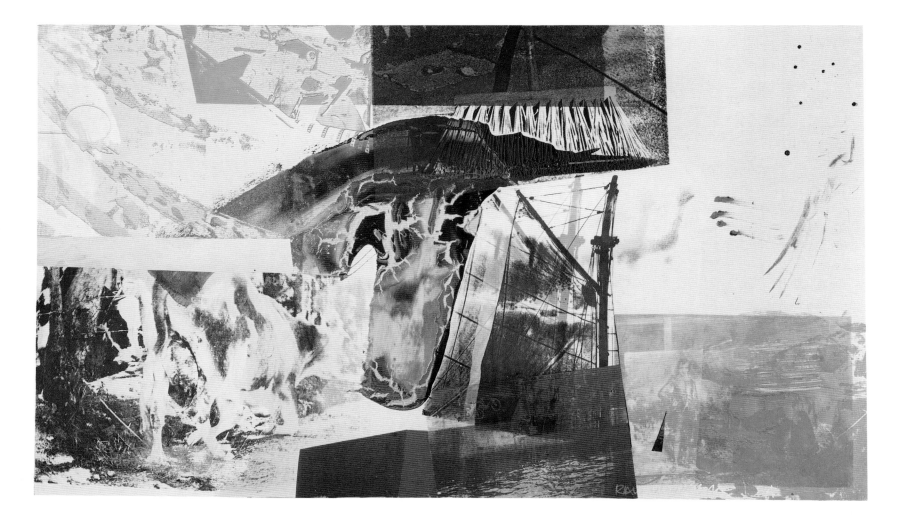

MANE (*Salvage*). *1984. Acrylic and collage on canvas, 49½ × 83⅝".*
Private collection. Thomas Gainsborough's The Blue Boy *is in the*
lower right of the painting.

SKYWAY *1964. Oil on canvas, 216 × 192". Dallas Museum of Art*
Purchase, the Roberta Coke Camp Fund, the 500 Inc., Mr. and Mrs.
Mark Shepherd, Jr., and the General Acquisitions Fund. Rubens's
The Toilette of Venus *(c. 1613), one of Rauschenberg's favorite paint-*
ings from art history class at the Kansas City Art Institute, became
a familiar figure in his silkscreen paintings.

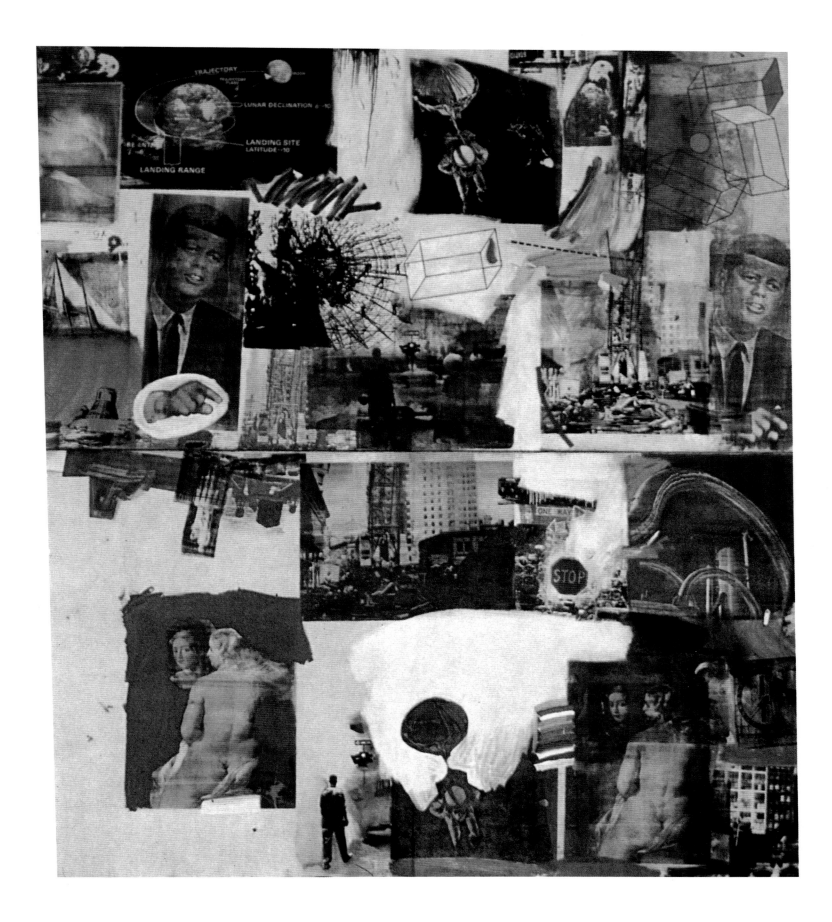

Blue Boy—that he recognized because he had seen them on playing cards. They were a revelation. Rauschenberg has said that the moment he discovered that "somebody actually *made* those paintings was the first time I realized you could be an artist."

When he was honorably discharged after the war was over in 1945, he hitchhiked home to Port Arthur to surprise his parents. To his own surprise he found that his family had moved to Lafayette, Louisiana, where his father had finally won his promotion to line foreman.

So Rauschenberg hitchhiked the 120 miles to Lafayette, where his ride ended at the Four Corners Cafe. Inside, he found his father having a cup of coffee. He visited with his family, but felt adrift. Lafayette was not home to him; neither was Port Arthur, with his family no longer there. Any plans for a career were, at best, uncertain. He had thought, when he first went to work in the hospitals, that his calling might be in mental health care. By the end of the war, however, he had changed his mind. He was deeply shaken by the suffering he had seen.

After a period of time alone at a friend's fishing cabin to recuperate and sort himself out, Rauschenberg turned around and headed back to California, where he found a job as a packing clerk in the Ballerina Bathing Suit factory in Los Angeles. He also made a friend, Pat Pearman, a buxom redhead who worked designing bathing suits for the company. After seeing his drawings, she convinced him that he had talent. Pearman was the first of a long succession of mentor/friends who would guide Rauschenberg throughout his career.

When Pearman returned to her hometown of Kansas City in 1947, she urged Rauschenberg to follow her. She knew that Thomas Hart Benton had taught at the Kansas City Art Institute and she convinced Rauschenberg that it would be a great place for him to study art—and be near her. To earn the bus fare he worked as a movie extra.

Arriving in the Kansas City bus terminal at two in the morning, Milton Rauschenberg tried out new names as he waited in the Savarin Coffee Shop to begin what he hoped would be a new life. He played with "Tom," but "Bob" was his first choice, and Bob he became. The new name, he believed, symbolized his rebirth as an artist.

He couldn't get enough of art. He was older than most of his fellow students and soaked up the courses with a passion that exceeded any in his earlier life. Even though the G.I. Bill paid his tuition beginning in February 1947, Rauschenberg went to school at night and took day jobs making window displays for a clothing store, building sets for a local promotional motion picture company, and making models for industrial exhibits.

In Kansas City, Bob Rauschenberg found his vocation. He discovered El Greco, Matisse, Monet, and Picasso. He heard stories about the Left Bank and Montparnasse, how the artists of the School of Paris inspired and cross-fertilized each other's work. He had to go to Paris, he decided. With Pearman's help, he investigated French art schools that would accept the G.I. Bill. By the end of the summer, Rauschenberg had saved enough money for passage to France. He went by bus to New York and in March 1948 arrived in Paris, along with a shipload of other American students, to enroll at the famed Académie Julian where Matisse, Bonnard, Vuillard, Léger, Duchamp, and other great artists had studied. Again, the G.I. Bill paid his tuition. He was twenty-two.

SUSAN WEIL, an eighteen-year-old New Yorker just out of the Dalton School, had also come to Paris to study at the Académie Julian. She and Rauschenberg lived in the same rooming house on Rue Stanislas, just off Boulevard Raspail. Their backgrounds could hardly have been more different. Susan came from a well-to-do and sophisticated New York German-Jewish family. Both her parents were writers. She had already studied art with Rufino Tamayo, Aaron Kurzon, and Vaclav Vytlacil, and she knew exactly what she wanted to learn in Paris. Yet she and Rauschenberg had much in common.

He was trying to find his way after what he had seen during the war. As a child, she had survived a horrendous fire when a boat exploded in the water near her family's summer place, Outer Island, in Long Island Sound off the Connecticut shore. A beloved brother, "Danky," was killed in the fire. Scarred by their experiences, Bob and Susan responded to each other's pain with empathy.

For Rauschenberg, the Académie Julian was a disappointment. He discovered that the time to be a young artist in Paris had long passed. "Picasso, Matisse, Brancusi, and Giacometti had become classics," he said. "The students at the Académie were now discussing Freud, Jung, and the psychology of art, which was not for me." He and Susan skipped class, haunted the museums, and groped their way toward a style of painting.

They wandered around Paris, sketching. They painted together in the drawing room of the pension. When they spilled paint on the worn Oriental carpet, they simply daubed paint into another part of the carpet to balance the design. Their landlady never seemed to notice the carpet gradually becoming brighter and brighter.

Despite its drabness and their poverty, the students in the pension had fun. One girl was given a ticket to the Paris Opera, but had nothing to wear. Rauschenberg concocted a costume. "He took a bedspread right off the bed in the pension—a taupe-caramel colored velveteen—went to the Galeries Lafayette to buy satin ribbon, stretched the ribbon across the floor, and stitched fresh ivy from the Bois de Boulogne to the ribbon," recalled Sue Weil. "Bob made a lattice with the ribbons and the ivy, and sewed it to the bedspread—it was her stole. We dressed her up in curtains and this magnificent stole, and off she went to the opera." At the opera, people would stop to ask who designed her wonderful creation. "Rauschenberg," she said.

He loved the smell and feel of paint so much that the brush got in his way. But he was not satisfied with his work finger-painting, palm-painting, or fist-painting. "The paintings had a lot of life, and we thought we were making all kinds of discoveries about painting because he was using bright colors. It wasn't a world discovery—just a personal discovery," said Sue Weil. "None of those paintings now exist."

In Paris, Rauschenberg had seen an article in *Time* magazine mentioning Black Mountain College in North Carolina. He heard also that the German émigré Josef Albers, reputed to be a great disciplinarian, taught drawing there. Rauschenberg no longer questioned his vocation, but he knew he needed discipline. Black Mountain College sounded more to his taste than the boring art classes in Paris. Besides, Susan Weil had already enrolled in Black Mountain on the advice of Aaron Kurzon, her teacher at the Dalton School. Bob Rauschenberg followed her there.

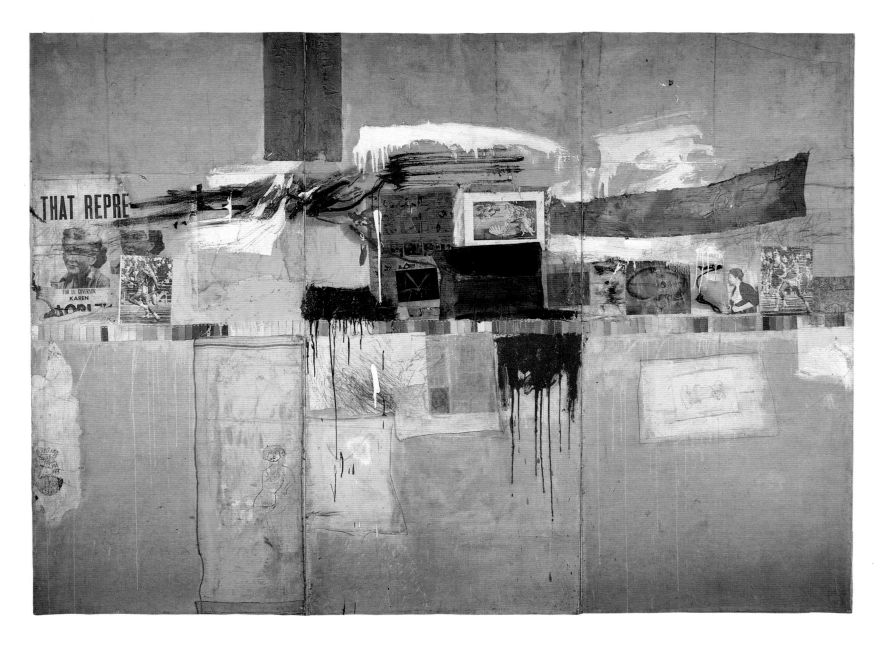

REBUS *1955. Oil, graphite, and collage on canvas, 96 × 131″. Collection Hans Thulin, Sweden. With* Rebus, *Rauschenberg began to think of himself as a reporter saying, "all of the materials were meant to be a record of the immediate environment and time." Botticelli's* The Birth of Venus *appears in the center as a figure in this early combine painting.*

CHARLENE *1954. Oil and collage on wood panels, 89 × 112″. Collection Stedelijk Museum, Amsterdam. Postcard souvenirs from art museums, used as collage elements, recollect the artist's student days at the Académie Julian in Paris. It was his first work combining painting, collage, and found objects in equal emphasis.*

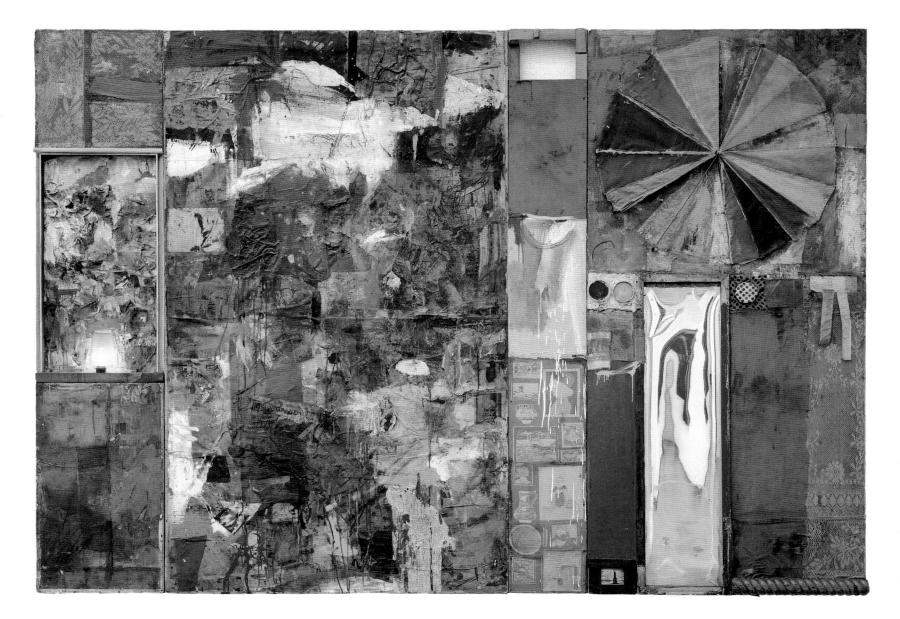

QUIET HOUSE

TWIN SHAFTS of sunlight illuminate a room, empty except for two cane-bottomed straight chairs that stand against a whitewashed wall. The interplay of light, shadow, and line in a photograph made by Rauschenberg at Black Mountain College captures the serenity of Quiet House. A small stone building erected by students and teachers at Black Mountain, Quiet House was like a Quaker meetinghouse—a place to be alone and to reflect.

Robert Rauschenberg spent many hours in this room while he was a student at the college, eighteen miles from Asheville, North Carolina. With its spectacular Appalachian peaks and valley mists, the area had held an attraction for artists and writers, including Thomas Wolfe and F. Scott Fitzgerald. "The mountains, the lakes—the whole place had some kind of special air," recalled Rauschenberg.

His experiences at Black Mountain were central to his development both as an artist and as a major figure in the American avant-garde in the 1950s. It was at Black Mountain that he discovered the themes and techniques that shaped the work he has created since that time. He came to Black Mountain as a brilliant although admittedly unfocused young novice. Rauschenberg studied at the college for one academic year in 1948–49 and during the summer sessions of 1951 and 1952; by the time he left he was a confident, iconoclastic artist. Over the years, until the college closed down in 1956, Rauschenberg appeared on campus as an unofficial "artist-in-residence" whenever he felt the need for its rejuvenating atmosphere. His exposure to disciplined techniques, to the work and style of major contemporary artists, combined with the contacts he made among other new spirits in the worlds of art, dance, and music, greatly extended his range.

Black Mountain was a unique, short-lived experiment in American education. It was founded by John Andrew Rice, a classical scholar who wanted to establish an ideal college, based on an Athenian model. The arts were to be the core of the curriculum, and faculty and students were to be equally responsible for running the college. Black Mountain incorporated values and teachings from the Orient as well as Western theology and philosophy in the quest to develop men and women who would create, and at the same time learn to take responsibility for their actions.

The experiment was, at first, remarkably successful. The tiny creative community wielded an influence on the arts of the twentieth century all out of proportion to its small size. At one time or another, the faculty included Willem de Kooning, Albert Einstein, Walter Gropius, Lionel Feininger, Alfred Kazin, Franz Kline, Jacob Lawrence, Richard Lippold, Robert Motherwell, M. C. Richards, Roger Sessions, Jack Tworkov, Ben Shahn, Peter Voulkos, John Cage, and Merce Cunningham. But Black Mountain's artistic authority was the German painter Josef Albers.

Albers had taught the famous Preliminary Course at the Bauhaus, the institution that began the revolution in modern design. Albers's own work there included innovative abstract collage in glass. Kandinsky and Klee were his students, and Albers, in turn, learned from them. When the Nazis closed down the Bauhaus in 1933, Albers and his wife, Anni, who was Jewish, fled Germany. They were welcomed at Black Mountain, even though he spoke no English and she spoke very little. With freedom to paint as well as to teach, Albers continued his own experiments in abstract art. Geometric abstraction, explored through color relationships, became his single-minded passion.

His Basic Course in Design at Black Mountain was premised on what he had learned and taught at the Bauhaus. From Johannes Itten, who had taught the Preliminary Course when Albers was a student, he had learned to study the nature of different materials and to "touch and experience" such objects as wood, grass, metal, feathers, stone, and paper. Kandinsky and Klee had influenced his thinking about the properties of forms and colors. As did Moholy-Nagy, Albers used wire, synthetics, and glass to create a deeper understanding of materials. At Black Mountain, Albers taught these lessons to his students as well in what he called "painting as a language of its own."

Albers was so obsessed with the purity of his work he always wore a white uniform and white gloves to class, Rauschenberg recalled. He was also a stern taskmaster. Rauschenberg felt that Albers singled him out for disapproval, much as his own father had—"No matter how hard I tried, he would look at my work and say, 'I don't vant to know who did this!'"

Although his wife, Anni, who taught Rauschenberg in a weaving class, was warm, "Mr. Albers" had a volatile temperament. One day Albers would attack a student's work, only to praise the same work the next day. Rauschenberg learned that he had to make up his mind about his own work. "He was a strange man," recalled Sue Weil of Albers. "If somebody felt good about himself, it was a challenge to him. He had this idea that students must be humble. Bob Rauschenberg is every kind of sweet, but he's not *humble*. Albers was offended by that kind of confidence. He thought it was his job as a teacher to make you feel uncomfortable."

Even though he was stung by Albers's sarcastic comments, Rauschenberg assimilated the barrage of instructions Albers gave the class. His innate gift for selection helped him take from Albers what he needed to train his eye for line, color, and balance, while discarding the maestro's rigidity. Albers's stated purpose was "to open eyes." Rauschenberg often states that his own purpose is to create "a new way of seeing." Years later Rauschenberg acknowledged that he was still learning what Albers taught him, "because what he taught had to do with the entire visual world."

Rauschenberg had—and still has—a passion for color, and a love of raw paint. From Albers, he learned how colors relate to each other, how optical illusions can be created by color, and the many ways of looking at intensity and hue. Albers taught drawing by assigning exacting exercises to train the eye and hand. Mirror-writing enforced motor control and loose line drawings from memory

captured form and freed the hand. The class drew the same model, week after week, working on what Albers called "the mountains and the valleys" of the figure. Sometimes they drew an aluminum pitcher without being allowed to do any erasing. In watercolor, a terra-cotta flowerpot was the model used month after month. "I was too messy for collage and too heavy-handed in my drawings," recalled Rauschenberg. "I had an awful time pleasing him." Albers, however, noted in the last grading period that Rauschenberg had "finally discovered that intensive work and discipline are the means of development."

Rauschenberg was receptive to *Werklehre*, Albers's method in basic design. "*Werklehre* is a forming out of material [i.e., paper, cardboard, metal sheets, wire]," explained Albers, to demonstrate the "possibilities and limits of materials." He sent his students into the countryside to scavenge for ordinary objects, junk, even living things, and to consider all their visual properties. His course, Surfaces, offered instruction on how to combine and contrast textures and structures. Using wood, cardboard, leaves, dirt, anything at all to learn "possibilities," Rauschenberg began making things out of these found materials.

The work program at Black Mountain was integral to the college; chores were shared by students and faculty. Rauschenberg and Susan Weil chose to collect the trash. In the rubbish they found objects for their art, as well as material for outlandish costumes for themselves and their friends and sets for little plays. Bob even made a centaur-like "unicorn" with long, shaggy "hair" out of raffia as a costume for his sister, Janet, to wear in the 1949 Mardi Gras parade.

Fellow students remember his soft Texas voice, quixotic humor, and the fact that he and Susan Weil were inseparable that year. They took part in lively discussions in the lakeside dining hall: Zen and Communism, poetry and drama, Tolstoy, Europe versus America. They laughed about "Bucky" Fuller's first geodesic dome that collapsed on the Black Mountain campus ("The Supine Dome"), and argued over Willem and Elaine de Kooning's wildly expressive abstract paintings.

Bob and Susan listened to Charles Olson's lectures on literature and tried out the Stanislavsky Method of acting, which Arthur Penn had brought to Black Mountain. In Johanna Jalowitz's music class, Rauschenberg learned about Hindemith and Bartok—and even made a vocal solo entrance, on A, in a performance of the Bach B Minor Mass.

Particularly liberating for Rauschenberg was the dance class given by Betty Jennerjahn, which encouraged free movement. He had always loved to dance. Now he and Sue held endless discussions of how painting could be freed, like dance. Dancing, it turned out, was not Sin, but Art.

THERE WAS a faculty upheaval also going on at Black Mountain. Albers and his wife moved to Yale in the summer of 1949. Sue Weil and Bob Rauschenberg also left. They enrolled in the Art Students League in New York for the fall semester. But first, they headed for the Weil summer home on Outer Island. There Bob lived and painted in the Boat House, a small cabin on the water. They also began more explorations. Having found some blueprint paper, they convinced Sue's five-year-old brother to lie on the paper and be "photographed" in the sun. "We chose him because he fit on the paper," she remembered. They positioned leaves, twigs, and their outstretched hands on the paper to make a blueprint picture for Sue's grandmother's birthday (*Light Borne in Darkness*). They made dance performances with the Weil children; on one rainy day, the show was inside the Boat House.

LIGHT BORNE IN DARKNESS

LIGHT BORNE IN DARKNESS *Robert Rauschenberg and Susan Weil.*
1951. Monoprint (cyanotype), 6¼ × 9¾". Collection The Milwaukee
Art Museum. Gift of Mr. and Mrs. Irving D. Saltzstein

FEMALE FIGURE *(Blueprint). 1949. Monoprint, 105 × 36". Collection*
the artist; on extended loan to the National Gallery of Art, Wash-
ington, D.C.. Pat Pearman, a friend, posed on blueprint paper
beneath Susan Weil and Bob Rauschenberg's sun lamp.

Seven-year-old Judy complained that they didn't have an audience. "We'll make one," Bob replied. He, Susan, and the children taped newspapers to the wall, painted faces (Rauschenberg drew a full-sized Indian), and pasted cutout faces, Judy Garland's among them. Bob, the tallest, drew the top tier; the children cartooned short figures at the bottom. Susan Weil, who kept a snapshot of the "audience" wall, recalled Bob's "tenderness with the children that summer, his inventiveness, his delight in playing."

At the Art Students League, he studied with Morris Kantor and Vaclav Vytlacil. He moved into a rented room on East Eighty-seventh Street near the Weils' apartment, then into a building downtown without heat and water—but big enough for a studio—in a grim neighborhood on Willett Street, with a group of classmates from the Art Students League.

Bob and Susan went from gallery to gallery in New York, looking at the first generation of postwar American art. At the Betty Parsons Gallery on 57th Street, they saw the abstract paintings of Adolph Gottlieb, Barnett Newman, Clyfford Still, Hans Hofmann, Mark Rothko, Ad Reinhardt, and Jackson Pollock. In their free-spirited innovations and their raw, aggressive use of paint, these artists differed from Albers and his carefully geometric color squares. Rauschenberg was "swept away," he said, by their apparently spontaneous freedom of expression.

Some critics were beginning to call them "abstract expressionists." Building on a movement born in Europe, they made the picture plane flat, eliminating or distorting recognizable objects. "What was to go on the canvas was not a picture, but an event. . . . The gesture on the canvas was a gesture of liberation from Value—political, aesthetic, moral," wrote Harold Rosenberg in *Art News*.

Rauschenberg, working energetically in his Willett Street studio, learned to slather paint on canvas with the freedom of gesture that critics Harold Rosenberg and Clement Greenberg had come to admire. He and Susan went to see the work of Robert Motherwell, with its large amorphous shapes, and of Jack Tworkov, who made restless, flamelike swaths of paint. They admired Willem de Kooning's distorted figures and frenzied brushwork, and Franz Kline's large calligraphic brush strokes. The two young painters were in awe of the energy and power emerging in American art.

They were also in love. In June 1950, they had a formal summer wedding at the Weils' home on Outer Island. Bob's family came from Louisiana, their friends from Black Mountain. After a wedding night in the Willett Street studio, Bob and Susan spent the summer at Outer Island painting, photographing, and developing their "blueprint art." Back in the city, in their new apartment on West Ninety-fifth Street, they sold blueprint paintings to supplement Bob's occasional income from construction jobs.

One of their friends who agreed to pose on the outstretched sheets of photographic blueprint paper beneath Rauschenberg's sunlamp was Pat Pearman, who had moved from Kansas City to New York. Her ample "mountains and valleys" were pleasing to Susan and Bob, who took their new blueprint art to *Life* magazine. To their surprise, the editors bought the idea for "Speaking of Pictures," and sent a nude model to their apartment to re-enact the process. Rauschenberg also took the blueprints to commercial designer Eugene Moore at Bonwit Teller, and his first "show" in New York appeared in the store's Fifth Avenue window. One of these works, *Blueprint: Photogram for Mural Decoration*, was selected for the spring show, "Abstraction in Photography," at the Museum of Modern Art.

Photography in black-and-white also occupied Rauschenberg that year; he made photographs of Susan, who was now pregnant, of Central Park, of their

apartment-studio. They wandered around New York sketching, as they had in Paris. One trip to the zoo yielded a notebook of anthropomorphic animals—a lion named Rhoda, cartoon-like in Bob's pencil drawing, and a doleful elephant. As Albers had instructed, no erasures were allowed and the lines were unbroken.

But it was in oil paint that Bob was making his new, serious work, painting simple, outlined forms within a field of abstract brushwork. One painting, made in Morris Kantor's life drawing class, was literally carved out. Ignoring the model, Rauschenberg scratched numbers into a field of thick white, wet paint. The numbers, chosen apparently at random, were surrounded by a penciled line, like a Greek key. In the bottom right corner he painted one red star, like those on a gallery wall indicating that the painting is sold.

When some of the other students complained about the painting, Kantor defended Rauschenberg's right to paint as he wished. Rauschenberg called the painting *White Painting with Numbers* (1950). Later, it became *22 The Lily White*, because he had written on the face "22 (two, two) the Lily White"—a line remembered from the song "Green Grow the Rushes, Ho."

A common theme in Rauschenberg's painting of 1950–51 was religion. His parents, in celebration of their twenty-fifth wedding anniversary in Louisiana, asked him to paint a biblical scene for the baptistry in their church. He did so. The painting, "by their son Milton," was acknowledged in their local newspaper. No longer a member of the strict Church of Christ, Rauschenberg nevertheless attended various churches in New York. His search for a meaningful spiritual reference spilled over into his work.

His painting *Crucifixion and Reflection* (1950) is of four squares which he had carved into a gray-white ground of thick wet paint. The result was an optical illusion; depending on the view, one or two crosses can be discerned. In the upper right corner a torn piece of newsprint, written in Hebrew, is used as collage. He also gave the other paintings religious titles such as *Trinity* and *Mother of God*, which defined their symbolic content. They featured simply drawn—or incised— figures: three circles for *Trinity*, a row of lollipop-like trees for *Garden of Eden*. He called these works "abstract allegorical cartoons."

Armed with as many of these paintings as they could carry, Bob and Susan walked into the Betty Parsons Gallery one winter day in 1951. Encouraged by Morris Kantor, Rauschenberg asked for a reaction to his work by the woman who was showing the vanguard of the new American painting. As Rauschenberg recalled, he was embarrassed by his impulsiveness, and began showing her the paintings faster and faster. "I just wanted her to tell me if I had something or not," he said. "Or if what I was doing was totally crazy." When he finished, Parsons said matter-of-factly, "I can't give you a show until May." Rauschenberg was stunned. "I could see right off that he was on his own tangent," said Betty Parsons, "that he wasn't influenced by anyone else or in the school of anything." She gave him his first one-man show, May 14 to June 1, 1951. By the time of the show, however, he had re-painted the paintings to Parsons's surprise and that of Clyfford Still, who helped her select the work. Rauschenberg had thought to "improve" them, he said. He was twenty-five years old and virtually unknown.

Parsons's acceptance of his work and the reviews that followed represented Rauschenberg's first break into the New York art world. He was taken seriously, if not approvingly, by Stuart Preston of *The New York Times*. Preston wrote that his pictures "seem to be spawning grounds for ideas rather than finished conceptions. Most composed and successful are the semi-geometrically planned oils [*22 The Lily White* and *Crucifixion and Reflection*]." Dorothy Seckler wrote in *Art News* that Rauschenberg "offers large-scale, usually white-grounded

Robert Rauschenberg and Susan Weil, at their wedding, June 1950, Outer Island, Connecticut.

22 THE LILY WHITE *1950. Oil and pencil on canvas, 39½ × 23¾". Collection Mrs. Victor W. Ganz. Painted in class at the Art Students League in New York. The numbers incised in the paint "serve as the device to activate the surface," according to the artist. Rauschenberg said it was the first painting he could wholeheartedly identify as his own individual creation.*

canvases naively inscribed with a wavering and whimsical geometry. On vast and often heavily painted expanses, a wispy calligraphy is sometimes added to thin abstract patterns and in other instances collage is introduced, either to provide textural effects—as in the picture whose background is made entirely of road maps—or to suggest a very tenuous associational content."

One haunting painting, *Should Love Come First?* (1951), incorporated a scrap of romance magazine paper with the words of the title, a diagram of fox-trot footprints from an Arthur Murray ad, the painter's own inked footprint, and a series of brushstrokes in oil connecting the elements. Rauschenberg was taking on popular culture's ideas of romance and with it Arthur Murray's ballroom dancing. Rauschenberg's own footprint, perhaps mischievous, was foremost his lampoon of romance in the 1950s. Perhaps more than the others, this now-lost painting pointed to Rauschenberg's future works. (Many of the paintings from the Betty Parsons show were subsequently destroyed in a fire at the Weils' summer home. Others were painted over in later years. Aaron Siskind's photographs, pictured in *Arts Magazine* in 1985, document the work.) Rauschenberg was beginning to create for himself a working collaboration between what he saw in the bold paintings of the artists of the New York scene and what he had learned from Albers.

The exhibition opened more doors for the young artist. Aaron Siskind's photographs of his work encouraged Rauschenberg in his own photography. Jack Tworkov and Leo Castelli invited him to join an exhibition of Abstract Expressionists they were assembling on East Ninth Street in Greenwich Village. Rauschenberg pulled *22 The Lily White* from the Betty Parsons Gallery for the "Ninth Street Show." The show, which included Willem de Kooning, Jackson Pollock, Franz Kline, and some of the other painters whom Rauschenberg admired, was held in a former antique shop in the spring of 1951. It was the first time the artists, sixty-one in all, had shown together as a group, and it consolidated a movement that would be called the New York School.

Rauschenberg found his Black Mountain experience to be an advantage in making contacts in New York avant-garde circles. The composer John Cage saw the paintings at Parsons and introduced himself to Rauschenberg. They talked of Black Mountain, where Cage had taught at a summer session. Cage left the gallery with a painting that Rauschenberg gave him. (Later, using Cage's apartment while the composer was in Europe, Rauschenberg painted over it in black, to Cage's surprise. At first, Cage was furious. However, when he saw the complexity of the black painting, Cage said, he loved it.)

At the Art Students League, Susan and Bob had become friendly with another young artist, a Virginian named Edwin Parker Twombly, Jr., who had adopted his father's nickname, Cy. Four years younger than Rauschenberg, Twombly had studied at the Boston Museum School of Fine Art and Washington and Lee University. Like Rauschenberg, he was trying to use the abstract mode to find his own brand of personal expression. He was painting in vivid pinks a series he called Chandeliers. Later Twombly's work would evolve into distinctive calligraphic scrawls and scribbles across the canvas, like a language all its own. Rauschenberg and Susan, who planned to go to Black Mountain for the 1951 summer session, convinced Twombly that he should go as well. Their baby was expected in July and they would join him after the birth.

Christopher Rauschenberg was born on July 16, 1951. In August, Rauschenberg and Susan went to Black Mountain as planned, with a newborn, colicky baby in tow.

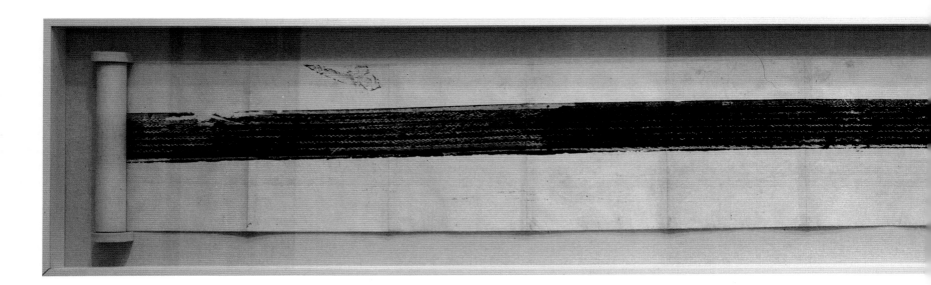

AUTOMOBILE TIRE PRINT *1951. Monoprint; ink on paper mounted on canvas, 16½ × 264½″ (fully extended). Collection the artist; on extended loan to the National Gallery of Art, Washington, D.C.. The print is a forerunner of the artist's use of everyday imagery as an integral part of his compositions, and of incorporating chance occurrence into an ordered artistic arrangement.*

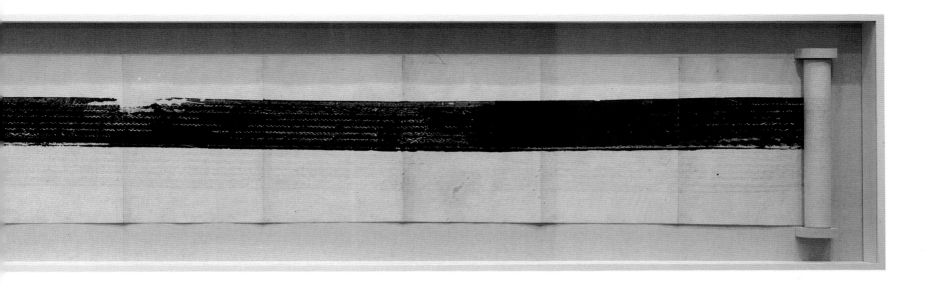

*John Cage behind wheel of car, 1954. Rauschenberg photographed
John Cage in the composer's Model A Ford, in which they had earlier
collaborated to make* Automobile Tire Print. *("He did a beautiful job,
but I consider it my print," said Rauschenberg. "But which one of us
drove the car?" asked Cage.)*

IN BLACK MOUNTAIN during the summer of 1951, Rauschenberg began to approach photography more seriously. He and Sue sat in on a seminar with Harry Callahan, Aaron Siskind, and Arthur Siegal, in which photography was lauded as an art form. "I want to photograph the entire country, foot by foot," Bob told his teacher, Hazel Larsen Archer.

He found the Black Mountain artistic community up in arms about the anti-Communist witch-hunt that was beginning to sweep the country. Henri Cartier-Bresson and Jean Renoir had been invited to the college that summer, but were denied visas. Visiting strangers were thought to be FBI agents. The students dressed like bohemian artists to proclaim themselves anti-Establishment. They listened to the music of John Cage as interpreted by pianist David Tudor, and the poetry of Kenneth Rexroth and others who later would be recognized as part of the "Beat" generation. The work felt exciting in part because they thought of it as "subversive."

Ben Shahn was teaching painting, as was Robert Motherwell, whose passionate abstract swipes of paint across canvas were the antithesis of Shahn's ideological figurative art. The two were rivals who soon caused factions among their students. Motherwell championed Twombly and encouraged Rauschenberg. Shahn ignored the two young abstractionists.

At the end of the summer, Ben Shahn asked to see Bob and Susan's work. They were thrilled at the honor. Rauschenberg and Weil straightened and cleaned their apartment, prepared a dinner, quieted Christopher, and carefully displayed their art around the room. Shahn came with his children, but said not a word about the art until he prepared to leave. He turned to his children, pointed at the pictures and said, "I just wanted to show you what some people are doing in New York. This is the kind of work you should avoid."

The two young artists were crestfallen. The summer session, which had begun so happily, was ending badly. Bob, Susan, the baby, and Cy Twombly drove back to Outer Island together. After a brief visit there, Rauschenberg returned to Black Mountain for the fall session, where he was to teach. Susan and the baby stayed in New York. "I never went back to Black Mountain," she said.

Back in New York in the winter of 1951–52, Rauschenberg found parenthood a strain. He worried about supporting a family. None of the paintings at the Betty Parsons show sold. He worked at window dressing for stores when there was work, at the Art Students League when he had a chance. John Cage had become a supportive friend, and together they collaborated on a project. Rauschenberg inked the front left tire of Cage's Model A Ford, assembled twenty sheets of paper end-to-end, and directed Cage as he drove the car down Fulton Street over the paper. The result was scroll-like, *Automobile Tire Print* (1951). Thus began the use of tires as images or objects in Rauschenberg's work.

The new year went badly from the beginning. Susan and Bob were not getting along well, and everything seemed to be going wrong. Rauschenberg, the avowed nonconformist, was chafing at the very conformity of marriage. Susan, also a serious artist who wanted time to paint, had her hands full with the baby and her solicitous, eccentric parents. By June, the marriage had collapsed. Rauschenberg returned to Black Mountain.

Rauschenberg had looked forward to the summer session of 1952. Cage would be there, performing and holding workshops with Merce Cunningham. Cy Twombly would be there, too, along with friends the Rauschenbergs had made in 1949. Bob and Twombly packed the old station wagon and drove down to North Carolina.

CRUCIFIXION AND REFLECTION *c. 1950–51. Oil, enamel, water-based paint, and newspaper on paperboard, 51⅛ × 47¾". The Menil Collection, Houston*

WHITE PAINTING *1951. House paint on canvas, 72 × 72″ (4 panels). Collection the artist*

Rauschenberg's antics that summer—dyeing his underwear purple in a vat on the kitchen stove, inventing elaborate schemes to avoid work duty—caused some of his Black Mountain associates to describe Rauschenberg as "not serious." He and Cy Twombly were known as inveterate pranksters, bent on having fun. "The first thing I remember about Bob is his laughter," recalled Merce Cunningham. "You could hear him across the dining hall." Rauschenberg and Twombly, like boys on summer vacation, enticed a young Canadian student named Dorothea Rockburne to join in some of their crazy expeditions. "Bob was very handsome and bright and wonderful, and a lot of fun," she remembers. "He had already shown in New York, been in the war. He and Cy were terrifically sophisticated. They were doing things like taking a vacation to Cuba and coming back with absinthe. I was seventeen and reading Rimbaud and this was truly the height of everything I was interested in." (Rockburne later worked for Rauschenberg in New York as a studio assistant. The first of his many protégés, she went on to become a well-known Abstract painter.)

Many of his contemporaries thought that the painting Rauschenberg was doing that summer, for which Cy Twombly stretched the canvas, was a prank,

Rauschenberg photographed by Susan Weil with their son, Christopher, in 1952.

Opposite:

BLACK PAINTING *1951–52. Oil and collage on canvas, 71½ × 52¾". Collection the artist. In the Black Paintings, Rauschenberg said he was interested in "creating complexity—without the pictures revealing too much."*

too. There were no images, just white house paint applied with a roller. When he painted the first one, Rauschenberg thought he would paint over it, but found the stark white so pure and pristine that he couldn't bear to. "I'd always thought of the White Paintings as being hypersensitive," said Rauschenberg. "One could look at them and almost see how many people were in the room by the shadows cast, or what time of day it was." Rauschenberg said he was seeking to see "how much you could pull away from an image and still have an image." In a recent discussion, Rauschenberg said that he was not aware at the time of Kasimir Malevich's 1919 *White on White*.

The White Paintings were first shown at Black Mountain that summer of 1952 in the dining hall, as part of what came to be known as "The Event," Cage's *Theater Piece No. 1*. It was a seminal event, in the development of American theater, from which emerged the theater of mixed means. The Happenings that later occupied the art world are traced to this first evening's activity staged by Cage at Black Mountain. The *Theater Piece* involved a simultaneous, and unrelated, reading of poetry, dance, music, "chance action," and paintings. Four panels of Rauschenberg's *White Painting* were suspended from the ceiling in the form of a cross, and used as screens for the projection of slides, a flickering eight-millimeter film, and as background for the action. Cage, Mary Caroline Richards, and Charles Olson stood on ladders reading poetry, Merce Cunningham danced his way through the audience, and David Tudor played Cage's music on a "prepared" piano, in which the sound was dampened by inserting pieces of felt and wood between the strings. The effect was like that of percussion instruments. Rauschenberg stood underneath his own *White Painting*, repeatedly switching on and off an old Edison horn record player, playing scratchy old Edith Piaf recordings.

Given his deep interest in Zen Buddhism, Cage was enchanted with the mysterious white paintings. ("They are airports for lights, shadows, and particles," he wrote.) They inspired him to write his now-famous musical composition, *4'33"*. For four minutes and thirty-three seconds, after the piano was opened, the audience was forced to listen to the wind and each other's breathing. The keyboard was then shut. It was, for all intents and purposes, a soundless score.

Cage adhered to the Zen belief that nothing is either good or bad, beautiful or ugly: "No value judgments are possible because nothing is better than anything else. Art should not be different from life but an act within life." Rauschenberg shared Cage's ideas instinctively, without having studied Zen, Cage reported. "He came into Black Mountain College, just a young man, but already full-blown," said Cage. "Nobody had better ideas."

Rauschenberg also studied that summer with two of his heroes—Jack Tworkov and Franz Kline, who were both making black-and-white abstractions. Kline, who was teaching the concept of negative space in abstract art, and Tworkov encouraged him to experiment with all-black paintings.

Rauschenberg's Black Paintings, unlike the flat, smooth White Paintings, had texture and depth. In places, the surface was as much as two or three inches thick. Rauschenberg tore pieces of newspaper comics pages into strips and wads, fixed them onto the canvas and painted the surface black. Sometimes he let the newsprint show through; sometimes it was covered with a thick black patina like a tar patch.

At Black Mountain in 1952, he was able to be part of a community he valued. The people he admired accepted him, and he was buoyed by their confidence in his work. A letter, filled with misspellings, that Rauschenberg wrote to Betty Parsons reveals the odd combination of modesty and poise, boyishness and sophisticated self-promotion that still characterizes him as a mature artist.

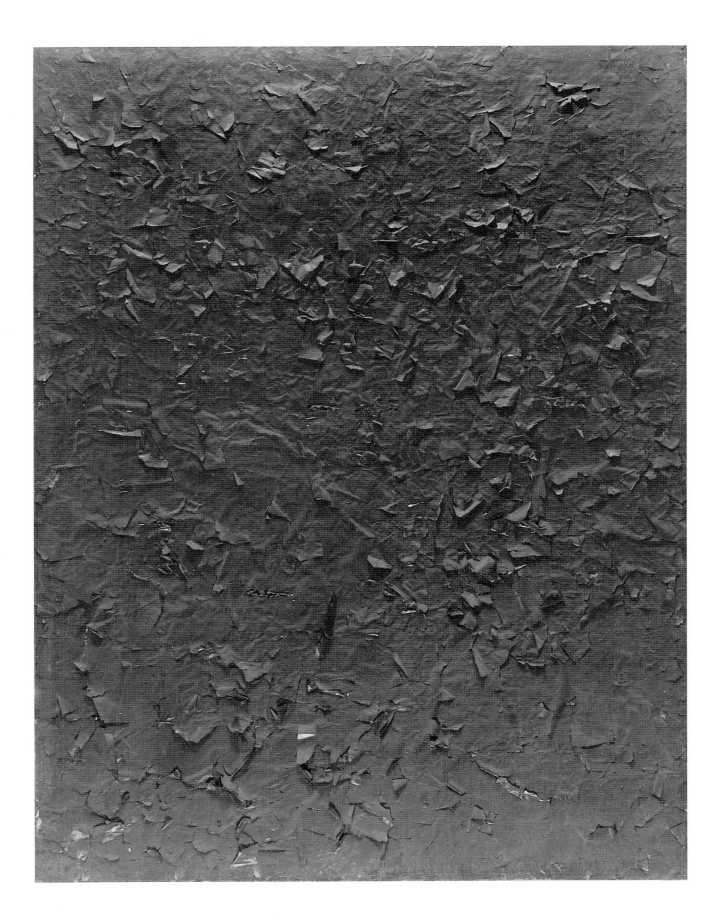

Despite his ebullient plea, Parsons declined to give Rauschenberg a show for his White Paintings.

WHEN RAUSCHENBERG returned to New York in the fall of 1952, he

found that Susan had filed for divorce. The breakup was traumatic for both of them and the causes were complex. He felt abandoned, and he felt that he was abandoning Susan and his son. But Rauschenberg also felt tied down by the relationship, by being "too married."

In addition to what he said was his immaturity, another contributing factor, according to Rauschenberg, was friction with his in-laws. They had disapproved of his going off alone to Black Mountain so soon after his son was born. His freewheeling activities there seemed a further abdication of his responsibilities. Susan's parents supported her decision to divorce Rauschenberg. She took an apartment near theirs, and a studio not far away.

After spending some time with Christopher, who was just over a year old, Rauschenberg took off for Italy with Cy Twombly, who had won a travel fellow-ship from Richmond's Virginia Museum of Fine Arts. Their plan was to share the support provided by the fellowship.

Rauschenberg savored Rome with Twombly. They managed to survive on a shoestring. His great joy was the camera, with which he recorded his adven-tures with Twombly in a series of soft-toned black-and-white images: Twombly among the statuary, Twombly on a street corner, Twombly at a flea market, Twombly and Bob in Venice, double-exposed with the horses on top of San Marco.

When Twombly's money ran out, Rauschenberg spent his last fifty dollars to fly to Casablanca, where he'd heard there were construction jobs. He bluffed his way into a position managing inventory (with the help of an American girl who helped him fake a resume) for the Atlas Construction Company, which was building a military airstrip. After two months he managed to save a thousand dollars.

He spent his free hours collecting objects in the countryside—rope, bones, sticks, nails—and assembling them into sculptures. He made strange boxes, somewhat like those that Joseph Cornell was showing at the Egan Gallery, but much more primitive and fetishistic, filled with stones, nails, feathers, bits and pieces of glass. His study of materials with Albers at Black Mountain, which he

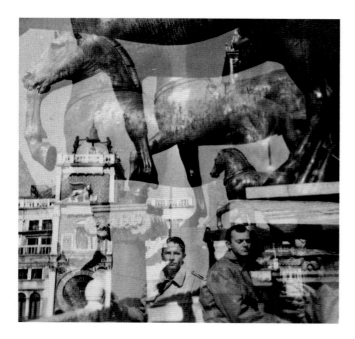

Rauschenberg made this double-exposure photograph of the artist Cy Twombly and himself with the horses atop San Marco in Venice, 1952.

Christopher Rauschenberg at 18 months, photographed by his father in 1953. This photograph appears as a collage element in Canyon *(1959).*

Overleaf:

THE RED PAINTING *1953. Oil and collage on canvas, 70¾ × 47⅞″. The Eli and Edythe L. Broad Collection, Los Angeles*

YOICKS *1953. Oil and collage on canvas, 96 × 72″ (2 panels). Collection The Whitney Museum of American Art, New York. Gift of the artist. This is the earliest painting in which the colors and pattern of the fabric itself become important elements of the composition.*

had so enjoyed, was the genesis of these boxes. Back in Italy with his savings, he took the boxes to the Galleria dell'Obelisco, the only Roman gallery to show contemporary abstract art. Thinking them outrageously funny, the owner exhibited the objects as the latest "modern art." To Rauschenberg's amazement and the gallery owner's amusement, some were sold. They called them *"Scatole: contemplative e feticci personali"* (Thought Pieces and Personal Fetishes). In Florence, the Galleria d'Arte Contemporanea showed the work. A local critic wrote that the art was a "psychological mess" and should be thrown into the Arno. Rauschenberg, who was about to leave for home, obliged. "It solved the packing problem," he observed later.

RAUSCHENBERG and Twombly returned to New York separately. For ten dollars a month, Rauschenberg rented part of an old building on Fulton Street near the fish market, where he set up a makeshift studio. Twombly divided his time between the loft and his parents' home in Virginia. Susan would bring Christopher down to visit Bob, and they re-established a friendly dialogue about their work. He lived on almost nothing. (He made a cold-water bathtub by lining fish boxes with tar, and allotted fifteen cents a day for his food budget.) Rauschenberg, at twenty-eight, was "known," but not yet "bought"—except for a black-and-white Black Mountain photograph of the interior of an old buggy (*Untitled*, 1949), acquired by Edward Steichen for the Museum of Modern Art in New York.

While Rauschenberg was in Europe, Jack Tworkov had persuaded Eleanor Ward of the Stable Gallery on Seventh Avenue near Fifty-seventh Street to show one of Rauschenberg's Black Paintings in a successor to the "Ninth Street Show," which she called the First Stable Annual, in January 1953. Rauschenberg's work was exhibited alongside Pollock's *Blue Poles* and works by de Kooning, Kline, and Motherwell.

In the spring of 1953, after coming down to the Fulton Street studio to see his work, Eleanor Ward decided to exhibit both his Black Paintings and his White Paintings. They would be shown with the quite different, but complementary, calligraphic abstractions of Cy Twombly in a two-man show at the Stable Gallery. (The two young artists literally cleaned out the stable before installing their work.)

The show, which opened on September 15, 1953, stunned its viewers. Some thought Rauschenberg's white stretched canvases and thick black surfaces were practical jokes. Some thought the white canvases represented the end of Abstract Expressionism, or at least a challenge to the status quo. "For Rauschenberg, and for us who saw them, the *Black* and *White Paintings* were an end to art and a beginning," wrote Allan Kaprow in 1966. "Once a man's shadow gets into a painting for a moment, everything becomes possible and the conditions for experimentation are thrust upon the scene. Possibility, artists know, is the most frightening idea of all." Others found the Black Paintings filled with dread and angst. The older Abstract Expressionists themselves were outraged. De Kooning thought Rauschenberg was "fooling around, not really serious"; Barnett Newman said, "He thinks it's easy. The point is to do it with paint."

In *Arts and Architecture*, James Fitzsimmons wrote that "there is a minimum of art and, consequently, of expression. The low point of Rauschenberg's exhibition, however, was provided by a number of 'white' paintings. I think there is less than meets the eye. Of course, a blank white canvas might be an aid to contemplation, but the four white walls the landlord provides will do as well. . . .

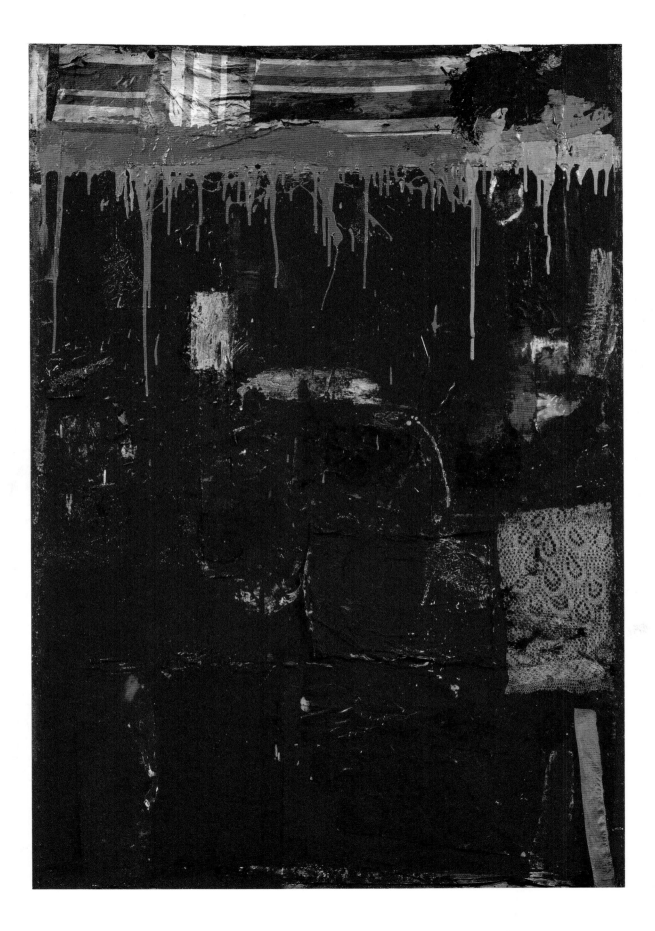

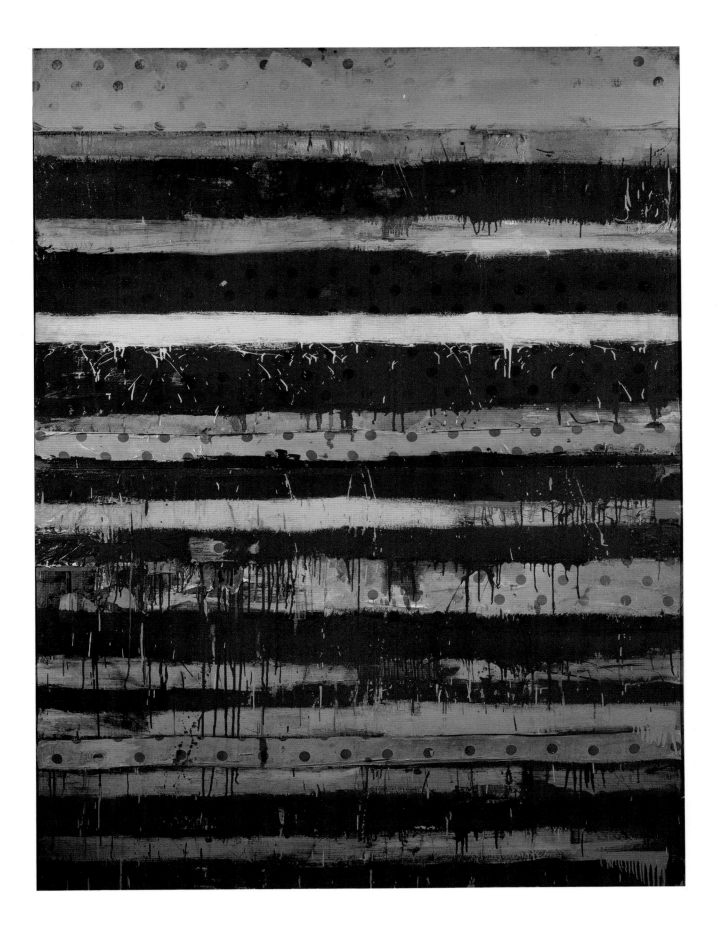

[Hanging these white canvases as works of art] is materially destructive because the function of a canvas . . . is aborted when it is misused in this way. And it is a self-destructive act, for Rauschenberg has backed himself into a corner where there is nothing for him to do but make wall coverings. . . ."

In *The Art Digest*, Hubert Crehan stormed that "white canvas, conceived as a work of art, is beyond the artistic pale." Yet Dore Ashton, in the same magazine, wrote that Rauschenberg "speaks of the nature of nature: Cloaked mystery and deterioration. Beauty is purity, he says, but decay is implicit. Appliquéd newspaper is his disdain of perpetuity. Life is cheap. Yes, these black and white canvases excite, incite, make vacuums in walls."

None of the paintings from the Stable show sold. Even the older artists—Pollock, Kline, de Kooning, Tworkov—with whom Rauschenberg drank at the Artists' Club on 8th Street and at the Cedar Tavern, were having a rough time selling their work. "We were all poor," recalled John Cage.

Despite what they thought of his art, the older painters liked Rauschenberg. His admiration for their work, his innocence and good humor were disarming. Rauschenberg has said that at the Cedar Tavern in Greenwich Village where the artists gathered he learned more about art than he had at the Art Students League. He often drove an inebriated Kline home in Kline's Alfa Romeo. Kline would then allow Rauschenberg to watch him paint until dawn. He listened with amusement at the bar as Kline teased Barnett Newman that the "process was too fancy" in Newman's austere paintings. When Rauschenberg was broke, at one point, Jack Tworkov permitted him to sleep in his studio on his modeling table. A thin wall separated Tworkov's studio from one occupied by Bill and Elaine de Kooning.

Rauschenberg was intrigued by his older friends, studying their techniques even as he mimicked their conversations. But he determined not to mimic their work. Making the point about his own independence in a particularly outrageous manner, Rauschenberg proposed that de Kooning give him one of his drawings, which Rauschenberg would then turn into his own work of art by erasing it. With some alarm, de Kooning agreed—and chose a work that would be particularly hard to erase. After one month and forty erasers spent rubbing out the thick crayon, grease pencil, ink, and pencil markings, Rauschenberg produced *Erased de Kooning Drawing* (1953). He jokingly called the work a "monochrome no-image." As Rauschenberg explained many years later, "I was trying both to purge myself of my teaching and at the same time exercise the possibilities."

RAUSCHENBERG provoked the critics and many of his fellow artists as he moved from one experiment to another. He had made white and then black paintings. Next came a series in red, begun with some cans of unlabeled paint he'd bought at discount that all turned out to be red. The series became the most admired of his early works. He found the color such a challenge he branched out into different shades of red—even using fingernail polish for variety. Red was the "most difficult color to work in," he said, because "if you're not careful, red turns black when you're dealing with it." Another explanation was that Albers had used colors only in relationship to each other, and Rauschenberg wanted to use color only in relationship to itself. Over the years his intellectualized explanations for the art of this period changed and became more elaborate. Whatever his artistic theories, it seemed clear that Rauschenberg's motives were to experiment, to challenge the accepted, and to do so in a way that shocked the Establishment.

In the Red Paintings, which like the Black Paintings began as paint over newspaper, collage played an important part. "I began using newsprint in my work to activate a ground so that even the first strokes in a painting had their own unique position in a gray map of words," he wrote. As the paintings changed, the printed material became as much a subject as the paint itself.

The most widely known of Rauschenberg's paintings of this period, *Charlene* (1954), is also the largest and most ambitious statement of the ideas, imagery, and techniques with which he was preoccupied while making the Red Paintings. The shimmering nine-foot-high red canvas is covered with mirrors, bits of cloth and wood, part of a man's undershirt, a flattened parasol, postcards, comic strips, drugstore reproductions of Old Master paintings, and its own source of light from an unfrosted electric light bulb that flashes on and off. (Every artist who studied Impressionism got the point: some people painted "light" into their pictures; Rauschenberg simply plugged his in.)

The painting represents a summary of his influences at Black Mountain and New York. He used a wide variety of different materials of contrasting textures and surfaces, as taught by Albers. His use of composition reflected some of Cage's ideas about Zen: Rauschenberg consciously placed his materials without "meaning," in a way that none was subservient to another. Nor did his collage make a "picture"; each part of the whole retained its own past identity. And finally, his handling of the red paint showed his four-year study of the Cedar Tavern artists. All in all, however, *Charlene* was something new.

The Red Paintings were shown from December 1954 through January 1955 at the Charles Egan Gallery (another dealer whom Tworkov had found for Rauschenberg). They caused as much controversy as had the black and white paintings. The critical views ranged from Frank O'Hara's appraisal in *Art News* that they were "ecstatic works by a serious, lyrical talent" to Stuart Preston's view in *The New York Times* that there was "no point in taking it too seriously." The show's main effect was "to reinforce Rauschenberg's reputation as an enfant terrible," wrote Calvin Tomkins.

In a period of a very few years, Rauschenberg had risen from obscurity to become one of the most controversial figures of the New York art world. Some of his work seemed bizarre, even comical. In the winter of 1953–54, he made paintings out of earth, which he seeded and watered until they became "grass paintings." The paintings, which began accidentally when birdseed fell into one of his boxes of dirt paintings and started to sprout, were shown at the Second Stable Annual in January 1954. But not everyone thought they were crazy. "They were very beautiful, even poetic," recalled New York art dealer Ileana Sonnabend. "He came into the Stable Gallery with a watering can every day."

His point, Rauschenberg said, was "responsibility. To keep something alive, you have to nurture it." If his exploration of what Albers called the "possibilities of materials" led to paintings made of dirt, there was no way of predicting what Rauschenberg would do next.

MUSIC BOX *1953. Wood box, nails, 3 stones, 11 × 7¾ × 9¼". Collection Jasper Johns. The box was intended to be picked up and gently shaken so that the stones would tumble across the antique nails to create sounds. When Marcel Duchamp picked up* Music Box *at the Stable Gallery in 1953, he told Rauschenberg, "I think I've heard that song before."*

THE MAN IN
THE WHITE SHOES

BED *1955. Combine painting: oil and graphite on fabric, 75½ × 31½ × 8". Collection The Museum of Modern Art, New York. Gift of Leo Castelli in honor of Alfred H. Barr, Jr.*

BED (1955) is a painting that began as a patchwork quilt stretched over a piece of board. Dorothea Rockburne, Rauschenberg's fellow student at Black Mountain, had given him the quilt, which he used to cover his old station wagon. Living in his cold-water loft, he no longer had a car. According to Rauschenberg, he painted on the quilt one day when he ran out of canvas and had no cash to buy more. He tried to turn the quilt squares into an abstraction by pouring on paint, but that didn't seem to work. The quilt remained a quilt. He added a pillow, part of a sheet, and even more paint. The additions transformed the work. The result is one of Rauschenberg's most famous, and controversial, paintings.

When *Bed* was first exhibited in 1958, *Newsweek* said it "recalls a police photo of the murder bed after the corpse has been removed." Italian authorities refused to show it at an art festival in Spoleto. Rauschenberg could not understand the commotion. "I think of *Bed* as one of the friendliest pictures I've ever painted," he said. "My fear has always been that someone would want to crawl into it."

Bed marked a new stage in Rauschenberg's career: the use of materials that had a history or meaning and use, all their own. Sometimes he used paint to "connect" the materials, using bold strokes in the style of Franz Kline and Willem de Kooning, or by pouring and dripping paint over and around them in a style recalling Pollock. He even went so far as to attach the objects to his paintings, hanging them below the picture frame, off the wall, and protruding into the room with the viewer. Often Rauschenberg made freestanding assemblages or constructions with the materials. Because these works combined elements of both painting and sculpture, but were neither, Rauschenberg called them *combines*. Like Calder's mobiles and Duchamp's readymades, the combines were a new concept in art. Between 1955 and 1959, he made more than sixty combines, including *Monogram* (1955–59), *Odalisk* (1958), and *Coca Cola Plan* (1958), which are still among his most significant and well-known works.

When Rauschenberg's combines first appeared in the mid-1950s, his use of real objects shocked viewers and enraged some critics. The combines featured various stuffed animals—a white rooster, a bald eagle, a goat—as well as found objects from the streets of New York: boards, bricks, chairs, ladders, tires, traffic signs.

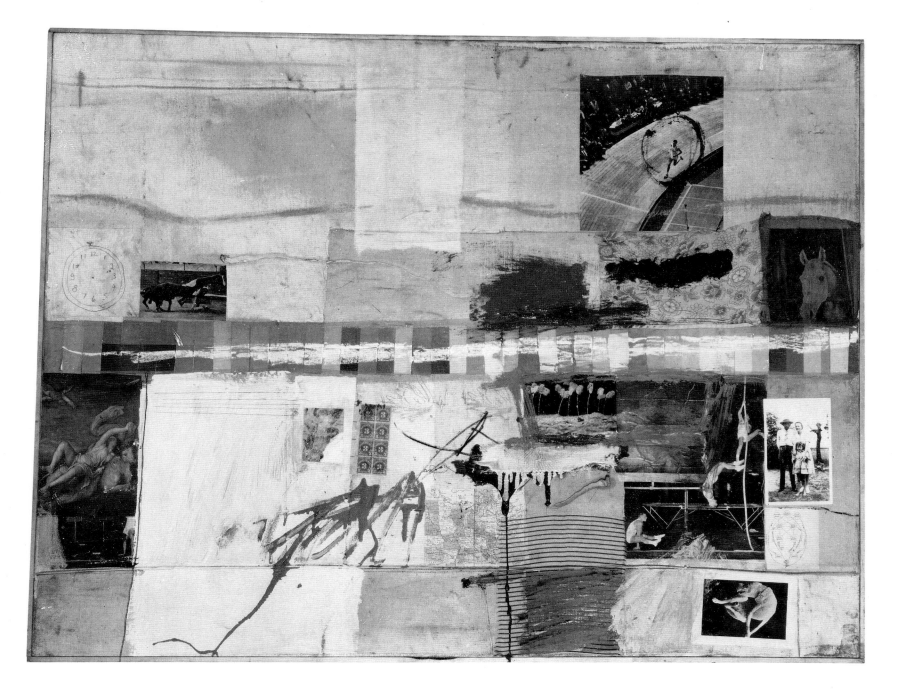

SMALL REBUS *1956. Combine painting, 35×46″. Collection Museum of Contemporary Art, Los Angeles. The Panza Collection*

The combines were also autobiographical. "Bob Rauschenberg painted himself into the picture, much as Velázquez did," said Richard Koshalek, director of the Museum of Contemporary Art in Los Angeles. "The difference is that 'himself' is what he happened to have around him, at the moment."

Untitled (1955) is the result of one of those "moments" in which Rauschenberg has appropriated autobiographical elements and employed them as artistic elements. *Untitled* stands on the floor, almost eight feet high, mounted like a box kite on a wood platform. Its wood panels are covered on all sides with an intricate collage made from oil painting, photography, drawings, letters, and newspaper clippings.

There are photographs of Rauschenberg's former wife, Susan; his sister, Janet, as a twelve-year-old girl and also in a newspaper clipping as the Louisiana Yam Queen; his parents as a young couple in Port Arthur, and in a newspaper story on their twenty-fifth wedding anniversary; and his son, Christopher, as a three-year-old, placed near a set of cherubs from one of Leonardo da Vinci's sketchbooks. The cherubs are surrounded by Christopher's scribbled pencil drawings and similar pencil scribbles which, according to Rauschenberg, were made by Cy Twombly. A pencil sketch of a man's face with paper clips drawn beside it was made by Jack Tworkov.

The care with which personal mementos are juxtaposed with found objects and published illustrations is characteristic of Rauschenberg's method. Every picture has meaning to him. A magazine illustration of a small house surrounded by floodwaters is echoed by a snapshot of the Rauschenberg home in Port Arthur, and a published photo of the 1953 Miss America contestants is paired with a 1923 snapshot of Dora Rauschenberg and her friends in bathing suits posed on a beach in Texas. The jug-eared man in Tworkov's drawing is placed near a photograph of Ernest Rauschenberg, whom it resembles.

Set against this elaborate detail are three large figures. The first, in a full-length photograph, is a handsome young man of the 1920s, wearing a white suit and white shoes. His fine features are reflected in the mirror at his feet, which also forms his platform. Next to him, on a platform covered with collage, is a stuffed speckled Plymouth Rock hen. Behind them, on the other side of the three-dimensional construction, a higher platform holds an actual pair of shoes painted white, with crumpled white socks dangling over their sides, as if the man in the picture had just stepped out of them and walked away. The shoes, haunting in their emptiness, set a tone for the loneliness that is conveyed overall by the combine, despite its treasure of personal associations. Pasted on the hen's platform is an elongated American flag, carefully drawn with colored pencils on paper. Near the white shoes is a portrait of a pensive young man in his twenties, in what Rauschenberg called "a gorgeous photograph." It is Jasper Johns.

The two met in 1954, shortly after Johns, a twenty-four-year-old artist from South Carolina, had arrived in New York. The next year they each found quarters in an old warehouse on Pearl Street, around the corner from Rauschenberg's Fulton Street loft.

Johns was a shy young man who knew virtually no one in the city. He was making highly disciplined paintings of single elements, such as the American flag, a target, or a series of numbers. To Johns, it was important that his work be arbitrary and impersonal, in contrast to Rauschenberg, whose art was based on personal references and evocative souvenirs.

Both men were concerned with the *surface* of their paintings, giving up traditional perspective for what critic Leo Steinberg called a "flatbed picture plane . . . that changed the relationship between artist and image, image and

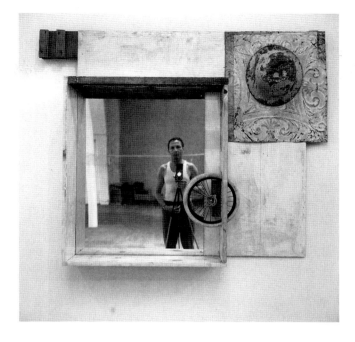

In his New York studio, Rauschenberg photographed himself in a mirror, as part of a work in progress.

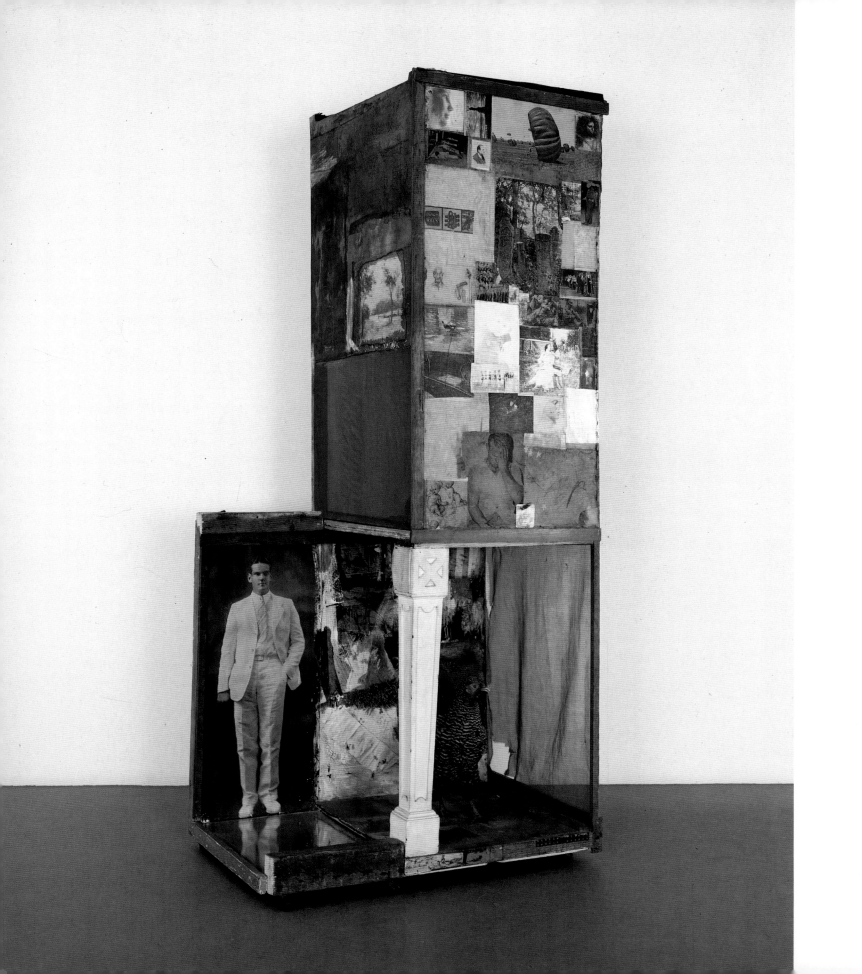

viewer." Rauschenberg filled his surface with objects, even expanding it to include the sides and back of the painting. Johns chose a single theme for each of his paintings, and developed the idea that the painting itself is an object. He built a thick surface with encaustic, a mixture of hot wax and pigment, over newspapers crumpled the way Rauschenberg had used them in the Black Paintings. Their work had one thing in common: both were going against the then-dominant grain of Abstract Expressionist art. Each, in his way, was forging a link between abstraction and representation.

"Bob was the first person I knew who was a devoted painter, whose life was geared to painting," Johns recalled some years ago. For a five-year period, the two saw each other's work daily. Rauschenberg said that they gave each other "the permission to do what we wanted."

Rauschenberg helped the younger artist make friends and contacts in the art world and enthusiastically showed Johns's work to dealers and curators. They worked together for commercial designer Gene Moore, earning more money making window displays for Bonwit Teller and Tiffany's than they did from their art. The fictitious commercial name for their display business was Matson Jones. Matson was Dora Rauschenberg's maiden name, Jones stood for Johns. About the relationship between Johns and Rauschenberg, Calvin Tomkins has written, "They were deeply involved with one another, both intellectually and emotionally, and the intensity of what passed between them filled up their lives." Rauschenberg said, "It would be hard to imagine my work at the time without his encouragement."

They were close to two older men, composer John Cage and dancer Merce Cunningham, who lived together. The four would get together almost every evening, either at the Cedar Tavern or at another bar down the street, to play the pinball machine and talk about the work they had done during the day. They were intense conversations, covering what Rauschenberg has described as "all the possibilities" of art. Cage recalled the friendship among them as "the most fulfilling moments of my life."

"We called Bob and Jasper 'the Southern Renaissance,'" Cage said. "Bob was outgoing and ebullient, whereas Jasper was quiet and reflective. Each seemed to pick up where the other left off. The four-way exchanges were quite marvelous. It was the *climate* of being together that would suggest work to be done for each of us. Each had absolute confidence in our work, each had agreement with the other."

For Cage and Rauschenberg, the purpose of art was not to create enduring masterpieces for an elite, but to further a perpetual process of discovery in which everyone could participate. They wanted to break down all barriers between art and life. Rauschenberg wrote, "Painting relates to both art and life. Neither can be made. (I try to act in that gap between the two.)" Art, said Cage, should be "an affirmation of life—not an attempt to bring order out of chaos nor to suggest improvements in creation, but simply to wake up to the very life we're living." As Rauschenberg began to work on the combines, Cage, he said, gave him confidence that "the way I was thinking was not crazy."

UNTITLED *1955. Combine: oil, graphite, and collage on construction with objects, 86½ × 37 × 26⅓". The Museum of Contemporary Art, Los Angeles. The Panza Collection*

IN THE LATE 1950s, the Abstract Expressionists "didn't think Jasper and I were serious," said Rauschenberg. Since the "Ninth Street Show" that introduced the New York painters as a group in 1951, Abstract Expressionism had come into its own. The influential critics Harold Rosenberg and Clement Greenberg endorsed the work, defining "action" painting, like Pollock's, and "gestural" painting, such as de Kooning's. Thomas Hess, the editor of *Art News*, described the New York movement as "a shift from aesthetics to ethics; the picture was no longer supposed to be Beautiful but True—an accurate representation or equivalence of the artist's interior sensation or experience."

Although this description also fit Rauschenberg, his work did not belong to any of the dominant strains of the movement. Rauschenberg had been influenced by the New York painters—especially de Kooning—though less by their theories, styles, and techniques than by their rebellious spirit. By the mid-fifties, he had rejected much of the philosophical outlook of the Abstract Expressionists. He had come to dislike their emotional upheaval, their "projecting of the unconscious onto canvas," and their search for symbolism in colors.

"There was a whole language [of Abstract Expressionism] that I could never make function for myself—words like 'tortured,' 'struggle' and 'pain,'" he explained. "I could never see those qualities in paint."

By the mid to late fifties, some of the Abstract Expressionists' work also followed Rauschenberg's earlier ideas. Barnett Newman made a black painting in 1955. Ad Reinhardt made his all-black paintings from the mid-1950s to 1967. Said Reinhardt, "Square black paintings are the last paintings that anyone can paint."

"It was a time when they were all discussing 'a sad cup of coffee,'" Rauschenberg said. " 'How can a cup of coffee be sad?' I wondered. 'Or how can red be passion? Red is red.' Jasper and I used to start each day by having to move out from Abstract Expressionism."

Rauschenberg's combine paintings *Factum I* and *Factum II* (1957) are pointed comments on the "purely emotional" spontaneity called for by the Abstract Expressionists. The first is painted with an apparent spontaneity of gesture; *Factum II* is an identical copy, brush stroke for brush stroke. No one can tell which came first, or which was the product of spontaneous creativity.

The most controversial of Rauschenberg's combines, and perhaps his best-known work, is *Monogram* (1955–59), featuring a stuffed Angora goat mounted on a platform of paint and collage. An automobile tire encircles the goat's midsection. The title is self-explanatory, or at least for Rauschenberg. As Robert Hughes interpreted it, monograms are intertwined letters, and the goat has been intertwined with the tire. Rauschenberg bought the goat for fifteen dollars after seeing it in the window of a second-hand typewriter shop. He shampooed it and painted its face. It did not work as a sculpture, however. In the next version, he put the automobile tire around its middle to make what Albers would have called a contrast in surfaces. It took him almost five years to decide, with help from Jasper Johns, to place it on a "pasture" of collage on a wood platform.

Since its first showing, art historians have disagreed about the meaning of *Monogram*. Some see the goat as autobiographical because as a child Rauschenberg had a pet goat whose death at the hands of his father had upset him greatly. To others, *Monogram* has a sexual meaning. "Goats are the oldest metaphors of priapic energy," wrote Robert Hughes in *The Shock of the New*. Rauschenberg totally dismissed this interpretation. "A stuffed goat is special in the way that a stuffed goat is special," he said. "I wanted to see if I could integrate an object as exotic as that."

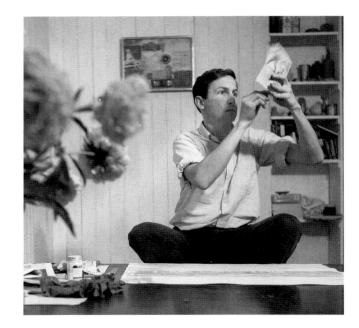

Rauschenberg, photographed by Jasper Johns, making drawings in his Pearl Street studio in 1955.

Monogram, owned by the Moderna Museet in Stockholm, is considered one of the seminal artworks of the 1950s. "It marks the end of the Abstract Expressionist era. The beginning of something that developed in the fifties and sixties—the return of the subject," said Pop artist Roy Lichtenstein.

Although Rauschenberg was sometimes confounded by the wildly differing interpretations of his combines, he sought the attention and controversy they stirred. He wanted to involve the viewer in his art, and he wanted to convey the randomness of experience. According to John Cage, "There is no more subject in a combine than there is in a page from a newspaper. Each thing that is there is a subject."

Rauschenberg's freestanding, multisided combines were a way to work with ordinary materials that clearly connected art and life. From the *Werklehre* exercises at Black Mountain using different materials, which Albers called "combinations," Rauschenberg had found the basis for his lifelong approach to art: "A pair of socks is no less suitable to make a painting with than wood, nails, turpentine, oil and fabric," he asserted. In *Coca Cola Plan* (1958), three empty green bottles form a heart between a pair of wings, reminiscent of the goddess's spread wings in the *Nike of Samothrace*. In *Canyon* (1959), a stuffed American eagle seems to take flight from the canvas. Other objects made their way into works of this period: a rooster and a satin pillow in *Odalisk* (1958), a ladder in *Winter Pool* (1959), and a straight chair in *Pilgrim* (1960).

"What is extraordinary," wrote the English critic Andrew Forge, "is the way in which such aggressive forms as the goat, as the umbrella [in *Charlene*] are brought to terms with the painting's surface. And they remain self-contained, intact."

In his use of materials, Rauschenberg was supposedly influenced by the Dadaists of the 1920s, whose ridicule of the Establishment and high jinks were amplified by their so-called anti-art. He and Johns were called neo-Dadaists by a number of critics. Rauschenberg resented the label. He said he was "pro-art, and, if anything, was trying to be neo-Rauschenberg."

In fact, Rauschenberg admired and consciously learned from all kinds of artists—from Leonardo, who he said "could paint a blade of grass even better than [he could paint] the Virgin Mary," to Picasso, whose inventiveness and virtuosity he prized. He studied the colors of Matisse, the pencil shadings of Ingres, and the drama of Rubens and Delacroix. Reproductions of the Masters are frequently found in Rauschenberg's work of this period, and he created "homage" works for many of his contemporaries, including Cunningham, Johns, and Marcel Duchamp. Duchamp, whom he admired for his "dynamic intention and willingness to go against the grain," also became his friend. (When Rauschenberg saw Duchamp's 1912 *Bicycle Wheel*, a wheel mounted on a stool, in 1953, he thought it was "the most fantastic piece of sculpture I had ever seen.") Like Duchamp, Rauschenberg felt that the observer had to be a collaborator, to help complete the work.

Critics often compared Rauschenberg's combines to the 1920s collages of Dadaist Kurt Schwitters, whose tight compositions were meant to expose a corrupt society. But Rauschenberg said he did not see Schwitters' work until 1959, five years after he began making collages with found objects. When he did discover Schwitters, in an exhibition at the Sidney Janis Gallery, he was delighted. "I felt like he made it all just for me," he said.

Jasper Johns, with one of his target paintings in background, photographed in 1955 by Rauschenberg in the Pearl Street warehouse where each had a studio residence. (Shown is a contact sheet with three frames missing.)

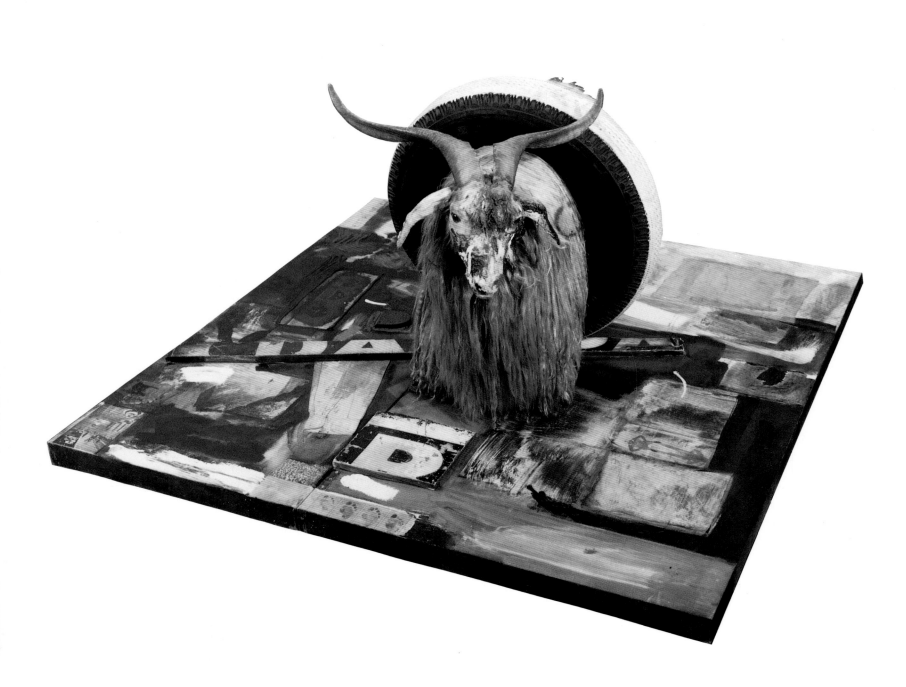

MONOGRAM *1955–59. Combine: oil and collage on canvas with objects, 42 × 63¼ × 64½". Collection Moderna Museet, Stockholm*

UNTITLED *1956. Combine painting: oil and collage on canvas,*
57 × 56½″. Collection Mr. and Mrs. S. I. Newhouse. A parachute, like
the flattened umbrella in Charlene, *became a favored form used by*
the artist.

In his Front Street studio in 1958, Rauschenberg and his combines:
from left to right, Interview, Untitled, Bed, Monogram *(foreground,*
in its second state), and Odalisk. *Photograph by Kay Harris*

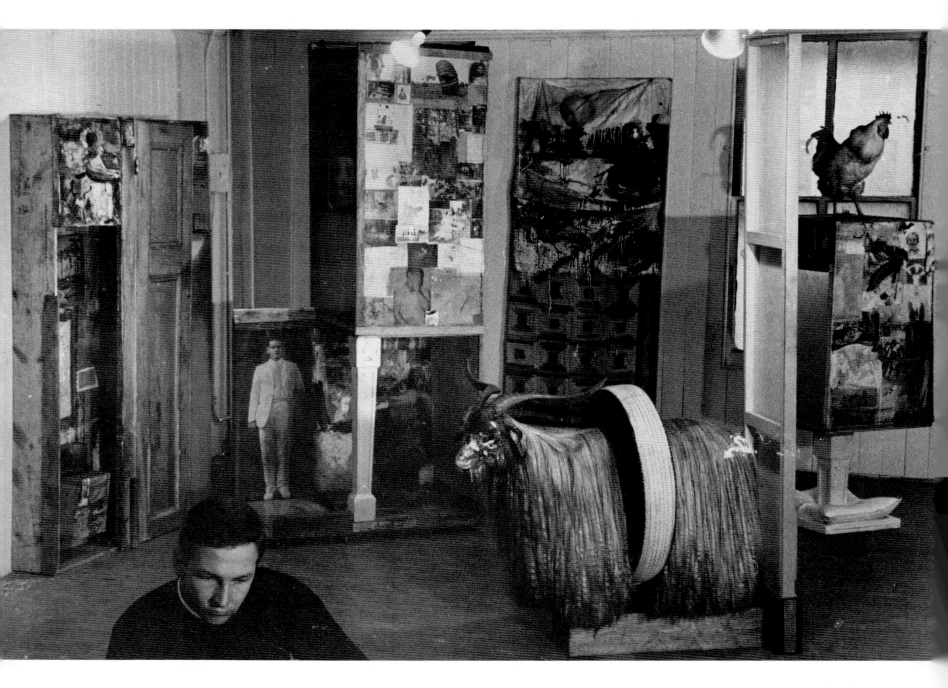

94

COCA COLA PLAN *1958. Combine: construction with oil, graphite, paper, and objects, 26¾ × 25¼ × 4¾". The Museum of Contemporary Art, Los Angeles. The Panza Collection*

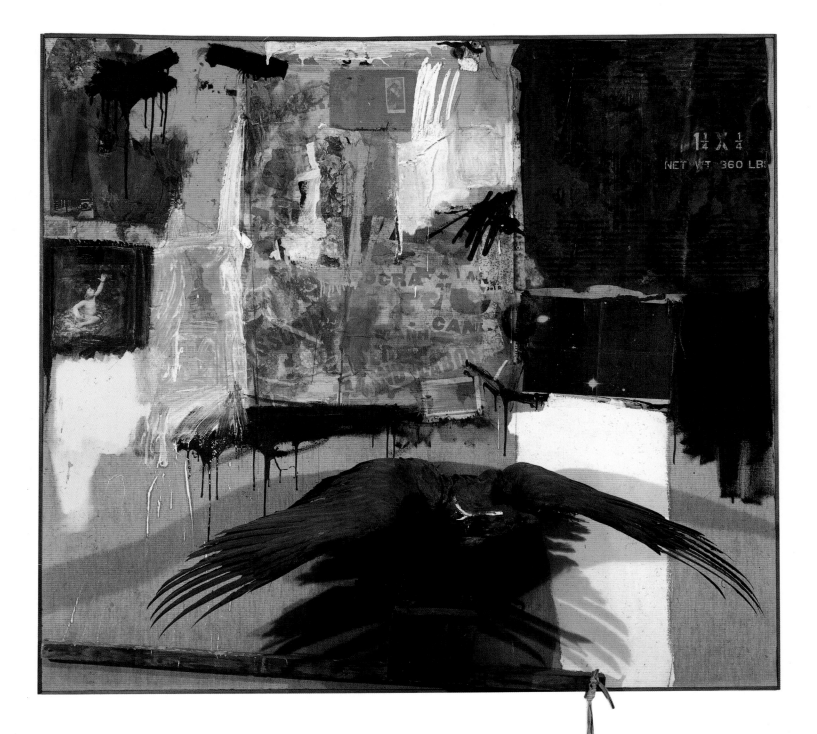

CANYON *1959. Combine painting: oil, graphite, and collage on canvas with objects, 81¾ × 70 × 24″. The Sonnabend Collection. The eagle incorporated here once belonged to one of Teddy Roosevelt's "Rough Riders."*

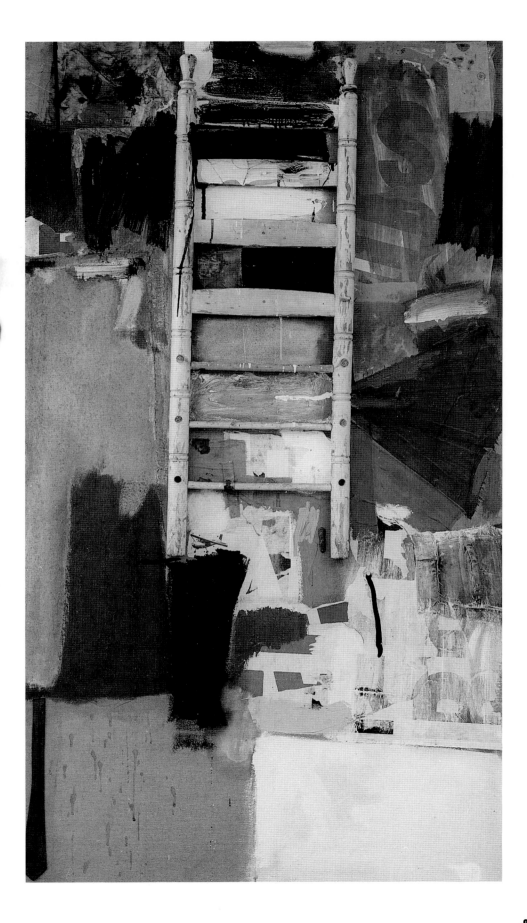

OCTAVE *1960. Combine painting: oil and collage on canvas with objects, 78×43". Collection Mr. and Mrs. Bagley Wright*

Rauschenberg and his dealer Ileana Sonnabend, pictured in Europe in the 1960s with other European art dealers.

AN IMPORTANT breakthrough for both Rauschenberg and Johns came in March 1957, when Leo Castelli and his wife, Ileana, visited Rauschenberg's studio on Pearl Street. The Castellis had recently opened a gallery dedicated to the work of upcoming young American and European abstractionists. They had known Rauschenberg for six years, but the visit was the first sign that they might exhibit his work. Rauschenberg showed them his paintings, and then took them down to Johns's loft. "I saw evidence of the most incredible genius," Castelli recalled of his viewing of Johns's pictures of flags and targets, including *White Flag* and *Target with Four Faces*. The Castellis bought one Johns painting on the spot, and agreed to put on one-man shows for both Johns and Rauschenberg.

The Johns show, in January 1958, turned an obscure young artist into an overnight sensation. His work was featured on the cover of *Art News*. The New York Museum of Modern Art immediately bought four pieces for its collection. Johns had clearly stepped out of the shadow of his friend and mentor. The Rauschenberg show in March of that year was a *"succès de scandale"* as Calvin Tomkins put it, showing the artist's combines, "all of which annoyed some viewers, and some of which annoyed nearly all of them." Three years later, Rauschenberg and Johns had a painful personal parting, and thereafter, said Castelli, "pursued their careers as rivals."

For Rauschenberg, the relationship with the Castellis was crucial to his career. They bought his work, became his dealers, and championed him in the art world. Castelli later recalled how he was struck by Rauschenberg's "amazing natural intelligence, broad range of knowledge, and openness to new experience." He was taken by what he saw as Rauschenberg's "restless spirit, always developing with grand ideas that would reflect our time." Some years later, the Castellis divorced and Ileana had married Michael Sonnabend and also opened her own gallery. Rauschenberg, she felt, combined a "strange mixture of boastfulness and humility, depression and high spirits. . . . There was a spiritual quality in his works, as well as a poetic and ephemeral quality. People like to hold on to what they know. Bob likes to shake them out of their habits."

BY 1959, Rauschenberg had embarked on a project to illustrate Dante's *Inferno*. He had several motives. He wanted to make a sustained series of drawings; he also wanted to counter the ridicule aimed at his one-color paintings and the combines, and to be taken more seriously as an artist. And he set himself a new challenge—narrative art. He knew he could do abstract work, he later explained, "but could I do anything else?"

Although Rauschenberg had never read Dante, he was attracted to the poem by Botticelli's illustrations of *The Divine Comedy.* Using a translation by John Ciardi, he worked with Michael Sonnabend, a Dante scholar, to study the layers of allegorical meaning in the poem. He decided to make one drawing for each of the poem's thirty-four cantos. The illustrations combined Rauschenberg's own pencil and crayon drawing and watercolor painting with images from the pictures that he clipped out of such magazines as *Life* and *Sports Illustrated*.

Rauschenberg transferred the images from magazine clippings to his pictures by employing a process he invented in Cuba, "in desperation, for wanting to make drawings as complex as collages." He moistened the illustrations with

lighter fluid, placed them face down on paper, and then drew an empty ball-point pen back and forth across the image until it was transferred to the paper. This technique, called solvent transfer, became his primary method of drawing.

Just as Dante had found characters and language in the vernacular of his day, Rauschenberg presented the images of his own, including mechanized war, space-age explorations, and politicians from Adlai Stevenson to Richard Nixon. For Dante himself, Rauschenberg chose an average-looking fellow wrapped in a towel, from a *Sports Illustrated* ad for Pro Fit golf clubs. Adlai Stevenson serves as Virgil, Dante's mentor; Italian racing cars are the centaurs; gas-masked Africans are the demon squads; uniformed policemen are the clergy; rockets are Dante's hell fires; Wall Street businessmen are corrupt Florentine politicians; and athletes from the pages of *Sports Illustrated* are the brave warriors.

Whenever Dante described noise, Rauschenberg used short, staccato pencil strokes. Arrows guide Dante along his journey through Limbo and the nine circles of hell. Stinging wasps are shown as a whirlwind of stabbing lines. A rusty red illustrates Dante's references to blood. In his rare uses of color symbolism, white surrounds Dante's heavenly messages, the stench of a sinkhole is depicted by ocher, and the tomblike refuge from the stench is colored gray. The worst fires of hell, those in the River Styx, are shown as oil derricks and the flames from refineries.

The drawings took Rauschenberg eighteen months and involved the most intensely disciplined work of his life. To finish them, he isolated himself for six months in a rented storage room in a fishing village near St. Petersburg, Florida.

When the drawings were shown in 1960, first at Castelli's gallery in New York, and then in Europe, they achieved for Rauschenberg his first substantial praise from the art establishment. "He attacks the problems of illustration with a classicist's sobriety," wrote Dore Ashton. "The drawings are transcendent," said William Lieberman, who later acquired them for the Museum of Modern Art when he was curator of prints and drawings. "They proved the genius of Rauschenberg." John Canaday called them "visually beautiful and poetically eloquent drawings." Roberta Smith in *The New York Times* later compared them to the "continuous tumult of Michelangelo's *Last Judgment* or a painting by Hieronymus Bosch."

RAUSCHENBERG has often said that once a certain technique or method became easy, he would give it up and try something else. He also tried to stay ahead of the field. By 1962, he noticed that collage using found objects was showing up in dozens of galleries and museums. He thought that the form was being used simply for its own sake. After finishing a series of paintings in 1960 in which he used large white areas of brushwork and alphabet letters (Johns, too, was using letters in some of his paintings), Rauschenberg turned to what was for him a new technique—silkscreen paintings.

He was attracted to silkscreen both for the technical possibilities it opened and for the way he could use it dramatically to portray the blizzard of images that flashed across the media, television in particular. "I was bombarded with TV sets and magazines," he said, "by the excess of the world. I thought an honest work should incorporate all of these elements, which were and are a reality."

Left to right:

CANTO II *(XXXIV Drawings for Dante's Inferno). 1959–60. Solvent transfer, collage, watercolor, wash, and pencil on paper, 14½ × 11½″. Collection The Museum of Modern Art, New York. Anonymous Gift. Dante, the towel-clad man (top right), descends into Limbo past Beatrice, a classical statue. His passage is marked by arrows.*

CANTO VIII *(XXXIV Drawings for Dante's Inferno). 1959–60. Solvent transfer, pencil, watercolor, gouache, and crayon on paper, 14½ × 11½″. Collection The Museum of Modern Art, New York. Anonymous Gift. Dante's arrow that "bored the air it rode dead to the mark" is Rauschenberg's directional arrow (top, right) pointing toward the initials "FA," Dante's political enemy. Below, Dis, the Capital of Hell, is indicated by a montage of oil refinery derricks and towers.*

CANTO XXXIV *(XXXIV Drawings for Dante's Inferno). 1959–60. Solvent transfer, pencil, watercolor, and gouache on paper, 14⅝ × 11½″. Collection The Museum of Modern Art, New York. Anonymous Gift. The final drawing, bringing Dante through his journey into the netherworld, delivers the poet, still wearing his towel, into the light of the heavenly divine (the sphere at bottom, center).*

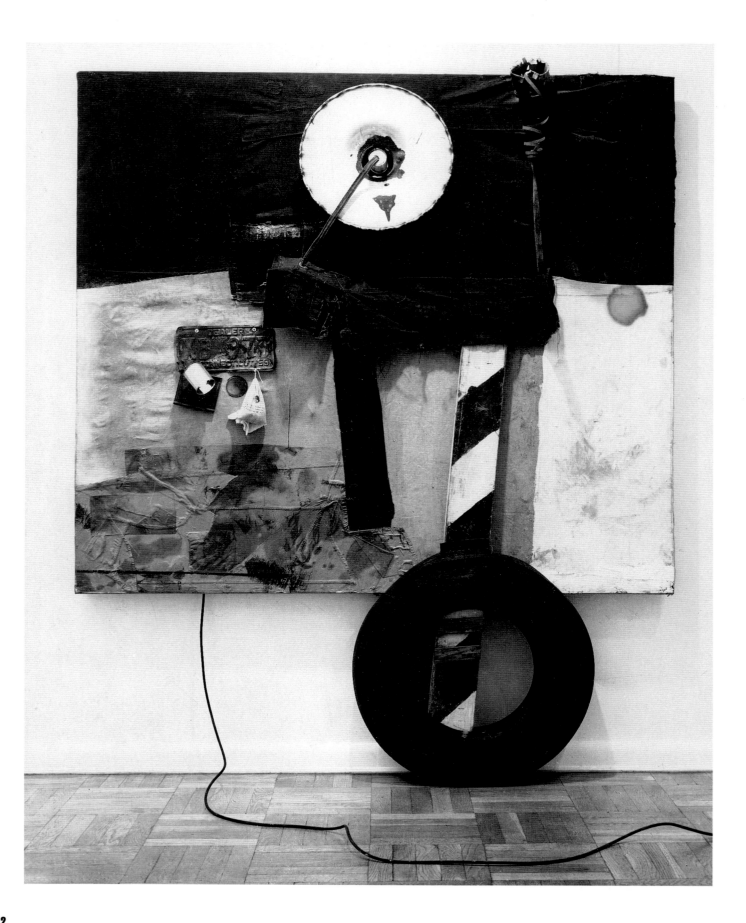

Rauschenberg and his friend Andy Warhol explored the silkscreen technique, finding a craftsman on Broadway whom Rauschenberg described as "a wonderful old drunk who did excellent work." As Lawrence Alloway explained, "Warhol developed the potential of the silkscreened image for repetition within each work as a metaphor of mass production. Rauschenberg repeated his screens from one work to another as a metaphor, perhaps, of recurrence."

Rauschenberg would bring in dozens of pictures from magazines or art history books, as well as photos he had taken himself, and have them enlarged and reproduced on photosensitive silkscreens. Once he had the silkscreens in hand, he would place them on a canvas laid out on his floor and force viscous inks through the images on the porous silk onto the canvas with a squeegee. He would then paint around the screened images.

With his Polaroid camera, Rauschenberg made photographs from his studio of the water towers and rooftops of New York. From magazines, he clipped pictures of the wars, athletic contests, and political campaigns that dominated the news. His found objects were now gleaned from the media, not the streets. The paintings were flat once again. In the silkscreen paintings he could alter relationships in scale for the purposes of composition. A mosquito could be as big as a helicopter, a car key could be as long as Rubens's *The Toilette of Venus*. Silkscreens gave him the freedom to manipulate images through color and by superimposing images on each other.

Rauschenberg's enthusiasm for silkscreen was apparent in *Barge* (1962–63), a thirty-two-foot-long painting that was his largest picture up to that time. The imagery is a cluster of urban and industrial subjects: a construction site, a football field with a game in progress, a navy missile, and city skylines. He arranged his images, he said, to reflect life's "extremely random order that cannot be described as accidental."

By the early 1960s, Rauschenberg was becoming a celebrity. In his spacious new loft at 809 Broadway, he accommodated a CBS television crew making a film about him by working on *Barge* for twelve hours straight, stimulated by vodka, by the presence of the camera crew, and by his own excitement.

AT THE AGE of thirty-seven, Rauschenberg was young for a major retrospective of his work, even though he already had produced an enormous quantity of art. Alan Solomon, director of the Jewish Museum in New York, nevertheless installed such an exhibition in 1963. The fifty-five paintings in the show covered his entire career: Blueprints, White Paintings, combines, the *Inferno*, the "painterly" paintings of 1960–62, and the early silkscreen paintings. Seeing all these artworks together gave critics, dealers, and museum curators a new sense of Rauschenberg's talent and energy. Brian O'Doherty of *The New York Times* described him as "one of the most fascinating artists around." Max Kozloff in *The Nation* called Rauschenberg's work "the most significant art being produced in the United States by anyone of the younger generation."

The Jewish Museum opening on March 29, 1963, was among the first of the highly charged art-world galas that became central to the New York social scene in the sixties. The audience ranged from society matrons in furs to long-haired hippies in jeans. O'Doherty wrote that what viewers felt "was not just a recognition of images, but a recognition of a familiar state of feeling that has to do with informational overload, a part of daily life everyone more or less learns to ignore." As one viewer told the *Times* critic, "The show didn't help me understand the world, but it helped me to understand my puzzlement about it."

FIRST LANDING JUMP *1961. Combine painting, 89⅛ × 72 × 8⅞". Collection The Museum of Modern Art, New York. Gift of Philip Johnson*

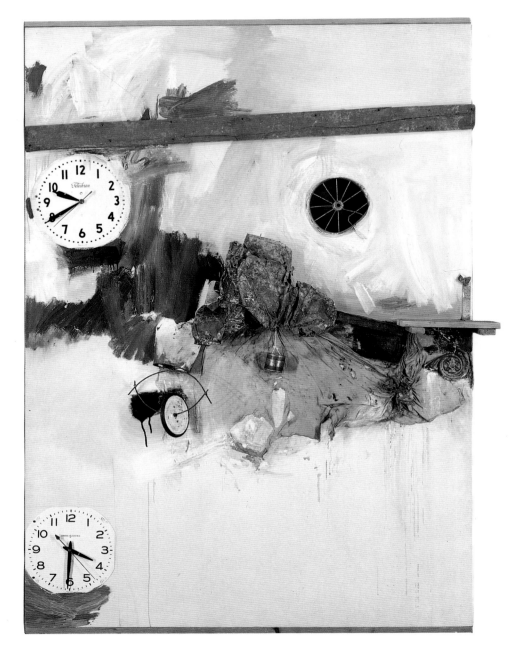

RESERVOIR *1961. Combine painting: oil and collage on canvas with objects, 85½ × 62½ × 14¾". Collection National Museum of American Art, Smithsonian Institution, Washington, D.C. Gift of S. C. Johnson and Son, Inc.. The clock at upper left was set when Rauschenberg began to work on the combine, the clock at lower left set to record the time when the work was completed.*

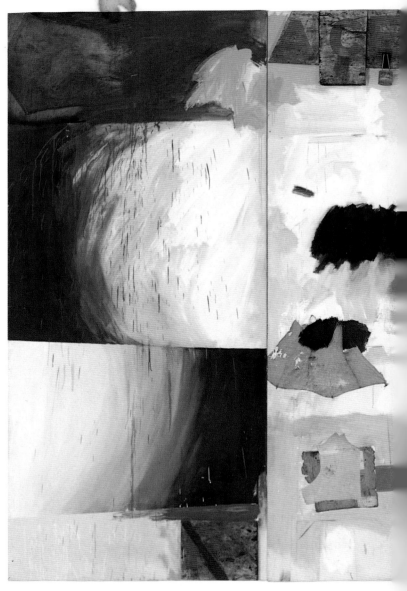

ACE *1962. Oil, wood, metal, cardboard on canvas, 108 × 240″ (5 panels). Collection Albright-Knox Art Gallery, Buffalo. Gift of Seymour H. Knox, 1964. In the 1960s, Rauschenberg moved from combines into other forms of art. In the five-paneled painting, ACE, and the Summer Rental series, his work became more painterly, his picture plane flat once more.*

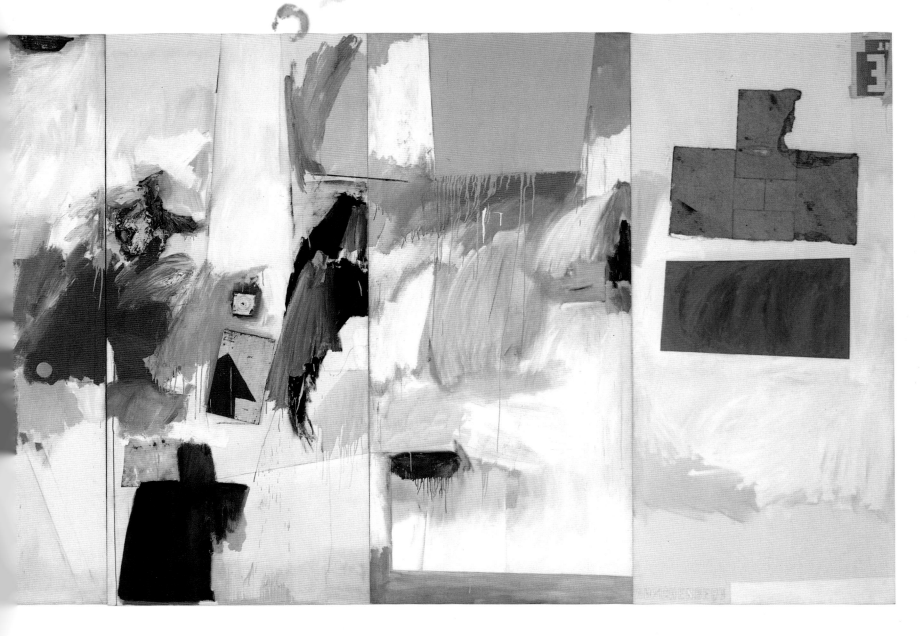

PAYLOAD *1962. Oil and silkscreen ink on canvas, 60 × 30". The Sonna-bend Collection. Rauschenberg adapted imagery from media to-ward a new innovation: silkscreen painting.*

EXPRESS *1963. Oil and silkscreen ink on canvas, 72 × 120". Thyssen-Bornemisza Collection, Lugano, Switzerland. The image at right is a magazine photograph of a nude descending a staircase—an hom-age to Duchamp's 1913 masterpiece.*

Rauschenberg was very much a part of the avant-garde spirit of the 1950s and 1960s, not just among New York artists, but of the zeitgeist that included Beat generation writers, jazz poetry readings, happenings, performance art, cultural and political protests. He participated in, and joyfully lent his support to, all that made up the shock of the new. He had, wrote Dorothy Seckler, "a habit of moving as if his tennis shoes carried an extra charge of bounce. . . . Far from seeming a rebel of any stripe, he conveyed a sense of continuous delight at the discoveries of every shining hour." As one cultural historian wrote, Rauschenberg had a "legendary capacity to charm everyone from fellow artists to Philistines."

His own studio was often the heart of the action. His large circle of friends gathered to drink and talk above the blare of the television set, to practice dance or drama routines, while Rauschenberg, a glass of vodka or Jack Daniel's in his hand, played with his dogs and laughed along with everyone while he worked on three or four paintings. He had an overwhelming way of being involved with everything at one time. "The way [Rauschenberg] occupied the New York scene was as influential as his art," wrote Brian O'Doherty in *American Masters*. "It was a groundbreaking personality, in the spotlight and at ease. Its uncanny magnetism did a lot toward creating a climate favorable to change."

Part of his charm was his sheer inventiveness and his delight in art. By his constant experimentation with materials, Rauschenberg tampered with the definition of "what is a painting." In little more than ten years he had opened the way for other artists to use junk, comic pages, and images from the day's news as part of art. Another side of his charm was the exuberance with which he mixed these materials and images, sprinkling jokes and visual puns throughout the work. It was a kind of focused recklessness.

Rauschenberg was also consciously avant-garde, with a "fondness for iconoclastic gestures," as critic Lucy Lippard put it. Among his most notorious gestures were the *Erased de Kooning Drawing* and his response to a request from French art gallery owner Iris Clert that he contribute a portrait of her for a show. He sent a cable: "This is a portrait of Iris Clert if I say so—Robert Rauschenberg."

That he would try anything or do anything had become his trademark. Rauschenberg himself ascribed his fearlessness in those days as "having nothing to lose. I had nothing to start with," he said, "so I could try anything I wanted to."

Rauschenberg's work profoundly affected both his contemporaries and the younger artists who emerged in the sixties. Although he jokingly called himself "Poppa Pop," Rauschenberg was no Pop artist. Yet his work, along with that of Jasper Johns, "set free the attitudes that made pop seem culturally acceptable," said *Time* critic Robert Hughes. "It is plain that there has not been much anti-formalist American art that Rauschenberg's prancing, fecund, and careless talent did not either hint at or provoke."

Rauschenberg championed the work of other young painters. Although many of his friends and contemporaries, including Andy Warhol, Jim Dine, Roy Lichtenstein, James Rosenquist, Claes Oldenburg, and Tom Wesselmann contributed their own vision to modern art, they also each owed a great debt to him. Andy Warhol said that Rauschenberg's use of objects in his combines made it possible for Warhol to do what he later did with soup cans, Coke bottles, and in his multiple portraits of Marilyn Monroe. Roy Lichtenstein, whose use of comic strips in art followed Rauschenberg's by ten years, acknowledges Rauschenberg's influence on him and on Pop art. "The Coke bottles he put into his art, the

Rauschenberg in 1962 at his studio at 809 Broadway, working with silkscreens. Photograph by Ugo Mulas

happenings and environments, all the things in which he was involved brought up a raw, strictly American material: merchandise as merchandise. Art became American, rather than European. The sixties, seventies, and eighties were all influenced by that work."

BARGE *1963. Oil and silkscreen ink on canvas, 79⅞ × 386". Collection the artist. The climax of the silkscreen series was the encyclopedic* Barge, *a thirty-two-foot painting.*

THE JEWISH MUSEUM exhibition of 1963 established Rauschenberg's reputation in America. Within the year, a second retrospective at the White-chapel Gallery in London brought him fame in England. "The most important American artist since Jackson Pollock," said the Sunday *Telegraph*. "The most enjoyable show of the year," wrote the *Observer* critic. "Every now and then a figure emerges from the bewildering currents of modern art who visibly marks a stage, a kind of distance post. Rauschenberg is one of these."

Four months later his work was displayed at the *XXXII Esposizione Biennale Internazionale d'Arte Venezia*, the prestigious Venice Biennale. On June 24, 1964, the announcement came that Rauschenberg had won the $3,200 First Prize of the Biennale, the international art world's top honor. That evening, a wild group of Italian artists hoisted Bob Rauschenberg on their shoulders and marched him around the Piazza San Marco, where he and Cy Twombly had stumbled in wonder just eleven years earlier. Soon after the Biennale, the Moderna Museet in Stockholm bought *Monogram* for $30,000, then an enormous sum of money for the work of a young, living artist. And then he decided to stop painting. He needed, he felt, the challenge of new mediums.

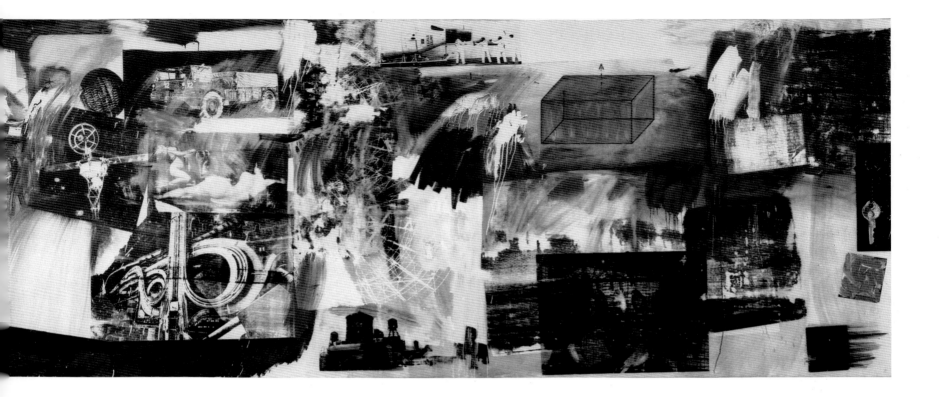

UNTITLED *1965. Solvent transfer, graphite, ink, chalk, and collage on paper, 8 × 9". Collection Leo Castelli*

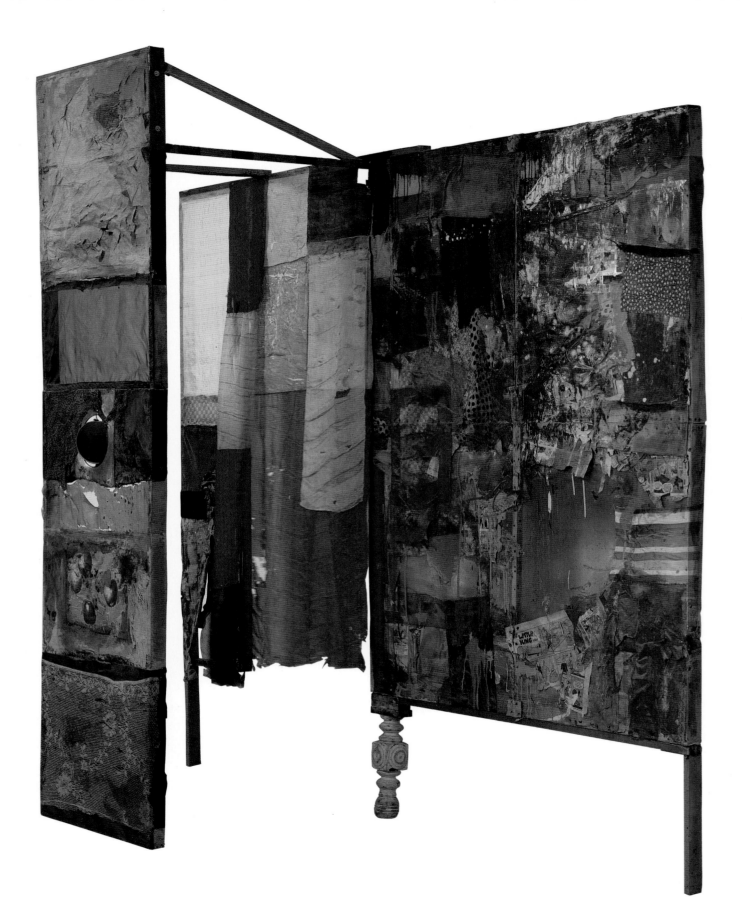

MINUTIAE

MINUTIAE (1954) is a freestanding combine of painting and collage, made in two sections, one behind the other. It shimmers with bright red fabric, a dangling mirror, and bits of lace. On the back section, pink and blue panels are fastened only at the top so that they flutter like veils at the slightest movement. *Minutiae* was created as a set for a Merce Cunningham dance of the same name; John Cage wrote the music. In 1954, at the Brooklyn Academy of Music, dancers wove their way around and through the panels, and won stunning reviews.

The making of *Minutiae*, Rauschenberg's first stage set, marked the beginning of a ten-year collaboration with the Merce Cunningham Dance Company, during which Rauschenberg designed sets, costumes, and lighting, and often served as stage manager.

Minutiae resembles his bright red paintings of the same period, such as *Charlene*. Although a dance critic at the time wondered if the set was supposed to be a beach bathhouse or a fortune-teller's booth, it is now considered to be Rauschenberg's most important stage piece, and is on extended loan to the National Gallery of Art in Washington, D.C.

Since high school, and continuing with his dance classes at Black Mountain, Rauschenberg, like many artists, had been fascinated with theater. Rauschenberg wrote in his lithograph *Autobiography* (1968) that the "dances, the dancers, the collaboration, the responsibilities and trust" of the cooperative enterprise were "the most important and satisfying element" of his life. Dance, he added, balanced "the privateness and loneliness of painting."

"Few artistic alliances in recent decades have proven so fertile," wrote artist and critic Douglas Davis of the Cage/Cunningham/Rauschenberg collaboration. The three shared the view that ordinary life offered untapped materials for the artist, whether found objects for a painting, found sounds for a concert, or everyday movements in dance. Influenced by Cage's view that all order is arbitrary, Cunningham separated dance from plot and storytelling. He also dismissed the concept of a dance as the union of dancer, sets, lighting, and music. Instead, Cunningham, Cage, and Rauschenberg agreed that dance, music, and setting should be independent activities taking place at the same time. Although they collaborated on the performance, choreographer, composer, and painter each had the freedom to pursue his own vision. As Rauschenberg had departed from Abstract Expressionism in his combines, Cunningham, aided by Cage, led a revolt in modern dance against the dominant influence of Cunningham's former mentor, Martha Graham, whose dance was weighted with messages and psychological meaning.

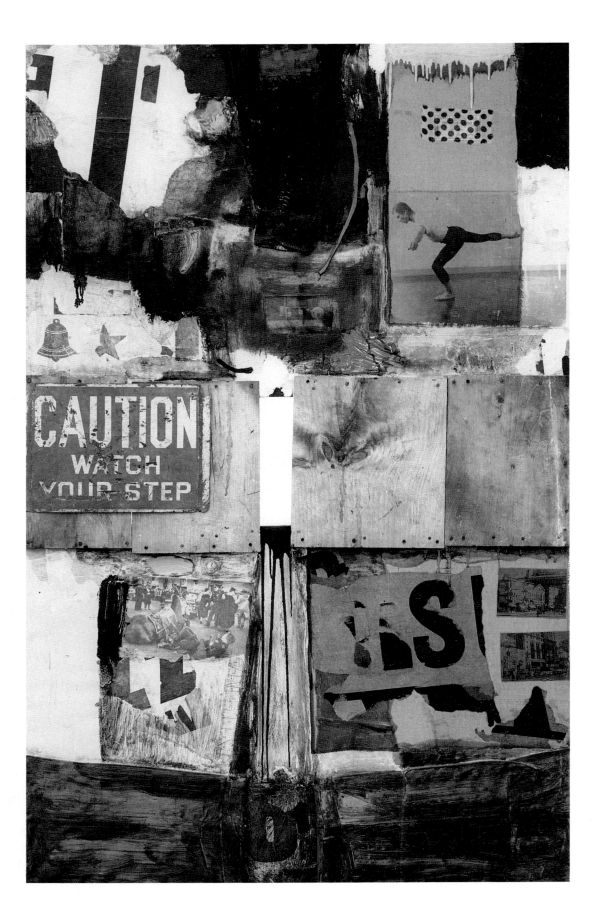

Carolyn Brown and Merce Cunningham in Cunningham's 1958 Antic Meet, *with costumes and sets designed by Rauschenberg. Cunningham danced with a chair strapped to his back. Photograph by Hans Malmberg/Tio*

Opposite:

TROPHY I (FOR MERCE CUNNINGHAM) *1959. Combine painting: oil and collage on canvas, 66×44×2". Collection Kunsthaus, Zurich. In this combine Rauschenberg playfully inserted a metal "Caution, Watch Your Step" sign below a photograph of Cunningham. It referred to the dancer having hurt his ankle in a fall on an old, uneven stage floor.*

John Cage, Merce Cunningham, and Rauschenberg outside Sadler's Wells Theatre in London during 1964 world tour of the Merce Cunningham Dance Company. Photograph by Douglas H. Jeffery

"I felt more at home with the discipline and the dedication of those dancers than I did in painting," Rauschenberg later said. "The idea of having your own body and its activity be the material—that was really tempting."

Although he had also designed costumes and sets for Paul Taylor in the 1950s, his major involvement was with Cunningham and Cage. Rauschenberg employed unconventional materials and visual techniques, even though many of his twenty works for the Cunningham company consisted of essentially traditional, though imaginative, sets and costumes. For example, in *Summerspace* (1958) the dancers' tights and leotards were painted with pointillist-like dots, which during the dance appeared to merge with a similarly dot-covered painted backdrop.

In the early days when the Cunningham company struggled to survive on a slim budget, practicality was paramount. The dancers would have to squeeze themselves and all their costumes and sets into one Volkswagen van. Rauschenberg and Cage took turns driving, amusing the others with games, riddles, and impromptu stops for mushroom-hunting. Out of the need to travel light, Cunningham conceived *Story* (1963), a dance for which Rauschenberg improvised a new set with whatever scraps were found around the theater at each stop on the tour. Improvisation was also essential. At Dartington, England, during the 1964 tour, the theater storeroom was bare, so the set for that performance consisted of the artist and his assistant, Alex Hay, standing at the back of the stage, ironing shirts on an ironing board. Rauschenberg joked that the improvisation represented "live decor." When a Brooklyn fire department inspector decided on the opening night of *Nocturne* (1956) that Rauschenberg's white gauze scrim was not fireproof, the artist hastily devised a new set—this one made of wire screening to which were attached fresh green boughs from nearby Prospect Park. For *Antic Meet* (1958), Cunningham told Rauschenberg that in a duet with Carolyn Brown he planned to dance with a chair strapped to his back. "Well, if you have a chair, could I have a door?" asked Rauschenberg. To Cunningham's delight, Rauschenberg designed a door that was rolled on stage, and through which Brown made her entrance.

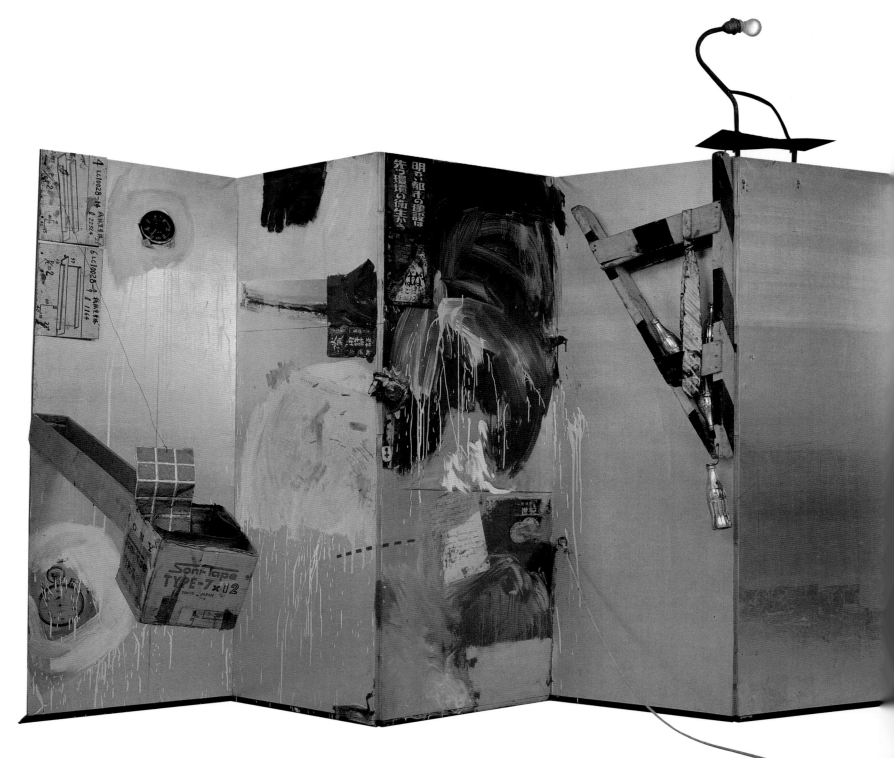

GOLD STANDARD *1964. Combine painting: oil and collage on folding screen with objects, 84¼ × 142 × 51″ (dimensions variable). Collection Hiroshi Teshigahara. With material found in Japan during the Cunningham World Tour—including an antique gold screen from a patron's home—Rauschenberg created* Gold Standard *onstage at the Sogetsu Hall during a performance with Steve Paxton, Deborah Hay, and Alex Hay.*

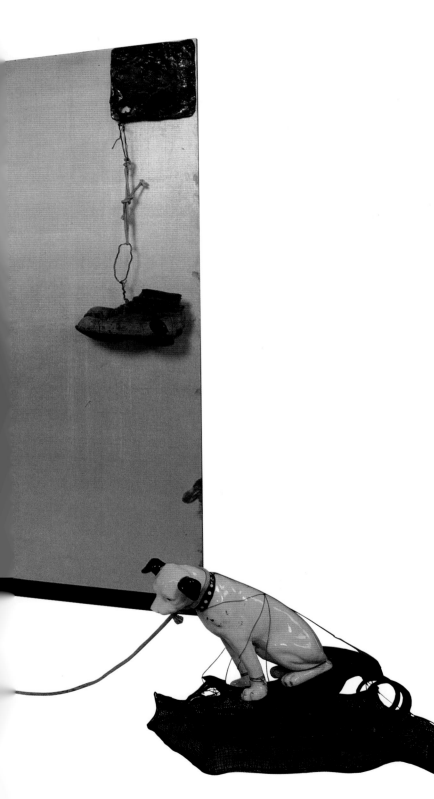

According to Cunningham, Rauschenberg "was and still is the finest lighting designer in American theater." The Rauschenberg stage lighting that Cunningham called "magical" was exemplified by the effects he created for *Winterbranch* (1963), a harsh dance performed in a nighttime setting. Rauschenberg's dramatic lighting, as described by reviewer Deborah Jowitt, looked "like auto headlights striking a rainy highway."

After ten years of collaboration among Cunningham, Cage, and Rauschenberg, the Merce Cunningham Dance Company achieved worldwide recognition as the leader of post-modern dance. Following a performance of the company's repertoire in London in 1964, Alexander Bland wrote in the *Observer* that "at a blow, ballet has been brought right up in line with front-rank experimenters in the other arts." Rauschenberg received his share of the credit, too. Clive Barnes of *The New York Times* praised his "dazzling colored leotards, extravagantly offbeat lighting," and his intriguing decor.

At the dance company's moment of triumph, however, Rauschenberg and Cunningham had a bitter falling out. The night of the Venice Biennale in 1964, the Cunningham dance company was performing at La Fenice there, as part of a yearlong world tour. The causes of the disagreement were complex, but according to Cage the rupture was precipitated when Rauschenberg, after winning the Biennale award, was quoted in an interview as saying, "the Merce Cunningham Dance Company is my biggest canvas." Rauschenberg continued on the world tour, but relations were strained. Recalling the incident years later, Cage said, "I didn't think it was proper for Bob to say that. In all my connection with Merce, I have given him the stage and I have stayed in the curtains. Bob didn't do that."

After the tour ended in Tokyo, Rauschenberg quit the company. (Many years later the friendship of the three men was renewed and Rauschenberg again worked with the Cunningham company.) Along with his close companion, dancer Steve Paxton, assistant designer Alex Hay and his wife, dancer Deborah Hay, Rauschenberg formed a group called the Sur + Theater.

With the Venice prize in hand, Rauschenberg in 1964 looked to stake out new ground. While still traveling abroad, he had instructed a friend in New York to destroy all the unfinished (mostly silkscreen) projects left in his New York studio, including the screens. Even though his fresh canvases suddenly were commanding between $10,000 and $50,000 each, Rauschenberg was determined not to repeat himself. For the next few years he focused more on dance and theater performances than on painting. These pursuits were supported by sales of his earlier paintings and combines. Contrary to some reports, however, he continued to make art. During his dance years, 1954 through the 1960s, he also made prints and drawings, and created unusual sculptural pieces employing light and sound.

FROM 1960 on, Rauschenberg had worked not only with the Cunningham company, but with other groups in which he took the various roles of choreographer, producer, and performer. During the 1960s, he created and appeared in nine performance works.

Rauschenberg made an initial stage appearance in 1961 at the theater in the American Embassy in Paris; the event became known as *Homage to David Tudor*. Tudor played a John Cage composition on the piano; French sculptor Niki de Saint-Phalle watched as a sharpshooter fired a rifle at one of her sculptures; her husband, Swiss motion sculptor Jean Tinguely, constructed a mechanical "stripper" that hopped about the stage shedding metal parts. Jasper Johns presented Tudor with a target made of flowers. During the action, Rauschenberg worked on *First Time Painting*, a combine which, since it faced away from the audience, was unseen. Because it had been fitted with a microphone that amplified the sounds of its construction, however, the picture was highly audible. When an alarm clock attached to the painting went off, a bellman from Rauschenberg's hotel appeared. Together they wrapped up the painting and carried it off the stage.

Rauschenberg making the combine First Time Painting *on stage at the American Embassy in Paris. Photograph by Harry Shunk*

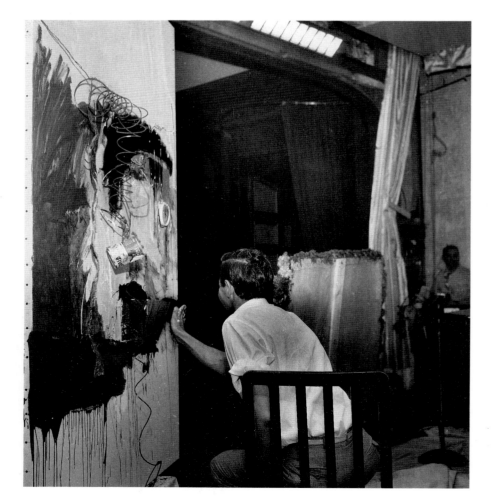

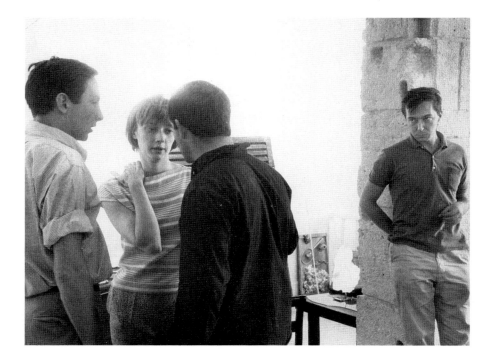

The Paris performance (reminiscent of the famed 1952 "Event" at Black Mountain College in which Tudor and Rauschenberg also had participated) was a preview of even stranger events in the 1960s, the happenings. Rauschenberg disliked the term, preferring "theater piece," a name thought up for his performances by dancer Steve Paxton and Jewish Museum Director Alan Solomon.

A second collaborative piece by Rauschenberg, Tinguely, and de Saint-Phalle, with a script by poet Kenneth Koch, was performed the following spring at the Maidman Playhouse in New York. Called *The Construction of Boston*, the sold-out performance included de Saint-Phalle shooting a rifle at her statue of Venus de Milo, which then dripped paint from its wounds; Tinguely, dressed in a flounced French gown, building a cinder-block wall separating audience and performers; and Rauschenberg, wearing pajamas, operating a rainmaking machine of his own design, which eventually drenched the cast. The audience, which included Marcel Duchamp and composer Virgil Thomson, was puzzled that the entire piece lasted only fifteen minutes. Jill Johnston reported in *Art News* that this "theatrical event didn't make much sense." Merce Cunningham, who directed the performance, refused to be credited.

Much of Rauschenberg's expanded theater activities were with the Judson Dance Theater, which was founded in 1961 by a group of young dancers who met at the Judson Memorial Church in Greenwich Village to take a choreography class from Cunningham instructor Robert Dunn. Several members of the group, including Steve Paxton and Deborah Hay, were Cunningham dancers. Others, such as Trisha Brown, Lucinda Childs, Simone Forti, and Yvonne Rainer, later became major post-modern choreographers.

The Judson group took Cunningham's ideas as a point of departure for their own far more radical experimentation. They wanted to explore the structure of movement, including everyday movements that were not "dancing," and to eliminate dance's dependence on fixed choreography, trained dancers, and expensive production. In these endeavors they were influenced by Rauschenberg, who served as stage manager, lighting director, performer, and—when he sold a

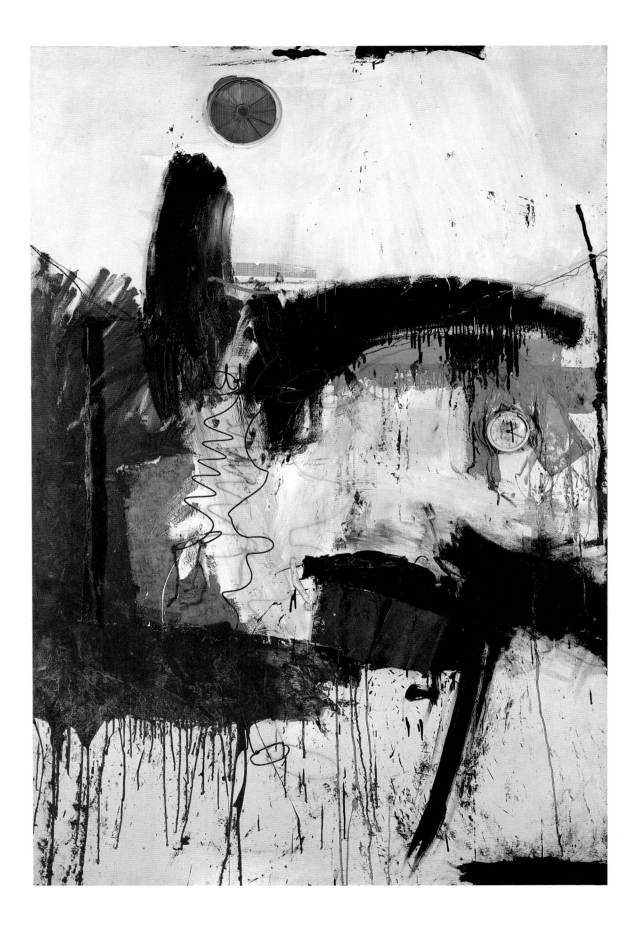

FIRST TIME PAINTING *1961. Combine painting: oil and collage on canvas with objects, 77×51¼". Collection Marx, Berlin*

The Construction of Boston, *a 1962 theater event in New York. From left to right: Jean Tinguely, unidentified man, Henry Geldzahler, Rauschenberg, Maxine Groffsky (partially obscured), Öyvind Fahlström, Niki de Saint-Phalle, unidentified woman on ladder. Photograph by Hans Namuth*

painting—patron. Steve Paxton said the Judson group "began with this idea of Bob's that you work with what's available, and that way restrictions aren't limitations, they're just what you happen to be working with."

"We were out to radicalize the limits of what was considered dance," recalled Deborah Hay. "We were out to shock one another, and whatever audience we had. Cunningham said anyone can dance and all movement is dance, but didn't practice it. We were out to make Merce eat his words."

Pelican, which followed in April 1963, marked Rauschenberg's unexpected debut as a choreographer. At the Pop Art Festival in Washington, D.C., organized by Alice Denney, curator at the Washington Gallery of Modern Art, Rauschenberg mistakenly was listed in the program as "choreographer" rather than as stage manager of the Judson group. When he read the program, he decided to take on the challenge. Discovering that the performances were to take place in a roller-skating rink called America on Wheels, he designed costumes, learned to roller-skate, and prepared a dance routine for himself and two dancers.

At that moment, Rauschenberg's career was soaring. His work was on exhibition at the Jewish Museum, in group shows at the Solomon R. Guggenheim Museum in New York, and in the Corcoran Biennial in Washington, as well as in various exhibitions touring Europe. He wanted his choreography to soar as well. In his light-filled studio at 809 Broadway, he moved his paintings off the floor, where he worked, to practice roller-skating with his friends, racing with his Samoyed puppy, Laika, and his two kinkajous.

The principal action of *Pelican* consisted of Rauschenberg and Swedish painter Per Olof Ultvedt, with open parachutes attached to their backs, skating about the arena. Around and between them, Carolyn Brown, the Cunningham company's most elegant dancer, danced on point, dressed in a sweat suit and toe shoes. "The soaring motion of Brown's classical ballet vocabulary juxtaposed to and amplified by the rapid birdlike swooping of the men on skates" made *Pelican* Rauschenberg's most memorable performance art, wrote curator Nina Sundell in her catalogue for an exhibition called "Rauschenberg/Performance."

The artistic success of *Pelican*, which Rauschenberg dedicated to his heroes, the Wright brothers, seemed to confirm one of his favorite theories of art. He had indeed, as Sundell points out, "used the limitation of materials [roller skates] as a freedom that would eventually establish form."

Rauschenberg, again sailing about in the open parachute, performed the dance a second time in New York in 1965, at the First New York Theater Rally, organized by Steve Paxton and Alan Solomon at a television studio on Broadway at Eighty-first Street. Erica Abeel wrote of that performance in the *Saturday Review*, "It's a bird, it's a plane, it's Rauschenberg It's the Pop vision of Kitty Hawk! It's Batman on wheels! Daedalus at the Rollerdome! It's *Pelican*."

Most of the new performances created by Rauschenberg between 1964–68 did not draw such enthusiastic reviews, however. According to dancer Deborah Hay, "his greatest contribution to the performance art world at that time was that he showed us how to play." In *Shotput* (1964) Rauschenberg danced by himself in a darkened room with a flashlight attached to his right foot, which he used to draw with light in space; he descended from the ceiling on a rope into a barrel of water while a cow wandered about onstage for *Elgin Tie* (1964); and the first scene of *Spring Training* (1965), his most complex performance piece, was described by Elizabeth Novick in *Studio International:* "Robert Rauschenberg in shirt and short cotton drawers, barefoot and barelegged, stands in the center of the auditorium and begins to mop up the eggs that drop from the rafters." The best-remembered of *Spring Training*'s five scenes is that of Rauschenberg's thirteen-

Opposite: In Elgin Tie, *which Rauschenberg created in 1964 in Stockholm, the artist descended from the ceiling into a barrel of water. Photograph by Stig Karlsson*

For his theater piece Spring Training, *Rauschenberg's featured performers included thirty turtles, each with a flashlight attached to its back. Explained Rauschenberg, "I like the idea of light being controlled by something literally alive and the incongruities of a small animal actually assuming that responsibility." Photograph by Peter Moore*

Wearing a parachute and roller skates, Rauschenberg performing
Pelican at the First New York Theater Rally in 1965. Photograph by
Peter Moore

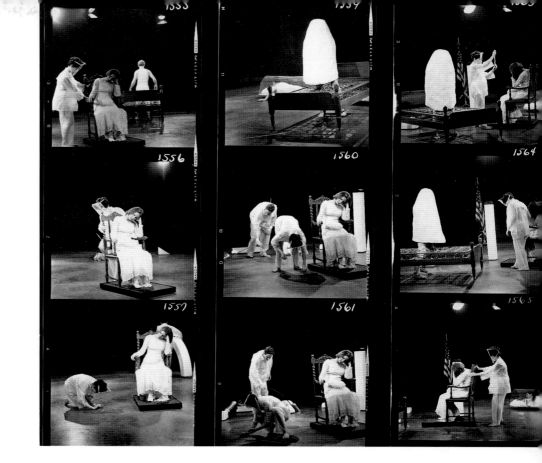

Linoleum was performed in 1966, at the NOW Festival, Washington, D.C. with Rauschenberg, Trisha Brown, Steve Paxton, and Deborah Hay. In this scene, Trisha Brown, wearing organizer Alice Denney's wedding dress, observes Rauschenberg and Alex Hay laying wet noodles end on end across the stage. Photographs by Wagner International Photos

In Rauschenberg's 1965 theater piece Map Room II, dancer Steve Paxton entered the stage, walking in automobile tires. Photograph by Peter Moore

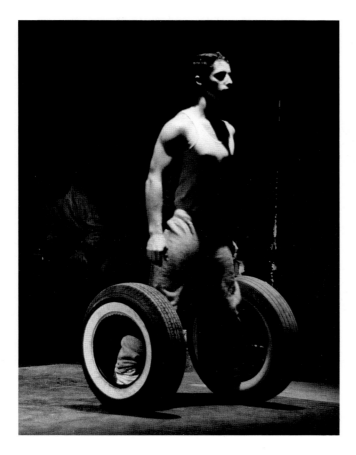

year-old son, Christopher, releasing onto the stage thirty turtles with flashlights strapped to their backs. (This was the debut of Rauschenberg's pet, Rocky.)

Walter Terry, the dance critic of the *New York Herald Tribune* wrote, "It has been reported that Robert Rauschenberg, the well-known avant-garde artist, has said he expects to give up painting for dancing. He shouldn't. Last evening, he danced in a program of avant-garde dance, or non-dance, at Judson Memorial Church. He was terrible."

In fact, he was not dancing. According to Trisha Brown, the Judson group was seriously studying "pedestrian movement" as part of a new art form. The idea of ordinary people "lumbering across the stage like bears," as one critic put it, their movement juxtaposed against that of classically trained dancers, was exactly what Rauschenberg aimed for in his combines. The idea was to connect art to everyday life.

Rauschenberg was not the only avant-garde painter in the 1960s to be caught up in the effort to break down barriers separating different art forms. But he was among the best known, received the most publicity, and seemed determined to push his ideas as far as they would go. "Art is about taking risks," Rauschenberg said of his performance art. "Danger and chaos—those are the real muses an artist must court."

He was full of creative energy and quick to formulate theories to explain the performances that resulted. After one especially haphazard piece, *Linoleum* (1966), Rauschenberg admitted that he probably should have spent more than one day designing it. But "I'd rather make a new piece in a raw state than an old one that I'm satisfied with, because I'm into the adventure," he added. (In this case, the adventure featured Steve Paxton rolling across the stage encased in chicken wire, surrounded by live white chickens, while munching on fried

chicken.) The performance, held at the Kalorama Skating Rink in Washington as part of the NOW Festival, featured equally outlandish theater pieces by Claes Oldenburg, Robert Whitman, and Andy Warhol.

If audiences were bored by these performances, Rauschenberg replied that his kind of theater "provides a minimum of guarantees," and that perhaps boredom represents "the purpose of the audience."

Rauschenberg's experience as a painter certainly contributed to his innovation in theater lighting and choreography. "It is not like any lighting that one sees," reflected Cunningham. "He lit the stage as a painter might paint." His dance pieces used images from his combines and echoed their dynamic tension. "I like the *liveness* of theater," said Rauschenberg, "that awful feeling of being on the spot." His experience in the theater affected his painting as well. The three-dimensionality of performers on a stage influenced the shapes of his combines; the rhythms and cadences of dancers, the textures and movements of the costumes and curtains helped train his eye for visual and textural movement in the paintings. His use of lights to change a theatrical scene or mood reappeared in his paintings with electric or battery-powered light.

Rauschenberg said he found in his "mixed means theater" the absence of hierarchy, which he tried to achieve in his combines and other works. "In a single piece by Yvonne Rainer you can hear both Rachmaninoff and sticks being pitched from the balcony without those two things making a comment on each other," he reported. In his pieces, no element was meant to be dominant. He celebrated the ordinariness of the world, whether in the objects for a combine, sets for a dance, or the dance itself.

As Rauschenberg devoted more time to performance art, the joy he found in ensemble productions caused him to shed what he describes as his affliction of shyness. Through his theater collaborations, his high spirits and playfulness flourished. At a raucous New York party for the rock group The Monkees in the early 1960s, museum curator Henry Hopkins recalled a dramatic entrance of the artist: "All of a sudden, from a mob of five hundred people, emerged a roar of laughter. There appeared an attractive, very naked young woman, hoisted above everybody's head. The crowd parted, and holding this naked young woman up in the air was the not-quite-so-young naked Bob Rauschenberg."

Although many intellectuals scoffed at his ideas, Rauschenberg emerged in the mid-1960s as a hero to those who thought they were in the vanguard of a cultural revolution. "Perhaps more than any other artist, Rauschenberg exemplifies the spirit of that time," wrote Jacki Apple in *Artweek*. "He crossed the boundaries of artistic disciplines as if those territorial borders no longer existed, transcending the strictures of art world specialization, like an astronaut breaking free of gravity."

The 1960s was the decade of the media celebrities, starting with President John F. Kennedy and extending to performers and artists. For the first time in his career Rauschenberg looked the part of the bohemian artist, with his longish hair and shirts opened in front. He played it to the hilt. *New York Times* art critic Brian O'Doherty observed that "as Rauschenberg extended process into a life style, programatically ignoring distinctions between art and life, his work became performance and his life became art."

In one area, Rauschenberg remained consistent. He never tired of talking about the importance of collaboration and of the search for new collaborators. "It seems that in theater and printmaking, every individual that you add to a project will result in ten times as many new possibilities," he said.

It was natural that his fascination with light, sound, and special effects in theater would lead Rauschenberg to collaboration in the world of technology.

Opposite: Rauschenberg's construction, a silkscreen painting, forms the backdrop for Urban Round, *in which he participated with Steve Paxton, Deborah Hay, Yvonne Rainer, Christopher Rauschenberg, and other friends, including his assistants Brice Marden and Dorothea Rockburne. Photograph by Peter Moore*

In Elaine Sturtevant's Relâche, *she and Rauschenberg performed the roles of Adam and Eve, previously created by Marcel Duchamp and Brogna Perlmutter in* ciné sketch, *from the Picabia/Satie ballet* Relâche *of 1924. Photograph by David Hayes*

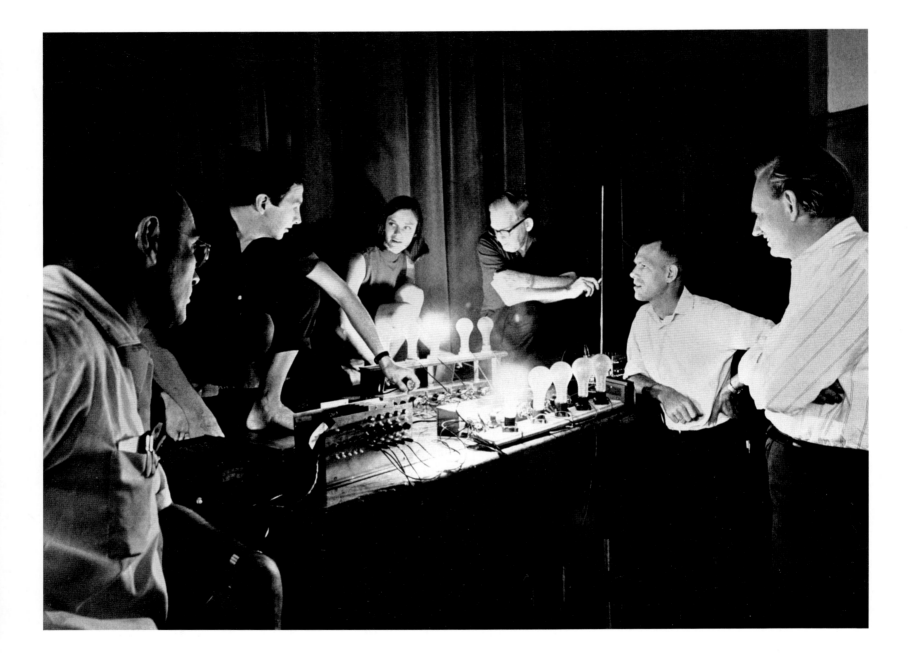

SOUNDINGS

RAUSCHENBERG'S *Open Score* (1966), performed under floodlights in the 69th Regiment Armory in New York, featured a tennis match between artist Frank Stella and tennis pro Mimi Kanarek. Every time Stella or Kanarek stroked the ball, a loud "pong" echoed through the Armory, and an overhead light was extinguished. After several briskly played games, the match ended in total darkness.

In the second scene of *Open Score*, five hundred volunteers came onto the darkened tennis court. There they combed their hair, removed their jackets, and performed other simple activities directed by Rauschenberg, who used flashlights as cues from the balcony behind them. The audience could see the performers only as ghostly images on three huge television screens above the arena of the Armory. When the lights came on again, spectators were surprised to see the mass of people on the stage, taking a bow. *Open Score* had ended. "Tennis is movement," wrote Rauschenberg in the program notes. "The unlikely use of the game to control the lights and to perform as the orchestra interests me."

The special effects of *Open Score* were made possible by new electronic technology. Tiny FM transmitters built into the tennis rackets picked up the sound of the racket meeting the ball, which was broadcast through the arena's loudspeakers and activated the switches that turned off the floodlights. An infrared television system that penetrated the darkness on the stage produced the images on the screen that Rauschenberg described as "seeing without light." Closed-circuit television projection of onstage activity was then a new and virtually unknown development.

Rauschenberg's fascination with sound, motion, light, and the new electronics spurred him to incorporate these into his paintings and dance and theater forays in the 1960s. *Open Score* was his contribution to a program called "9 Evenings: Theatre and Engineering" at the Armory. (The site was an auspicious choice, having housed the famous Armory Show of 1913.) The performances in October 1966 were the result of a ten-month collaboration between a group of ten artists and thirty engineers from Bell Laboratories in New Jersey, directed by Dr. Johan Wilhelm (Billy) Klüver.

Rauschenberg and Klüver first met in 1960, at the performance of Jean Tinguely's *Hommage à New-York* at the Museum of Modern Art in New York. Klüver, an electrical engineer, had helped Tinguely build his kinetic sculpture, which self-destructed before the audience there. Rauschenberg's contribution to the sculpture was his own self-destructing apparatus, a box containing explosive powder, with metal coils holding in place twelve silver dollars. He called it "Money Thrower." As Tinguely's piece devolved, triggered by a timer rigged by Klüver, Rauschenberg's box exploded, tossing the coins into the air.

Rauschenberg with artists and engineers who collaborated in 1966 to produce 9 Evenings: Theatre and Engineering *at New York's 69th Regiment Armory. From left, Herb Schneider, Rauschenberg, Lucinda Childs, L. J. Robinson, Per Biorn, and Billy Klüver. Photograph by Elliot Landy*

ORACLE *1965. Construction in 5 parts with objects, water, and electronic equipment. Collection Musée National d'Art Moderne, Centre Georges Pompidou, Paris. Rauschenberg called this five-part ensemble* Oracle; *the sound from five different radios broadcasts through speakers concealed in the sculptures.*

BLACK MARKET *1961. Combine painting: oil and collage on canvas with objects, 60×50″ (panel size). Collection Museum Ludwig, Cologne. First shown at the "Motion in Art" exhibition at the Stedelijk Museum in 1961,* Black Market *was designed as a participation piece. Viewers were to exchange a small object for one in the valise, and sketch the object on the clipboard.*

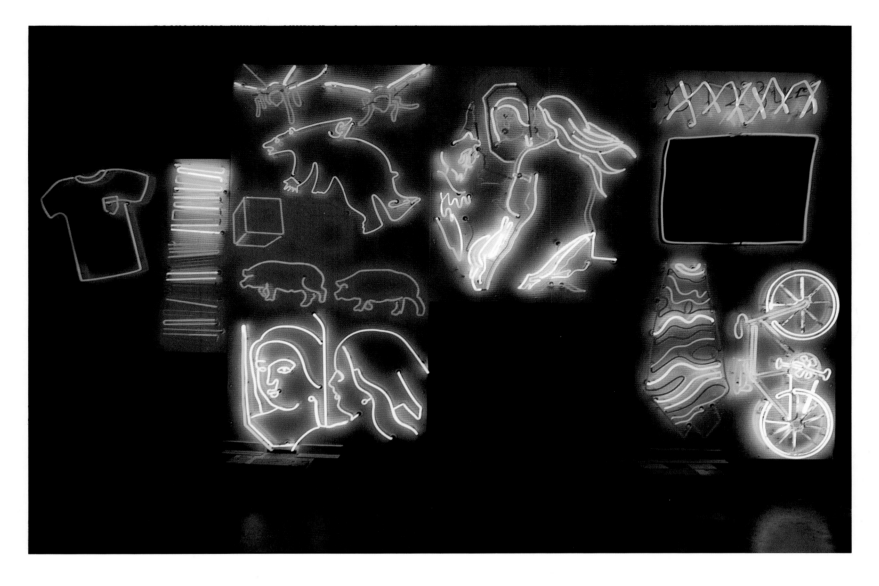

GREEN SHIRT *1965–67. Neon and painted metal, 9'11" × 20' × 10½".*
Collection The Norton Simon Museum of Art at Pasadena. Gift of
the artist. This enormous neon piece was made for the U. S. Pavilion
at Expo 67 in Canada.

DYLABY *1962. Combine painting, 109½ × 87 × 15". The Sonnabend*
Collection

In the spirit of collaboration that has always marked Rauschenberg's style, and with his characteristic open-mindedness, he was interested in working with Klüver, bridging together two seemingly disparate worlds: art and technology. Some artists saw technology as a force to be avoided, a dehumanizing influence on society. For Rauschenberg, however, technology was "contemporary nature." Much of his imagery clearly depicted man's interactions with machines. Problems of the environment or the military-industrial complex could not be solved, he believed, by a return to some simpler form of life. Both Rauschenberg and Klüver saw the participation of artists working with engineers as a promising collaborative effort that would lead to a richer, more humane world.

The combined efforts of Rauschenberg and Klüver began with the "9 Evenings" event at the Armory. Following that, the two men, along with artist Robert Whitman and engineer Fred Waldhauer, decided to form a permanent organization, Experiments in Art and Technology (E.A.T.), Klüver was president and Rauschenberg chairman of the board. E.A.T. was to be a service organization, clearinghouse, and catalyst, matching artists with scientists, and working together under industrial sponsorship. At its first meeting on November 30, 1966, three hundred artists signed up to seek help with their projects.

The notion of linking art and industry was not new. The Italian Futurists, Russian Constructivists, and Bauhaus artists all looked to industry for material to express fresh creative ideas. Kurt Schwitters, for instance, had called for "solid, liquid and gaseous substances" in his proposal for a Dadaist "Merz theater." Still, no full-scale collaboration between art and industry such as the one envisioned by E.A.T. had ever been attempted.

On October 10, 1967, Klüver and Rauschenberg announced E.A.T. to the business, labor, and technical communities at a combined press conference, science fair, and art exhibition at Rauschenberg's new studio and home at 381 Lafayette Street on the edge of Greenwich Village. The five-story building had been a Catholic orphanage. Part of the chapel had been sliced away and torn down to make a parking lot, and Rauschenberg turned the remaining part of the chapel into a studio, having first had it deconsecrated by a priest. To show the possibilities of artists and engineers working together, the exhibition in Rauschenberg's house included Andy Warhol's helium-filled silver pillows, a large picture of a nude drawn by two engineers on a computer, and a roomful of noisy sculpture, Rauschenberg's *Oracle* (1965).

The result of Rauschenberg's first collaboration with Klüver, and three years in the making, the sound-activated *Oracle* was one of the first truly outrageous freewheeling sculptures. It consists of five mobile pieces on wheels: a car door attached to a typewriter table, a window sash, a curved air vent that resembles a saxophone, three ascending steps from which a whitewalled tire hangs like a noose, and a makeshift bathtub into which a T-shaped vent sends a continuous spray of water. "Five pieces in the round with sound," wrote Alan Solomon in the Castelli flyer for its first showing in New York.

Rauschenberg had originally conceived the idea of the sound-activated *Oracle* as a painting. He had used three radios in his 1959 painting *Broadcast*, and by 1960 had more ambitious ideas for a series of paintings, from which he wanted sounds to emerge, and which viewers could control.

At the Stedelijk later that year, Rauschenberg had created a roomful of five sculptures using industrial materials. The project, sponsored by the Stedelijk, was "Dynamic Labyrinth," or Dylaby, which included art technology projects by five artists, including Niki de Saint-Phalle and Jean Tinguely. In this "sculptural environment" Rauschenberg tried to incorporate sound—an electric pump forcing air into a large tub of water, and clocks set to run at different speeds.

Back in New York, early in 1962, Rauschenberg began assembling the pieces for *Oracle* as Klüver refined the sound system to meet Rauschenberg's demand to create a "painting as an orchestra" in which the viewer could be the conductor. Rauschenberg wanted radios to broadcast a continuously changing cacophony of real-world sound from each piece of sculpture. Klüver installed radios, whose tuning dials were slowly rotated by a motor, so that each radio picked up snatches of broadcasts from all the New York City AM radio stations. According to Klüver, it would have been much easier to work with FM because there would have been less interference. "But Bob didn't want FM, because in New York, FM was too high-class and esoteric," said Klüver.

To avoid wiring between the sculptures, signals from a central control panel located on one sculpture were relayed by small transmitters to speakers in the others. Visitors could turn knobs on the control panel to vary the speed and volume of the sound as it swept the radio stations. Those who wandered through *Oracle* were exposed to Rauschenberg's randomly ordered world of objects, words, and music. Each viewer was supposed to decide what it all meant.

The critics generally praised *Oracle*. Writing in *Arts Magazine*, William Berkson described the collection of pieces as "suave ventures into modern sculpture [that are] witty, gorgeous and inviting." He found that "the waves of radio sound made the room a funhouse, a torture-chamber or a laboratory for testing perceptions."

Alan Solomon said that *Oracle* reflected Rauschenberg's "special sense of humor . . . the very understatement, the irony, the hilarious sense of absurd juxtaposition." At the very least, *Oracle* gave E.A.T. a noisy send-off.

With Billy Klüver devoting full time to the organization, E.A.T.'s membership grew rapidly. In November 1967, E.A.T. announced a competition for the best work of art produced in collaboration between artists and engineers, with the prize going to the engineer. Some of these works were part of a major exhibition in 1968, "The Machine," at the Museum of Modern Art. All the entries were shown in an E.A.T. exhibition, "Some More Beginnings," at the Brooklyn Museum. Harold Rosenberg wrote that "with its computer tapes, transistors, high-intensity lights, plastic sheets, projectors, blowers, electromagnetic animators, and programmed rhythms" the exhibition resembled a "Wonders of Science pavilion" at a World's Fair.

During E.A.T.'s first year, Klüver and Rauschenberg, with the help of labor mediator and arts supporter Theodore Kheel, raised $100,000 for E.A.T. in corporate support from such companies as AT&T, IBM, and Atlantic Richfield. Organized labor was helping by housing the E.A.T. headquarters in the AFL-CIO's Automation House, then on East 60th Street in New York City. By the spring of 1968, it had forty chapters in the United States and abroad, and was successfully matching artists and engineers who wanted to work together. By 1969 its artists and engineers numbered three thousand members each.

Rauschenberg continued to explore the use of various technologies in his own work. As a commission for the U.S. Pavilion at Expo 67, he had created a ten by twenty foot painting in multi-colored neon, called *Green Shirt*. His art expanded in dimension and scope through his collaborations in E.A.T.

Rauschenberg constantly talked of his desire to create art that "would be responsive to people viewing it." Technological innovation would shape the art of the future, he said, since "nobody wants to paint rotten oranges anymore." He had in mind a work whose visual images could be determined by activity on the part of the viewer, "a construction in which no two people will ever see the same thing." *Soundings* (1968), shown at the Museum of Modern Art, 1968–1969, was the construction.

The front of the painting consists of nine separate Plexiglas panels joined together to form a wall thirty-six feet wide and eight feet high. Observed in a room where there is only silence, the picture seems to be a huge smoked mirror. When people move around the room and speak, however, different parts of *Soundings* selectively light up, revealing images of several dozen straight-backed wooden chairs which Rauschenberg had silkscreened onto other Plexiglas panels that stand behind the front mirror wall. The specific response varies according to the timbre and tone of the speaker's voice. "Everybody sees his own work of art by speaking to it," said Rauschenberg.

The special effects for *Soundings* were created for Rauschenberg by four engineers from Bell Labs, led by L. J. Robinson. They installed microphones in front of the painting to pick up sounds from the environment. A complex electronics cabinet placed behind the screen transforms the picked-up sounds into coded signals that activate a system of lights hidden behind the mirrored silkscreen panels. The lighting system is sensitive to different ranges of the human voice, so that different people who speak the same words will cause different visual effects.

Critics disagreed about *Soundings'* merits as art. Andrew Forge approvingly compared *Soundings* to Rauschenberg's White Paintings, noting that in both cases "the presence of the spectator is a lively shifting factor in the picture's surface."

Writing in *The New York Times*, however, Grace Glueck dismissed *Soundings* and Rauschenberg's claims for it. "No matter how loud you shout or how low you whisper at *Soundings*," she wrote, "you still see the same old static chairs. That's 'participating in the creation' of a work?"

Between 1965 and 1971, Rauschenberg turned out several dozen artworks made in collaboration with engineers. One series, called Revolvers (1967), consists of five motorized Plexiglas discs six and one-half feet in diameter, each silkscreened with diverse found imagery, like the imagery in his earlier silkscreen paintings. The viewer can make an endless kaleidoscope of pictures by pushing five switches that cause the discs to revolve.

In *Solstice* (1968), four rows of silkscreened Plexiglas doors automatically slide open, permitting the viewer to walk through the artwork and experience multiple impressions from another large repository of Rauschenberg images within the piece. As part of organized labor's collaboration with E.A.T., *Solstice* was first shown at Documenta II in Germany, then was on display at Automation House in New York before its acquisition by the National Museum of Art in Osaka, Japan.

The most controversial of Rauschenberg's mechanized pieces is *Carnal Clocks* (1969), a group of fifteen boxes with a time switch which causes lights to flash, revealing erotic details of human anatomy. In an exercise in voyeurism, the viewer can see himself in a Plexiglas mirror, tell the time by observing the position of the lights, and glimpse various body parts of Rauschenberg and some of his friends, photographed by the artist and rearranged into collage patterns.

In an interview with art historian Barbara Rose, Rauschenberg said that part of the *Carnal Clocks* project "was about my working out my shyness to photograph my friends' intimate parts." Gregory Battcock of *Arts Magazine* thought the pictures were "socially provocative and important social documents." *Los Angeles Times* art critic William Wilson, however, dismissed Rauschenberg's clocks as representing a "kind of garbling of intention that suggests a Renaissance artist who thought his painting would be better if he puts a cog behind it to move the pictures."

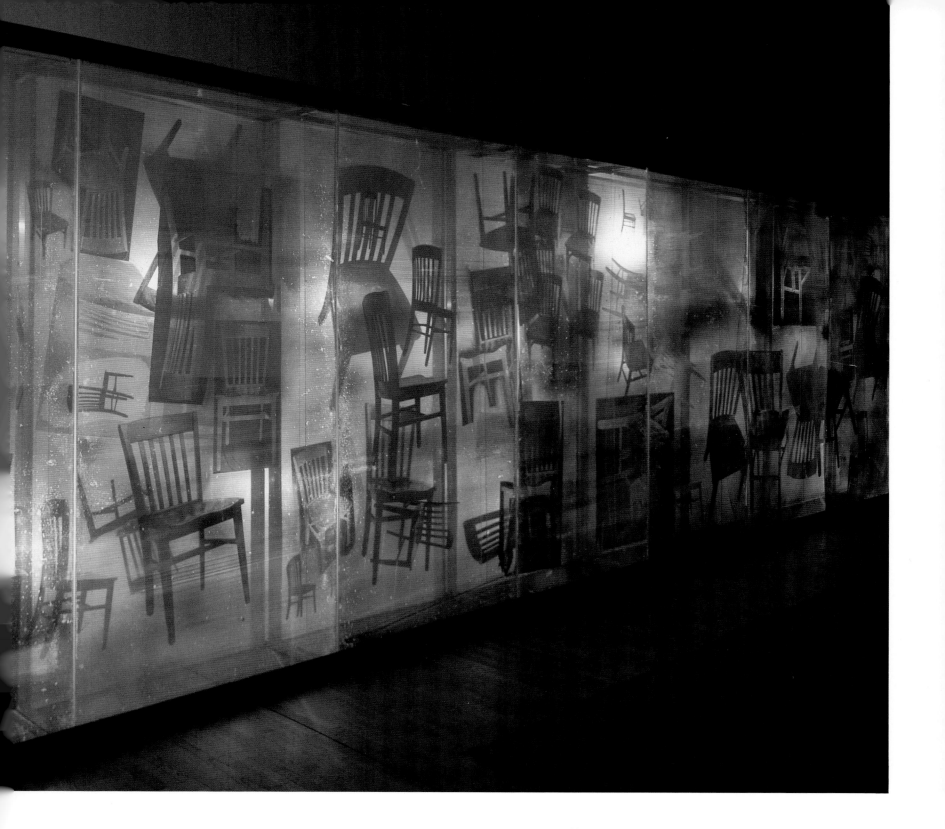

SOUNDINGS *1968. Silkscreen ink on Plexiglas with electrical components, 94×432×54" total (3 rows of 9 panels each). Collection Museum Ludwig, Cologne. Created in collaboration with engineer L. J. Robinson, the images in* Soundings *appear when voice-activated by people in the room.*

A PARALLEL effort to E.A.T. was launched by Maurice Tuchman, then senior curator of modern art at the Los Angeles County Museum of Art (LACMA). Tuchman and former curator of twentieth-century art Jane Livingston developed a plan for "Art and Technology," an ambitious program of nearly eighty artists-in-residence at major corporations, that culminated in an exhibition for Expo 70 in Osaka and at LACMA in 1971.

Among the blinking, zooming, pulsing, and flashing works of art on display in Los Angeles were Claes Oldenburg's *Giant Icebag*; Roy Lichtenstein's films of ocean and black-dotted sky; and Andy Warhol's holographic field of printed flowers seen through sheets of falling water.

Rauschenberg was represented by *Mud-Muse* (1971). Both the work itself and his comments about it showed that he had tired of dazzling technological art-works, including his own. "I called it my 'blowing fuses' period," Rauschenberg later reflected. "I practically had to hire a twenty-four hour restorationist and a twenty-four hour electrician." He now wanted to design a piece to involve viewers on a "basic, physical level," he said.

Mud-Muse, owned by the Moderna Museet, is a nine-by-twelve-foot vat filled with industrial drilling mud which bubbles and spurts in response to auditory signals. The project was the result of a three-year collaboration between Rauschenberg and engineers from the Teledyne Corporation. Rauschenberg told his Teledyne collaborators that he wanted to create art that would respond to those who viewed it. He got his wish. The thick mud sputters and bubbles in response both to Rauschenberg's programmed soundtrack of birdsongs, ocean surf, musical notes, and machine gears, and to the random noises made by gallery visitors. Hidden microphones pick up the sounds, which activate pneu-matic valves controlling air inlets at the bottom of the tank. "It *is* primitive," he said, "but I hope in being primitive that it can be simple and the intent be legible: It is an existing fact that the world is interdependent."

Opening-day visitors at the "Art and Technology" exhibit in Los Angeles unabashedly immersed themselves in *Mud-Muse*—literally. They grabbed handfuls of the gray mud out of the tank and slathered it all over the walls of the gallery, forcing the entire exhibit to close down temporarily. When it reopened, *Mud-Muse*'s pneumatic system had been turned off and guards were stationed around the exhibit. "That was not what anybody had in mind," recalled Jane Livingston. "Bob was not thrilled by that development."

A number of art critics dismissed the art that derived from technological collaboration as meaningless gimmickry. Nevertheless, Rauschenberg was seri-ous about his commitment to art and technology. Speaking about the *Mud-Muse* project during its construction, Rauschenberg stressed his concern that human-ity learn to understand and come to grips with technology if it is to survive. "It's hard for me not to build in a lesson," he said, "because I care so much about [technology and the environment]. We're really going to be lost if we don't come to terms."

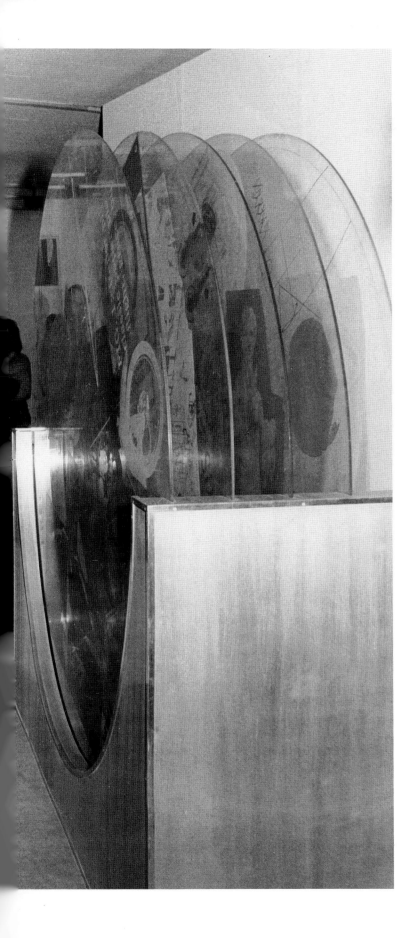

The collaboration of science and art involved far more than aesthetics, said Rauschenberg. "I'm talking about conscience in industry, and individual responsibility among artists, scientists, engineers, bankers, politicians, and doctors, leading to a more realistic structure of the earth and its activities."

Given his ten-year commitment and strong feelings, Rauschenberg was deeply disappointed when E.A.T. disintegrated as an organization in the early 1970s. The failure, he felt, was caused by both artists and industry, and because the issues were "art, money, power and ethics." Rauschenberg believed that industry never committed itself to a real collaboration. "E.A.T. was resisted on both sides, by industry and artists," said Rauschenberg. "Artists expected us to be kind of a library or source for new materials, but E.A.T. was interested in a total and mutual commitment. We didn't want the artist to use an engineer or an industry merely to execute preconceived ideas, but to conduct research in which both sides would share and grow."

Klüver, on the other hand, never conceded failure. "We wrote in our first newsletter that E.A.T. will be a success when it will not be necessary for the organization to exist anymore," he said, "and that is what happened. Industry was closed to artists in the 1960s; in 1989, we have access to 200,000 engineers worldwide. The E.A.T. foundation still exists to help artists find engineers. We answer calls every day."

Some technologies which Rauschenberg first used in his art have since found broader use. In theater, for example, the wireless transmitters of *Open Score* are now widely used in cordless microphones, onstage environmental electronic systems have become standard for most musical performances, and closed-circuit projections are part of contemporary multi-media theater. The technology developed for Rauschenberg's *Soundings* has contributed to a promising way of treating certain kinds of deafness.

The "9 Evenings" of 1966 inspired many young artists to broaden their horizons. Other exhibitions focused on art and technology have continued over the years. The sophisticated works of machine-and-light artists such as Steve Barry, William Stone, Alice Aycock, Dan Flavin, Keith Sonnier, and James Seawright have entered the vocabulary of post-modern art. At the 1988 New York exhibition called P.U.L.S.E. ("People Using Light, Sound, Energy"), artists used sound and light in ways only forecast in 1966.

One of the exhibiting artists at P.U.L.S.E., Ted Victoria, who creates moving images in camera obscura projection boxes, attributes his involvement in technical art to his experience as an undergraduate in the audience at "9 Evenings." "It was a catalyst," he said. "The tennis match definitely influenced me. I'll never forget Rauschenberg's Revolvers show—nor, at the Museum of Modern Art, that wall of chairs made from silkscreen on acetate [*Soundings*]. Our whole generation was influenced by him."

It is typical of Robert Rauschenberg's career that at the same time he was experimenting with electronic technology, he was also beginning to work with a technique perfected in the eighteenth century—lithography.

Rauschenberg with Revolver *at Fundación Juan March, Madrid, 1985.*

SOLSTICE *1968. Mechanized construction with silkscreen ink on Plexiglas panels, 10 × 16 × 16'. Collection The National Museum of Art, Osaka, Japan. The viewer steps into the environmental construction: Plexiglas doors, silkscreened with various images, slide open, and then enclose the viewer. A different image appears in each direction.*

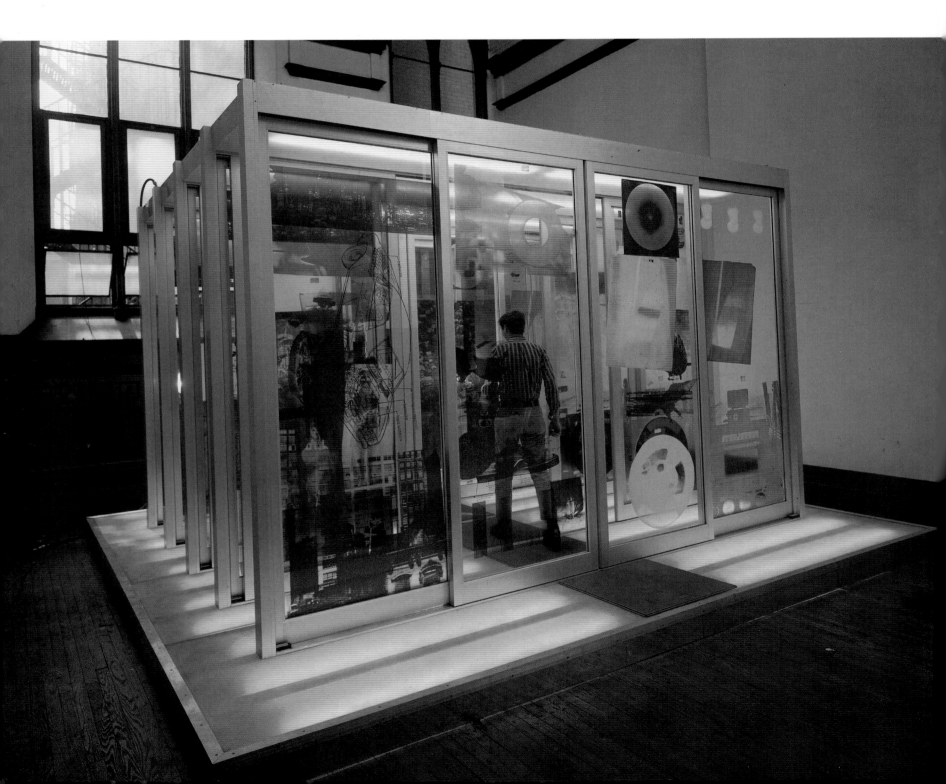

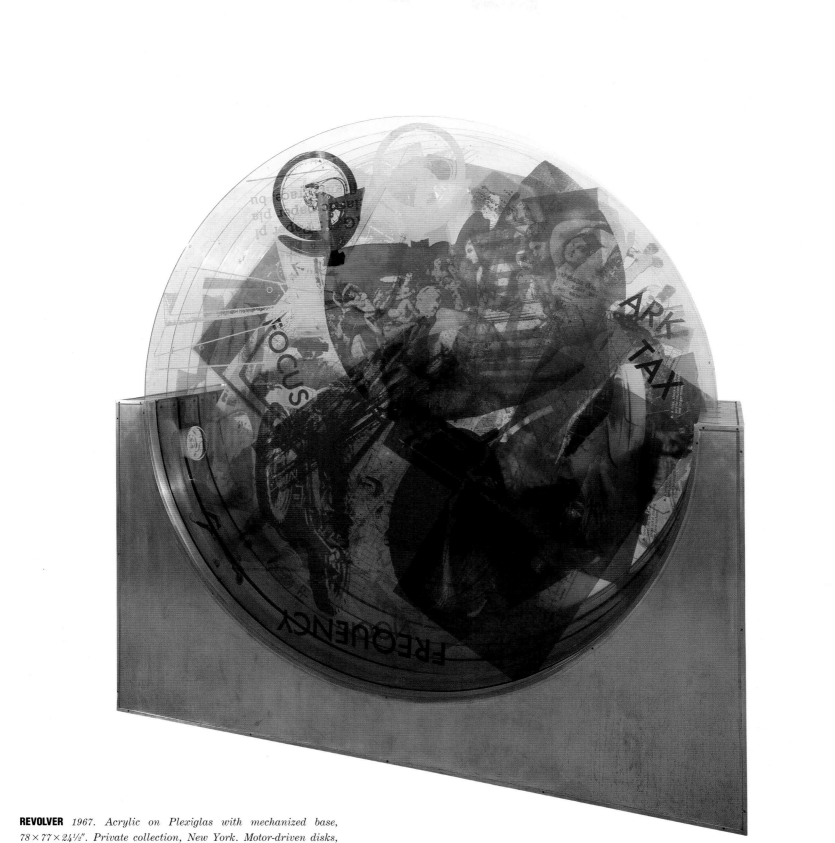

REVOLVER *1967. Acrylic on Plexiglas with mechanized base, 78 × 77 × 24½″. Private collection, New York. Motor-driven disks, covered with silkscreen imagery like a collage, revolve separately, controlled by the viewer with switches to create endlessly varied combinations.*

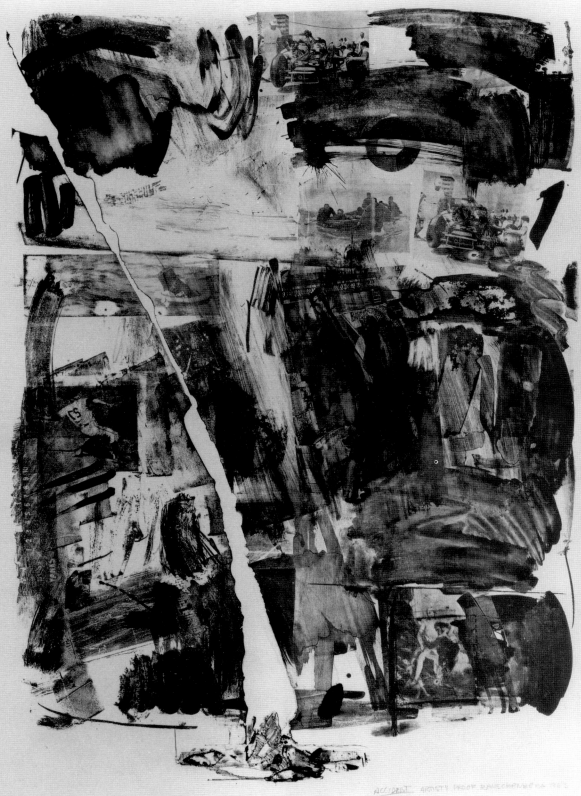

VEILS

ACCIDENT *1963. Lithograph (edition of 29, ULAE), 41 × 29"*

UNTIL THE 1960s, Rauschenberg thought that printing was an obscure craft, lacking the immediacy of paint or collage, the impact of theater. Lithography had engaged painters from Goya to Picasso and beyond, but Rauschenberg thought that "the second half of the twentieth century was no time to start writing on rocks." However, Rauschenberg's association with Tatyana Grosman, the founder of Universal Limited Art Editions (ULAE) and the leader of a revolution in lithographic art in America, changed his attitude toward printmaking.

Tanya Grosman was the daughter of a Siberian publisher and the wife of an artist. She and Maurice Grosman lived in Paris in the 1920s and 30s, and came to the United States as refugees in 1943, barely escaping the Holocaust. In the early 1950s, they lived in a former gardener's cottage in West Islip, Long Island, where Tatyana Grosman discovered two old European lithographic stones in the front yard, used as stepping stones. When her husband became ill in 1955, she thought of trying to make a living by using the stones for lithography.

The daughter of a publisher, it seemed logical that her thoughts turned to bookmaking. With hopes of publishing fine limited-edition books, she purchased a lithographic press for $15 and went to New York and Philadelphia to search for more of the rare old limestones. By 1957, she was persuading well-known artists such as Larry Rivers, Helen Frankenthaler, and Robert Motherwell to draw on the stones in her garage in collaboration with her and a lithograph printer.

Jasper Johns began working with Mrs. Grosman in 1960, creating a portfolio of his "Numbers," *0–9*. In 1961, when she brought two lithographic stones to the Front Street building where Johns and Rauschenberg lived, Rauschenberg helped drag the seventy-five-pound limestone slabs up the four flights of stairs to Johns's studio. "I didn't know modern art was that heavy," Rauschenberg joked.

In 1962, after nearly two years of invitations from Mrs. Grosman and encouragement from Johns, Rauschenberg began what would be an ongoing involvement with printmaking. His concurrent work in silkscreen paintings helped to overcome his aversion to the "once-removed" feeling of graphic arts. He began with the challenge of transferring to the lithographic process his found everyday images and collage compositions. One way that Rauschenberg accomplished this was with some used printer's mats and photoengraving plates of current news photographs. He would dip them into the tusche and press them onto the stone. He then would work the crayon back and forth on the stone itself, using the same short scrubbing marks that characterized his drawings.

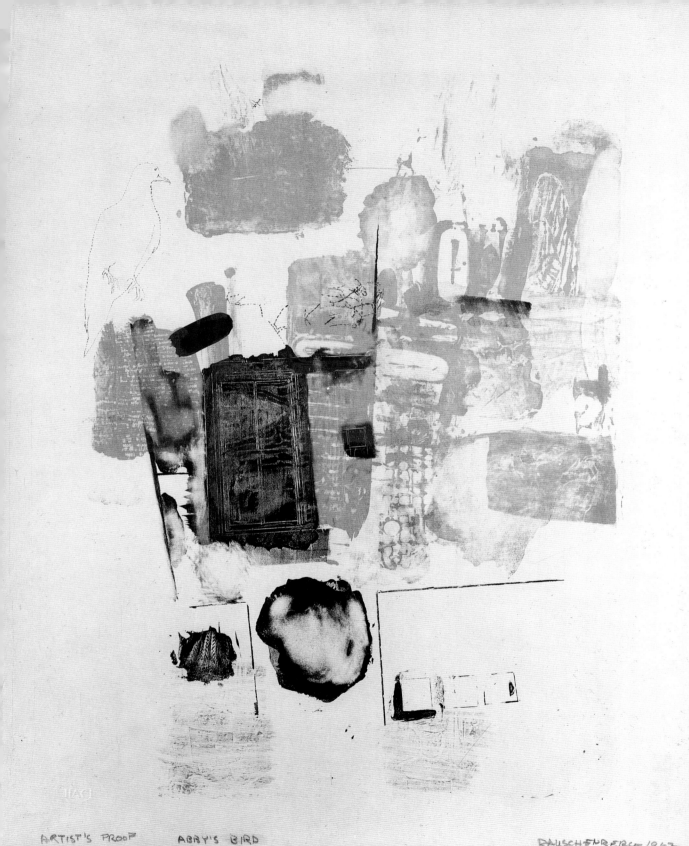

ARTIST'S PROOF ABBY'S BIRD RAUSCHENBERG 1962

In lithography, the artist draws a design with a greasy crayon or ink (tusche) on the flat surfaces of the limestone. The printer then treats the stone with a chemical that fixes the design. When water is applied, it is repelled by the greasy drawings, but absorbed by the surrounding porous stone. With a roller, the printer applies a greasy printer's ink to the dampened stone. Given the natural antipathy of oil and water, the ink adheres only to the drawing, and rejects the wet portion of the stone. A sheet of paper is placed on the inked stone, and then is pressed against the stone with the weight of the lithographic press. The drawing is transferred, in reverse, to the paper.

Abby's Bird (1962), commissioned for the newly opened New York Hilton Hotel, was his first project at Mrs. Grosman's ULAE. The composition was arranged like a collage of diverse images from the newspaper, with a simple drawing of a dove outlined in the upper left. *Abby's Bird*, *Merger*, on which Rauschenberg collaborated with Jim Dine and Jean Tinguely, and seven other of his lithographs done at ULAE that year collectively won the Ohara Museum Prize at the Third International Biennial Exhibition of Prints at the National Museum of Modern Art, Tokyo, in 1962.

Rauschenberg liked the medium of lithography. "It's such a paradox," he said. "The stone is so heavy and clumsy and immobile, yet at the same time it's the most flexible, responsive surface there is." The stone has, he said, "all the sensitivity and frailty of albino skin." Lithography was a new venue for experimentation with materials: he "printed" leaves, his handprints, his key chain, and anything else that he could dip in the tusche or rub with the crayon. "The image that is made by a printer's mat, a metal plate, a wet glass or a leaf plastically incorporated into a composition and applied to the stone, stops functioning literally with its previous limitations. They are an artistic recording of an action as realistic and poetic as a brush stroke," he wrote.

At ULAE he discovered a way to transfer magazine illustrations and his favorite Old Master reproductions, such as Velázquez's *Venus at Her Mirror (The Rokeby Venus)*, to stone, carrying on the solvent-transfer technique he had developed in his drawings by soaking the surface of the stone with a solvent and placing the magazine images face down on the wet stone. He placed a sheet of newsprint saturated with an acetone-based solvent on the stone, secured it by a sheet of mylar, and ran it through the press four or five times. (The subsequent runs were necessary for forcing the inks, thus transferring the desired image.)

Most of all, he loved the collaboration with the master printers and Tatyana Grosman. If Ileana Sonnabend, who introduced him to European buyers in her Paris and Geneva galleries, was his advocate in the art world, then Tanya, according to Rauschenberg, was his artistic muse. The Grosmans' cozy one-story gray clapboard house, with its open kitchen and long trestle dining table, was like a second home. The print shop, whose walls were lined with old Bavarian lithographic limestones Mrs. Grosman had found in an old New York bullet factory, opened into the house. In the shop, Mrs. Grosman stood on the opposite side of the press from him, pinning paper to the stones or sponging the stones while he worked.

One day in 1963 when Rauschenberg arrived at the ULAE studio to continue work on a complicated print, Mrs. Grosman told him that the stone had broken. Rauschenberg then made his composition on a new stone, only to have it break too.

"This time we print it," said Rauschenberg. "The print will be named *Accident*." He dipped the broken chips from the stone in tusche and pressed them into the base stone to emphasize—and document—the "broken" aspect of the image,

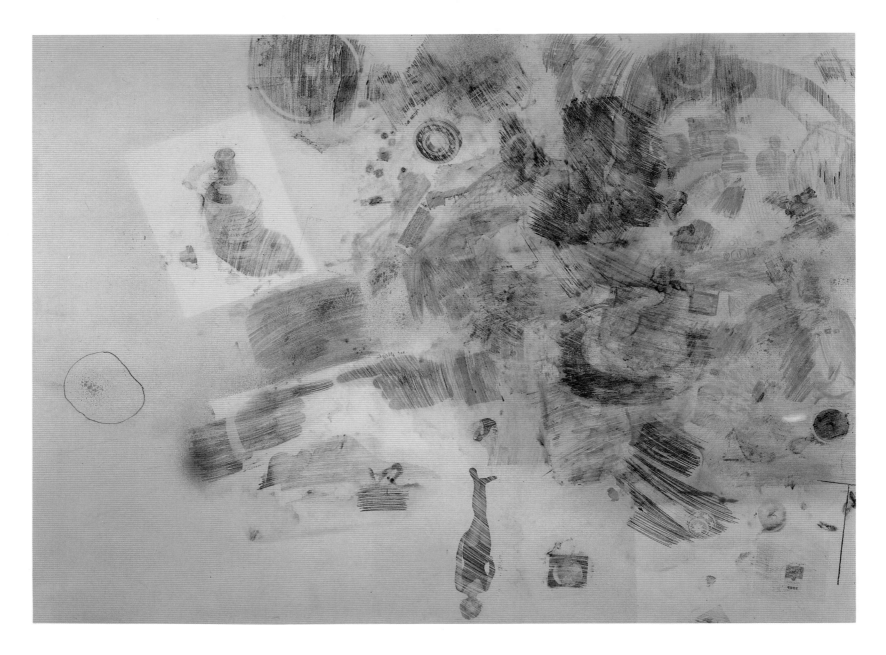

QUICKSAND *1965. Solvent transfer, ink, watercolor, gouache on paper, 36×48". Collection Herbert and Lenore Schorr. Rauschenberg adapted his technique of solvent transfer drawing, used in* Quicksand, *to lithography.*

and with some difficulty printer Robert Blackburn printed *Accident* on the broken stone. The top-to-bottom crack in the stone gave the print a unifying jagged line. Mrs. Grosman submitted the print to the Fifth International Exhibition of Prints in Ljubljana, Yugoslavia, where it won the Grand Prix in 1963. For the first time the coveted graphics award had gone to an American. The award established ULAE's international reputation and contributed to its subsequent commercial success.

Tanya Grosman came to love Rauschenberg like a son. She admired his work, even claiming him as "the artist who de-throned Picasso." Rauschenberg returned her feelings. He portrayed her lovingly in *Tanya* (1974), a soft brown and white print incorporating a 1969 photograph of her by Steve Shapiro. "For every artist," he said, "there was a different shape to her affection." In their relationship, Mrs. Grosman responded to Rauschenberg's verve and antic ways, and he to her warmth and eye for quality.

From 1962 to 1975, Rauschenberg created more than fifty print editions at ULAE. In addition to working with Mrs. Grosman, he collaborated closely with director Bill Goldston. Goldston was also from the South—Oklahoma—and their shared origins contributed to the easy collaboration between the two. Goldston had helped develop a process for transferring photographic images to lithographic stones as a master of fine arts project at the University of Minnesota and had honed his skills as a printer in the Army. When he came to ULAE in 1969, he brought along a knowledge of offset printing. This helped expand the possibilities for artists at ULAE, as did the purchase of a photomechanical camera and hand-offset press.

"We photosensitized the stone," said Rauschenberg, "and developed it as you would a piece of photo paper." Using that process, ULAE printers Zigmunds Priede and Goldston applied a thin coat of photo emulsion to the stones. Rauschenberg made a collage by cutting up acetate negatives—usually of his own photographs—and arranging them on the stone. Secured to the emulsified stone by a quarter-inch sheet of glass, the negatives were exposed by an ultraviolet, quartz-iodine lamp. The emulsion was then developed, processed, proofed, and printed on the lithographic press. Out of this process came three prints in 1969, *Tides*, *Gulfs*, and *Drifts*, which featured images of different parts of the human anatomy. The new printing process permitted Rauschenberg to make prints that in imagery and composition looked remarkably like his original drawings and paintings.

One afternoon in 1974, Rauschenberg and Goldston set out to do something creative with the photomechanical camera. Their experimentation led to an innovative series of lithographs called Veils, whose central image was Tatyana Grosman's scarf. Along with a group of printers and Rauschenberg's friends, Goldston and Rauschenberg worked through the night, at what they called a "printing party."

Mrs. Grosman, who needed her sleep, left the party early. She had given Rauschenberg a scarf, which he wore all night "because he wanted to bring something of Tanya with him," recalled Goldston. A light in the ceiling exposed film in what printers call a contact frame. Rather than insert the film in a traditional manner, Rauschenberg had them simply lay the film on the surface of the stone, then he dropped the scarf onto the film. Goldston would expose the light at what he thought might be the proper setting. The film was then developed in developing fluid that had been used all night long. "Technically, nothing was as it should be," said Goldston, "developing times had to be extended, light simply guessed at." They kept dropping the scarf and exposing the film until about 8:30 in the morning when the chemicals ran out.

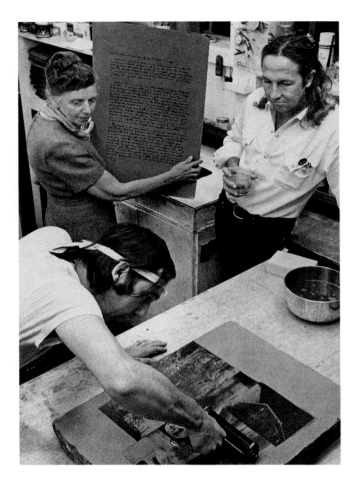

William Goldston, Tatyana Grosman, and Rauschenberg printing Traces Suspectes en Surface, *by Rauschenberg and Alain Robbe-Grillet, 1978. Photograph by Hans Namuth*

Opposite:

SHADES *1964. Lithograph on Plexiglas in aluminum frame with electric light (edition of 24, ULAE), 15 × 14 × 11³/₄". Shades was printed on six movable Plexiglas sheets. "Nobody ever heard of printing on Plexiglas, but he wanted to try it, and we did, and it worked," said Mrs. Grosman.*

Overleaf:

TREATY *1974. Lithograph (edition of 31, ULAE), 54¹/₂ × 40" (2 sheets)*

FROM A DIARY *(collaboration with Andrei Voznesensky). 1978. Lithograph (edition of 28, ULAE), 28³/₄ × 19⁷/₈"*

The "printing party" yielded eight lithographic prints: *Treaty* (1974 diptych), *Veils 1–4* (1974), and *Tanya* (1974). Images from that evening were used in *Kill Devil Hill* (1975), and *Kitty Hawk* (1975). The remarkable feature in these prints is the delicate image of Mrs. Grosman's scarf, which appears luminous yet transparent. "The series is an investigation of the perceptual process—how a three-dir isional object looks flat through the use of light," wrote Susan Ginsburg in *Print Collector's Newsletter.*

Another Rauschenberg innovation at ULAE had resulted in *Shades* (1964), a six-panel, lighted lithographic object printed on Plexiglas, which foreshadowed his more complex experiments in technology. Mrs. Grosman was astonished that anyone would try to print on Plexiglas, but she encouraged the project, which Rauschenberg called his "book." The clear Plexiglas panels, fifteen inches square, are arranged like pages of a book within an aluminum frame. They can be rearranged by hand, thus creating the possibility of an endless kaleidoscope of images. The images, as in many of his graphic works, include athletes in action, helicopters, satellites, buildings, machines, and Old Master paintings.

When Rauschenberg expressed interest in collaborating on a more traditional handmade book, Mrs. Grosman found two partners for him: the French novelist/philosopher and screenwriter Alain Robbe-Grillet, and the Russian poet Andrei Voznesensky.

The Rauschenberg/Robbe-Grillet collaboration produced a handsome book, *Traces Suspectes en Surface* (1978). The title is police jargon, loosely meaning that things are not what they seem. It began in 1972, when Mrs. Grosman went to a Robbe-Grillet lecture in New York and, to her surprise, heard him mention Rauschenberg "with great reverence and admiration." She enticed the writer to her home to meet Rauschenberg, who was staying there.

With Tanya Grosman acting as translator, the writer and artist enthusiastically sketched out a project for a book. While Rauschenberg placed his images on lithographic stone, Robbe-Grillet was sequestered in his château in France writing on aluminum plates. The result of their "dialogue" (they agreed that although they would exchange words and images, neither would illustrate the other) was a thirty-one-page book, in an edition of thirty-five. To Robbe-Grillet's mysterious story of lost romance and murder in the city, Rauschenberg responded with a portrayal of everyday life, with supermarkets, underwear, and bicycles. Mrs. Grosman saw both contributions as equally nostalgic and sad. "The effect was a *Last Year at Marienbad* quality," she said.

When Mrs. Grosman brought Voznesensky and Rauschenberg together, the two immediately got on well. At their first meeting in 1978, Voznesensky agreed to write six poems, which ULAE would print in Russian, and Rauschenberg would create the art. Goldston ordered woodblocks of Cyrillic type made specially for Voznesensky. The Long Island poems, written while Voznesensky was staying at Mrs. Grosman's, included *From a Diary* (1978), the story of the poet's amorous encounter on Long Island with a young woman he had known in Moscow who had emigrated to the United States. Their heads are on the pillow, he wrote, "like a Russian-English dictionary." To accent the mood of the poem, Rauschenberg colored the lithograph in two shades of red but overlapped and combined them in different intensities.

During the collaboration, a strong friendship grew between artist and poet. Interviewed the following year for a Radio Free Europe broadcast to the Soviet Union, Rauschenberg said, "I would like to say hello to my wonderful friend Andrei Voznesensky, and I would like to tell him that the prints are selling very well." Fifteen years later, at the opening of the ROCI Moscow exhibition,

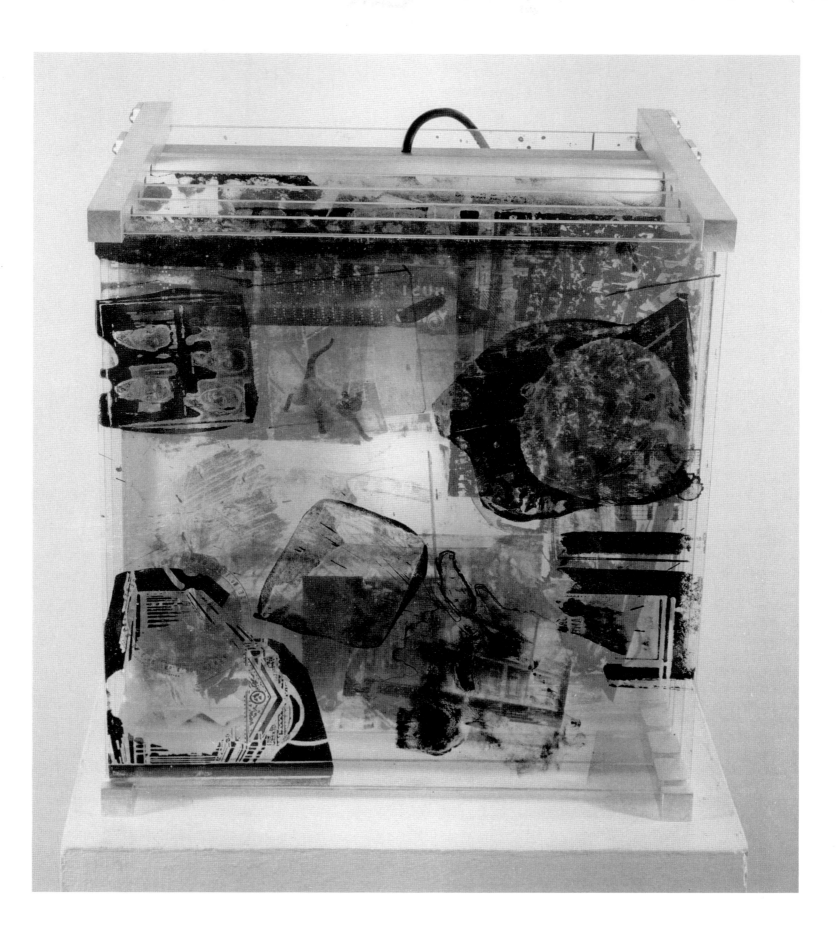

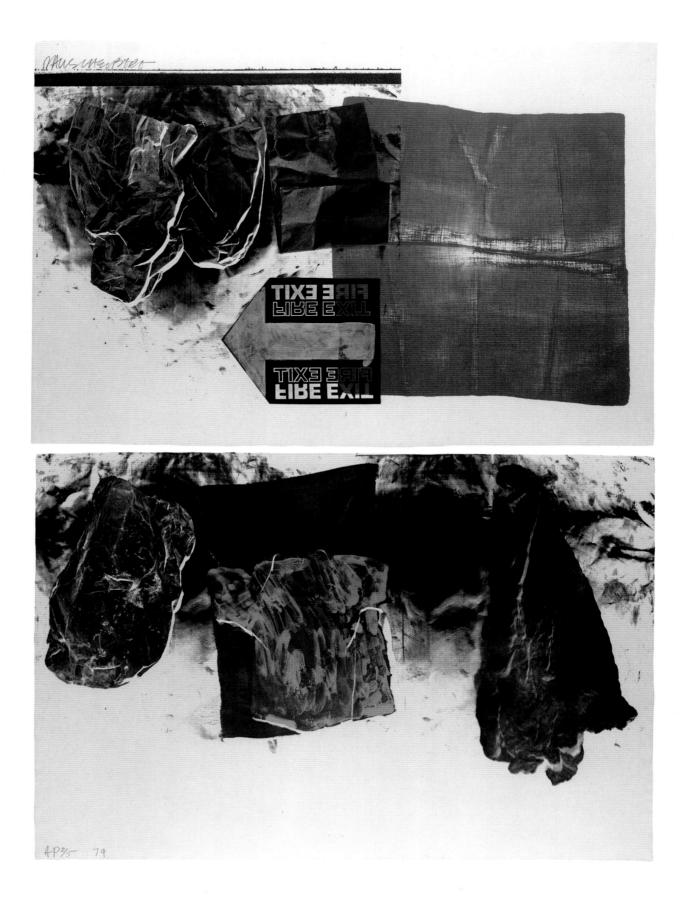

РАЗВЕ МЫСЛИМО БЫЛО ПОДУМАТЬ
ЧТО В НЬЮ-ЙОРКЕ КАК НЕКОГДА ВСТАРЬ
РАЗМЕТАВШИСЬ ЗАСНЕМ НА ПОДУШКЕ
СЛОВНО РУССКО-АНГЛИЙСКИЙ СЛОВАРЬ

МИРОВЫЕ ГРАНИЦЫ ОТРИНЕМ

БУДУТ СТУЛЬЯ В ДЖИНСОВОМ ТРЯПЬЕ

ЗАСЫПАЯ ТЫ СКАЖЕШЬ МНЕ

'dreaming'

'ДРЕМА ДРЕМА'-ОТВЕЧУ ТЕБЕ

RAUSCHENBERG 78

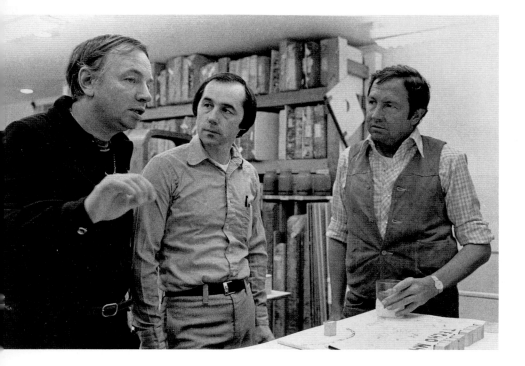

Voznesensky told Rauschenberg that the broadcast may have saved him from prison. He was being harassed by the KGB for his outspoken views and his ties to the West. After the broadcast, with his name in the spotlight once more, he said the pressure ceased.

Work done by Rauschenberg and many other recognized artists at ULAE and at other studios in the 1960s gave the graphic arts cachet in the art world. The flowering of contemporary American lithography meant that the work of leading artists was no longer limited to museums or millionaires, but could be purchased, and enjoyed, by a much wider audience.

Rauschenberg's collaborative innovations at ULAE also created a revolution in the definition and application of lithography, according to Goldston. Many of the ideas he experimented with on the stone during those marathon all-night sessions are now standard methods in college courses on lithography, including solvent-transfer and photo processes. Previously, a lithograph, as strictly defined, was created only by drawing on the stone. "Rauschenberg began a whole new method when he brought in printer's mats to be inked and pressed on the stone," said Keith Brintzenhofe, Studio Director of ULAE. Rauschenberg's success at inking and printing different materials to make, in effect, a collage on the "skin of the stone," as he called it, brought a new generation of artists into lithography. Rauschenberg has said that his lithographs are "the realization and execution of the fact that anything that creates an image on stone is potential material."

Many of his advances in lithography were due to the shrewdness and boldness of the softspoken Tatyana Grosman, who constantly urged her artists to expand the limits of lithographic art. Rauschenberg was in Japan in 1982, printing on ceramics at the Otsuka factory, when he received word of Mrs. Grosman's death at the age of seventy-eight. From his 1974 ULAE portrait, *Tanya*, which he had brought with him, he created a high-fired ceramic panel at Otsuka and placed it in his garden among the bamboo, where he could see "Tanya" every morning. When he returned home, he gave her name to his beloved white Samoyed dog.

IN THE LATE 1960s, Rauschenberg entered into another graphic arts collaboration, with Gemini G.E.L. in Los Angeles. Gemini was founded in 1966 by Kenneth Tyler, a master printer, in partnership with Sidney Felsen, a certified public accountant who had gone to art school, and Stanley Grinstein, a fork-lift manufacturer and art collector. Gemini's purpose was to work with artists on the cutting edge of technology and to produce fine editions of prints and sculptures. The first artist to work with Gemini was Josef Albers, who made a monochromatic geometric abstraction, *White Line Squares* (1966). Shortly afterward, Felsen invited Rauschenberg to print at Gemini.

It was an exciting if chaotic period in lithography. When the print explosion began in the 1960s, there were few master printers in the United States. At about the same time that Tatyana Grosman had started ULAE, artist June Wayne in Los Angeles began the Tamarind Lithography Workshop to train artisans in the graphic arts. Because of the sudden interest in lithography and the limited space and personnel of the workshops, many artists moved back and forth from one studio to another, according to their schedules or that of the printers and to the kinds of technical expertise needed for a particular project.

Rauschenberg arrived at Gemini G.E.L. determined to make the largest print ever produced by hand-lithography. *Booster* (1967) "virtually redefined the possibilities of size and scale in contemporary prints," according to Ruth Fine, curator of graphic arts at the National Gallery of Art. "With the six-foot-tall *Booster*, lithographs began to rival paintings in terms of their size and powerful presence on a wall."

Rauschenberg wanted his lifesize skeleton to be the central image of *Booster*. Felsen arranged for a doctor to take x-rays of Rauschenberg's body in one-foot segments from skull to toes. "And the doctor told him to stay well for the next two and a half years," Felsen said. "He'd had enough radiation to last awhile." At five feet ten inches, Rauschenberg was too big for a single lithographic stone. To solve the problem, the skeleton was printed in two operations from two separate stones and in two sections on a single sheet of paper. Superimposed on the skeleton and printed in red is an astronomer's chart for the year 1967 that tracks the movement of heavenly bodies by day and year. As a border around the skeleton, magazine images of athletes, machinery, and two power drills with circular arrows appeared, which Rauschenberg made using the solvent-transfer method pressed onto the stone. In the upper left-hand corner is the image of a straight-backed chair in blue, the same chair used in *Soundings*. Rauschenberg also drew and painted on the stones, leaving faint marks around the edge of the print.

Rauschenberg's energy and late-night, sometimes round-the-clock working hours exhausted the Gemini G.E.L. crew by the end of two and a half weeks. "Every day was like a party," recalled Grinstein, "Rauschenberg with a contingent of friends, everybody helping, everybody laughing." For Rauschenberg, collaboration has been a sought-for goal in virtually all his artistic ventures. "What's really nice about printmaking is working with other people," he said. "You get a constant exchange that's absolutely limitless." The printers found the exchange equally satisfying. "Rauschenberg is the ultimate collaboration artist," said Timothy Isham, a former Gemini master printer. "He values the personal exchange of minds and skills. It is rewarding to work with him because he makes you feel part of what's going on."

RAUSCHENBERG continued to look for new ways to use lithography by experimenting in different studios. In 1968, he created *Autobiography*, a sixteen-foot-tall print, at Broadside Art, Inc., a new press sponsored by his friend Marion Javits, the wife of New York Senator Jacob Javits. Printed in three sections, *Autobiography* was the first fine-art print to be made on a billboard press, with a run of two thousand copies. In it, the image of his skeleton used for the Gemini *Booster* appears, reduced slightly in size, and encircled by Rauschenberg's zodiac chart. On the center panel is his autobiography, set in type in an oval, around a photograph of the Rauschenberg family at Port Arthur. The bottom panel of the triptych composition is a near-lifesize blowup of Rauschenberg in *Pelican*, wearing his open parachute. He is skating, it would appear, on the rooftop water towers of lower Manhattan.

At Multiples, Inc., in New York, he produced *Star Quarters* (1971), a four-panel Plexiglas mirror with a brightly colored zodiacal whimsy silkscreened across the surface. The constellations stretch across the mirrors, with colorful "found" pictures of the mythical figures superimposed on each: lion, crab, ram, plus a few of his own interpretations, including a snail and an antelope. The viewer finds himself in the mirror facing his own zodiacal sign, fulfilling Rauschenberg's intent of "completing the picture."

At the same time, at Styria Studio in New York, Rauschenberg celebrated his own American Indian heritage with the hauntingly iridescent *Opal Gospel* (1971). An unbound "book," it contains poems from the Nootka, Chippewa, Navajo, Iglulik, Pawnee, and Apache tribes, printed with his illustrations from nature in iridescent ink on clear Plexiglas. The panels, or pages, are interchangeable in their stands, as in the earlier *Shades*.

IN 1969, Rauschenberg felt the need for a quieter existence and, following his astrologer's advice, began to search the east coast for a warm place to live close to the water. He discovered Captiva, a barrier island in the Gulf of Mexico near Fort Myers, Florida. Rauschenberg bought a small house on the beach, along with several other modest buildings that he could use as space to make art.

There, he and Robert Petersen, a California artist who had worked as a master printer at Gemini, established Untitled Press. Adjoining the beach houses Rauschenberg bought for himself was a house for printing, with an old Fuchs and Lang proofing press. His neighbor, artist Maybelle Stamper, contributed the press and some proofing stones. Petersen and Hisachika Takahashi, another assistant of Rauschenberg's, took the press apart, and sandblasted, oiled, and restored it. Gemini G.E.L. contributed some lithographic stones to the new effort. The printing press was in one room, quarters for guests in another. Over the years, small neighboring houses and two more presses were added to the compound.

Rauschenberg began to invite artists to Captiva to collaborate on making prints with himself or with Petersen, where they would not be pressured by time or commercial considerations. The purpose of Untitled Press, Rauschenberg said, was to give opportunities to "emerging artists," or artists who have not worked in direct collaboration with a printer, as well as to established artists. Any prints that resulted would be marketed by Castelli Graphics.

BOOSTER 1967. Lithograph and screen-printing (edition of 38, Gemini G.E.L.), 72 × 36"

AUTOBIOGRAPHY *1968. Offset lithograph (edition of 2,000, Broadside Art, Inc.), 198¾×48¾″ (3 sheets). Broadside Art, Inc., was a publishing venture established to utilize billboard presses as an art medium for "visual journalism."*

OPAL GOSPEL *1971. (Two views). Screen-printing on Plexiglas sheets with base (edition of 200, Styria Studio), 21 × 23 × 7". The iridescent inks used in the work suggested opals to Rauschenberg. The "gospel" is traditional American Indian poetry.*

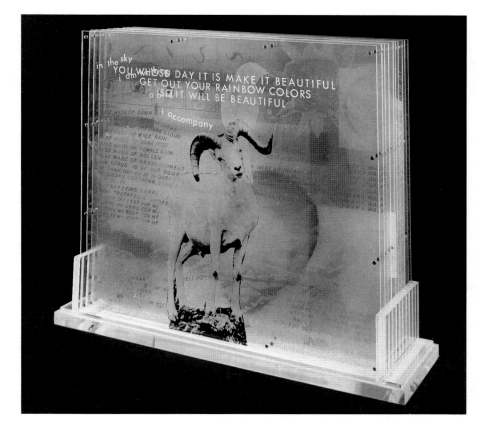

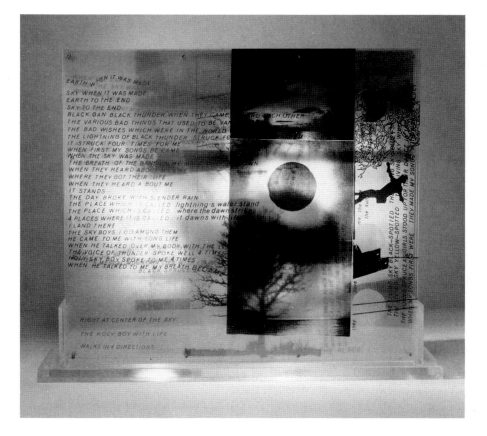

In 1971, Cy Twombly came down to work at Untitled Press, which was his first experience in drawing on stones. The next year, David Bradshaw made Bullet Holes, completing the series by actually shooting holes through the prints with a pistol. Brice Marden also worked at Untitled Press that same year.

Rauschenberg had remained friends with his former wife, Sue Weil. In 1974, Weil, along with her husband, sculptor Bernard Kirschenbaum, their daughter, Sara, and Christopher Rauschenberg, who was just out of college, came down from New York to work at Untitled Press. Weil recalled the relaxed atmosphere at Captiva: "Bob and Chris in the kitchen, cooking something spectacular, Bernie sponging lithographic stones, Sara racing down the beach on Bob Petersen's bicycle, the television set going all day long, and above all, the laughter."

STAR QUARTERS I–IV *1971. Screen-printed on mirrored Plexiglas (edition of 45, Multiples, Inc., New York, and Castelli Graphics), 4 panels, 48×48" each. The viewer becomes part of the composition.*

IN 1971, while Untitled Press was in full swing in Captiva, Rauschenberg also began one of the strongest associations of his career, with Graphicstudio U.S.F. One hundred miles to the north in Tampa at the University of South Florida, Graphicstudio was founded in 1968 by professor Donald Saff as a center for research in the arts. A New York artist who missed the lively exchange with his peers, Saff devised a way to bring them to Florida as artists in residence at the university. They would make art in his workshop, which Graphicstudio would market to subscribers, who included collectors, publishers, and museums. In return, the artists would donate one copy of their editions to the university, and would involve graduate students in their work.

Graphicstudio U.S.F. contributed to the explosion in graphic arts set off by June Wayne and Tatyana Grosman. In addition to those artists invited from New York, Saff recruited printers from Wayne's Tamarind Workshop and acquired stones and a press from the Syracuse China Corporation. Because many of the artists were interested in creating sculptural editions, Saff brought in a sculptor, Alan Eaker, to collaborate with them. As Dean of the College of Fine Arts, Saff turned to other departments of the university—chemistry, engineering, architecture—for consultation as artists experimented with editions in metals, clay, plastics, as well as various combinations of printing on paper.

The professional, noncommercial atmosphere at Graphicstudio attracted artists such as Jim Dine, Philip Pearlstein, Sandro Chia, Ed Ruscha, Roy Lichtenstein, Robert Mapplethorpe, and James Rosenquist.

After a serious auto accident in Tampa, Rosenquist spent nearly all of 1971 at Graphicstudio while his wife and son were recovering from their injuries. When Rauschenberg came to visit him in the hospital, Rosenquist sent him to see the prints he was making at Graphicstudio. By the end of the tour, Rauschenberg had accepted Saff's invitation to work there.

Rauschenberg combined his own facilities with Graphicstudio's to make his Crops and Airport suites. In Crops, he created a silkscreen print at Graphicstudio, leaving space on the paper for another process. At Captiva, he applied solvent transfer to newspaper and magazine cutouts, from which he made individually tailored impressions on each silkscreened sheet of paper, thus combining transfer printing and silkscreen (serigraphy) techniques. The silkscreen element remained constant, but the transfer portion changed in each one. To make the Airport suite (1974), Graphicstudio's printers, Saff's etching press (which Rauschenberg named Atlas), and materials were moved to the Captiva studio. It was Rauschenberg's first use of the intaglio process, in which an artist incises images *into* the plate and fills them with ink, rather than printing from

MINK CHOW *(Chow Bags). 1977. Screen-print and collage on paper, (edition of 100, Styria Studio), 48×36¼".*

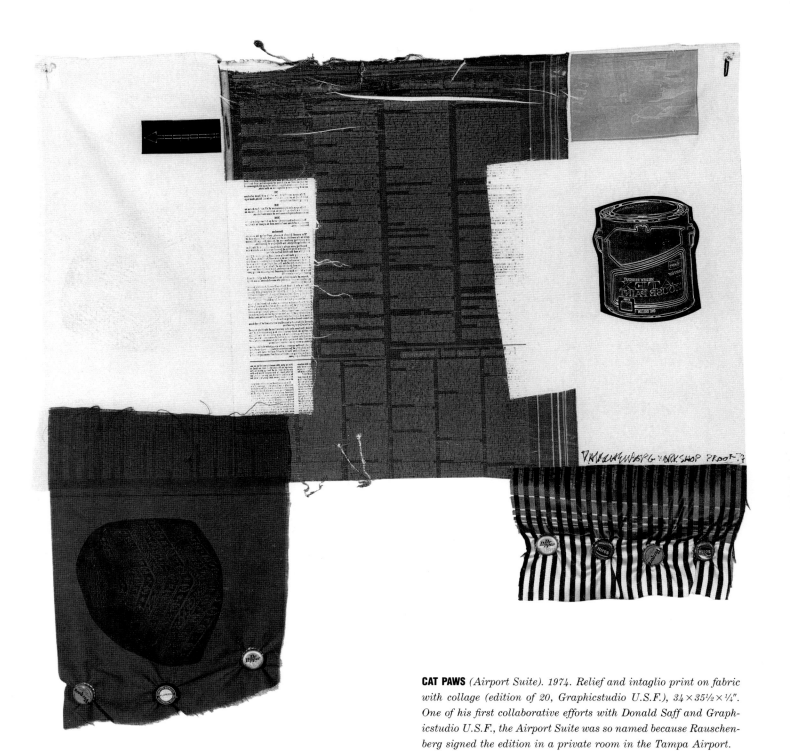

CAT PAWS *(Airport Suite). 1974. Relief and intaglio print on fabric with collage (edition of 20, Graphicstudio U.S.F.), 34×35½×¼". One of his first collaborative efforts with Donald Saff and Graphicstudio U.S.F., the Airport Suite was so named because Rauschenberg signed the edition in a private room in the Tampa Airport.*

the raised areas, known as relief printing. Each piece in the Airport suite is printed on stiff thick paper, with real newspaper mats used as elements of the design. To contrast with the mats, he transfer-printed on fabric some of his favorite images of tires, paint cans, and bicycles, as well as imagery from the newspaper mats. "By folding fabric of different weaves, he was able to print through the materials simultaneously," said Saff. After the material was printed, Rauschenberg unfolded the fabric, and an assistant sewed on the sections, to hang like veils from the mat paper. To adorn some prints even further, he added bottle caps, rulers, and most of the neckties in his closet.

OVER THE YEARS, Untitled Press became less a guest-artist facility and more a laboratory and studio for Rauschenberg himself. During his career, an idea from one series of work often evolved to become the central theme of the next one. The quality of translucency in Veils (1974) led Rauschenberg to this new series, experiments in printing on fabric. The result was a series of beautiful paintings on unstretched fabric, which he called Hoarfrosts. "I read the word in Dante," said Rauschenberg. "Hoarfrost is like a mock frost, but it's a warning about the change of seasons." The Hoarfrosts are unstretched fabric paintings made of a variety of transparent, translucent, and opaque fabrics from simple cotton cheesecloth to exotic satins and silks. The fabric paintings are pinned on the wall along their top edges to make the stress lines in the soft material part of the composition. The Hoarfrosts, most of which are white and larger than bed sheets, are designed to waft in a slight breeze. "These shimmering layered veils of unstretched fabric are as delicately vague as the imagery which they gauze over with a sweet warm frost," wrote art critic Devonna Pieszak in the *New Art Examiner*.

Hoarfrosts began when Rauschenberg noticed that the cheesecloth used to clean the stones with solvent retained some of the newsprint images from the transfer-printing process. As he unfolded the gauze-like cloth, he saw that the images "printed" through several layers, creating an interesting blurred effect. The first Hoarfrosts were printed on cotton gauze. Later Hoarfrosts were made on translucent silk chiffons and satins with the addition of objects: a pillow (in *Gush*), cardboard, or paper sacks. "The first ones [1974] were very obscure," said Rauschenberg. "They were almost like brushstrokes. And in many cases you had to know what the image was in order to be able to see it. . . . I was actually trying to dematerialize the surface as much as I could so that you had a sense of the fabrics being there so the light would have something to fall on."

Rauschenberg made the Hoarfrosts at Captiva on his new Griffin flatbed press, which he painted green and called Grasshopper, because it looked like a giant insect. Eight feet long and three and one-half feet wide, it was capable of exerting eight hundred pounds of pressure per square inch, which meant that it could print on almost anything. Rauschenberg laid the fabric on the press, then arranged his paper images on top. Some were placed flat and face down, while others were wadded and crumpled. He then sprayed a fine mist of solvent over the papers, covered both papers and fabric with padding, and sent the whole package through the motor-driven, low-speed press. The press's powerful motor squeezed the material tightly between the rollers and the flat, movable bed of the press. As fabric, papers, and padding moved under the rollers, thousands of pounds of pressure imprinted the images on the cloth. In all, Rauschenberg made one hundred and fifty original Hoarfrosts. He liked the idea so much he took it to Gemini G.E.L. for replication.

GLACIER *(Hoarfrost). 1974. Solvent transfer on fabric with pillow, 120 × 74". The Menil Collection, Houston. Printed on diaphanous, flowing fabrics, the imagery is transferred to the veils of cloth directly from the magazines and newspapers themselves.*

GUSH *(Hoarfrost). 1974. Solvent transfer on fabric with pillow, 98×48×18". Private collection*

The nine Hoarfrost editions at Gemini were closely patterned after the one-of-a-kind originals made on Grasshopper, except the imagery was bolder, clearer, and larger. To create the edition, Rauschenberg and Felsen first went to a silk store. The material Rauschenberg chose, a leftover 1930s lingerie fabric, was not enough to fill their order of one hundred yards, so Gemini had it replicated in Italy. "It took six months to get that particular texture, but it was worth the wait," said Felsen. "His eye for detail is that discerning."

Hoarfrosts, originals and editions, were enthusiastically received when they were shown at Castelli and Sonnabend galleries and at Castelli Graphics in December 1974. "Decidedly brilliant visual poetry," wrote Joseph Dreiss in *Arts Magazine*. "Breathtaking degree of elegance," said David Bourdon in the *Village Voice*. "Some magic inhabits there," wrote Houston's Contemporary Arts Museum curator Linda L. Cathcart some years later. "The artist has captured the effect of veils of paint, layers of color and translucency, for his own. He uses it for an illusionism which is whole, complete, and finally abstract."

With the Hoarfrosts Rauschenberg showed a mastery of printing mediums. His innovations spanned lithography, silkscreening, intaglio, and ceramics. Ruth Fine terms his contribution to graphic art "monumental," stretching the notion of the size of materials, combinations of media, and encouraging a larger role for collaborators in making prints.

At the same time that Rauschenberg was exploring techniques in printing, he had begun to concentrate on specific subject matter, finding in the graphic arts a way to communicate some of his political convictions. Through lithography, transfer printing, and screenprinting Rauschenberg had begun to use his art to deliver a message.

Overleaf:

BLUE URCHIN *(Hoarfrost). 1974. Solvent transfer on fabric, 76×49″. Collection Paul Hottlet, Antwerp*

UNTITLED *1973. Solvent transfer, acrylic, collage, and graphite on fabric-laminated paper, 60¼×38½″. Private collection. While Rauschenberg was making Hoarfrosts, his unique drawings reflected the use of similar imagery. First he painted on the paper with watercolors, then transferred found images by the solvent transfer method. Some of the inks would bleed onto the paper around the images. The final brushwork was applied after the transferred images had dried.*

In Rauschenberg's print shop, Captiva, Florida, 1977. From left, Sheryl Long, Tim Gault, Rauschenberg, Sid Felsen (of Gemini G.E.L.), Tim Pharr, Peter Wirth, and Cloud, one of Rauschenberg's dogs. Photograph by Terry Van Brunt

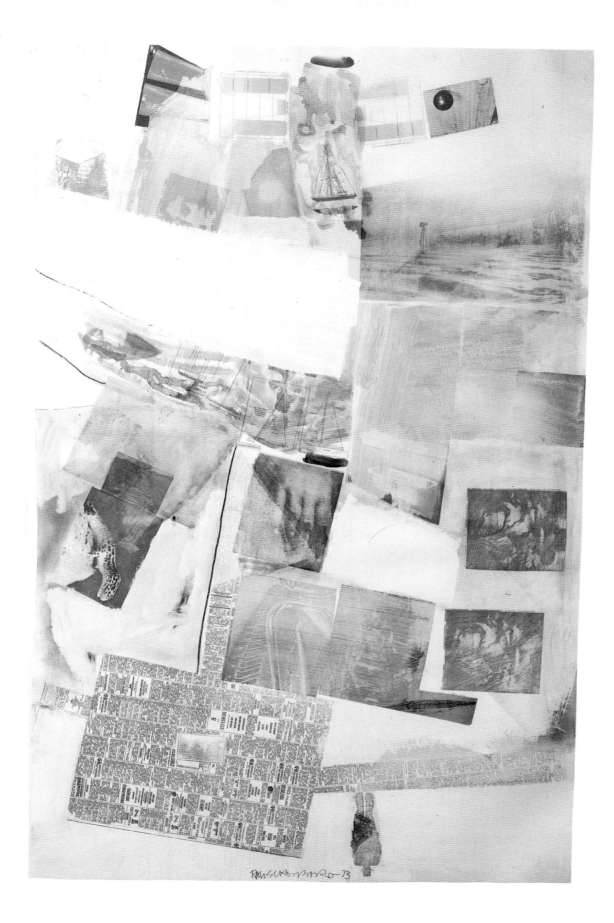

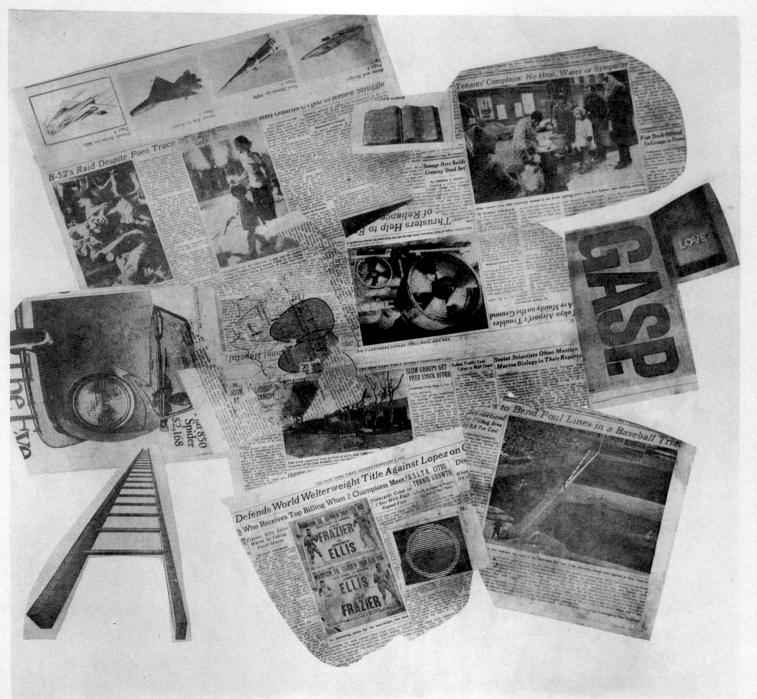

SIGNS

IN 1965 *Life* magazine commissioned Rauschenberg to make a work of art for the 700th anniversary of Dante's birth. The result, a series of collage drawings, *A Modern Inferno*, appeared on six full pages of the magazine on December 17, 1965, just five years after Rauschenberg had illustrated Dante's *Inferno*. This time he was much more explicit in portraying good and evil; this time evil was indeed the ascendant theme.

As seen in *Modern Inferno*, President Kennedy rides through Dallas in the open-air limousine, his head targeted in the cross hairs of a telescopic rifle sight. He is flanked by mass murderer Adolph Eichmann and a hooded Ku Klux Klansman holding a hangman's noose. Another image in the series depicts uniformed Neo-Nazis exciting a crowd of followers with signs that read "Who Needs Niggers?" The theme is mass violence: massacred black South Africans, emaciated survivors of Nazi concentration camps, the mushroom cloud over Hiroshima. In the midst of devastated cities and piled-up corpses is an elaborate electronic control panel; no one is at the controls.

Rauschenberg's *Modern Inferno* reflected the impact of events in the preceding five years since the *Inferno* drawings of 1960. The brave warriors whom Rauschenberg drew then as athletes have become the martyred Kennedy and embattled Martin Luther King, Jr. The corrupt politicians portrayed as slick Wall Street businessman in the 1960 *Inferno* are now cigar-chomping southern sheriffs in riot gear. And the affable Dante—formerly adapted from a Pro Fit ad for golf clubs—is now an astronaut who, like a visitor from another planet, observes with puzzlement the bestiality he sees around him.

By the mid-1960s, Rauschenberg's social conscience and political commitment were major factors in his work. He had grown more sensitive to forces around him—he identified with the oppressed, yet he was hopeful that individuals could affect the state of the world. He spoke frequently of his concern for justice, equality, and peace. More specifically, he felt that artists should be instrumental in changing society. Rauschenberg's philosophical beliefs reflected the upheavals of the time: political assassinations, racial violence, the war in Vietnam.

LINCOLN *1958. Combine painting: oil and collage on canvas, 17 × 20⅞". Collection Art Institute of Chicago. Gift of Mr. and Mrs. Edwin A. Hokin, 1965. The portrait of Lincoln is among the first of many works in which Rauschenberg depicted presidents and other political leaders, in comments on the times. Lincoln's image had special meaning to him when the civil rights movement began.*

CROCUS *1962. Oil and silkscreen ink on canvas, 60 × 36". Collection Mr. and Mrs. S. I. Newhouse. Rauschenberg's concerns about war surfaced in his first silkscreen paintings, with images such as the military truck and mosquitoes as big as helicopters. The white area emerging like a new season from a dark picture gives meaning to the title.*

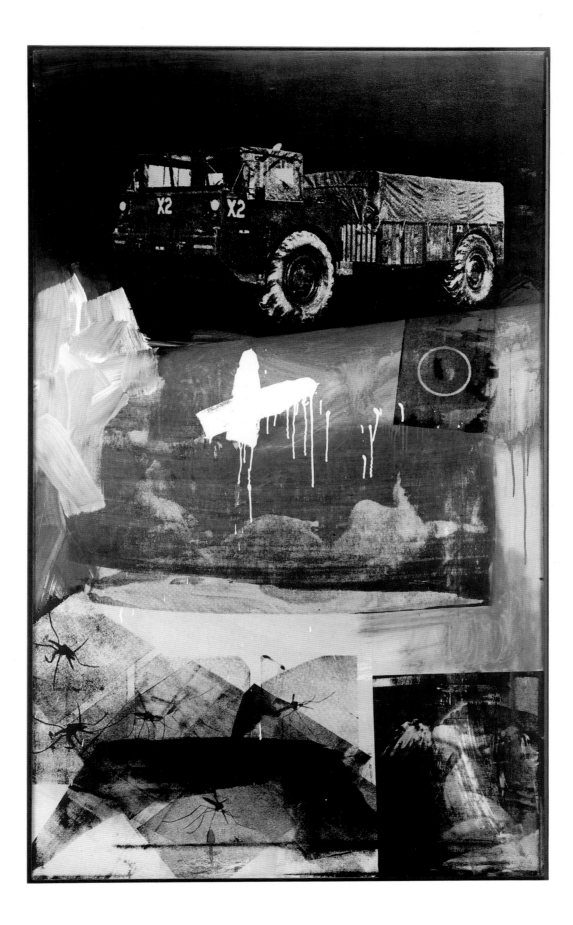

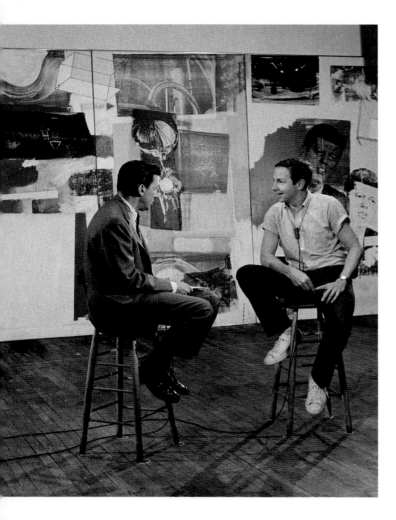

Rauschenberg being interviewed by reporter Mike Wallace for television in 1967. Axle is in the background. Photograph by Nancy Astor

RAUSCHENBERG'S views about artistic involvement in social issues evolved late in 1963. While the bus carrying the Cunningham dance troupe roared across Texas that November, Rauschenberg wrote a page of diary-like "Notes on Painting" in response to an art historian's request. Like a verbal collage, it included descriptions of what he saw along the highways, interspersed with his reflections on painting. He affirmed the classic view that an artist's work should not be aimed at serving politics and causes. "To do a needed work shortchanges art," he wrote. "It is extremely important that art be unjustifiable."

On November 22nd Rauschenberg left the tour to bring some of the troupe to visit his mother in Louisiana. His father had died suddenly of a heart attack only a month before. The fact that they had never gotten along only made the loss more difficult. On the way to his mother's house he heard the news of Kennedy's assassination. The news pierced him as it did many Americans. Rauschenberg, who had huge silkscreen paintings of Kennedy unfinished in his New York studio, was faced with a dilemma. He worried that to finish the pictures would be "celebrating a murder." But to leave them unfinished would be to turn his back on a man he admired and to ignore the fact that Kennedy had become an emblem of change in American culture and society.

He decided to finish the works. In all, he made eight silkscreen paintings, each containing the same enlarged photograph of a handsome Kennedy at a news conference. In both *Quote* (1964) and *Retroactive I* (1964), the other dominant image is that of an astronaut gracefully parachuting back to earth after a space flight. The paintings, infused with vivid color, capture Kennedy's verve and his optimism about conquering the frontiers of space.

After Kennedy's death Rauschenberg became involved in the civil rights and antiwar movements. His paintings more explicitly portrayed his concerns. In *Kite* (1963), a stern American eagle looks down at a U.S. Army helicopter landing in a tropical jungle, while off to the side unconcerned vacationers sit under umbrellas on a placid beach. At the bottom of the picture, U.S. soldiers wave flags celebrating their victory in World War I.

In 1965, Rauschenberg began making a series of posters to raise money for a number of causes. The first was for the Congress of Racial Equality (CORE), the militant civil rights organization that attacked segregation in the South through direct action demonstrations such as restaurant sit-ins and voter registration marches. In October 1967, Rauschenberg met Dr. Martin Luther King, Jr., when both men received honorary degrees from Grinnell College in Iowa. He was shaken by the contrast in their personal circumstances. "I was privileged to share an intimate, unforgettable two-hour lunch with him," said Rauschenberg, "and then he was flown back [south] to jail." At the time, the United States Supreme Court upheld King's contempt-of-court conviction for the 1963 marches in Birmingham, and King entered jail to serve his sentence. In his work for the civil rights cause, Rauschenberg did not use his art as overt political propaganda. The CORE poster, for example, was a typical Rauschenberg "random order" collage, mixing pictures of President Kennedy, an American Indian, the Statue of Liberty, and the statue of a Civil War soldier with scenes of highways, industrial smokestacks, and a racing car in the desert. He said of his contribution to an exhibition of art opposing nuclear weapons: "I wasn't going to do skulls and bones. We needed to give them something to look forward to. I have never believed in just one possibility."

THE ACTIVISM of the sixties which began with civil rights and the antiwar movement spread to other causes, among them women's rights, consumer rights, and the environment. Not surprisingly, artists' rights eventually became an issue too. Rauschenberg and Rubin Gorewitz, an accountant who represented Rauschenberg and other well-known artists, founded Artists Rights Today (A.R.T.). The organization campaigned for artists to receive a royalty on resales of their art. Artists, who often sold their work for very few dollars when they were poor and unknown, realized nothing when the pictures were resold—often years later—for many times their original purchase price.

Rauschenberg raised funds for A.R.T. and testified before Congress in favor of legislation to provide artists with royalties on resales. For example, at a Parke-Bernet auction at which taxi tycoon Robert Scull received $85,000 for a Rauschenberg work he bought from the artist fifteen years earlier for $950, Rauschenberg made a scene. "I've been working my ass off just for you to make that profit," he shouted at Scull. Scull replied that Rauschenberg should be grateful, since publicity about the sale would raise the prices of his new work. Despite the advocacy efforts of Rauschenberg and other artists, Congress did not respond with a law to provide royalties on the resale of artworks.

Rauschenberg was fortunate to be economically secure by the late 1960s and not in need of royalty income. Most artists, however, barely scraped by, and Rauschenberg helped dozens of them when they were in trouble. "He was known as one of the most generous people in New York," said Roy Lichtenstein. Gorewitz discovered the extent of Rauschenberg's philanthropy when he prepared his tax returns. Rauschenberg, in a panic about the large sum he owed, claimed he did not have the money. "Sure you do," Gorewitz told him. "Look at your income." "I gave it all away," said Rauschenberg, who then asked if he could take a deduction for his gifts to artist friends who couldn't afford to eat.

In 1970, Gorewitz helped Rauschenberg set up Change, Inc., to donate emergency funds to artists in need of medical care, rent, food, or art supplies. The organization, which Rauschenberg assistant Nicholas Howey has run today from Rauschenberg's New York office, had helped more than two thousand artists by 1989. Change, Inc. was embraced by other successful artists. In one project, artists contributed art to New York hospitals in return for the hospitals' agreement to treat indigent artists. At a fundraiser for Change at the Museum of Modern Art, sixty-five works of art were contributed for auction by artists including Rauschenberg, James Rosenquist, Claes Oldenburg, and Frank Stella.

ON APRIL 6, 1968, Rauschenberg was an honored guest at a labor dinner held at the New York Hilton. Dr. Martin Luther King, Jr., had been killed two nights earlier, and labor mediator Theodore Kheel had urged Rauschenberg to honor the slain civil rights leader by reading from his "I have a dream" speech, which Kheel had brought with him. Rauschenberg demurred. At the dinner, however, angered by what he considered to be the unseemly celebratory mood at what he thought should be a time of national mourning, Rauschenberg changed his mind, and strode to the podium where he read the speech that proclaimed Dr. King's dream for an America in which all people would be free. "It was a very moving and powerful moment," recalled Kheel.

King's assassination was the first in a series of violent events that turned the last years of the decade into a nightmare. His death was followed by the murder of Senator Robert F. Kennedy, violence at the 1968 Democratic National Conven-

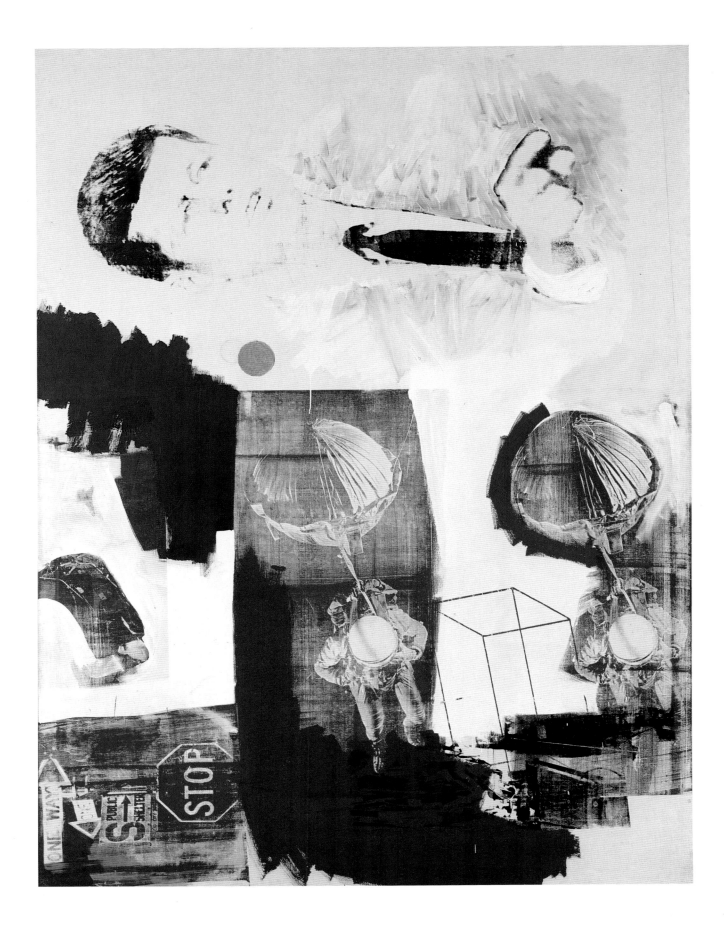

tion, riots in urban ghettoes, and massive demonstrations against U.S. participation in the Vietnam War. "Rauschenberg and others . . . could not help but respond to the threatening forces about them," wrote Dore Ashton. "They became, almost against their will, social critics."

All around the country, artists were organizing and responding to world events. In Chicago, artists held an art exhibition to protest the brutality of police against antiwar demonstrators at the Democratic National Convention that year. Claes Oldenburg contributed a sculpture of Mayor Richard Daley's head severed and sitting on a platter. Rauschenberg's *Political Folly* (1968) included images of Democratic presidential candidates Hubert Humphrey and Eugene McCarthy and a scene from Grant Park, where the Chicago police clubbed antiwar demonstrators. In 1970, sculptor Mark di Suvero designed an *Artists' Tower Against the War in Viet Nam*, to which several dozen other artists contributed their own work. Also that year the Art for Peace program auctioned works (including a Rauschenberg painting) to help elect antiwar candidates to Congress. And in protest of U.S. government sponsorship of the 1970 Venice Biennale Rauschenberg and twenty-five other artists withdrew their works. (Ironically, Rauschenberg's award six years earlier was made on the first occasion of U.S. government support.) Artists belonging to the Art Workers Coalition picketed the Metropolitan Museum of Art because the museum failed to close down in support of a national peace demonstration.

Rauschenberg was also involved with the environmental movement. Years earlier his grass paintings had carried the subtle message that the earth must be cared for. "Those paintings were about looking and caring," he said. "Those pieces would literally die if you didn't water them."

To promote the nationwide Earth Day demonstration on April 22, 1970, Rauschenberg produced the poster *Earth Day*. The classic Rauschenberg collage techniques served his political message: the human destruction of the environment. The images are of forests cut down, land devastated by strip mining, factories belching black smoke, polluted beaches, junkyards filled with the carcasses of autos and beer cans. The only living things are a bald eagle and a gorilla, both endangered species.

One government effort raised Rauschenberg's spirits and engaged his artistic support. He had been captivated with the space program and in love with flight. His great heroes were Orville and Wilbur Wright and in the 1960s he admired the astronauts. Rauschenberg dedicated a drawing to astronaut Edward White. He also named his dog for the first dog in space, Laika. He saw the peaceful exploration of space as a hope that man could use technology to improve human life. Rauschenberg eagerly accepted when he was among those artists invited by NASA to watch the launching of Apollo XI, the manned flight to the moon, at Cape Canaveral, Florida. NASA officials, hoping for favorable publicity, gave the artists extraordinary access to the launch site for several days before the flight, as well as a grandstand seat for witnessing the blast-off on July 16, 1969. "The incredibly bright lights, the moon coming up, seeing the rocket turn into pure ice, its stripes and U.S.A. markings disappearing—and all you could hear were frogs and alligators," Rauschenberg recalled. "The whole project seemed one of the only things at that time that was not concerned with war and destruction."

Rauschenberg decided to produce a major body of work on the space program and Apollo II mission. Working at a hectic pace of fourteen-to-sixteen-hour days at Gemini G.E.L. in Los Angeles, he made Stoned Moon, a series of thirty-three lithographs. Using hundreds of photographs supplied by NASA in his composite imagery, he responded to the technology of the booster rocket, the astronauts'

UNTITLED (FOR ASTRONAUT WHITE) *1965. Collage on graph paper, 15 × 20". Collection the artist. After Edward H. White became the first American astronaut to walk in space, June 3, 1965, the artist made this collage as a tribute.*

Opposite:

EARTH DAY *1970. Lithograph and collage (edition of 50, Gemini G.E.L.), 52½ × 37½". Few Rauschenberg works carried as strong and explicit a message as his lithograph and poster for Earth Day, April 22, 1970.*

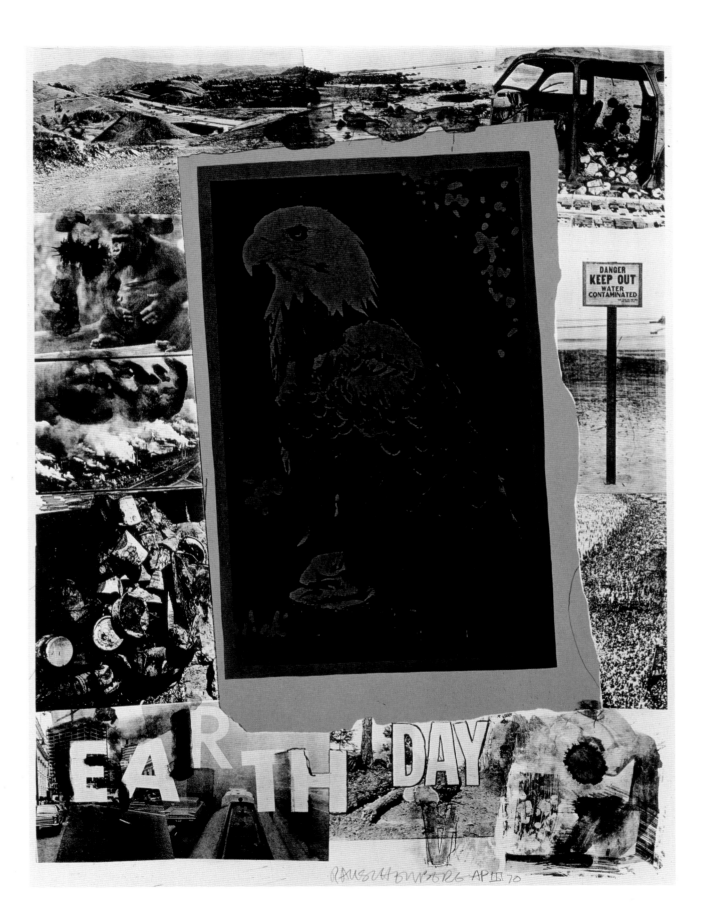

walk on the moon, the technicians at the NASA control center, and the surrounding Florida scenery.

Sky Garden (1969) and *Waves* (1969), from the Stoned Moon series, were the largest lithographs ever produced up to that time on a hand-operated lithographic press, each measuring seven feet, five inches high, and three and one-half feet wide. The size was achieved by laminating two stones together. "*Sky Garden* was so long that there was no way a single person could roll it out," recalled printer Timothy Isham. "We had two printers and two spongers. My hands were rolled over many times, we were moving so swiftly." In the center of *Sky Garden* is a white diagram of a rocket with many of its parts neatly labeled (boost protective cover, retrorocket, auxiliary tunnel, heat shield, and so on). Around the rocket are images of the control center, tropical birds, palm trees, and the official NASA seal.

Rauschenberg was proud both of his collaboration with craftsmen at Gemini to make such extraordinary lithographs, and of the Apollo XI accomplishment itself. He saw the successful space mission as an example of a "responsive, responsible" collaboration between "man and technology."

The Stoned Moon series was praised by the critics. Writing in *The New York Times*, John Canaday said, "How wonderfully [Rauschenberg] combines celes-

Opposite:

SKY GARDEN *(Stoned Moon). 1969. Lithograph with screen-printing (edition of 35, Gemini G.E.L.), 89×42"*

Rauschenberg working on the Stoned Moon *series at Gemini G.E.L., 1969. Photograph by Malcolm Lubliner*

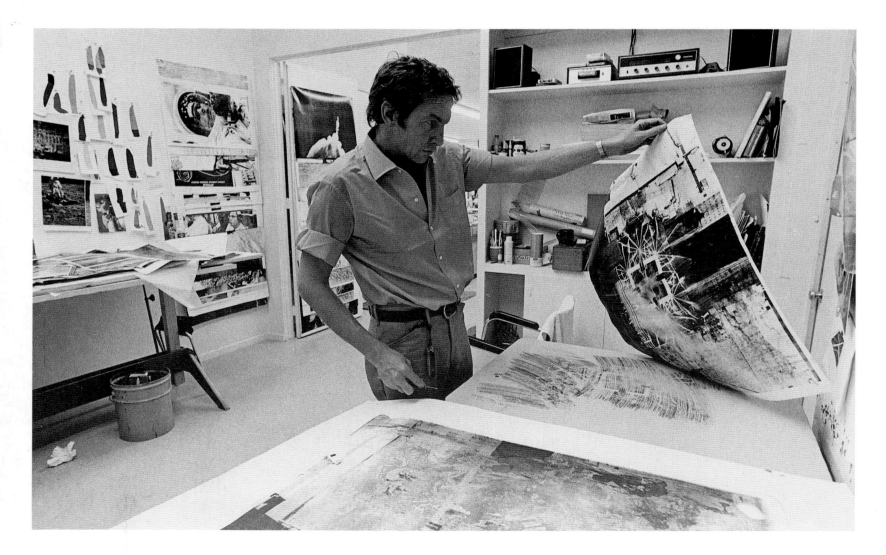

BOOST PROTECTIVE COVER

LAUNCH ESCAPE
MOTOR

COMMAND MODULE

RCS ENGINE

SERVICE MODULE

SPACECRAFT
LM ADAPTER

LH₂ TANK
FORWARD DOME

INSTRUMENT
UNIT UMBILICAL

INSTRUMENT UNIT

S-IVB FORWARD
UMBILICAL

AUXILIARY TUNNEL

HELIUM STORAGE
SPHERE

MAIN TUNNEL

APS MODULE

AFT DOME

FUEL FEEDDUCT

S-IVB AFT
UMBILICAL

ULLAGE ROCKET

AFT INTERSTAGE

J-2 ENGINE

SPIDER BEAM

S-IB FORWARD
UMBILICAL

OUTER LOX TANK

FUEL TANK

S-IB AFT
UMBILICAL

FIN

HYDRAULIC
ACTUATOR

SUPPORT AND
HOLDDOWN FITTING

HEAT SHIELD

H-1 ENGINE

GEMINI

RAUSCHENBERG G.I 69

tial diagrams, photographs of Cape Kennedy, navigation charts, x-rays of the human body, and a whole category of related data from the space program. . . . Rauschenberg is as good a printmaker and as brilliant a designer as you are going to find around."

Lawrence Alloway credited Rauschenberg with having "produced the first persuasive public art of the early space age." In his book on modern American art, Alloway compared Rauschenberg's portrayal of the space program with Rubens's celebration of the Medici "in its pomp, wit, and fidelity."

THE NATIONAL exhilaration over the moon landing was cut short. Two days after the successful lift-off, the last remaining Kennedy brother, Senator Edward M. Kennedy, drove into the waters off Chappaquidick Island, where his passenger drowned. Antiwar protest demonstrations grew more strident after revelations of a secret U.S. invasion of Laos and the murder of four hundred fifty Vietnamese civilians by U.S. troops in the village of My Lai. Rauschenberg felt assaulted by the news.

The decade of the sixties had been a rich, complex period in his life. The paintings, both *Inferno*s, the lithographs with Tatyana Grosman, the silk-screens, the performance pieces and dance, and the involvement with technology all flowed out of him in approximately the same period of time as his growing political involvement. But the decade seemed to be ending badly—for the country and for the extended family of artists who were Rauschenberg's friends and colleagues. The so-called Age of Aquarius would not last out the decade.

Rauschenberg's friend, art historian Barbara Rose, described his Lafayette Street home as resembling a hospital ward where people had come seeking Rauschenberg's assistance. In an odd way, Rauschenberg said, he felt that somehow he was responsible for his friends' problems. He even had gone to an astrologer because "there was such an abundance of bad news that eventually I began thinking that maybe it was my spirit or lack of spirit that was doing it." The astrologer told him "to head for the sun and the sea." So Rauschenberg went to Malibu with the intention of doing a large, peaceful watercolor. "I went out there on the beach and started gathering my materials," he said. "But I could not escape."

Instead, he made *Currents*, a silkscreen project with a grim message. The title stood both for current events and for the depressing currents engulfing modern society. Working with assistant Bob Petersen, Rauschenberg clipped headlines, news stories, photographs, and ads from the January and February 1970 editions of *The New York Times*, *New York Daily News*, and *Los Angeles Times*. He arranged the clippings in thirty-six collages, each thirty by thirty inches square. From these he produced two portfolios of prints, *Surface Series* from *Currents* and *Features* from *Currents*, in order to reach a larger audience. To emphasize the gravity of these world events, he then joined all the imagery together to form the world's largest silkscreen drawing, six feet high and fifty-four feet wide. *Currents* became an enormous black-and-white scrapbook, which Rauschenberg described as the "most serious journalism I had ever attempted."

The materials are the headlines themselves, such as "Russia, China Gird for War," "Pope Sounds Warning on Drugs and Porno," "Runoff Flushes Raw Sewage to River," "New Ritual Slayings," "Tenants Complaint: No Heat, Water, or Sympathy." The bad news is occasionally relieved by pictures and by a few hopeful stories, among them "Your Heart and How to Live With It."

SIGNS *1970. Screen-print (edition of 250, Castelli Graphics), 43 × 34". Distressed by the death of his friend Janis Joplin (upper right) from a drug overdose, Rauschenberg created this print which summed up the tragic events of the 1960s.*

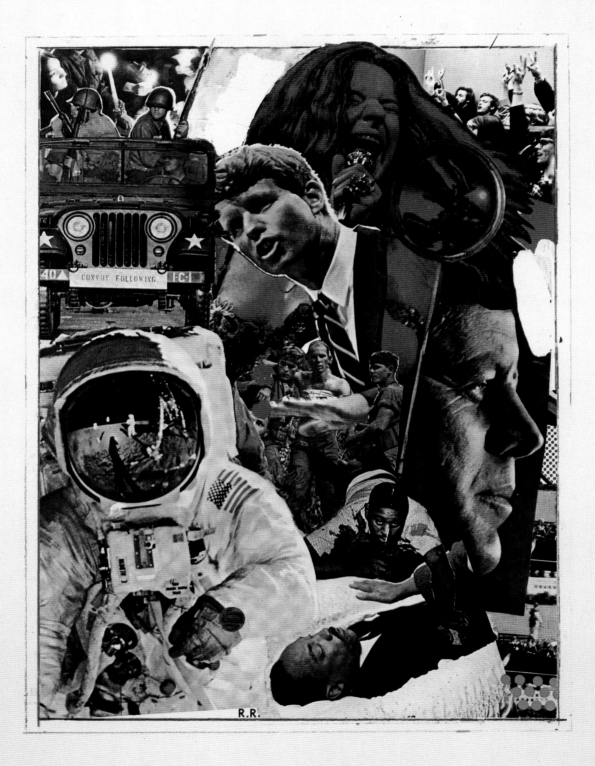

R.R.

In a catalogue accompanying *Currents*, Rauschenberg described the work as "an active protest attempting to share and communicate my response to and concern with our grave times and place," and an effort to "encourage individual conscience." Rauschenberg had drawn into himself, saying that *Currents* "became my excuse to submerge myself in a personal solo activity after an overdose of group efforts. The world condition permitted me no choice of subject or color or method of composition." Never before had he talked so much about one of his paintings, constantly explaining himself as it was exhibited around the country. Like an evangelist, he hoped to inspire people to take responsibility for conditions around them. "I want to shake people awake," he said. "I want people to look at the material and react to it. I want to make them aware of individual responsibility, both for themselves and for the rest of the human race. It has become easy to be complacent about the world. The fact that you paid a quarter for your newspaper almost satisfies your conscience: Because you have read your newspaper, you have done your bit. And so you wrap your conscience in your newspaper just like you wrap your garbage. . . . I made that series [*Currents*] as realistically as I could, as austerely as possible, in the most direct way I knew how, because, knowing that it was *art*, people had to take a second look, at least, at the facts they were wrapping their garbage in."

Critics disagreed strongly about the merit of *Currents* as art. Writing in *Newsweek*, Douglas Davis praised Rauschenberg for making "his own kind of *Guernica*, taking his stand, working quickly because the times demand it." John Gruen, in *New York* magazine, said that Rauschenberg had communicated his political message through collages showing his "particular genius for juxtaposition, visual irony and compositional tension and invention." Reviewing *Currents* in the *Los Angeles Art Examiner*, Peter Plagens wrote, "It is technically remarkable, but it ends up rather dull taken as art and, taken as propaganda, probably aimless and ineffective." John Canaday of *The New York Times* said, "My feeling about Mr. Rauschenberg's protest is that it is stale and redundant. . . . It tells us nothing that we don't already know and adds nothing in the way of interpretation or clarification for anyone with a grain of sense. Project art usually turns out that way, although it seldom provides us, as Mr. Rauschenberg does, with a generous portion of esthetic pleasure to atone for its superficiality as social observation."

After *Currents* was finished, Rauschenberg went back to Captiva, to the quiet tropical setting in which he hoped to find serenity. But on October 4, 1970, he learned that his friend Janis Joplin had died of a drug overdose at the age of twenty-seven. Rauschenberg and Joplin were both rebels who had escaped what they felt was the stifling conformity of their birthplace, Port Arthur, Texas. It was a cruel end to a decade that had started with such hope.

If one work of Rauschenberg's can sum up that decade, it is his silkscreen montage *Signs* (1970). In it, Senator Robert Kennedy reaches out to a group of soldiers in Vietnam, expressing his determination to end the war. A wounded black man reaches out for help over the body of Dr. Martin Luther King, who lies in his burial casket. Astronauts walk on the moon and peace marchers demonstrate. At the top of the picture, Janis Joplin, the symbol of the intensity of her generation, is pictured singing her wild and exuberant songs.

Rauschenberg wrote that *Signs* was meant to "remind us of love, terror, violence of the last ten years, [and] that the danger lies in forgetting." In Captiva, he named his new press "Little Janis," and went on with his job of making art.

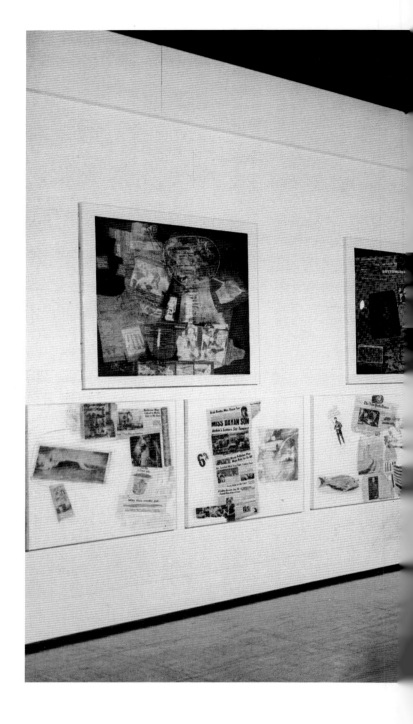

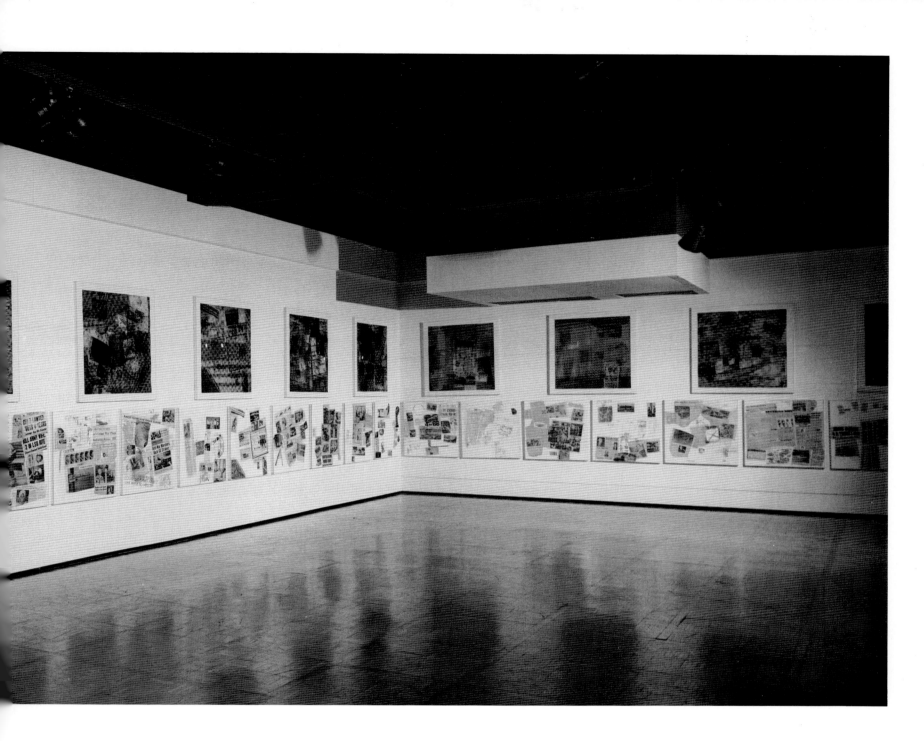

Installation view, Currents *at Dayton's Department Store Gallery 12 in Minneapolis.*

CARDBOARDS

THE SHOW of Rauschenberg's new work at the Castelli Gallery in October 1971 featured only one material—cardboard. Visitors to the gallery saw several dozen cardboard boxes that had been flattened, buckled, or left whole, then nailed to the walls. Printed brand names and instructions, stamps and mailing labels, dents and punctures, staples and packing tape, as well as smudges of dirt and oil stains, were all left untouched. Rauschenberg had neither painted on nor attached anything to the cardboard. *New Born Indian River* (1971), which is typical of the works in the show, is a T-shaped collage glued together from a variety of boxes. The title was taken from the brand names printed on two of the boxes, Newborn Pampers and Florigold Indian River Citrus Fruit.

In the catalogue for the exhibition, Rauschenberg explained what he was doing: "For five years I have deliberately used every opportunity with my work to create a focus on world problems, local atrocities, and in some rare instances celebrate man's accomplishments. . . . After awhile . . . a desire built up in me to work in material of waste and softness. Something yielding, with its only message a collection of lines imprinted like a friendly joke. Boxes."

Rauschenberg's move to Captiva Island in 1970 in search of a simpler, more serene life led to work that in its spare imagery marked a return to the minimalism of his Black Paintings and White Paintings. He had established his reputation with his use of complex imagery. Over the next six years, this dense imagery would all but disappear. Instead, the emphasis in his art would be on using primitive or basic materials, ranging from cardboard sculptures to making paper itself. It was no accident that this new turn in his work coincided with his move to Florida. Not only did he respond to the quiet of the world around him by avoiding the jumble of images that had bombarded him in New York, but he also followed his usual practice of making art with whatever he found around him. At first that proved a dilemma. He had combed Captiva for materials to make art, but soon realized that compared to the New York streets, the beautiful, clean island had no lode of detritus.

What he found around him were seashells. Shelling on his barrier island had become a minor industry for craftspeople, and Rauschenberg wanted no part of it. A dedicated conservationist, he thought the shells "ought to stay on the beach." He asked himself, "What's the most common material?"

Simple cardboard boxes were everywhere. He had packed his clothes in them. He had used cardboard in the combines. The very plainness of the boxes, their pliability, and the fact that they had been made for some previous need attracted him as a vehicle for his return to solitary work.

NATIONAL SPINNING / RED SPRING *(Cardboard). 1971. Cardboard on plywood, 8'4" × 8'2½". Private collection*

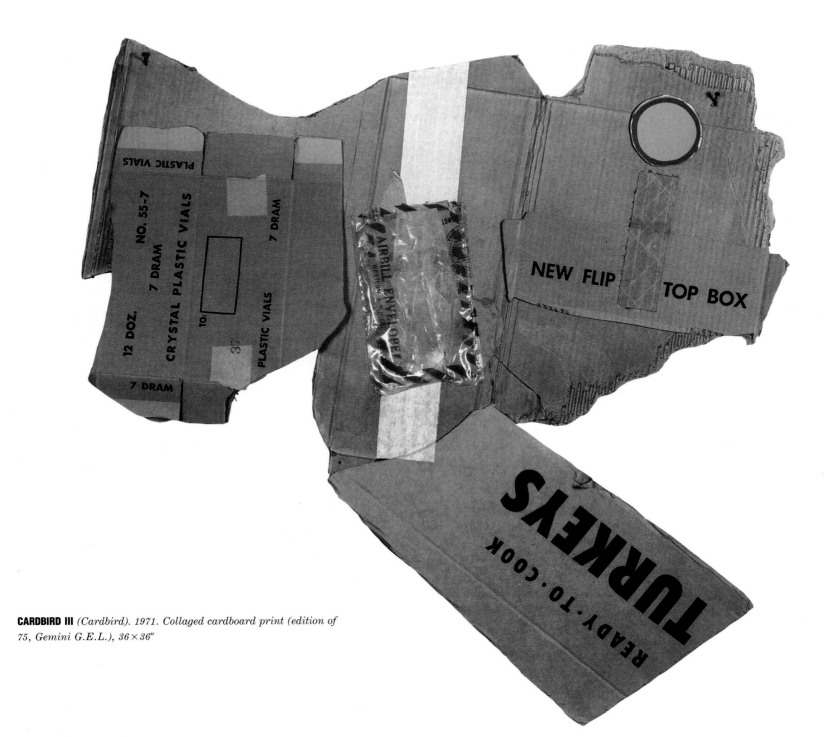

CARDBIRD III (Cardbird). 1971. Collaged cardboard print (edition of 75, Gemini G.E.L.), 36×36"

Opposite:

CARDBIRD DOOR (Cardbird). 1970–71. Three-dimensional collaged and printed object (edition of 25, Gemini G.E.L.), 80×30×11"

He tampered with the boxes only slightly, and to reinforce their identity. He flattened them and glued them together for a totemic, sculptural effect, as in *Nabisco Shredded Wheat* (1971). He attached whole boxes to each other, added armlike appendages made from flattened boxes, and named them for their contents, to make works like *Anchor Federal Tumbler* (1971). He chose them for the colorful imagery that he found on some boxes, as in the bright red imprints of maps of the United States on *National Spinning/Red Spring* (1971). With his unique gift for arrangement, Rauschenberg managed to create from the cardboard interesting compositions with a formal dignity. In the view of Professor Willard McCracken of the University of South Florida, Rauschenberg had "celebrated the worth of the most humble and common products."

The critics were generally friendly, praising Rauschenberg's shift back from political to aesthetic expression. David Shirey of *The New York Times*, however, wrote that "those who like to think of [Rauschenberg] as the enfant terrible may have to think of him as the enfant docile [after viewing] the tamest, most sedate efforts that Mr. Rauschenberg has produced since he acquired his reputation. . . . They are in a way non-statements."

Castelli wondered if his clientele agreed with Shirey. Few collectors were brave enough to venture $25,000 for an unadorned bunch of discarded cardboard boxes, even when arranged by the hands of Robert Rauschenberg. As the Cardboards moved to exhibitions around the country (and later around the world in ROCI), other sophisticated viewers questioned whether plain cardboard boxes could be "passed off" as art. Nevertheless, Rauschenberg next worked at Gemini G.E.L. to carry the idea of the boxes a step further. He wanted to create the most complicated, fool-the-eye series he had ever done. He made exact replicas of the Cardboards, calling them Cardbirds.

The eight Cardbirds (seven Cardbirds [1971] and one *Cardbird Door* [1970–71]) are trompe l'oeil of a high order. Prototypes of real cardboard boxes were photographed, transferred to photo offset, printed—corrugation and all—and laminated onto another piece of cardboard. Everything on the boxes was reproduced, from shipping tape to the tiniest rips and tears. "Each label, each piece of tape, each smudge of dirt was carefully printed to duplicate the qualities of 'found' cartons on which it was based," according to former Gemini G.E.L. printer Timothy Isham, who helped make them. Rauschenberg then added authentic rubber stamps, bills of lading, other cardboard boxes, and even strips of real sealing tape next to the printed tape to "finish" the edition.

The *Cardbird Door*, which was printed in an edition of twenty-five, can actually function as a door, having been designed to fit a door frame. (One serves as the door to Rauschenberg's guest room in Captiva; another opens off Jasper Johns's dining room in New York.) The door is printed and collage added on both sides. Its knob is a wooden spool. On one side, the labels "Ready To Cook Turkeys" (the "birds" in "Cardbirds") and "Glass Handle With Care" are printed near the bottom. Isham has said that a "Fragile" sign printed on the other side may indicate the artist's feelings. According to Isham, at the Gemini opening in Los Angeles, the artist di Suvero punched his fist through a *Cardbird Door*. "That's okay," said di Suvero, "Look what Rauschenberg did to de Kooning!"

Critical reactions to the Cardbirds were mixed. "As offset-photo lithographs of a complex production, the Cardbirds are simply not interesting," wrote Robert Pincus-Witten in *Artforum*. But according to Ruth Fine, curator of graphic arts at the National Gallery of Art, they were fascinating. "The Cardbirds are elegant, and the *Cardbird Door*, the most elaborate and refined of all. In this intricately conceived object, cardboard is transformed by the artist,

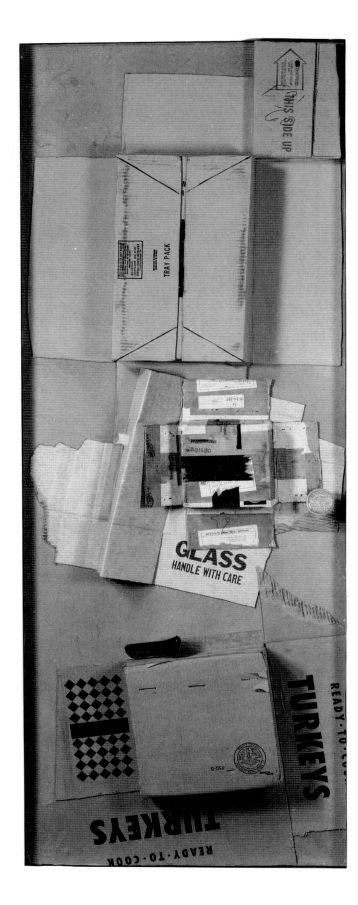

VOLON *(Cardboard). 1971. Cardboard on plywood, 55½ × 147 × 10¾".*
Collection the artist

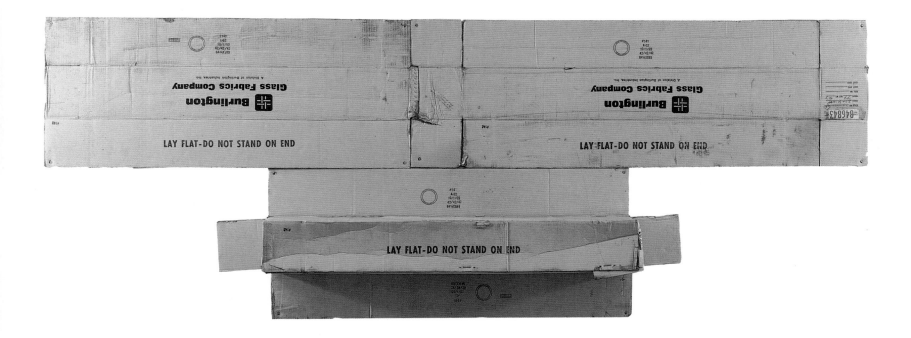

TAMPA CLAY PIECE 1 *(Tampa Clay Piece). 1972. Ceramic with decals (edition of 10 Roman Numerals, 10 Arabic Numerals, Graphicstudio U.S.F.), 14½ × 15½ × ¾"*

taken away from its usual, disposable function, and given new life. This is the revelation in Rauschenberg's art. He continually forces us to reconsider the meaning and purpose of the quotidian experience."

For his next experiment with cardboard, Rauschenberg turned to Donald Saff's Graphicstudio U.S.F. Rauschenberg and Charles Ringness, the printer, searched the stores of Tampa for the right cardboard boxes. Soon after they brought fifteen prized boxes to Graphicstudio, however, the cleaning crew hauled the boxes away. Fortunately, the boxes had already been photographed for documentation of the project. Ringness took the photos to the city dump and raked through piles of garbage until he found the "appropriated" cardboard, and the project was saved. (Rauschenberg was delighted at the addition to his boxes of still more "character" from the dump.) The result of this effort was the 1972 Made in Tampa series of forty prints and nine proofs on industrial tar paper—a "dialogue," wrote Diane Kelder in *Art in America*, between "the faded impression of the soaked and battered box and the aggressively textured surface of the paper."

The next Graphicstudio project, Tampa Clay Pieces (1972), challenged the ingenuity of the printers for six months. Encouraged by Graphicstudio sculptor Alan Eaker, Rauschenberg decided to turn cardboard boxes into ceramic pieces. After many tries at copying the boxes, Rauschenberg was concerned that the first clay pieces did not replicate the color or the slightly oily surface of the cardboard. Eaker and printer Julio Juristo solved the problem by adding garden soil to the clay, and then rubbing grease from their faces onto the surface. The ceramic that resulted looked so much like cardboard, even down to the printed labels, that Rauschenberg had to thump it with his fingers before a group of reporters was convinced that it was not in fact cardboard. Rauschenberg was so pleased with the flawless trompe l'oeil Tampa Clay Pieces that he wanted to make a ceramic sculpture from the burlap bags in which the dry clay was shipped. The burlap did not survive the firing, so Rauschenberg suggested using a fiberglass bag, which fused successfully with the clay, and looked exactly like burlap. When this piece was finished, it was so realistic that Rauschenberg himself was fooled. "Works in his Tampa Clay Piece series are prints of prints, therefore statements about graduated levels of reality," wrote Philip Larson in *Print Collector's Newsletter.*

RAUSCHENBERG also used cardboard boxes in the 1973 Venetian series, which was inspired by his many visits to the city. Some of the Venetian pieces were made in Italy, others in Paris and New York. On approaching Venice by boat, Rauschenberg always "grew very quiet, taking in the details of the sight," recalled Bob Petersen. "He loved the beauty and fragility of water. When we came to dock, he'd point out the posts sticking out of the water—the sculptural aspect of them." In the Piazza San Marco, according to Petersen, Rauschenberg would always admire the movement of the draperies used to shade the cafés from the afternoon sun—"how they look in the archways when the wind catches them." It was those simple impressions, and the "rotting grandeur" of the back alleys of Venice, that he sought to capture in his new sculptures. He used the plainest materials—a tree branch, for example, that resembles a gondolier's pole, from which a tattered lace curtain hangs like a banner—to create a vision of Venice that was spare and minimal, emphasizing the shapes of ordinary objects.

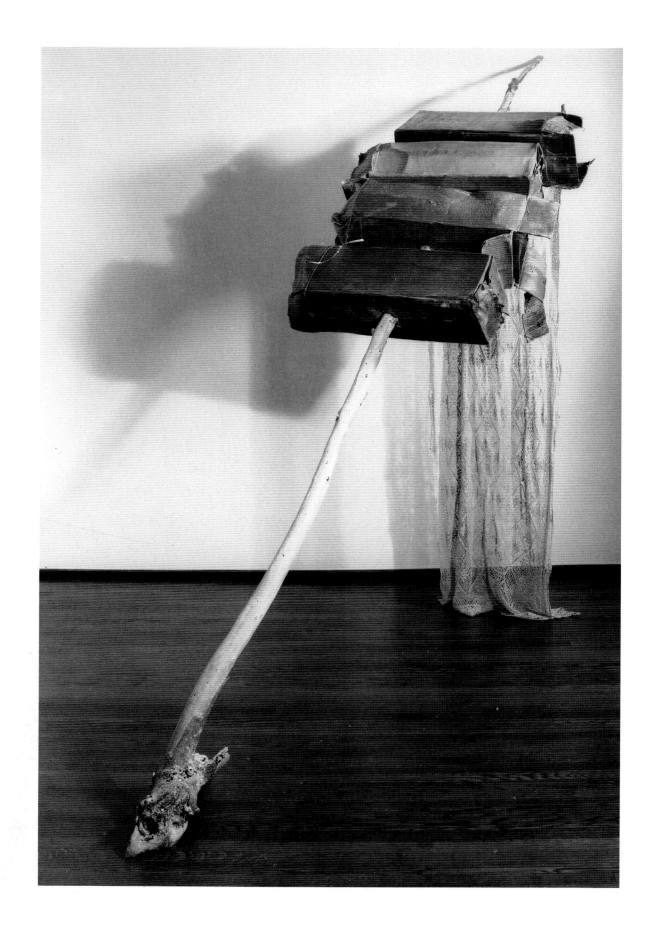

UNTITLED *(Venetian). 1973. Wooden branch with objects,*
86 × 26½ × 105". Private collection

UNTITLED *(Venetian). 1973. Assembled wood and rubber,*
27½ × 90 × 16½". Collection the artist

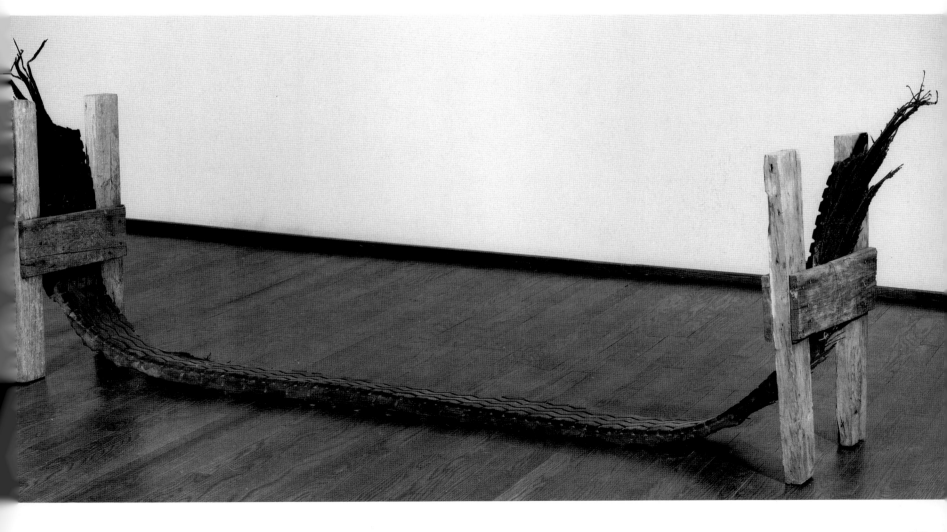

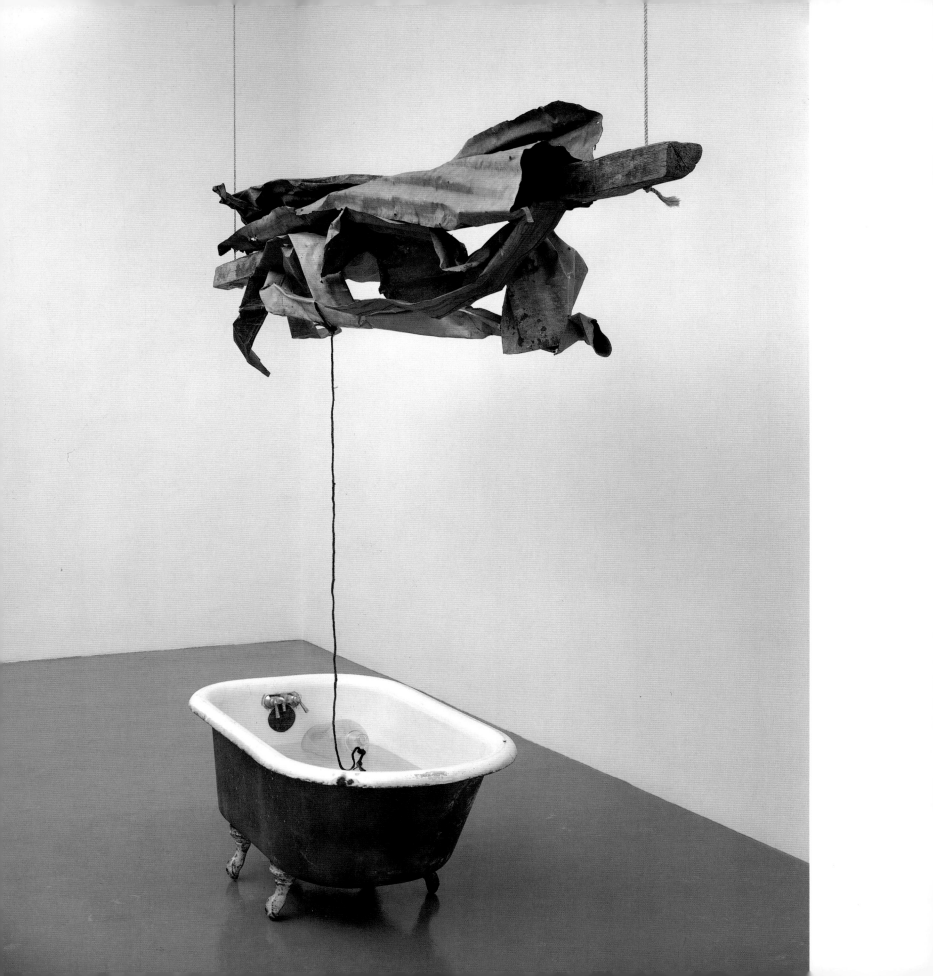

SOR AQUA *(Venetian). 1973. Assembled objects with water, 98 × 120 × 41". Collection Teresa Bjornson, Los Angeles, California*

THE NEXT Rauschenberg venture in art made with simple or basic materials came in August 1973, with a trip to France to work on a project with Gemini G.E.L. Since he first smeared paint with his hands as a student in Paris, Rauschenberg had enjoyed the tactile experience of being as close to his material as possible. As a printmaker, he had learned from Tatyana Grosman the importance of fine paper. Now he wanted to begin at the beginning and make the paper itself. Gemini arranged for him to work at Moulin à Papier Richard de Bas in Ambert, France, a producer of high-quality handmade paper for hundreds of years. At the start of the project, Rauschenberg said he had "no preconceived ideas," he was "merely interested in shapes and prints that could come out of an artist's having made paper."

Working with owner Marius Peraudeau and his staff in the Loire Valley mill, Rauschenberg began by making sketches of the shapes he wanted the paper to take. A local plumber made tin molds based on Rauschenberg's drawings. Rauschenberg then worked with vats of unbleached gray pulp and bleached white pulp, mixing the pulp in five buckets to get shades ranging from snow white to dark gray. When he was satisfied with the colors, he poured and stirred the pulp into the tin molds, adding cord, twine, and rag to the mixture. (He said it reminded him of "very bad yogurt.") During the next stage, called "couching," Rauschenberg flipped the fibrous mass of pulp out of the mold onto a felt mat and pressed the water out of it. His hands were nearly frozen by the water, which was actually melted snow from the nearby mountains of the Massif Central.

Working with paper, Rauschenberg used techniques that resulted in a series with two quite different variations: Pages, austere, modernist treatments of plain paper as sculpture; and Fuses, in which the paper was colored with brilliant dyes, then decorated with silkscreened images.

The Pages have a primitive, ceremonial quality, like objects used in ancient rituals. *Page 2* (1974), for example, is a simple flat circle with a hole in the center. There is no imagery. Ranging in color from light gray to creamy white, the rich, uneven texture of the paper and the simple design lead viewers to create their own images. *Page 2* evokes an ancient stone wheel, or a South Sea island stone coin.

For Fuses, Rauschenberg used magazine images he had selected before leaving for France and which the Gemini printers already had silkscreened onto thin sheets of Japanese tissue and sent to France. He poured dyes into different areas of wet paper pulp in the tin molds. Then he gently pressed the silkscreened tissue paper into the still-wet sheets of colorful pulp, so that the images and colors fused, giving meaning to his name for the series. The prints are in deep glowing shades of red, yellow, blue, pink, and green. The most frequently reproduced is the irregularly shaped *Link*. Divided into three vertical bands of red and yellow, white, and sky blue, it contains images of a telephone pole and a sea gull.

Once again, Rauschenberg had accomplished a unique technical feat. Writing in the *Print Collector's Newsletter*, Joseph E. Young said that Pages and Fuses were "the first works of art in the history of papermaking that represent a major artist's personal involvement in transforming the art of making paper into art itself." And Ruth Fine of the National Gallery of Art wrote in *Gemini G.E.L.: Art and Collaboration*, that Rauschenberg's paper work in France "may well have been the stimulus for the expansive interest among artists in the use of paper as a medium for making art rather than one on which art is made."

Rauschenberg's trip to Ambert marked the beginning of his travels to different countries for making art, collaborating with local artisans, and using the resources he could find there. The French experiment fired the idea of making art throughout the world that in turn gave rise to the Rauschenberg Overseas Culture Interchange (ROCI).

THE IDEA of a peaceful artistic venture took further shape during this time, as Rauschenberg made art relating to the Middle East. His concern for peace was expressed at a particularly turbulent time in the Arab-Israeli conflict. From his interest and his work in the area emerged two series, the Egyptian series (1973) and the Made in Israel series (1974).

For years Rauschenberg had been fascinated by the Middle East—not so much by elaborate Middle Eastern art, but by the colors of the desert and architectural forms, and the textures of fabrics there. Rauschenberg's direct contact with the politics of the region came in 1972 when Senator Jacob Javits introduced him to Israeli Foreign Minister Abba Eban, who invited him to visit Israel. Through Eban, Rauschenberg became friends with Prince Sadruddin Aga Khan, who invited the artist to his home in Egypt, and gave him a "Pharaoh's Eye" stone from a mummy. At about the same time Marion Javits, the senator's wife, gave Rauschenberg a book on the pyramids, which captivated him. Before he could make a planned trip, however, war broke out in the area. From this skein of impressions emerged his Egyptian series of sculptures, which he made in Rome, Paris, and Florida in 1973.

The Early Egyptian pieces are cardboard boxes coated with glue, then rolled in sand or wrapped in gauze like mummies and stacked like obelisks or stelaes. When properly lit, bright color painted on the back of each piece casts a soft, mysterious glow onto the wall behind it. The effect is meant to evoke the reflected sunset on the Great Pyramid at Giza or the ruined monuments in the Nile Valley.

Working with his assistants Bob Petersen and Hisachika Takahashi, Rauschenberg at the same time made an Egyptian series of drawings, or works on paper. Created from paper sacks or bits of cheesecloth on a background of handmade white paper, the drawings are actually collages. The sacks were first flattened or crumpled by running them through the press, and then attached to the paper with matte medium adhesive. Then they were whitewashed with gouache and outlined in pencil to form a central image on the paper. Sometimes a "shadow" of the sack appears in cardboard. Seen so starkly, liberated from their former context, the folds and lines of the sacks both balance the flow of the composition and are set free to be appreciated on their own.

IN 1974 Rauschenberg was invited to be a guest artist by the Israel Museum in Jerusalem, where he spent three weeks. Guided by museum curator Yona Fischer, Rauschenberg walked around the Old City, the shores of the Dead Sea, and the city of Jericho. He saw the Dead Sea Scrolls and the wrecked jeeps and tanks left from Israel's Yom Kippur War with Egypt the previous October. As when he first moved to Captiva, Rauschenberg had a hard time finding materials. He jokingly complained to Jerusalem Mayor Teddy Kollek that his city's streets were so clean that he was deprived of supplies. Ultimately, the desert itself inspired Rauschenberg's Made in Israel series.

He told Fischer that he wanted to make work with sand from each of the deserts, so he set to work. Rauschenberg shoveled white sand from the Dead Sea, pink sand from the Jericho road, and collected sand from Tel Aviv Beach and Caesarea. He picked up an old water tank, a battered ladder, a broken wheelbarrow, used tin cans, and, of course, cardboard. He brought everything to the exhibition hall, which he used as his studio.

There he worked rapidly with his assistants Petersen, Takahashi, Christine Kozlov, and Mayo Thompson to create six sculptural constructions, named for the places where he gathered sand, and five drawings (mixed medium on paper) that he called Scriptures. Fischer was amazed to see Rauschenberg and his assistants work as a team to collect materials, make spontaneous decisions about the art, and get the work done.

Even though Rauschenberg went to Israel "without preconceptions," the area was rich with meaning to him, and drew upon his quest for religious certainty. The five pieces called Scriptures, which he assembled on the museum floor, are homage to the Dead Sea Scrolls and to Israel's religious heritage. *Scripture 2* (1974) includes desert sand rubbed into paint on flattened cardboard. From a plastic streamer attached to the cardboard a rag droops to the floor. In *Scripture 3* (1974) three tin cans dangle on thin ropes from scraps of Hebrew newspapers. A transfer-printed cloth, like a shroud, haunts the upper left. *Scripture 1* (1974), made of found objects—pieces of cardboard, printed gauze and paper sacks— was stretched across the museum wall like an unfurled Torah.

Fischer and younger Israeli artists admired the work, but Rauschenberg's minimalist, abstract art puzzled and even angered many Israelis. At a discussion following the opening, he was attacked for denigrating the country by using its trash in his art. Rauschenberg responded that he always aimed "to confront people with something that might remind them of their own lives. In some way, they might look at it differently." He was asked if he had "put this water tank on show in order to show us how ugly our surroundings are?" "Who says a water tank is ugly?" he answered. "What is beautiful is in the most common things . . . I see more humanity in that water tank than in the silver [collection] in the next room, and no less beauty."

While Rauschenberg was sensitive to the tension of people living in a state of perpetual siege, he was distressed by what he perceived as the feeling of "angst" and "the sorrow and weight of the world" that seemed to pervade Israeli art. If life in Israel was so depressing, he later told Japanese art historian Yoshiaki Tono, he thought people "would want to break out of it sometimes and use art for some kind of spiritual uplift."

While he was in Israel, Rauschenberg also dined in Arab restaurants and visited Bedouin tribesmen in their tents. When he returned home to Captiva, he continued to work in the spare, white minimal mode of his Israel pieces. After returning from the Middle East in 1974, Rauschenberg continued the Early Egyptian series of sculptures. He painted more cardboard boxes with sand, including one monumental four-columned piece that echoes the temple at Abu Simbel. He also made two series of drawings: Pyramids to evoke Egypt; Tablets for Israel.

In *Pyramids* (1974), triangular white gauze strips shaped like pyramids are embedded between white handmade sheets of paper with the cloth ends hanging loosely, suggesting the loose folds of a Bedouin's white burnoose. Sheets of cardboard sandwiched between sheets of white paper in *Tablets* (1974) resemble the stone tablets held by Michelangelo's *Moses*.

BIT *(Pages and Fuses). 1974. Handmade paper with laminated screen-printed tissue (edition of 33, Gemini G.E.L.), 18½×17½"*

UNTITLED *(Early Egyptian). 1973. Acrylic and collage on paper, 70×31". Collection the artist*

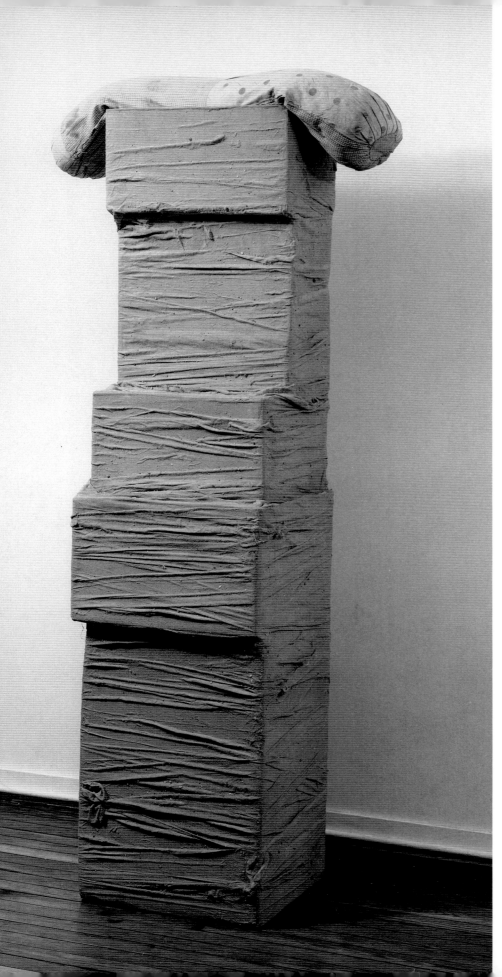

UNTITLED *(Early Egyptian). 1973. Fabric, sand, and acrylic on cardboard construction, 78 × 28 × 18½″. Private collection*

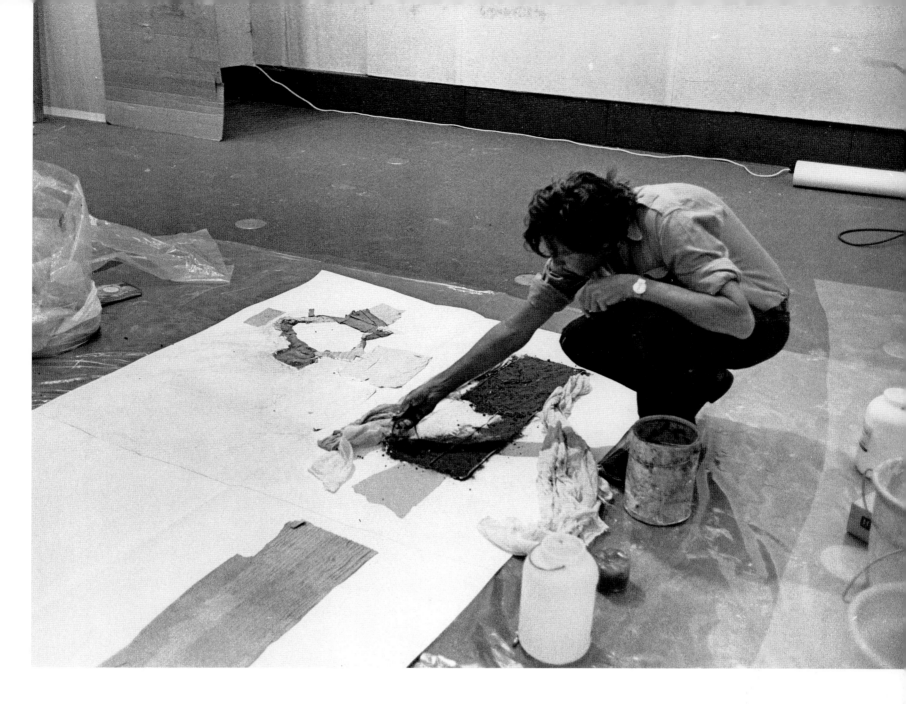

Rauschenberg, as 1974 guest artist at the Israel Museum, mixing sand and paint for a work in progress. Photograph by Nir Bareket

UNTITLED *(Scripture). 1974. Collage and graphite on fabric-laminated paper, 85×59″. Collection Peppino Agrati, Milan*

"Pyramid" works on paper, installed at the Museo d'Arte Moderna, Ca Pesaro, in Venice, 1975. Untitled sculpture in foreground.

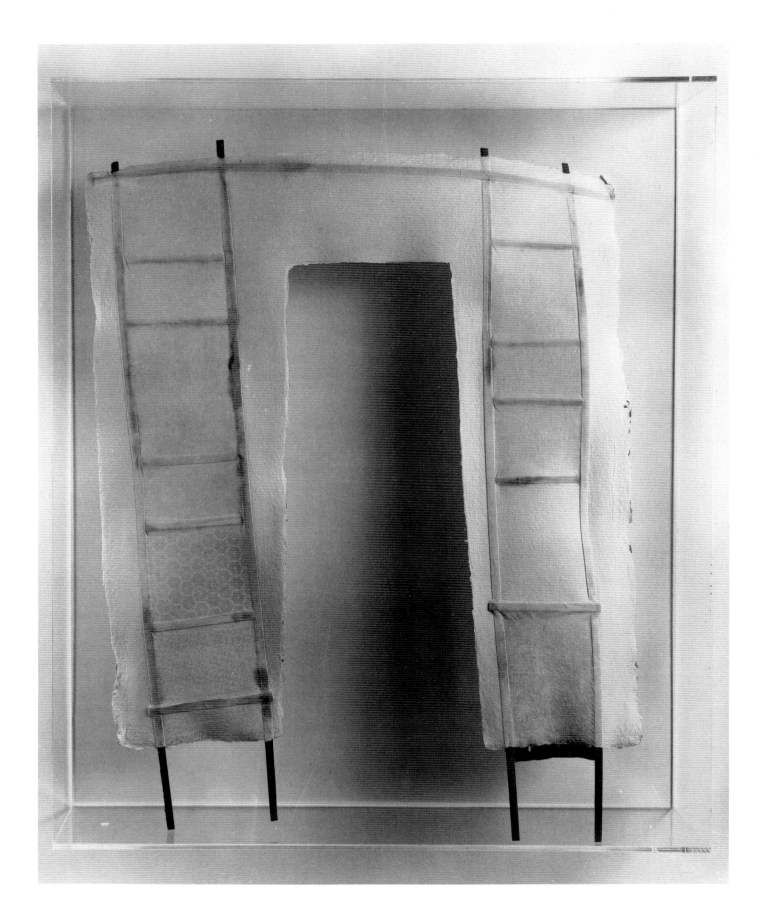

IN 1975 Rauschenberg was invited to work in a paper mill in India that had been founded by Mahatma Gandhi as an ashram for untouchables. The invitation came from the Sarabhai family, the owners of the mill in Ahmedabad, who were friends of John Cage and admirers of Rauschenberg's work. The idea, as in France, was to make art while making paper in the traditional way. The expedition was a project for Gemini G.E.L.

In Ahmedabad, Rauschenberg was struck immediately by the contrast between the conspicuous wealth of the Sarabhai family and the poverty of the several hundred mill workers who worked for them. The mill owner and his family lived in a mansion designed by Le Corbusier, set in elegant gardens with a swimming pool. It seemed a paradise, complete with monkeys, peacocks, and water buffalo decorated with spangles, but Rauschenberg was uncomfortable. He moved out of the air-conditioned studio provided for him into the mill itself to be with the workers. There he set up worktables under the trees for assembling the editions.

His first project, a series called Bones (1975), was conceived after he had watched the workers "cooking" white paper pulp mixed with rags of Egyptian cotton and after visiting the local calico mill. Rauschenberg had the workers in the ashram lash bamboo strips together to make a frame. As he described the scene, "There were ten little old ladies sitting on the floor with little strands of string, wrapping the bamboo. Over on the other side of the room there were beautiful old men with long pieces of bamboo and a sort of razor—really a string saw. They'd hold one end in their toes while they made the little supports for the papers. These people looked like they were two hundred years old, just squatting for hours and hours—all these beautiful people working in the dreadful heat."

Rauschenberg at the Gandhi Ashram in Ahmedabad, India, with Christopher Rauschenberg, Sid Felsen, and Gemini staff, 1975. Photograph by Gianfranco Gorgoni

Below: Rauschenberg in Ahmedabad, India, 1975, making a rag-mud sculpture, Ally. *Photograph by Gianfranco Gorgoni*

ALLY *(Unions Suite). 1975. "Rag-mud," with bamboo, rope, and dyed*
string (edition of 13, Gemini G.E.L.), 45 × 49 × 3½" (variable)

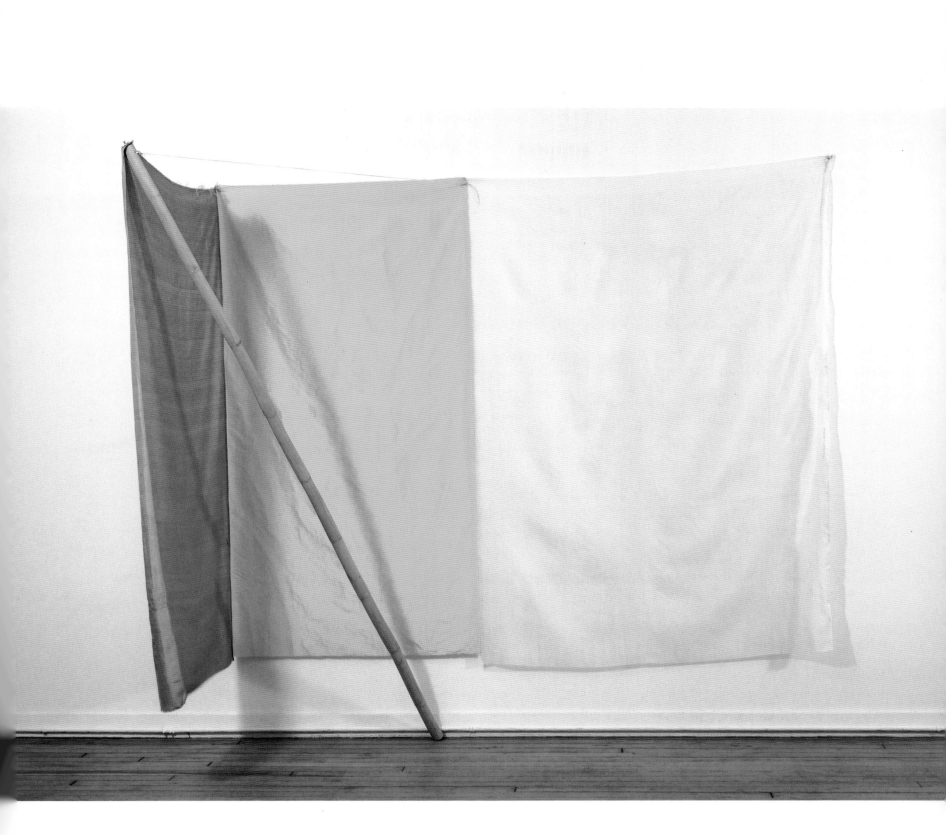

PILOT *(Jammer). 1976. Bamboo pole, sewn fabric, and string,
81×85×39". Collection the artist*

After the intricate bamboo frames were ready, Rauschenberg's crew and the workers laid pieces of patterned fabric from the calico mill on top of the bamboo in specially built wooden molds. Paper pulp was poured on top and pressed down; this trapped the bamboo latticework and fabric into the paper itself. Thus, the bamboo and fabrics were collaged into the paper and laminated at the time it was made. The result was a series of five Bones, none larger than two by three feet, in editions of twenty-eight. They looked, as Rauschenberg noted, like kites, with the bleached "bones" of the bamboo structure and the fabric colors faintly visible through the textured white paper.

His second project, Unions, involved making sculptural objects out of mud. He wanted to work with the mud used to build simple Indian houses. According to Rauschenberg, the mud itself was aesthetically interesting, and using it would be his way of paying homage to the ordinary people of India.

The mud was made from camel or cow manure, dirt, and straw. Rauschenberg thought it had "a beautiful look—very primitive." The problem was that in the rainy season the houses tended to dissolve. When that happened, "the family [would] get together and build another one," he said. "But I couldn't do that because it's *art*." He tried recipes that would make the mud more permanent. In the humid weather, however, some of his experimental mixtures began growing mold and fungus. With the help of the Sarabhai family, the Gemini staff, and workers from the mill, Rauschenberg finally devised two kinds of mud that could be fired successfully. One was made of a lightweight cardboard, coal tar, and chalk. Another included herbs. With Rauschenberg as the chief cook tossing in ingredients, a rag-mud was composed of paper pulp, fenugreek powder, ground tamarind seed, chalk powder, gum powder, and copper sulfate. Making the mud was a heady experience: the mixture produced a strong pungent curry-like aroma that lasted long after the mud had dried. (Fourteen years later the sculptures still smelled of India.)

Once the recipe was perfected, ropes purchased, and the rag-mud stirred and shaped, Rauschenberg made six prototypes for the Unions. He laid them on the long worktables outside the mill and traced them for his crew, who then made the editions. The workers stood at the tables as they shaped the mud pies, dried and baked them in the kiln, and attached decorative appendages.

The Unions present contrasts as keen as those between the Sarabhais and their workers. Bright flaps of sari fabric are juxtaposed against dark, rough mud sculptures which are as plain as the homes of the villagers. Some, such as *Capitol* (1975), were attached to strips of sari material by bamboo poles, while others had simple ropes attached, such as *Junction* (1975).

Like other artists and writers before him, Rauschenberg was deeply affected by the sensual richness and color he saw in India. "For the first time, I wasn't embarrassed by the look of beauty, of elegance," he said. "Because when you see someone who has only one rag as their property, but it happens to be beautiful and pink and silk, beauty doesn't have to be separated." In India, Rauschenberg said, he lost his fear "of something being beautiful. I've always said that you shouldn't have biases, you shouldn't have prejudices. But before that I'd never been able to use purple, because it was too beautiful."

Rauschenberg took his son, a promising photographer, to shop for fabric. "He was very excited by what he saw there," recalled Christopher. "I can see him now, rolling out bolts and bolts of sari material, each one more beautiful than the last. He was feeling the texture, just amazed at the colors. A new sense of fabric came to him there."

Just as the Red Paintings in the 1950s had liberated Rauschenberg from the "color block" he imposed upon himself in reaction to Albers, so the experience in

India liberated him from his self-imposed restraint in the use of fabric. In the ensuing years, he used shades of purple, pink, and emerald green, turquoise blue and other jewel-like colors in silks and brocades. (This new sense of color was reflected, for example, in the remaining Hoarfrosts Rauschenberg produced after his trip to India. In contrast to the earlier monochrome paintings on cheesecloth, later works in the series gave way to luxuriant, colorful fabrics.)

The most direct result of this new sense of fabric came in the Jammers (1975–79), a series of silk wall hangings. The Jammers are little more than brightly colored panels of silk held together by string and propped against the wall by long poles. Sometimes multicolored silk panels were sewn together with the precision stripes of a Gene Davis painting. Others were monochrome.

Rauschenberg is drawn to the sea, wherever he is, and the title Jammers comes from windjammer, the sailing vessel. Individual Jammers have such nautical titles as *Sea Dog, Gear, Frigate, Pilot,* and *Reef.* The constructions themselves evoke the sweep and grace of sailing ships. Jammers sailed out of the Captiva workshop like a flotilla of billowing saris. "The Jammers construction is so simple," said Rauschenberg, "that ten minutes after something *worked,* I was through with it, and it was whipped off to a sewing machine; it just had to be hung." Rauschenberg has described them simply as "large, beautiful pieces of silk, just held with the string."

"The Jammers . . . set up delicate tensions between pinned fabric and leaning poles," wrote critic Lawrence Alloway. "They are frontal but tenuous, factual but pale. Soft creases and natural edges combine with a persistent regularity, but one that flutters at the displacement of air when somebody passes . . . [they are] works in which [Rauschenberg] dropped the imagery and concentrated on the properties of fabric."

While he was making Jammers in Captiva, Rauschenberg turned out another spare, restrained edition at Graphicstudio. *Tracks* (1976), automobile tire tracks cast in clay and strengthened with fiberglass, was a sculptural reprise of the *Automobile Tire Print* that he and John Cage had made in 1951. It would be his last minimalist art for some time.

In an interview in August 1976, Rauschenberg was asked what he would do after Jammers. "I think if there is any idea I have that I could actually predict," replied the artist, "it obviously wouldn't be necessary to do it." Throughout his career Rauschenberg had indeed taken unpredictable directions. Still, after a five-year period largely devoted to working with simple materials, minimal use of color and imagery, he changed directions again, returning to the large pictures and rich imagery that were characteristic of his work prior to 1970.

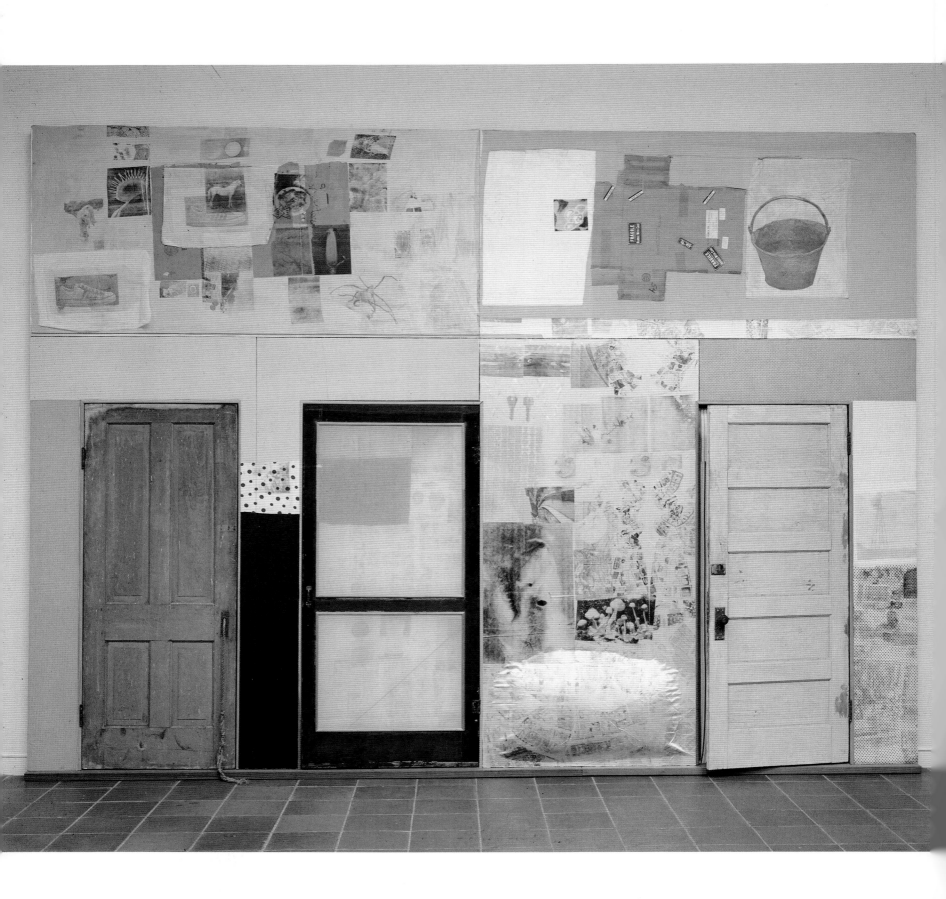

SPREADS

TO CELEBRATE the Bicentennial of American independence, the Smithsonian Institution decided to honor a living American artist with a solo exhibition. After considerable debate, Rauschenberg was chosen. "We are pleased to be able to salute the fresh store of creative energy, surprise and wonder that Robert Rauschenberg has bestowed on American art," said Joshua C. Taylor, director of the Smithsonian's National Collection of Fine Arts, as he introduced the exhibition in October 1976.

The exhibit, displaying one hundred fifty-seven works created between 1951 and 1976, was the largest Rauschenberg retrospective to date. *Rodeo Palace* (1975–76), the newest work in the show, and the first that viewers saw, showed that he was still full of surprises. After five years of making mostly austere, minimalist art, he had returned with *Rodeo Palace* to the size and complexity of his earlier combines and large silkscreen paintings.

Standing twelve feet high and sixteen feet wide, *Rodeo Palace* looks like a stage set. It contains three rough-hewn doors that open and close. One wooden door opens to reveal simple blue-and-white-striped mattress ticking. Behind another, shiny silks and satins are transfer-printed with the Sunday comics and magazine pictures. The third door opens to a strip of red satin densely printed with imagery in the style of the Hoarfrost series. Beside the center door a white satin rectangle with a pillow embedded near the bottom is in the style of some of the combines of the 1950s. The contrast between rough wood and sleek satin creates a dynamic tension in the painting. "Rural opulence," Rauschenberg has called it.

The painting had been commissioned by the Fort Worth Art Museum for its celebration of the Bicentennial. The theme was the Great American Rodeo. At first, Rauschenberg was reluctant to tailor a work to such a specific charge, but eventually he decided to take on the challenge. Instead of depicting the rodeo itself, he set out to convey the tawdry glamour of a rodeo performer's life.

For Rauschenberg, at the age of fifty, *Rodeo Palace* was a breakthrough, celebrating his roots in images as straightforward and homely as those in the old combines. The references to the West include horses, cactus, and an oil derrick. At the top of the painting's six panels, on a surface painted in opalescent peach, is a picture of an ordinary bucket, like the kind used to water horses. In the end, Rauschenberg did not just confine *Rodeo Palace* to rodeos or the old West. Through his joyous, random-order imagery, Rauschenberg once again became the reporter of past and present. Buried in the iconography are references to popular entertainment, ranging from fabric worn by Marilyn Monroe and Montgomery Clift's characters in the film *The Misfits*, to the shark in the recent movie *Jaws*.

In *ARTnews*, Benjamin Forgey described the painting as "a huge compendium piece, like a travelogue of Rauschenberg's own amazing journey. . . . "

Since the 1950s combines, Rauschenberg had made few obvious references to Texas in his work. In *Rodeo Palace*, he came home again. "I think the reason *Rodeo Palace* turned out to be a great piece is that it took him back to where he came from," said Richard Koshalek, director of the Museum of Contemporary Art (MOCA) in Los Angeles. "His experience of Texas was one of isolation. There's a loneliness in *Rodeo Palace*, the loneliness of inexpensive, tacky motels, the loneliness you feel in Texas."

Rodeo Palace was the first of what turned out to be a major series of several dozen large paintings and floor-standing pieces that Rauschenberg called Spreads and Scales. These new works were shaped by his own response to the Smithsonian retrospective, where he saw many of his older paintings for the first time since he had made them.

IN 1973, Walter Hopps, then curator of twentieth-century painting and sculpture at the National Collection of Fine Arts (now known as the National Museum of American Art), had suggested to director Joshua Taylor that Rauschenberg should be chosen for the nation's bicentennial exhibition. Hopps felt that Rauschenberg's range of materials, techniques, and experimentation exemplified American ingenuity. "The program should celebrate life and vision," he told Taylor. "What you want is an artist who is also a great citizen, who is engaged in the political dialogue and discourse, takes public stands, is a benefactor and philanthropist, who believes not only in his own art, but in the fate and lives of other artists, and has invested in them."

There were bureaucratic hurdles to be overcome. Rauschenberg was controversial, from both the artistic and political points of view. But despite the ingrained caution of a government institution and the conservative bent of the Nixon Administration, versus the outspoken liberal activism of Robert Rauschenberg, Taylor finally agreed to name him.

In preparation for the exhibition, Hopps spent many hours with Rauschenberg in his Florida studio, watching the creation of *Rodeo Palace* and other works. "There's an extraordinary flow of new work coming out of Captiva," he reported to Taylor. "It's as though he's gone back to the special waters and flowerings of his roots on the Gulf Coast, but in a new and triumphant way."

Rauschenberg brought his son, Christopher, and a band of assistants and friends to Washington to install the show. Their freewheeling style and night-owl habits were ill-suited to the bureaucratic rigidity of a government museum. "It was like an Indian tribe and a bunch of their cowboy friends moving in on an encampment," said Hopps. As Hopps has described it, the cigarettes and Jack Daniel's in the gallery night after night upset museum administrators greatly until they realized that Rauschenberg and his crew were the only people who could handle and install the eccentric works of art. They worked through the night painting pedestals, building walls, and repairing torn silk on the combines.

Beginning with *Rodeo Palace*, the installation moved the viewer back in time through Rauschenberg's career, from Jammers and Hoarfrosts through the somber Venetian and Egyptian pieces, the painterly canvases of the 1960s and the silkscreen paintings that followed, to the combines, Red, Black, and White Paintings, little fetish-boxes and blueprints of the early 1950s. An entire room was devoted to his prints and a wall to his photographs.

The exhibition was a triumph. As it moved to the Museum of Modern Art in New York, the San Francisco Museum of Art, the Albright-Knox Art Gallery in Buffalo, and the Chicago Art Institute during 1977 and early 1978, critics echoed

the praise of Benjamin Forgey in *ARTnews:* "This show strongly suggests that Rauschenberg is one of the giant artists of our century. . . . The exhibition proves that Rauschenberg's work, in all its formal, technical, metaphysical and iconographical variety, encompasses a range of human experience that no other artist of our time has dared to take on." In *Newsweek*, Douglas Davis wrote that "for sheer energy—artistic and social—he is probably without peer in the art world. Indeed, Rauschenberg's only serious flaw may be that his is an art impossible to follow." John Russell said in *The New York Times* that "some of the finest art that has been made in our lifetime can be seen in the Robert Rauschenberg retrospective."

Time magazine put Rauschenberg on its cover (he was the first living American artist to be so featured), having also commissioned him to design it. Even the cover was a mini-retrospective. Rauschenberg chose *Winter Pool, Charlene, Bed,* a Gulf of Mexico sunset, and a snapshot of himself braiding Christopher's long hair. In the article, "The Most Living Artist," Robert Hughes wrote, "With his anarchic sweetness and prodigal talent, Robert Rauschenberg has for . . . twenty-five years been the *enfant terrible* of American modernism . . . he is a model of the joy of art. . . . It is to him that is owed much of the basic cultural assumption that a work of art can exist for any length of time, in any material (from a stuffed goat to a live human body), anywhere (on a stage, in front of a television camera, underwater, on the surface of the moon or in a sealed envelope), for any purpose (turn-on, contemplation, amusement, invocation, threat) and any destination it chooses, from the museum to the trash can. 'A protean genius,' Art Historian Robert Rosenblum calls him. 'Every artist after 1960 who challenged the restrictions of painting and sculpture and believed that all of life was open to art is indebted to Rauschenberg—forever.'"

A major dissent came from Harold Rosenberg, the art critic of *The New Yorker*, and a champion of the original New York School of Abstract Expressionists. Rosenberg's complaint was that Rauschenberg had failed to acknowledge artistic influences on his work—including Albers, Schwitters, Dada, the Abstract Expressionists, and commercial photomontage—claiming instead that his pictures were uniquely his own creation. Rather than being a spontaneous original, said Rosenberg, "Rauschenberg has been in and of the art world; he is an art-world wit, attuned and responding to prevailing opinions and phases of taste. . . . There is nothing discreditable in his role of Mannerist of postwar American vanguardism. But his performance has been anything but playful, particularly in disengaging himself from artists to whom his work is indebted."

WHILE HE WAS pleased to read the adulatory reviews, Rauschenberg was determined that the praise not affect his work. His solution was to head back to his Florida hideaway and plunge himself into his new painting. Rauschenberg said that the retrospective had opened up "autobiographical feelings" in him, bringing back the "passions and nostalgia" that he had felt in making the art. Old styles, material, and images consciously influenced his two new series, Spreads and Scales.

In beginning the big, densely printed Spreads, Rauschenberg also followed his old pattern of alternating between simplicity and complexity. After the austerity of the Jammers and Cardboards, he said, he was ready for the "excesses" of the new work. Because it began with *Rodeo Palace*, he named the series Spreads, both as a reference to the wide open range of the Texas ranch, and because the big pictures spread out across a wall.

Rauschenberg and his son, Christopher, at the Museum of Modern Art's opening of the 1977 retrospective of his work. Photograph by Helaine Messer

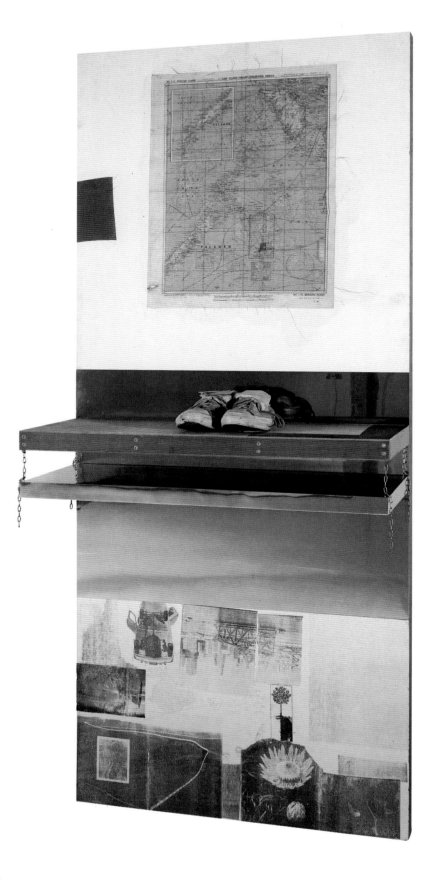

EMERALD CARRIER *(Spread). 1978. Solvent transfer and collage on plywood panels with objects, 84×36×16¼". Private collection*

CORINTHIAN COVET *(Spread). 1980. Solvent transfer and collage on plywood panels with objects, 84 × 185 × 19". Collection Robert and Jane Meyerhoff*

The Spreads, laid out in gridlike, usually rectangular patterns, refer back to Rauschenberg's silkscreen paintings in that they are filled with colorful imagery from magazines. He plucked disparate images from the media, juxtaposing them in ways that have more to do with composition than narrative. The method was transfer-printing, using the enormous weight of Grasshopper—eight hundred pounds of pressure per square inch. The magazine images were placed face down on the flatbed, squirted with solvent, and then pressed onto extra-fine, smooth-weave canvas or a swatch from Rauschenberg's storeroom of found fabrics. The canvas or fabric had been laminated onto mahogany panels by using matte medium (an acrylic) adhesive and iron-on heat glue. In the workshop underneath the painting studio, found objects were nailed, riveted, screwed, or glued onto the surface. Sometimes a piece was wired for lights, or, as in *Sea Cow Treaty*, fitted for plumbing. Twin faucets attached to the surface of the painting pour red and blue liquid into twin buckets.

Nearly every Spread has some eccentricity of shape. Panels jut out from the background, carrying images and objects into the viewer's space. The paintings feature images of animals, flowers and other plants, along with athletes, planets, maps, children of all cultures, and the wonders of technology. The colors reflect the atmosphere around Captiva—muted Gulf-blues and palm-greens, accents of bright yellow and scarlet. A feature of Spreads is Rauschenberg's frequent use of twin images: telephones, piano keyboards, propellers. Some had drainpipes, gutters, or pails attached, "to contain the excesses," he joked.

One of the conscious echoes of earlier works that Rauschenberg said he "gave himself permission to use again" is the tire in *Monogram* (1955–59). It appears in *Hog Heaven* (1978), attached to the painting by a two-by-four board extending out on the floor, into the room. *Hog Heaven* is a Scale, the sculptural part of the series. The inside of the tire is filled with printed imagery. On the painting itself, the colorful imagery includes a picture of a bearded patriarch, much like a frowning Claude Monet, framed on both sides by a McDonald's Big Mac burger.

The parasol of *Charlene* (1954) reappears in the middle of *Musical Mollusk* (1978). This diaphanous white umbrella, more than seven feet in diameter, is covered with hazy, transfer-printed images. The ladder that connected two panels of the combine *Winter Pool* (1959) returns in *Caucus* (1980), this time leaning against the Spread painting with two buckets hanging from its rungs. Echoes of "the man in the white shoes" in the 1955 combine *Untitled* can be found in *Emerald Carrier*, a 1978 Spread in which a pair of battered white tennis shoes (left behind in Captiva by Rauschenberg's nephew, Rick Begneaud) sits on a platform below a cloth map of the South China Sea. In *Corinthian Covet* (1980), Rauschenberg used a patchwork quilt, as he had in *Bed* (1955).

Rauschenberg's return to imagery and to large combine-like paintings was hailed by some reviewers. "In recent years this artist has left everything out, the Jammers being the prime example. . . ." wrote critic William Zimmer. "[In Spreads and Scales] Rauschenberg has put everything in again. Replacing the raucous gestural passages that mark his early work are tighter passages, surely informed by the elegant geometry of the Jammers. Although there is once again a lot going on, it is cleaner. The whole earth catalogue, from arcane imagery to very public signs, is back and actual pendant objects reappear—a rubber raft, chairs, tires, electric lights."

Other critics found the series disappointing. His self-teasing anthology of past techniques and images met with less than enthusiasm from Grace Glueck of *The New York Times*. In reviewing several Spread paintings, she commented that there was "nothing new about the images. . . ." For Roger Cranshaw, writing in *Artscribe*, Rauschenberg's use in the Spreads of objects such as the tire "be-

comes self-parody rather than the fresh rebirth of old images . . . a nose dive instead of rising from the ashes."

Rauschenberg considered that the dense imagery and references to his earlier art in Spreads were well-earned indulgences—"my present to me." The series engaged him for five years, one of his most prolific periods. In all, he created more than fifty-two Spreads and thirteen Scales between 1975 and 1981. As the series developed, it became more sophisticated in layout and less autobiographical in imagery. Found objects such as chain links and airport windsocks joined the more familiar stock of old wooden chairs, washboards, ladders, and buckets that evoked rural Texas in the Spreads and Scales. Sheets of transparent colored acrylic and colored Plexiglas mirrors entered his store of materials in the series; concealed neon and other kinds of electric lighting gave most of the new Spreads a colorful glow. Many of the works were architectural, with three-dimensional triangular shapes used as surfaces for the printed panels. The compositions became more formal, the rectangular arrangement of images laid out, according to John Cage, like the compositions of Mondrian. The imagery itself was more exotic, with pictures gleaned from *Soviet Life* and other foreign magazines, but it still is a record of the world as Rauschenberg sees it. "For many years to come, people will be identifying the various levels of personal subtext—a great portion of which is quite conscious on Bob's part—in his work," said Walter Hopps.

Not surprisingly, the Spreads were more successful commercially than the Cardboards. The widespread and generally favorable publicity following the 1976 Smithsonian retrospective had contributed to a rise not only in the value of Rauschenberg's older paintings but in the prices he could command for new ones. He received $200,000 for *Bank Job* (1980), a Spread painting commissioned by the Equitable Trust Company of Baltimore for the lobby of its new building, and $100,000 for *Periwinkle Shaft*, a complex mirrored mural commissioned for Children's Hospital in Washington, D.C. In this painting, filled with horses and lizards, red lights, fun-house mirrors, and a large stuffed purple fish, Rauschenberg's aim was to entertain sick children as they traveled up and down a moving staircase in the hospital.

Rauschenberg's next series, called Kabal American Zephyr, grew out of Spreads and Scales. Through the juxtaposition of found objects and printed imagery Rauschenberg set out to depict a surreal and mysterious world. He called it "fantasy-macabre." The inspiration for the Kabals came from the work of the nineteenth-century Japanese woodblock printmaker Tsukioka Yoshitoshi. In 1980, Rauschenberg had seen an exhibition of "The Bizarre Imagery of Yoshitoshi" at the Los Angeles County Museum of Art. He found the imagery brutal, erotic, and bizarre indeed. In Yoshitoshi's prints, violent events take place in an exquisite world of brilliant colors, elegant silk kimonos, and Japanese gardens. Rauschenberg was haunted by the titles: *Twenty Eight Famous Murders with Poems, The Ancient Incident, The Wicked Thoughts of the Priest.*

Yoshitoshi's chilling use of the supernatural and his anomalous imagery challenged Rauschenberg's imagination. The title was intended to give the series its own inscrutable flavor. "Kabal" hinted at a secret conspiracy; "American" referred to the essence of his own work; "Zephyr," a gentle breeze, was also the brand name of a beloved bicycle in his youth. The pieces, however, were Oriental in inspiration only.

While the imagery was transfer-printed, like the Spreads, Rauschenberg made the Kabals more three-dimensional and he emphasized found objects more than he had in Spreads. The shoes, ladders, or lanterns of Spreads usually accented the printed panels; in Kabals, the objects were more prominent, often dominating the work.

TOADY ENTERPRISE *(Scale). 1980. Solvent transfer, acrylic, and collage on plywood panels, 80 × 108 × 28″. Collection the artist. Usually three-dimensional floor-standing pieces, Scales are more sculptural than Spreads. An exception is this wall piece that sweeps down and curves forward onto the floor.*

SNOWBERRY FUDGE *(Spread). 1980. Solvent transfer, acrylic, and collage on plywood panels with objects, 95¾ × 126½ × 26". Private collection*

Rauschenberg attempted to translate Yoshitoshi's brutally incongruous juxtapositions into an American idiom, even though he appropriated Yoshitoshi's titles. In Yoshitoshi's woodblock *The Ancient Incident*, a slave dealer confronts a frightened boy beneath the cherry blossoms on the banks of the Sumida River. Rauschenberg's *The Ancient Incident* is a pyramid of two sets of rough wooden stairs with two wooden captain's chairs facing each other at the top. In Rauschenberg's *The Interloper Tries His Disguises* (1982), a mutilated old tire tread is stretched out against a painting containing a collage of silky imagery, and then curves out onto the floor. In *The Lurid Attack of the Monsters from the Postal News* (1981), a line of razor-sharp timber saws are arranged menacingly on an image-encrusted rectangular box, which sits like a seesaw on a pair of iron wheels.

As he made the works in the series, Rauschenberg began making up his own titles. One of his favorite Kabals is *Pegasus' First Visit to America in the Shade of the Flatiron Building* (1982). The piece is about the discovery of America by the mythical Pegasus, as Rauschenberg has explained. "I figured that Pegasus would be interested in not just 'flying' things on his first trip to America, but also in science. I also like the idea of 'Made in Great Britain,'" he added, noting a sign on a flattened cardboard box affixed to the work above the flag. This clue about America's British ancestry amused Rauschenberg. "I can indulge, as eccentrically as I please, and be perfectly right—being as how it's my work."

The Kabal series is made up of "highly disparate parts joined in unusual and often very erotic ways," wrote Linda L. Cathcart, curator of the Contemporary Arts Museum in Houston, Texas, where some of the works were exhibited. "The whole experience of the work is one of unexpectedness, yet it suggests with great accuracy the emotional quality of our world."

In Spreads and Kabal American Zephyr, Rauschenberg deliberately reached back into his past for material, although he used it very differently in each series. As he told art critic Yoshiaki Tono, "I would love for my work to have the early crudeness, but I'm not going to affect it. That's one of the reasons that I change materials so often—and locations." In addition to its references to Rauschenberg's earlier work, the Spreads offer a cosmopolitan chronicle of the 1970s, while the Kabals represent his lifelong fascination with mysticism.

RAUSCHENBERG'S interest in the mystical had always coincided with his involvement in spiritual subjects. In 1978, like many artists before him, he was inspired to make art based on the Stations of the Cross. His was a sculptural edition of seven works called Publicons (1978), made with Gemini G.E.L. (To emphasize that his are not the traditional Stations, Rauschenberg made exactly half the number of pieces as are in the fourteen Stations of the Cross.)

Publicons deal symbolically with "the matter of spirituality—or lack of it—in contemporary culture," according to Ruth Fine. In their resemblance to Renaissance altarpieces, they are "icons"; because Rauschenberg and the Gemini crew constructed them so viewers can push, pull, open and close them, they are also "public." The Publicons are boxes that open to reveal an enshrined object. Rauschenberg made the prototypes for Publicons in his Captiva studio, and the edition of thirty was built in Gemini's Los Angeles workshop.

PUBLICON/STATION I *1978. Wood construction with collage and objects, (edition of 30, Gemini G.E.L.), closed: 59 × 30 × 12", expands to 59 × 58 × 12"*

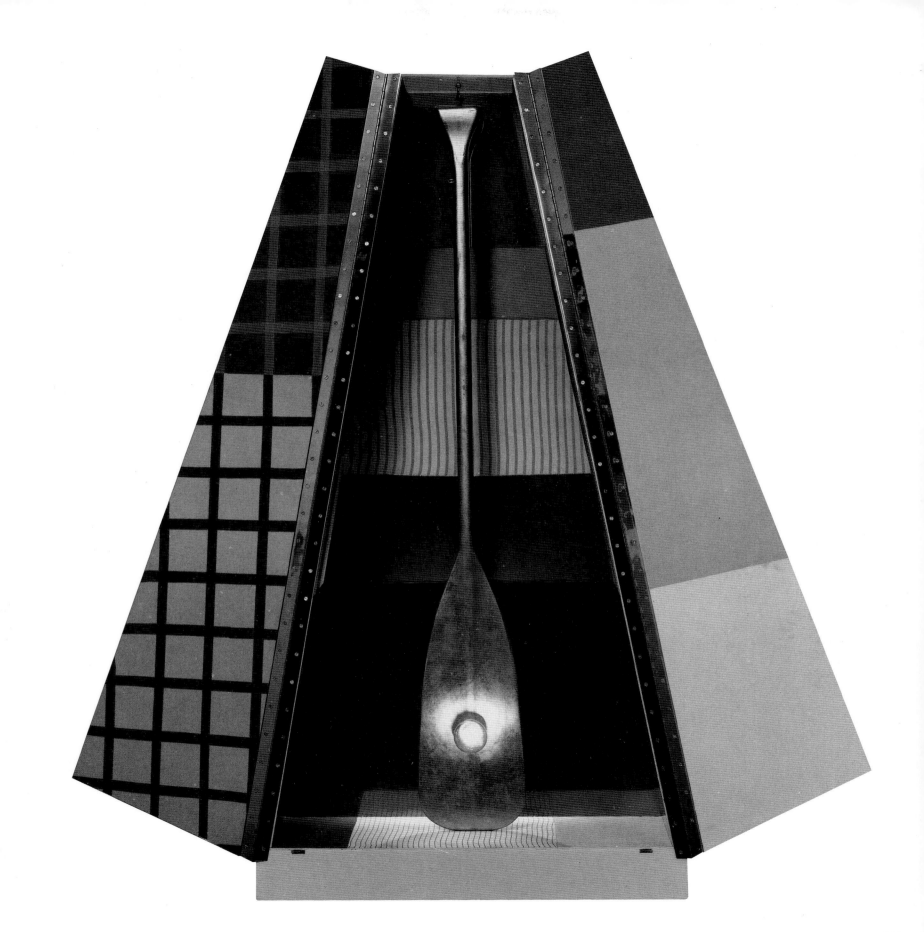

Rauschenberg in his Captiva, Florida, studio making Bank Job *(1979), a Spread commissioned for the lobby of the Equitable Trust Company, a Baltimore bank. The materials used are solvent transfer, acrylic, and collage on plywood construction; final dimensions are 130×356×30". Pictured in last three frames is Terry Van Brunt. Photograph by Terry Van Brunt*

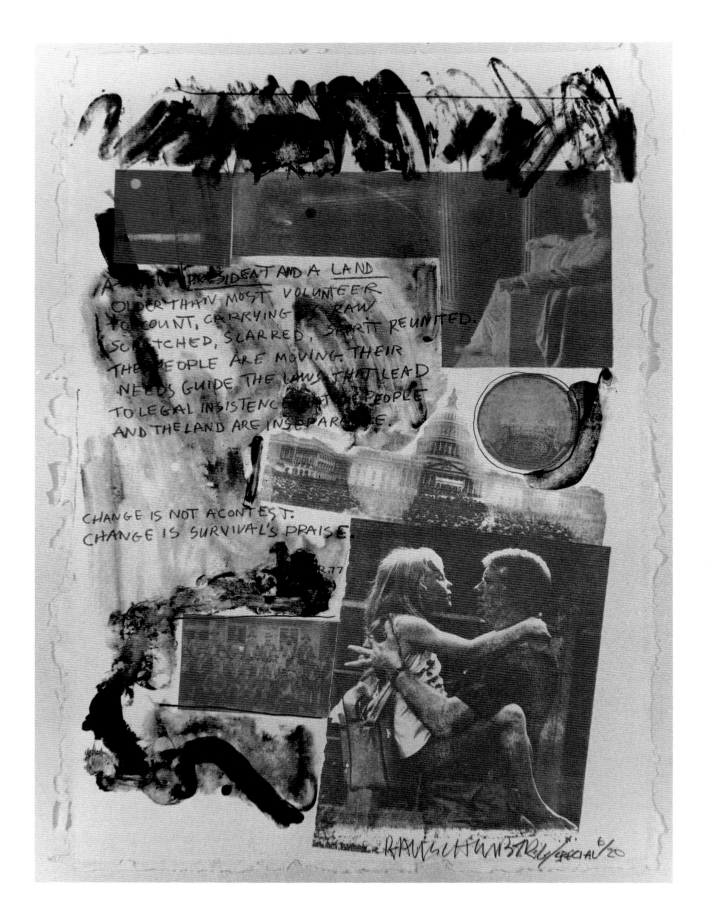

A NEW PRESIDENT AND A LAND
OLDER THAN MOST VOLUNTEER
YOCOUNT, CARRYING RAW
SCRATCHED, SCARRED, SPIRIT REUNITED.
THE PEOPLE ARE MOVING. THEIR
NEEDS GUIDE THE LAWS THAT LEAD
TO LEGAL INSISTENCE THAT THE PEOPLE
AND THE LAND ARE INSEPARABLE.

CHANGE IS NOT A CONTEST.
CHANGE IS SURVIVAL'S PRAISE.

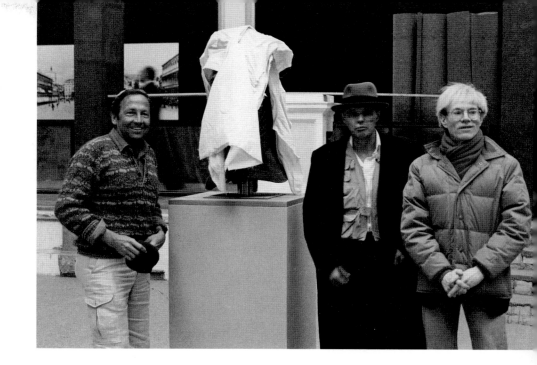

In the late 1970s and early 1980s, Rauschenberg continued to be involved in projects outside the studio. A tax reform law aimed at politicians who took huge deductions for gifts of their papers was clearly hurting artists. Under the 1969 law, artists and writers could only deduct the cost of materials used in their work—cameras, paint, or in Rauschenberg's case, old cardboard boxes. The museum community was understandably alarmed; artists felt they were being penalized unfairly. Along with artist James Rosenquist and accountant/arts advocate Rubin Gorewitz, Rauschenberg lobbied on Capitol Hill and around the country for a provision that would allow artists to take tax deductions for donating their works to museums and other nonprofit institutions. He also continued an unsuccessful congressional campaign for a law ordering resale royalties for artists when their works were sold by secondary owners, by dealers, or at auction.

Rauschenberg had ventured back to politics, contributing a print to President Jimmy Carter's 1977 Inaugural Portfolio. And he found a ready advocate on tax reform in Joan Mondale, the vice president's wife, whom Carter designated as Ambassador to the Arts. (She had used Rauschenberg's print *Signs* as the cover image for her book, *Art in Politics*.) Rauschenberg also supported senators Edward Kennedy of Massachusetts and Howard Metzenbaum of Ohio, and advised them on federal arts policy. He was in Washington frequently, meeting with senators in the Capitol, and presenting testimony to Congressional committees.

After a ten-year hiatus, Rauschenberg also ventured back into the world of performance. In 1976, Merce Cunningham asked him to design the set and costumes for a new dance, *Travelogue*, for which John Cage was composing the music. The three old friends had healed their rift.

Remembering the effect of the parachute-on-skates in *Pelican* (1963), Rauschenberg made silk panels that hung like skirts between the dancers' legs, and opened into multicolored circles which they held up as high as their heads. When Cunningham's *Travelogue* premiered at the Minskoff Theatre in New York, January 18, 1977, Rauschenberg's sets of huge silk banners floated from the ceiling like Jammers.

GLACIAL DECOY (ETCHING III) *1979. Etching (edition of 22, ULAE), 24¾" × 16¾". Images from in and around Fort Myers, Florida, photographed for a stage set for the Trisha Brown Dance Company, led Rauschenberg back to his own photography, which was incorporated in this print.*

YARDARM *(Rookery Mounds). 1979. Lithograph (edition of 53, Gemini G.E.L.), 41 × 31". Made from Rauschenberg photographs taken in Fort Myers, Florida.*

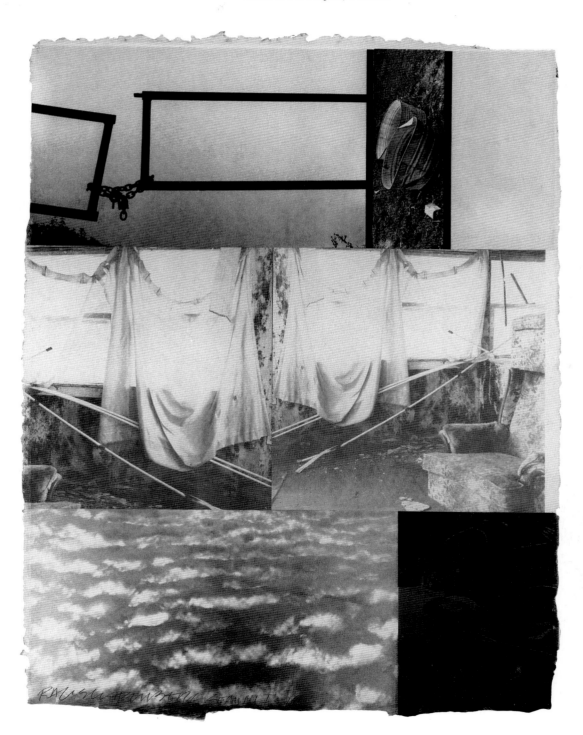

PEGASUS' FIRST VISIT TO AMERICA IN THE SHADE OF THE FLATIRON BUILDING
(Kabal American Zephyr). 1982. Solvent transfer, acrylic, and collage on plywood and aluminum with objects, 96½ × 133½ × 22½". Collection the artist. Rauschenberg's imagery is based on a whimsical impulse: how best to educate a mythical flying horse about contemporary America. (A prominent image of New York's Flatiron Building is printed on the panel behind the American flag.)

28 FAMOUS MURDERS WITH POEMS *(Kabal American Zephyr). 1981.*
Solvent transfer, acrylic, and Plexiglas on wood construction,
93 × 94 × 94" overall (diameter of circular wooden structure is 92½").
Private collection. Inspired by Yoshitoshi's art of the same name,
Rauschenberg's "murders" include imagery of the martyred Martin
Luther King, Jr., and other references to violence, such as boxing.
The circle is formed by two old half-circle windows.

ALTAR OF THE INFINITE LOTTERY WINNER *(Kabal American Zephyr).*
1981. Solvent transfer, acrylic, and collage on table, with objects,
46½ × 40½ × 23¾". Private collection, New York. Unusual jux-
tapositions of unexpected objects, often the roughest with the most
delicate, characterize the Kabal American Zephyr series.

The next year, Rauschenberg designed a set and costumes for Trisha Brown, a friend since the Judson Theater days, who had formed her own dance company. For her new dance, *Glacial Decoy*, first performed at Marymount Manhattan College Theatre in 1978, Rauschenberg designed white, diaphanous gowns with wide, winglike sleeves which enhanced the dancers' flowing movement. The sets were a stark contrast. Four floor-to-ceiling screens stood at the rear of the stage. Cameras projected onto the screens hundreds of black-and-white photographs, such as a cow, an ice vendor's sign, a palm tree, a zinc tub, a freight car. Each screen contained a different image and each image progressed from left to right from screen to screen. The clicking sounds of the light projectors as the slides changed was the "music" for the dance.

Rauschenberg had taken the pictures for *Glacial Decoy* in and around Fort Myers, Florida. "I became addicted [to photography] again," he said. After the decision early in his career to forego photography for painting, he now was drawn back to the camera both as a tool for adding images to his art, and as a tool to create art. "It [the camera] had heightened my desire to look," he explained. "The constant survey of changing light and shadows sharpens all of the awarenesses necessary not only to make photographs, but functions as fertilizer to promote growth and change in any artistic style. . . ."

Rauschenberg recycled the *Glacial Decoy* images in a set of photo etchings and a suite of lithographs of the same name, both published by ULAE, and in a series of lithographs at Gemini G.E.L. called Rookery Mounds. His son, Christopher, now the proprietor of a photography studio, Blue Sky Gallery in Portland, Oregon, encouraged Rauschenberg in his new photographic work. For his photography, Rauschenberg had a new assistant, Terry Van Brunt. (Van Brunt had a 1960s commune and a nightclub in Florida before going off to Japan to study acupuncture. While there, he was surprised to see on the cover of *Time* in 1976 a photograph of Rauschenberg that he had made on a visit to Captiva. Soon after, Van Brunt accepted an invitation from Rauschenberg to help make art in Captiva. His skills in photography, video, and electronics were soon put to good use.

At Black Mountain College in 1949, Rauschenberg had declared that he wanted to photograph the United States "inch by inch, foot by foot." In 1980, he and Van Brunt set out on a modified mission—to photograph it city by city. He had bought an antique touring car, a 1936 Ford Phaeton, in New York that spring and decided to drive it to Florida. From New York to Atlantic City, Baltimore, Charleston, and Savannah, Rauschenberg supplemented his store of Fort Myers photographs with a larger view of America. "Most days Terry and I didn't travel more than forty miles," he said. "The car being open afforded me maximum visibility," he said, and in the cities, he and Van Brunt explored alleys and byways on foot. Rauschenberg was looking for neither regional character nor municipal uniqueness, but rather for small scenes or details. Among the results was the rear half of an old bicycle on a New York street; twin urinals against a tile wall in Charleston; a plastic-covered Santa doll in Baltimore.

The black-and-white pictures were shown in a major exhibition in April 1981 at the Centre Pompidou in Paris, and published in a book, *Rauschenberg Photographs*, the same year. He and Van Brunt subsequently traveled to Boston, Los Angeles, and elsewhere for Rauschenberg's series *In + Out City Limits*. Photographs were made and shown in each of the appropriate cities: Fort Myers, Charleston, S.C., Baltimore, Boston, New York, and Los Angeles. Books of the photographs were published for the Boston and New York shows.

UNTITLED *(Charleston). 1980. Photograph.. From a series of photographs of American cities.*

Rauschenberg at his New York residence, with Agathe Gonnet, January 1981, preparing a scale model of his photography exhibition at the Centre Pompidou, Paris, which was to open that April. Photograph by Terry Van Brunt

"The photographs of *In + Out City Limits* make no attempt to flatly document, moralize, or editorialize the specific locations," he wrote. "They are a collection of selected provocative facts (at least to me) that are the results of my happening to be there." In Boston, for example, Rauschenberg recorded architectural details with equal regard for the humble and the grand.

Writing in *Artweek*, Mark Johnstone compared Rauschenberg's photography to that made by Walker Evans and Robert Frank: "There is attention to surfaces, evidence of the many ethnic ghettos, signs of widely differing lifestyles, ironic and humorous visual juxtapositions—in short, all the characteristics producing an ephemeral sense of moving through the landscape."

Andy Grundberg in *The New York Times Magazine* compared the work to that of Laszlo Moholy-Nagy's: "The photographs . . . are most remarkable for their acceptance of, and interest in, the optical—that is, the ways in which space is altered by a camera's built-in system of perspective and by the film's rendering of light and shade. . . . By using photographic imagery with a free hand over the years, Rauschenberg created a style that is revolutionary in terms of both painting and photography. Now, by presenting his photographs without embellishment, he quietly asserts that his signature as an artist is centered not in his hand but in his eye." Grundberg pointed out that Rauschenberg is able to see the world itself as a collage. "He photographs in such a way—directly, yet so as to render scale and perspective ambiguous—that physical objects seem flattened and pasted next to each other. When he photographs a goose walking next to an

automobile, he not only points to a similarity of form between the bird's neck and the car's tire, but also manages to make the goose look like a decal whimsically attached to the picture plane."

From Rauschenberg's store of photographs came two other series. His etchings in Razorback Bunch (1981) contain scenes from the countryside, mailboxes, and automobile tires used to decorate a lawn. At Gemini he turned the photographs into a series of lithographs called Snowflake Crimes (1982). Photems (1981) is a series of photo assemblage. The images were laid out edge to edge so that they complement and butt together like flattened totems.

Rauschenberg collaborated with author William Burroughs on a series of six Gemini lithographs, American Pewter with Burroughs (1981–82), which he made and proofed on Little Janis in his Captiva studio. (Gemini sent nineteen lithographic stones to Florida, along with two printers.) Each of Burroughs's phrases ("The Sky Is Thin As Paper Here," for example) is embossed on the paper and surrounded by Rauschenberg's photographs.

From the *Rodeo Palace* of Fort Worth to the photography at Fort Myers, the late 1970s and early 1980s was an unusually fertile period for Rauschenberg. Even his various collaborators were astonished at his ability to juggle so many different projects. His creative energy seemed boundless. While continuing to expand his "palette," as he called his whole range of materials and sources, he began to reach still further into his own life for his imagery.

Rauschenberg and Terry Van Brunt laying out photographs for a Photems collage in the artist's Captiva studio, 1981. Photograph by Emil Fray

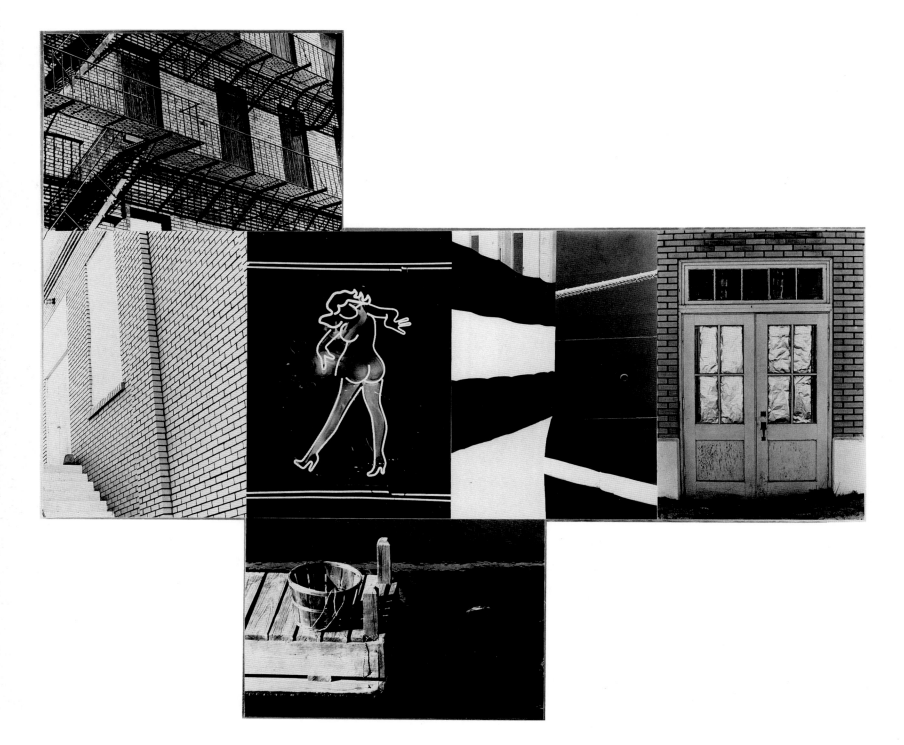

PHOTEM SERIES I *#9 Photo collage on aluminum, 99 × 23¼". Collection the artist*

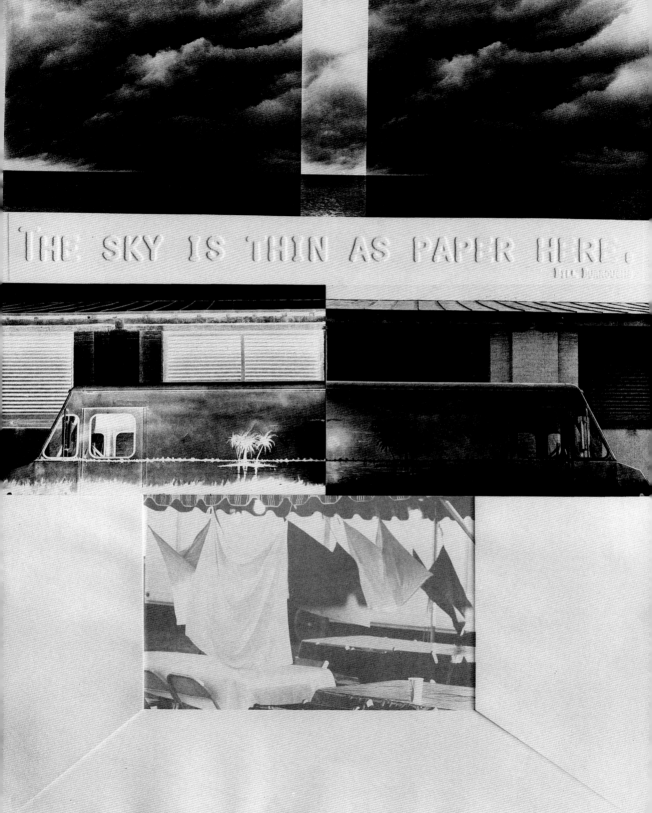

THE SKY IS THIN AS PAPER HERE.

SALVAGE

GOSPEL YODEL (Salvage). 1984. Acrylic on canvas, 81½ × 118". The Oliver-Hoffman Collection. Images were salvaged from Rauschenberg photographs made during his international travels for ROCI.

WHEN TRISHA BROWN approached him in 1983 to collaborate again on a major dance project, Rauschenberg responded with an elaborate and unusual stage set—*Elastic Carrier: Shiner*, a thirty-six-by-eleven-foot freestanding construction for Brown's *Set and Reset*, which was first presented at the New York City Center that fall.

The stage was dominated by two silvery fabric-covered pyramids flanking a rectangular box. As the theater darkened, the geometric forms rose slowly above the stage to become translucent screens onto which black-and-white films were projected. (The films were made from old newsreels, television comedies, and NASA footage.) From the orchestra pit, Dickie Landry played jazz on an alto saxophone while Laurie Anderson whispered the song "Long Time No See" to the accompaniment of electronic percussion. Trisha Brown made her entrance by walking on the rear wall of the stage while being held aloft by four other dancers.

Rauschenberg also designed the dancers' costumes—loose-fitting, white diaphanous pants and blouses on which he had silkscreened his own black and white photos of New York street scenes. As the dancers darted about the stage, springing into handstands, T'ai Chi movements, and classical ballet lifts, four movie projectors simultaneously displayed images on the overhead screens. They included shots of the moon landing and earth as seen from space, interspersed with films of children playing, a dog wagging its tail, and a scene from a television sitcom.

Rauschenberg and Brown were both interested in exploring everyday reality in extraordinary settings. With its flickering images and pulsating movements, *Set and Reset* was meant to be an exercise in perception. The barrage of different sights and sounds—a theatrical version of the tumultuous impulses rained upon ordinary people in any given day—made it virtually impossible for the audience to follow all the action.

IT WAS TYPICAL of Rauschenberg's creative process that his work on *Set and Reset* serendipitously led to his next paintings. While he was silkscreening photography onto the fabric for the dancers' costumes, the inked images bled through to the dropcloth, a length of canvas underneath the fine silk. Rauschenberg liked the chance compositions that resulted, thinking they might be "rich raw material" to work with. "Let's see if we can salvage some of that," he said.

ELASTIC CARRIER *(Shiner). 1983. Fabric-covered aluminum construction, 7'9" × 25' × 7'3". Rauschenberg's three-dimensional set for* Trisha Brown's Set and Reset *is made of a silver synthetic fabric developed for NASA, onto which film footage is projected throughout the dance. Photograph by Beatriz Schiller*

Trisha Brown (on floor) and dancer Diane Madden in costumes designed by Rauschenberg for Set and Reset, *1983. The fabric is printed with details from his photographs of New York. Photograph by Jack Mitchell*

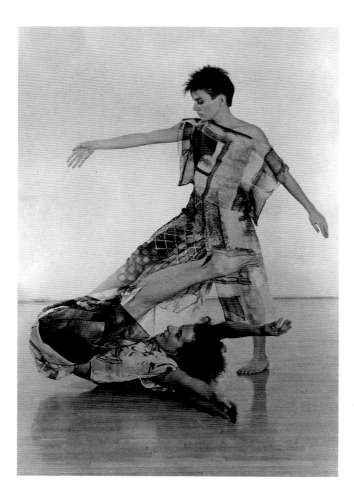

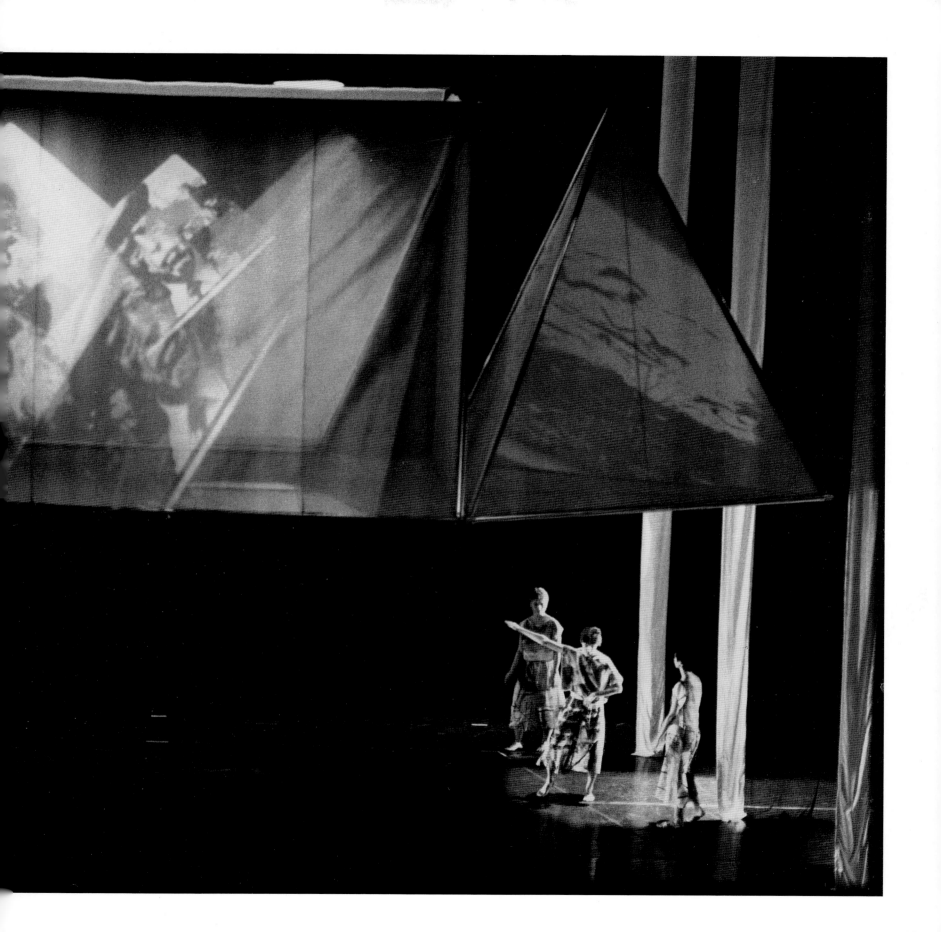

The chance discovery was the impetus for a major series of paintings called Salvage, in which he silkscreened his own photographs onto canvas and painted over and around them with brilliantly colored acrylics. Working rapidly at Captiva from January through April of 1984, Rauschenberg made twenty-six Salvage paintings for an exhibition that summer at the Fondation Maeght, the museum of contemporary art at St.-Paul-de-Vence on the French Riviera. For its two major one-man shows of the year, Rauschenberg had been selected, with Marc Chagall, to celebrate the museum's twentieth anniversary.

Characteristic of the Salvage series is *Wall Rites* (1984), a seven-by-six-foot painting which seems to say that East meets West in the selling of a deity. In the left lower quadrant is a silkscreened photograph of a souvenir stand selling prints of the "bleeding heart" image of Jesus, Buddha, Krishna, and Kwannon, the many-armed goddess of mercy.

Rauschenberg called the series Salvage, because he used materials, techniques, and experiences that had appeared in his work over a period of thirty-five years. The photographic images in Salvage were appropriated from his *In + Out City Limits* project and from his ROCI travels in Asia and Latin America. Salvage also signified the recycling of a technique he introduced in the early sixties—silkscreening images onto canvas. The bold brush strokes with which he painted over and around these images, as well as his splashes of poured acrylic, were a return to his painting style of the 1950s and 1960s. In a typical Rauschenberg pun, Salvage also described his use of leftover objects such as abandoned oil cans, ticket stubs, motorcycle parts, and packing crates.

The series was Rauschenberg's resolution of the problem that he was always expected to produce something shockingly new. In *American Masters*, Brian O'Doherty described this dilemma: "Rauschenberg was always on the run, sentenced by his idea of short-term art to be a brilliant hare in front of the perceptual hounds. As with most artists of a didactic nature, visual conventions, habits of perception were Rauschenberg's material. His aim was to jog those conventions, affording a fresh glimpse, a momentary escape from habit. He worked in the gap between a new perception and its organization into convention."

As O'Doherty predicted, fresh glimpses soon became conventions. "The hounds drew closer to the hare, until both appeared to be hunting together." When Rauschenberg's art no longer shocked, some critics pronounced that his paintings "were mere shadows of what his work once was," that his "prolific production seems hollow," and that Rauschenberg was "repeating himself."

Visiting with Calvin Tomkins, who was working on his biography *Off the Wall: Robert Rauschenberg and the Art World of Our Time*, Rauschenberg acknowledged this trap as "the pressure to repeat yourself, to continue turning out a product, instead of remaining in the unfamiliar terrain of experiment and discovery." For years, Tomkins wrote, Rauschenberg "felt that he could continue to elude the trap, because his only real incentive as an artist was curiosity about what a picture could be, and his curiosity apparently was insatiable." But by 1980, when Tomkins asked him whether he could still escape the trap, Rauschenberg said, "I don't think so, I think the shadow of the escape has cut me off at the pass."

Nevertheless, through the conscious practice of salvage and reuse in the Salvage series, Rauschenberg's curiosity continued to drive him. He revitalized himself by using old ideas and techniques in new ways. "The most astonishing single fact about the Salvage series is the lush, abundant paint handling," wrote art historian Nan Rosenthal in an introductory essay to the Fondation Maeght exhibition catalogue. "These are among the most painterly works Rauschenberg has produced."

WALL RITES (Salvage). 1984. Acrylic on canvas, 81½ × 74½". Collection Lawrence Rubin, New York. Religious symbols from East and West interact in Rauschenberg's Wall Rites. The Salvage series marked his return to lavish use of paint.

The Salvage works reveal the artist looking at himself and his art with a new introspection. They also show the insights Rauschenberg gained from his worldwide travel for the ROCI project. In Salvage, he presents his own world view with greater discipline, painterly force, and graphic power. The large canvases are well ordered (or "built with blocks of images," as Rauschenberg explained) into stately compositions. In some, large areas of paint float on the canvas; in others, the images fill up the picture to the edges.

The entire series has an order all its own. Within each work, rectangular shapes balance and counterbalance each other. Some images recur in several of the paintings, in which they are turned in different directions and printed in different colors throughout the series, a repetition that helps establish a continuity in the series even though many of the works differ sharply in style and in content.

In *Lichen*, Rauschenberg is at his most serious as a painter and social commentator, describing the plight of the homeless. On this canvas, painted in muted pastel colors, a photograph shows a derelict man walking underneath open windows. Repeated twice, once alone and once collaged by an image of a rack of signs ("Caution," "Beware of Dog," "Employees Only"), images of the man are held into the composition by a photograph of Chinese water lilies. In the lower right-hand section, a palmist's sign is silkscreened over a blotch of moss green and white paint that resembles lichen.

A vision of mortality is conveyed in *Shade*, a painting that shows a lovely blue shaded scene underneath a spreading tree, connected to a lifesize human skull by heavy strokes of black paint. The picture is balanced, at the bottom, by images of metal industrial springs on each side. At the bottom center, printed in orange, is an automobile window shattered by a bullet hole. The picture has a somber, even ghostly cast. The most obvious meaning of the title comes from the shade of the tree; the skull suggests the specter of death, or "shade."

The series contains many autobiographical touches, such as a photograph of a print of Thomas Gainsborough's *The Blue Boy* (the first painting to engage the young Rauschenberg), and an image of Rauschenberg's late beloved dog, Cloud. There also are salutes to other artists of the sixties and other moments in Rauschenberg's life—a flag image for Jasper Johns, a cartoon image of a basketball player, "White Boy Fake," for Roy Lichtenstein, and Oriental soup cans for Andy Warhol.

For his French hosts, Rauschenberg offered a special touch with a series-within-a-series comprised of hundreds of images supplied by the Renault company. These drawings depict a mechanized global society with the inner workings of an automobile at its heart. In *Contacts*, the East-meets-West theme is expressed by the juxtaposition of a Buddhist goddess with a Renault diagram. In a strong vertical composition the images are organized as a cross, or religious icon. With its numerous spiritual allusions, the series leads to still another interpretation of Salvage as Salvation.

"All the great artists speak truth," said Fondation Maeght director Jean-Louis Prat. "Rauschenberg's truth is important because he speaks out of concern for others." In an interview following the opening of the exhibition, Prat explained why Rauschenberg uniquely represented the art of the last two decades: "Rauschenberg is now an Old Master. It is necessary to study him because he understands the language of this century. Through his 'complex order due to chance,' Rauschenberg has brought us not only the moments—the times in which we live—but he has transformed the sensibility of the moment into the permanence of art."

IN 1984 Rauschenberg was also represented at the Venice Biennale by Japanese Recreational Clay Works, which paid homage to Old Masters Leonardo, David, and Botticelli. At the same time, his art was exhibited almost continuously around the world with shows in Sweden, Switzerland, Japan, China, Australia, Italy, Canada, and in America in Michigan, Maryland, North Carolina, and California. Also that year Rauschenberg made a trip he had long avoided. After an absence of forty years, he finally went home again to Port Arthur, Texas. Although he had quite consciously left Port Arthur because he had felt stifled there, imagery from Texas persisted in his work. Joking about the constant use of tires and wheels in his art, Rauschenberg said that "wheels were crucial in Texas—the only way I could get out of Port Arthur." He had felt that being from Texas "was of no particular advantage in New York" as he made his way in the sophisticated art world of the 1950s. Although he referred to himself jokingly as "Texas white trash," he had tried with some success to rid himself of his Texas accent.

Yet when the Port Arthur Public Library and the Historical Association asked to hold an exhibition of his works, Rauschenberg accepted. Once he had overcome his initial trepidation, Rauschenberg acted with customary generosity, creating a poster to be sold to benefit Lamar University in Port Arthur. For the exhibition he chose work with recognizable imagery, and designed the poster using photographs of himself as a baby in front of the town's old library, as a boy with a largemouth bass, as a Biennale prizewinner in a Venetian gondola, and as an American artist in mid-life, posed before the Sphinx. The homecoming was not as awful as he feared. His mother and sister were there to celebrate and also to help with lost names.

People who remembered Ernest Rauschenberg came to the opening. Gulf States Utilities, the electric power company where he had worked, was one of the sponsors. Driving around Port Arthur, Rauschenberg went past the empty lot on 17th Street, where their house had once stood. Downtown Port Arthur was a crumbling ghost town. But the smell of the oil refineries, belching their smoke into the muggy sky, was unchanged. The canal still collected flotsam and jetsam from the oil tankers; in the marshes beside it, water birds stalked insects.

It turned out that Rauschenberg's re-entry into Texas would not be limited to a showing in Port Arthur in 1984. In 1985, the one hundred fiftieth anniversary of Texas's independence from Mexico, Rauschenberg was named the Sesquicentennial artist in recognition of the fact that he was "the state's most famous artist, whose work embodies an expansiveness which is undoubtedly Texan in spirit." The honor included a major exhibition, shown in museums throughout the state. Organized by the Contemporary Arts Museum in Houston, the Sesquicentennial exhibition, "Rauschenberg: Work From Four Series," was exhibited for a period of eighteen months there and in San Antonio, Dallas, and Corpus Christi. The work was chosen from Kabal American Zephyr, Cardboards, Hoarfrosts, and Bifocals (a series made in 1982 of freestanding works with collage on both sides of their flattened cardboard surfaces). There was enough Texas imagery in the exhibition to show that the native son who went north still had roots in his home state. At the gala opening, Texas matrons wearing spangled dresses and diamonds wandered among an old straight chair perched atop a wooden porch column, a rope like a hangman's noose, a battered oil barrel, a wagon wheel, a

LADY KNIGHT *(Bifocal). (Two views). 1982. Acrylic and collage on cardboard, 29½ × 24½". Private collection. The Bifocal series is double-faced; each side combines rough cardboard with delicate fabric collage, solvent-transferred imagery, or paint.*

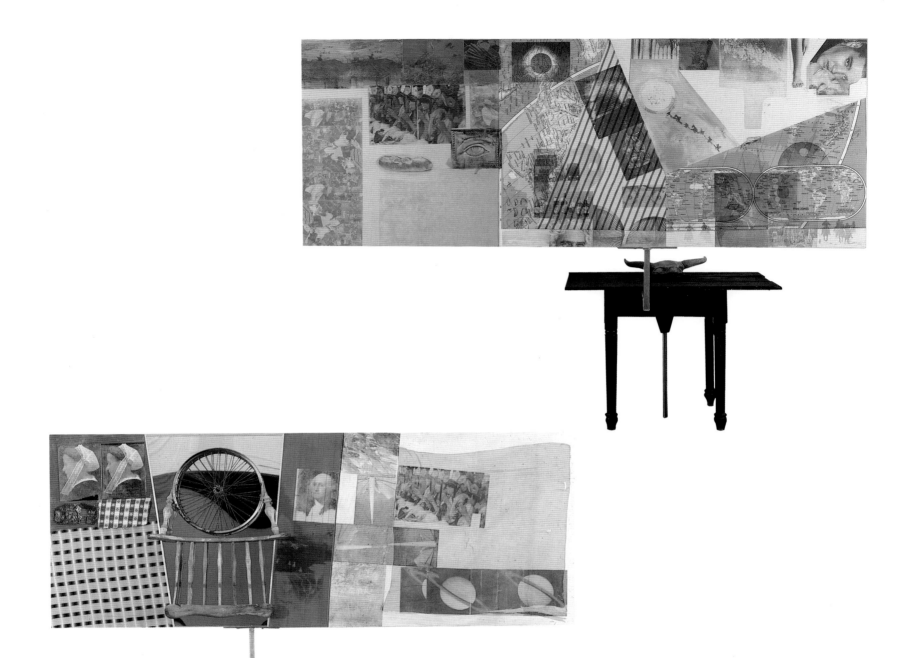

THE VAIN CONVOY OF EUROPE OUT WEST (*Kabal American Zephyr*).
(*Two views*). *1982. Construction with solvent transfer, acrylic, and
collage on plywood panel with objects, 74 × 96½ × 41½". Collection
Mr. and Mrs. Roy S. O'Connor*

rural mailbox, a milk can. (The artist titled the sculpture of the milk can *Classic Cattleman Counter Column*.) The centerpiece of the exhibition was a three-dimensional floor piece, *The Vain Convoy of Europe Out West*, a 1982 work from the Kabal American Zephyr series. With its transfer imagery of George Washington, Indians, and cowboys placed against maps of Europe and the Americas, the painting alludes to the colonization of the West.

Rauschenberg basked in his Sesquicentennial triumph. He told stories about living in Port Arthur. ("My mother says 'Milton, why on earth are you doing this? You never would have had to leave Port Arthur if you hadn't decided to be an artist.'") More seriously, the Sesquicentennial honor allowed Rauschenberg to come to terms with his Texas roots. Like many Texans, Rauschenberg is a storyteller. His stories, and his art, are infused with a sense of the ridiculous, a joy and zest in the absurd. At the Houston celebration, he could even laugh as his friends retold the story "The night Bob got thrown in jail," during another homecoming—one that at the time struck him as an unpleasant encounter with Texas rural gothic.

It happened in 1977 when *Whistle Stop*, in memory of Ernest Rauschenberg, was presented to the Fort Worth Art Museum. Friends honored Rauschenberg with a big barbecue on their ranch, forty miles out of Fort Worth, where the mayor presented him with a key to the city. Early in the morning on the way back to the city, the bus carrying the celebrants made a rest stop in a small town. Seeing the long line to the service station men's room, Rauschenberg went around to the other side of the bus, out of sight, he thought. Unfortunately, three Texas highway patrolmen were watching and in spite of his explanations, Rauschenberg spent several hours in an ancient jail before his host could reach the sheriff and plead Rauschenberg's fame and good intentions. The story goes that after he was released his mother chastised him by saying that if news of the event reached Port Arthur she would not appear in public with him.

But eight years later proud Dora was with him at the Sesquicentennial celebration in Houston, and sailed across the dance floor with her son to the country western band's rendition of the "Beer Barrel Polka."

AMID THE REVELRY of the 1985 Sesquicentennial celebration, Rauschenberg also saw a grim side of Texas. As a result of a glut on the oil market the Texas economy was in a shambles. He heard stories from ruined millionaires about empty skyscrapers, but was moved more by the sight of abandoned gasoline stations where weeds grew beside gas pumps advertising rock-bottom prices.

On his return to Captiva, Rauschenberg collected materials from a salvage yard and launched a new series of sculptures called Gluts. The first pieces related directly to the Texas oil glut. They were made out of the crumpled remains of metal gasoline signs, license plates, and other detritus of gas stations. Typical was *Regilar Diary Glut* (1986), which consisted of a crumpled yellow gas station sign with "reg'lar"—as regular was pronounced in Texas—printed in black letters riveted across the top. Also riveted to it was part of a truck license plate with fuel tax stickers from various states. The gas station sign listed gasoline prices whose bent numbers drooped like the Texas economy. "It's a time of glut," Rauschenberg explained. "Greed is rampant. I'm just exposing it, trying to wake people up. I simply want to present people with their ruins."

As he produced more Gluts, however, Rauschenberg's sculptures of found metal evolved from his sociological message into a more fanciful, purely aesthetic use of the material. As was the case in the combines of the 1950s and the Cardboards of the 1970s, the essence of Rauschenberg's art was to place common objects in new contexts. In Gluts, he worked with pieces of twisted metal from the salvage lot, including air conditioning grilles and aluminum sinks, automobile dashboards, and strips of awning. *Traffic Flower* (1987) consists of a red stop sign stapled to a "Men Working" sign surrounded by a circle of license plates. In *Urban Katydid* (1986) battered Fort Myers street signs are riveted together on top of a rectangular mirrored platform to suggest a swarm of large insects. Even when Rauschenberg shaped flowers, vines, or crickets in the crumpled metal, the past use of each piece was recognizable.

"I think of the Gluts series as souvenirs without nostalgia," he said later. "What they are really meant to do is give people an experience of looking at everything in terms of what its possibility might be."

RAUSCHENBERG turned sixty in 1985. And in the last half of the 1980s he has been more prolific than ever. In addition to the Salvage and Gluts series, he continued to travel constantly, making and exhibiting art for the ROCI project. Out of these travels came ideas for still other series, including Shiners (1986–87), in which he silkscreened images from his photographs on large sheets of stainless steel or aluminum and applied metal objects such as screens or grilles to them. Part of the appeal of the shiny metal to Rauschenberg was that viewers became part of the picture by seeing their own reflections in it. Thirty-five years earlier Rauschenberg had advanced the same notion of viewer participation with his White Paintings.

After working with the vivid primary colors on painted, galvanized stainless steel, anodized aluminum, and mirrored aluminum for the large wall pieces of ROCI/Cuba, he salvaged that idea, revising it into Urban Bourbons, a 1988 series first exhibited at the Knoedler Gallery in New York. Like the Cuba pieces, the Urban Bourbons use silkscreen images of Rauschenberg's photography on bright fields of yellow, blue, orange, or red metals. From Urban Bourbons grew the Borealis series of 1989, which, like the previous series, employed sheets of metal (in this case brass) as a "canvas" for Rauschenberg's work. Gluts, Shiners, Urban Bourbons, and Borealis were made in collaboration with two young artist-assistants, Darryl Pottorf and Lawrence Voytek. (Pottorf specializes in poured acrylic paintings on metal surfaces; Voytek welds witty metal sculptures from previously used materials.)

As Rauschenberg renewed his interest in photography, he had looked for new ways to incorporate photography into his art. He mounted a large-format Polaroid camera on a truck and rode around the streets of Miami looking for "instant Rauschenbergs." The results were interesting, but not spectacular. He then found a new use for the big camera in making black-and-white photographs. After setting them out to dry, he noticed that the sun faded out some parts more rapidly than others. Intrigued by the effect, he fixed the portions he wanted to keep dark and brushed over the faded sections with Clorox to manipulate the fading of the images. Playing with composition and light, as he had with the sun photographs of 1949–50, he soon assembled a new series of unique photographic prints called Bleachers (1989), in which images appear highlighted like ghosts against a subdued gray and white background.

REGILAR DIARY GLUT *1986. Assembled metal parts, 85×116×24".*
Private collection

TRAFFIC FLOWER GLUT *1987. Assembled metal parts, 50×75½×8".*
Private collection, Japan

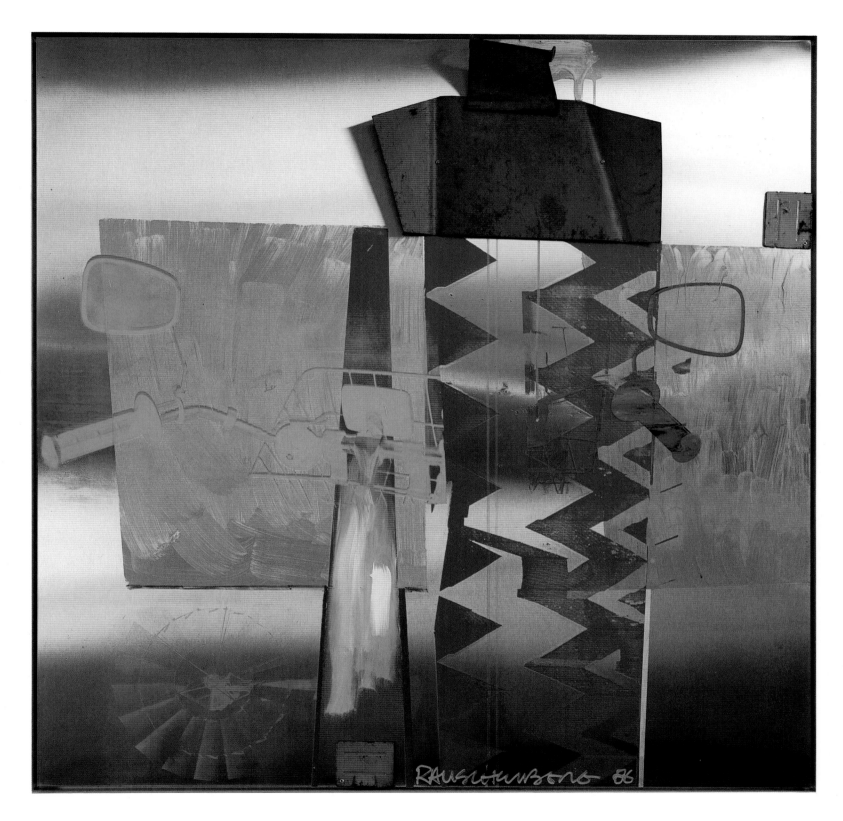

NAVAJO ROLL *(Shiner). 1986. Acrylic and silkscreen on aluminum,*
48¾ × 48¾". Collection Kerstin Flodin. With Shiners, Rauschenberg
said he was exploring the surface of the painting, absorbing its entire
environment by light in reflections, as with mirrors.

SUMMER GLUT HURRICANE BLOOM *1987. Assembled metal and plastic parts, 73¼ × 151½ × 25½". Collection the artist. The "bloom," which once was a steering wheel, rises up from a metal sheet, twisted as if by the hurricane that battered Captiva. The Florida road sign indicates the place.*

CATHEDRAL LATE SUMMER GLUT *1987. Assembled metal parts, 50 × 115 × 22" overall (2 parts). Collection the artist*

Imagery gathered by Rauschenberg during his travels and at home also went into a new series of photogravures, the Bellini series (1988). He borrowed allegorical imagery from five small panels of the virtues (Fortune, Truth, and Justice among them) by Giovanni Bellini, which are preserved in the Accademia in Venice. From photographs of the original twelve-inch-high paintings, Rauschenberg enlarged the Bellini images to thirty-nine inches. He then isolated the images from their backgrounds and placed them in a montage of modern-day scenes—a fountain in Central Park, a New York fire hydrant. With these, he created a continuous-tone gravure edition, printed at ULAE. The prints are washed in colors of the Renaissance: purple, rose, sapphire blue, and emerald green. From the five prints, Rauschenberg selected nine proofs to add still further color by hand, creating three unique trilogies which he calls unigraphs. John Russell cited elements from Bellini that Rauschenberg incorporated in the prints, noting that "He plays them straight, sets them in a grand formal structure, and slips in some arbitrary images from our own time, the way a champion pool player plays a winning shot from somewhere behind his back."

In 1989, Rauschenberg's art continued to rise in value. Large new paintings sold from $100,000 to $550,000. At a Sotheby's auction in New York in November 1988, *Rebus* (1955) brought $6,325,000. Later that same evening a painting by Jasper Johns sold for a staggering seventeen and one-half million dollars. Rauschenberg's reaction to the sale was mixed. He had not realized any money from the resale. (The artists' rights bill was still being debated in Congress.) He had requested that the seller donate one percent of the profit to Change, Inc. to aid artists in need; in fact, the request drew a much smaller contribution. The sale itself pleased him, however, for it ensured higher prices for his own works with which to finance ROCI. He insisted that whether his art sold or not, "you couldn't pay me enough *not* to make art."

Rauschenberg is most often portrayed as the enfant terrible of the 1950s who shocked people with the White and Black Paintings, the *Erased de Kooning* and with *Bed* and *Monogram*. Less well known is that there has been a consistency in his attitudes and in his work during a career that in forty years has produced some sixteen hundred paintings and sculptures, fifteen hundred drawings, and more than five hundred editions. Even while constantly experimenting with new materials and techniques, he has adhered to a basic set of principles. With his use of commonplace objects he has tried to fulfill his own goal of operating in the gap between art and life.

"Curiosity is the main energy" that drives his art, Rauschenberg has often said. The same kind of curiosity that led him to seek to make the largest-ever lithograph, *Sky Garden* (1969), resulted in yet another project. During the 1980s Rauschenberg had also been working quietly to make the world's largest painting.

COURTYARD *(Urban Bourbon). 1989. Acrylic and enamel on enameled aluminum, 121×144¾". Private collection*

TRILOGY FROM THE BELLINI SERIES *1987. 3 unigraphs: photogravure with monotype and hand additions (edition of 3 unique pieces, 3 sheets each, 60½ × 38″), adapted from ULAE Bellini series. Collection the artist. The series is named for elements of Giovanni Bellini paintings reproduced prominently among the imagery—and for a favorite Rauschenberg drink: champagne with peach juice, called a Bellini.*

TALKING HEADS ALBUM COVER/SPEAKING IN TONGUES *1983. Offset lithograph on vacuum-formed plastic with three movable disks (edition of 50,000, Sire Records), 13 × 13″. Courtesy Talking Heads. Rauschenberg's design for a Talking Heads album won a 1984 Grammy Award for "Best Album Package." The printing technique recalls his Shades and Revolvers series of the 1960s.*

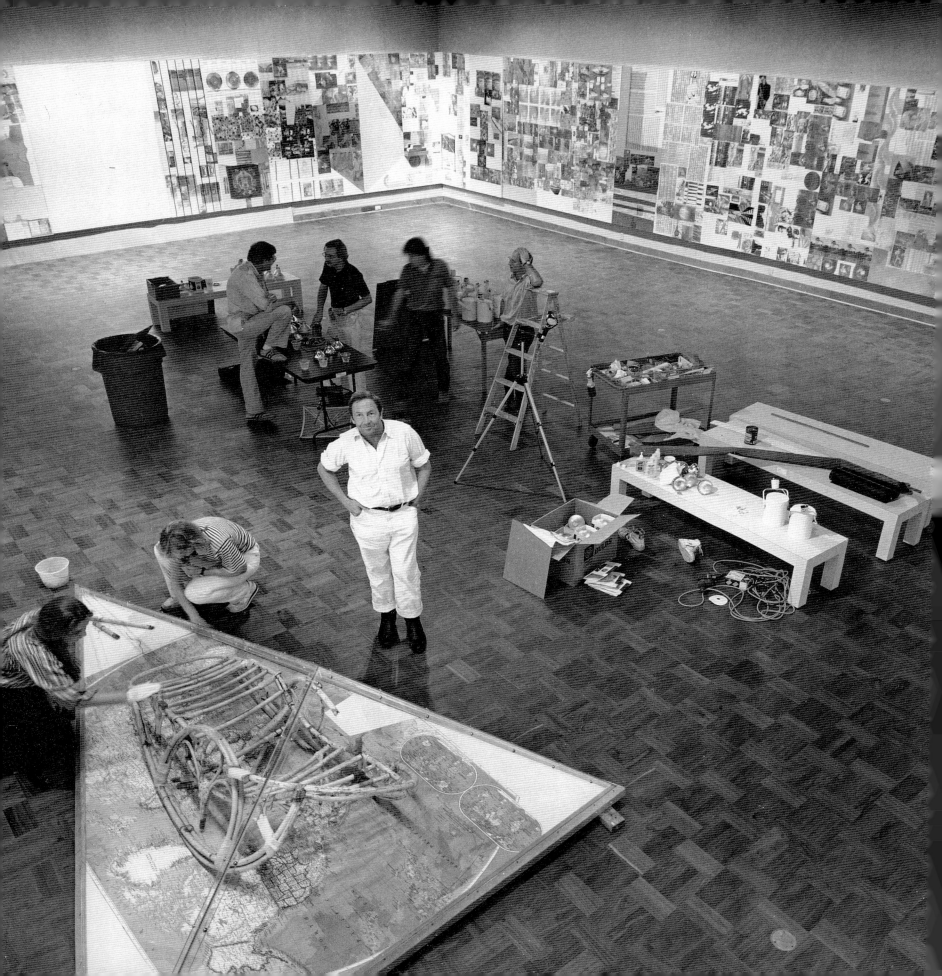

THE BIG PICTURE

ALMOST THIRTY years ago, in 1961, Rauschenberg said, "There is no reason not to consider the world as one gigantic painting." Since then he has cut a wide path across the globe with his various ROCI ventures, and in this country with his largest single work yet: *¼ Mile or 2 Furlong Piece*. (The name of the work was a private reference to collectors Jane and Robert Meyerhoff, who named one of their racehorses "Rauschenberg." A furlong is an eighth of a mile, or six hundred sixty feet.) The idea for the piece came while Rauschenberg was working on his Spreads series in 1981, predating ROCI by three years.

Given how many images from his travels, previous artworks, friends, and his past Rauschenberg has incorporated into *¼ Mile*, this big picture has become in effect a one-painting retrospective. Above all, Rauschenberg has said he wanted *¼ Mile* to convey a message: "If I could write, I would be a journalist. I would report on the world, and try to get people to take responsibility for it. But I can only make art." And in *¼ Mile* that message is a celebration of life in the universe.

The piece was put together for the first time in 1982 at the exhibition hall in Edison Community College in Fort Myers, a space where Rauschenberg often tries out new works. One hundred ninety feet of the painting covered the walls of the vast room, with not an inch to spare. Orange trees in large pots were placed in the center of the room. From speakers in each corner came sound effects— street noises of Cairo blended with Florida surf and bird song. Rauschenberg was so pleased with his giant statement that he decided to go for the full quarter mile. "It had no conceptual predestination," he said. "I consider [the painting] my treat, my hobby, something I work on at will, whenever I have time and feel like it." Rauschenberg completed thirty units of the painting in 1981, thirty-six in 1983, seven in 1984, seventeen in 1985, and in 1986, nineteen.

During the making of Salvage and in his ROCI travels, Rauschenberg gathered images and materials for the *¼ Mile Piece*. By 1984, he had assembled four hundred feet of the painting, by now a giant combine of paint, collage, and construction, at the Miami Center for the Fine Arts. *Miami Herald* art critic Helen Kohen wrote, "Bringing together his systems of thought and expression, there is no broader statement of his philosophy, and no larger statement of how that applies, than the *¼ Mile Piece*."

In 1987, much of its seven hundred fifty feet, called the First Furlong, inaugurated the Special Exhibitions Gallery of the new Lila Acheson Wallace Wing of Twentieth Century Art at the Metropolitan Museum of Art in New York.

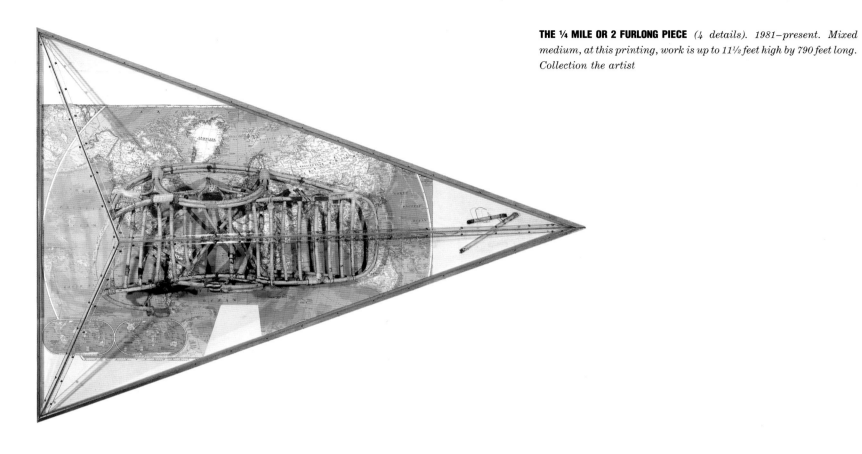

According to William Lieberman, curator of twentieth-century art at the Metropolitan, Rauschenberg was chosen for the honor because he "explores new techniques, and he reaches into other cultures . . . his narrative unfolds into a vortex of colors, materials, and photographic images. Bob's juxtapositions, spontaneous yet exact, demand deep study now and in the future." In the Metropolitan Museum of Art Bulletin, Lieberman explained the mammoth work as a "scaled-up scroll that examines the artist's vision of his art and his world, extending the parameters of traditional painting."

During the ¼ Mile Piece's year-long installation, the gallery came to be known as the "Rauschenberg room." Eighty-one of the painting's more than one hundred and ten panels hung on the walls and the center room dividers. Freestanding pieces such as an oil drum and a totemic stack of books were placed beside the wall panels. Many panels are three by eight feet, laminated onto sanded mahogany plywood like the Spreads, and transfer-printed on Grasshopper. Others are screen-printed in larger dimensions and cover the broad range of materials that Rauschenberg calls his palette.

The first impression was color: fields of magenta, orange, yellow, and a range of blues, plus splashes of reds, whites, and blacks and grays. Color was everywhere—washed over pictures with a brush, and printed on gleaming copper, canvas, linen napkins, Indian madras, and kimono silk. Rauschenberg had applied his color in quietly controlled panels as well as in wild free-form patches. In color alone, ¼ Mile Piece was a bravura performance.

Rauschenberg's bold brushwork connects one fleeting thought to another. The imagery is a jumble of pictures and odd objects: A stately formal wall of colorful striped fabric is interrupted by a horizontal totem of flattened cardboard boxes. A construction sign, in Spanish, warns "Danger: Deep Excavation." The sign, directing the viewer to look for meaning below the surface of the painting, is a clue to the role of the artist within ¼ Mile Piece. "It reflects my travels, changes in my own life, my desires and prejudices," said Rauschenberg.

Installed in the order of its creation, ¼ Mile begins with a pointed finger, as did Rauschenberg's XXXIV Illustrations for Dante's Inferno (1960). An identical finger below the first points in the opposite direction. (This is a joke that doubles as social commentary, according to critic Helen Kohen: "In the first panel he thwarts a connection made originally by Michelangelo, namely the touching fingers that touched off creation. The extended fingers are there, but they miss. The unified spirit of the Renaissance, we are to understand, is not around today, though we have the components.") The right-pointing finger directs the eye to a bedsheet as white as the White Paintings (1950–51) of his early career. The patched sheet, which once belonged to Rauschenberg's Florida neighbor Maybelle Stamper, serves as an indicator that the painting reflects various series, periods of work, people, and places in his life.

¼ Mile Piece replays in many ways the themes, styles, and subjects of Rauschenberg's past work. The recurrent images of athletes, animals, flowers, man's inhumanity, and the manmade beauty of technology and industry appear in coherent composition. If the first impression is color, and the second impression imagery, the glue that binds the pieces is Rauschenberg's disciplined use of form. With a controlled hand, he produces a connecting repetition of shapes: mirror images of circular objects, and triangles, large and small. Forms interact to produce a rhythm and cadence that crescendos, according to Leo Castelli, "like music."

¼ Mile Piece displays Rauschenberg's varied painting styles. Brush strokes where the hand is in command follow the rules laid down in painting class by Josef Albers. In other places thick paint is slashed on boldly with a knife or

rubbed in by hand, like Rauschenberg's early paintings in Paris, or as luscious pours and drips, their shiny acrylic crackling and bubbling.

Within the painting's expanse are Black Paintings, Red Paintings, and combines. Umbrellas, parachutes, and veils tumble about in new situations. A clear acrylic arch, to which is attached a cascade of varnished cardboard boxes, juts out into the room like a cathedral door. Printed newspaper headlines echo the Currents series. In a reprise of the style Rauschenberg used in Spreads, images of war atrocities and the flowering of spring are transfer-printed alongside the floating beauty of Saturn and its rings. A vertical row of shapely buttocks, like quotation marks, punctuates the end of the Spreads section.

The roughest piece—a battered oil drum looking as though it had just floated up from Port Arthur's canal—is reminiscent of the Gluts series. It is placed next to the most elegant piece, a panel incorporating a lustrous silk obi from Japan, geometrically patterned and arranged on the panel as if in homage to Mondrian. Above the obi, an arrangement of colorful long-sleeved shirts—laminated onto plywood and placed directly on the wall—appears ready to take flight.

Another wall of the painting is dominated by silhouetted lifesize drawings, reminiscent of his early Blueprint paintings. Rauschenberg's mother, Dora, and some of his assistants and close friends climbed onto his worktable at Captiva so that Rauschenberg could trace their heads and bodies with bright orange crayons. "I wanted to give them a gift—people who'd never before had their portraits in the Metropolitan Museum of Art," said Rauschenberg.

Later sections of ¼ Mile chronicle ROCI: the caryatids from Chile's national museum, street stands from Mexico, and favelas from Venezuela serve as vibrant notes emphasizing the intent of the painting.

John Russell wrote of ¼ Mile Piece in The New York Times that "it has in part, the character of a travel diary, for Mr. Rauschenberg in recent years has been a great globetrotter in the cause of multinational understanding. The result has an aerial fancy, allied to an unbounded generosity of spirit."

In his productivity, inventiveness, and continuing artistic renewal, Rauschenberg has often been compared to Picasso. "If Picasso invented collage, then Rauschenberg completely re-invented it," said Nan Rosenthal, curator of twentieth-century art at the National Gallery of Art, during a program there. Jasper Johns, speaking to Leo Steinberg, once said that "Rauschenberg is the artist who has invented the most since Picasso." "Among artists, he is the most inclusive," said Roy Lichtenstein. "He includes the whole world in his work, and he includes an enormous number of people in his life."

In 1987, at the age of sixty-two, Rauschenberg's energies were unabated. His ROCI expeditions inspired a creative outpouring and also provided widespread international exposure for his art. The ROCI work was drawing excellent reviews, and the exhibition of ¼ Mile Piece at the Metropolitan Museum added still another triumph.

A month before the official opening of the new Twentieth Century Wing at the Metropolitan, a small private dinner was given there in Rauschenberg's honor. Rauschenberg had been caught in traffic and arrived after the museum's guests had completed their tour of ¼ Mile Piece and had adjourned for dinner.

Rauschenberg walked through the Special Exhibitions Gallery alone, stopping to look at the bits and pieces of his life flying at him from all sides of the room. It was not just the ¼ Mile Piece that threw him into a state of awe, he later recounted, it was the Met itself. "The Met!" he said. "Where I used to hang out. To take in all I could from the Romans and Greeks and Rembrandts . . . and now, I'm *it!*" he said in genuine amazement.

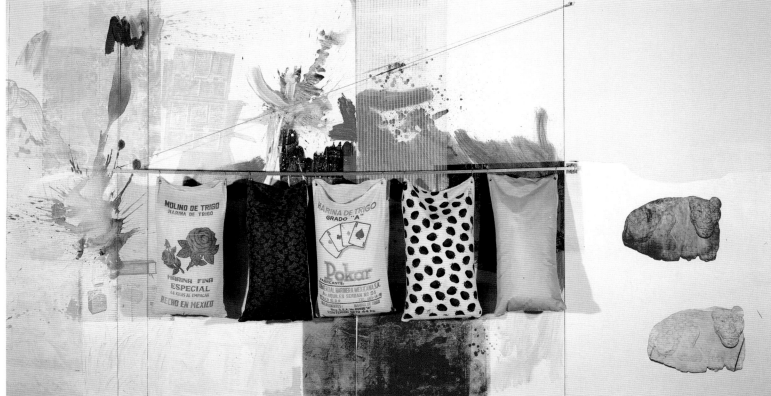

THE ¼ MILE OR 2 FURLONG PIECE *(4 details). 1981–present. Mixed medium, at this printing, work is up to 11½ feet high by 790 feet long. Collection the artist*

THE GRAND OPENING of the Metropolitan's new Wallace wing on January 21, 1987 was the New York art event of the year. The *¼ Mile Piece* was the biggest Rauschenberg exhibition in New York since his 1977 retrospective at the Museum of Modern Art. Although he had annual exhibitions at Castelli and was often shown at museums, his isolation in Florida had distanced him from the New York scene, and few of its denizens knew of Rauschenberg's work with ROCI. As ROCI had gathered momentum, his main exhibitions had been overseas, and for these he frowned on press releases and the usual pre-event publicity. According to Castelli, Rauschenberg was still an innocent who felt that the values of ROCI would be realized only if news of it traveled by word of mouth. Many New Yorkers had not heard the news.

Rauschenberg has long been known for his gregariousness and his desire to be around people. To stoke his energies for the opening at the Metropolitan, Rauschenberg hosted a pre-opening party at his Lafayette Street house. It was characteristically swarming with people and goings-on. The red brick townhouse is in NoHo, just north of Houston Street, the line of demarcation for the artists' colony of SoHo (South of Houston). The house, which before his move to Florida had served as his home, studio, and theater rehearsal space, was now headquarters for Rauschenberg's archives, exhibition space for his new work, and a base for his New York visits. It is spare and austere, with dark hardwood floors and white walls. The deconsecrated chapel, with its four-story ceiling and cathedral windows, is a reminder that the building was once a Catholic orphanage. For the party, the chapel walls were covered with the crumpled remains of yellow gas station signs that comprised Rauschenberg's Gluts.

After climbing two flights of wooden stairs past rooms filled with new Shiners, the guests assembled on the third floor in another wide gallery room that runs the length of the house. At one end of the room is the black industrial-size Vulcan gas stove that yielded meals for generations of orphans and is now a proving-ground for Rauschenberg's spicy cooking. For once, Rauschenberg was not at the stove. His sister Janet's son, Rick Begneaud, had prepared a big pot of Louisiana jambalaya and crawfish gumbo. Beside the stove was Rauschenberg's "treasure wall," a grouping of an early 1950s gold leaf painting by Rauschenberg and his *Erased de Kooning* drawing next to works by Cy Twombly, Josef Beuys, and René Magritte. Johns's *Alley Oop* (1958), an impressionistic cartoon on a bright orange field, was centered on the wall.

Johns was not at the party. But Sue Weil was there, as were Billy Klüver, the engineer who worked with Rauschenberg to combine art and technology, and his wife Julie Martin, James Rosenquist, accountant Rubin Gorewitz, Theodore Kheel, the labor mediator and friend from civil rights days, Leo Castelli, Trisha Brown, and many others. Dora Rauschenberg, the artist's eighty-four-year-old mother, had come with her daughter, Janet, from Lafayette, Louisiana. (His mother had made her dress from fuchsia sari silk that Rauschenberg had brought from Thailand.) Rauschenberg's staff from New York and Florida, old friends from the lean days and newer, younger friends mingled at the bar. Above the bar hung a silver eight-foot-long Shiner titled *Knight Dribble* (1986), in which an image of a huge bottle pouring champagne into a glass over an industrial scaffolding was enlarged from a photograph of a neon sign from Venezuela.

At the opposite end of the gallery room overlooking Lafayette Street stood ceiling-high tropical plants, a fine Egyptian mummy case (with mummy inside) acquired during the Made in Israel trip, and a Rauschenberg sculpture from the

Venetian series: a simple rock on the floor attached to a hook on the ceiling by a square-plaited rope. Rocky, the artist's large thirty-year-old turtle ambled around the floor between the feet of men in black tie and women in evening dresses.

Later in the museum, Rauschenberg was greeted by more old friends and fellow artists. Their cheers drowned out the melee of Van Brunt's recorded sounds, such as those of Cairo streets and the Gulf of Mexico surf that accompanied ¼ *Mile Piece*, which was already more than two football fields long and still growing. "I may never finish it," he told the television reporters. "It may turn out to be several miles long."

Dora Rauschenberg was laughing, a bit embarrassed that her portrait was hanging in the Metropolitan Museum of Art. "When I first saw it, I told Milton I was surprised at my hair," she said. "It looks a little squinched up in the back. But I guess that's the way it's going to be." Standing in front of the wall of flying shirts, she said, "Just look at those shirts. I recognize some of them. Wish I had a nickel for every buttonhole I've sewn on."

In front of the shirts, Rauschenberg had impaled on a pole a tower of books discarded from the Captiva Public Library.

"Isn't it something how he can see the beauty in almost anything?" asked the artist's mother.

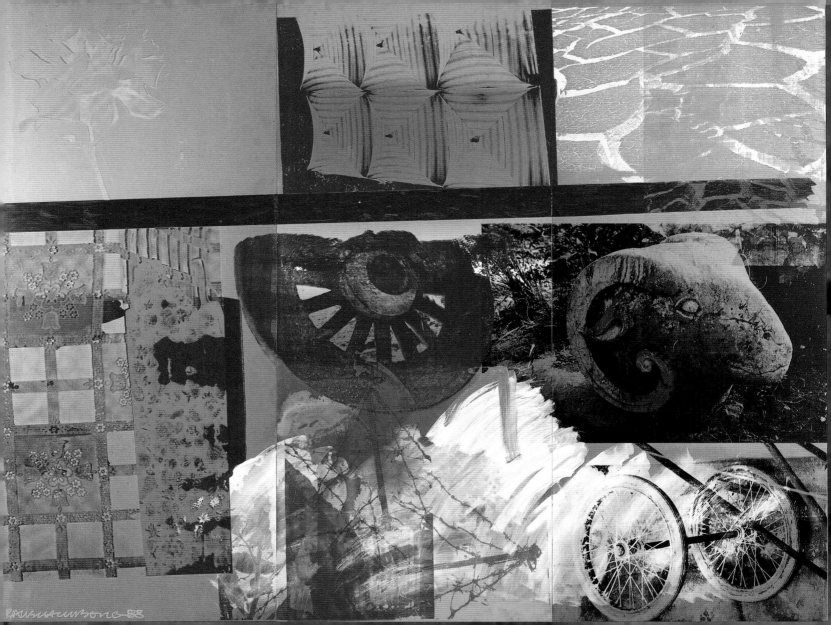

RAUSCHENBORG-88

CAPTIVA

WORK IS MY JOY, Rauschenberg says. "Work is my therapy. I don't know anybody who loves to work as much as I do." The artist is in his studio in Captiva, Florida, an island where he has found inspiration and peace for the past twenty years. "Every time I came to Captiva something magic happened," he once told an interviewer. "Like having to stop the car because of a big turtle crossing the road, or stepping out of the car and having forty yellow butterflies all of a sudden come at you. . . . I had the ghost of having been here before. There was something familiar about it."

A narrow island five miles long, Captiva is green, quiet, and unpretentious. It is reached by a small bridge from Sanibel Island, which is linked to the mainland near Fort Myers by a causeway. (Rauschenberg remembers the days when a ferry was the sole connector.) His simple white house, built on stilts, faces the Gulf of Mexico. Surrounded by sea grapes, palms, and casuarina trees (Australian pines with soft green needles), Rauschenberg lives and works in a thirty-seven acre forest of tropical greenery. Within this compound are Rauschenberg's studio, also a white house on stilts, and another white building that holds his print shop and guest quarters. Hidden in the jungle across the road is an old Florida summer house. Out in Pine Island Sound is the even more secluded "Fish House." Built on stilts in the water at the end of a pier, the Fish House once belonged to J. N. "Ding" Darling, the famous political cartoonist whose lifelong crusade for nature conservation helped make Sanibel-Captiva a federal bird sanctuary. Pelicans, herons, and exotic birds of all feathers gather at the Fish House. "It has good spirits," says Rauschenberg.

Nowhere on his land is Rauschenberg more at home than in his two-story studio. On the studio's ground level is the welding studio, or fabrication shop. The sculptor Lawrence Voytek assists Rauschenberg with welding Gluts, making frames for Shiners, cutting large photographs, and crating ROCI pieces or prints for shipment to New York. The big found objects that may find their way into future projects are stored here, as is a massive collection of silkscreens made from Rauschenberg's photographs. The studio is where Darryl Pottorf, another assistant, Rodney "Tup" Schmidt, and others also work as craftsmen with Rauschenberg, drilling, sawing, hammering, and riveting works of art.

Dozens of large silkscreens, made to size from Rauschenberg's photographs, are propped against the wall. Each one is numbered on its wooden frame. On the second-floor porch dozens more of the wooden-framed silkscreens are neatly stacked. Other not-yet-ready-for-artworks, including part of an old carousel horse, lean on the porch.

A sliding glass wall opens onto Rauschenberg's studio, a large, pristine white-walled room. The roofline windows all around the room open to the bright Florida sky, the wall of windows at the back looks out at the tropical forest.

It is an orderly room. Shelves on one wall contain a variety of instruments and a chromatic lineup of at least eighty paint jars, each with a number written on it. Occupying most of the studio is an enormous linoleum-covered table, twenty-four feet long and ten and a half feet wide. The table, made from smaller tables bolted together, is necessary for Rauschenberg's large-scale works. (Once, he made them on the floor. Now his back appreciates the table height.) This is the table on which Hummingbird Takahashi and his father, Hisachika, as well as Rauschenberg's other friends, stretched out to have their portraits traced for the ¼ *Mile Piece*.

Rauschenberg apologizes for the linoleum tabletop. It is beige with an octagonal pattern, an ordinary, mobile-home piece of linoleum. It doesn't jibe with his aesthetic. "Can you imagine coming to work in your old background?" he jokes. "All we need are some kitchen chairs that are painted in yellow and brown enamel. But it's the only surface I could find that was totally smooth, totally seamless and this big. We need an absolutely smooth surface for silkscreening in the scale I work in. No texture. Anything shows in silkscreen. Sand shows."

On the table, he has laid out materials for a new work. There are three panels, like a triptych. The left panel is galvanized aluminum, the central one stainless steel, the right made of the dull-finish anodized aluminum.

He has begun the piece with a horizontal red stripe painted near the top, light pink brush strokes overlaying the red. In the bottom third of the painting is a horizontal row of brushwork in white, perfectly controlled, in perfect balance with the top. The white brushwork is a close zigzag, like a fleshed-out Cy Twombly scrawl. Beautiful as is, the painting could be a Minimalist abstraction.

Rauschenberg is reluctant to work on it further, and wanders around the studio, nibbling on artichoke canapes brought in by Hisachika Takahashi, drinking Jack Daniel's and water, and watching a videotape of the recent wedding of his assistant, Tup Schmidt, on one of two constantly running television sets. A sporting event is being played out on the other set. Both screens generally operate simultaneously when he is working.

"My work is about what's *outside* the studio, not what's in here," he explains. He checks out the painting again. "If I was doing early Mardens, I would have just left this like it is." As a young artist, Brice Marden assisted Rauschenberg in the studio, as Darryl Pottorf is doing now. "You know, some people might want it to stay that way," says Pottorf, also a minimalist abstract painter.

Rauschenberg has been measuring the painting with his eyes. "Well if I just left it that way, life probably wouldn't be complicated enough." But he still doesn't touch it. He talks for awhile about his travels for ROCI and describes how he empties his mind before entering a country or beginning a painting.

"You just—what's that thing you do in the Catholic Church? Throwing yourself on the ground? You just belly down. You make yourself as vulnerable as possible, so that you empty yourself of as many preconceptions as you can possibly manage," he says.

Rauschenberg, wearing jeans, sandals, and a multicolored green-and-red plaid shirt with pearl buttons, walks over to a bookshelf containing a dozen ring-bound vinyl notebooks filled with black-and-white photographs. The notebooks are labeled by country, the photographs matched by number to the silkscreens that stand on the porch and in two of the studio's storage rooms. He flips through several notebooks, coming back to one labeled Chile. Rauschenberg scrutinizes a photograph, turns it one way, then another, upside down and sideways from all

Rauschenberg's Captiva, Florida, studio. An image of the artist's face was screen-printed to T-shirts commemorating the 1985 Texas Sesquicentennial. Photograph by Terry Van Brunt

angles, then calls out, "Number 116." Pottorf and John Peet bring in the heavy wood-framed screen, about four feet square. Orange and green from previous use, the screen shows a highly magnified image of a rose with some foliage around it. Rauschenberg studies the screen. Areas around the rose have been blocked out so that only the blossom shows. His assistants stand patiently, holding the frames while the artist stoops over to study closely the painting on the table, his eyes crinkling to a squint. He stands back, still scrutinizing the panel, and cups his chin in his hand: "One of the first things I decided about this particular piece is that I liked the panels so much laid out the way they are. It was a visual excitement that I wasn't going to print above. And that's why I put the red line there." (He indicates the metal portion he had intended to leave unpainted.) "My first screen is going above the red line and up in the top left corner. You can't trust an artist, right?"

Pottorf is standing on the table, holding the screen; Rauschenberg motions to him exactly where he wants it laid on the metal. Once it is down, Rauschenberg takes the screen and moves it two inches to the left so that it is no longer in the center of the panel grid.

After a long joking digression, during which he has been studying the rows of acrylic paint jars, he asks for "Orange #17"—a vibrant, hot orange. Rauschenberg takes the open paint jar and sniffs the thick paint. "I don't know why I have to sniff it," he says sheepishly, "but I always do. It doesn't even have an odor." Directed by Rauschenberg, Pottorf begins to apply the paint with a putty knife onto the right hand vertical side of the screen. Peet and Takahashi are anchoring the screen frame. Pottorf and Peet, with Rauschenberg watching closely, guiding a hand alongside, take a long rubber squeegee and pull it across the screen in one smooth, quick movement. Carefully they lift the screen. "Let's do it again," says the artist. The screen is inked again, the squeegee making a high-pitched squeal as the men pull it across again. "I think that's gorgeous. Don't you?" Rauschenberg grins in delight. The closeup of an orange flower, the single blossom floating on gray metal, its background blocked out, blooms slightly off center in the top left panel. Peet quickly runs with the screen to the porch, where he hoses it down. Each "pore" must be unclogged immediately if the screen is to be used again. "At this size, they are too precious to ruin," says Bob.

He calls for the heat lamps, which have been hovering over the table. The bright lights are turned on the rose, and Rauschenberg reflects on the re-use of materials while eyeing the painting. "I can't bear to waste anything," he says.

"I was asked to speak at a symposium on Josef Albers at the Guggenheim," he says. "I'm the only one who will tell the truth about 'The Old Maestro,'" he laughs. "I was thinking about what he said to me: that you don't do a painting like pulling down the window shade! Of all the things he ever said to me, that was the most persuasive. It sent me off in the *wrong direction*." Rauschenberg underlines the phrase with laughter. "A direction which was *opposite* from him."

He is walking around the table, looking at the orange-sherbet rose from every angle, leaning close over it, asking, "Is that dry enough up there?" He goes back to the notebooks, poring through page after page of his black-and-white photographs from Venezuela, Japan, China, Sri Lanka. Finally he comes back to Chile, selects a numbered image, which Peet and Pottorf bring from downstairs. This one, a stained-glass window, he sets in place himself, inching it onto the lower left of the metal field underneath the orange rose. The color he chooses is a luscious red, "Cadmium 21." Once screened, it is set to dry under the lamps, the wattage is increased and lamps brought closer. The red and orange glow in the late afternoon light. Peet rushes out with the screen, washes it, and before he can store it, Rauschenberg asks for the same screen again. After the red

Jasper Johns and Rauschenberg at Gemini G.E.L., 1980. Both artists work at Gemini and ULAE. Photograph by Terry Van Brunt

stained-glass window has dried, he holds the screen up, then places it carefully on top of its own image, shifting it about a quarter-inch to the right. "Exactly what we want—is not *exactly*," he explains. The top edge overlaps the red stripe, the bottom over the white, wavy stripe. He calls for the orange jar again. He daubs on the orange-sherbet color and with the help of his collaborators squeegees it across the screen, slowly lifts it, and smiles in delight.

The stained-glass window now looks like a *negative* of a stained-glass window. The light orange over the bright red casts a diametrically different effect from the orange rose above it. "It makes the rose a whisper," says Rauschenberg.

Now he is cooking. He moves quickly to the books, looks through photographs and stops again in Chile at an almost-abstract picture of cracked earth—the dried lake bed of Antofagasta. It was a desert, he said, "Such a vivid brick red color—they had turquoise stones lying around on the ground, as big as your fist." He opens a book of photographs from China, selects two pictures: a wheel and axle and a giant close-up of a ram's head.

He studies the rows of color jars, a variegated spectrum in perfect order which have been mixed by the factory to his precise specifications. "There are not enough colors," he says. "It is my torment. It is my every day's wish that there could be more colors."

He reaches toward a murky shade of violet. "I have to set myself a challenge. How could anyone possibly like this color? We have to see if we can rescue it from its own fate. I have to make myself use colors that I don't like just to keep in shape. I have to work against my prejudices." The cracked earth of Chile, enlarged like stepping stones, becomes a murky violet on the top right of the third panel. It dries. The Chinese wheel and axle, in a dark gray he calls "Mars," rolls across the white paint in the shiny stainless steel center panel. The enormous Chinese ram's head, its circle of an ear echoing the wheel and the rose, is printed in purple, crossing over from shiny to dull background, linking China to Chile, linking color to color. A Chinese sunflower behind a barbed-wire fence is printed in a copper brown color. Each screen has to be carefully placed, the thickness of paint carefully gauged, the squeegee applied with the right pressure, then "cooked" dry with the heat lamps.

Rauschenberg is always surrounded by his family of dogs, as here with Star, Sasha, Tanya, and Sea C. in Captiva, 1982. Photograph by Terry Van Brunt

The process on this big painting so far has taken about six hours. Even as he talks with his assistant/collaborators, his eyes measure the picture plane on the table. He walks around it, looking at it from every angle. When he chooses a photograph, he turns it in every direction. Which way will the line flow? Which way will the curve fall? "You almost have to pull the images out of the air, and put them close enough to nearly smother you," he says. He does the same when the screens are fetched—testing his choice against his steel "canvas." He is building a painting like a collage.

"I'm turning it into a Rauschenberg," he jokes. "I think I like it like it *was*. But something makes me want to fill up this space. It must be in the genes. Collage is my medium," he explains. "I think I inherited it. People would come from all over to have my mother lay out a pattern. She could take a piece of fabric, and always salvage whatever it was they wanted to sew and make it fit. And she also was very good at not wasting anything. Still is! I'm like my mother in that sense, too. I *can't* throw anything away. Some use will be found for it, sometime."

The images he has just re-used are from China and Chile, two societies as diametrically opposed to each other as their positions on the globe. What these countries have in common to Rauschenberg—in addition to their repressive governments—is the beauty of their ordinary, everyday objects. There is a tension and a commonality in their use here. In plain, ordinary objects he keeps searching for links between cultures.

"Let's stop for now," he tells his assistants, unconsciously washing his hands in midair. "Is it finished?" he is asked. "I'll have to think about it," he says. It seems his mind is still on Texas. "From the ninth grade on, until I was in my senior year, I kept thinking 'I wish I could have a readymade shirt like everybody else, without offending my mother.' I couldn't complain because—even as a teenage monster—I thought it was really quite beautiful that she would do that for me. I was aware that none of the other kids' mothers took time to make their shirts." He laughs: "Even though I was embarrassed to show up in mine. She always told a story about how all of her clothes were hand-me-downs. And how embarrassed that made *her* feel, always wearing somebody else's clothes. I'm glad I didn't complain," he says. With a faraway look in his eyes, he talks about why his mother felt so strongly about making "originals." Suddenly the merry flying shirts in ¼ *Mile Piece* take on another layer of meaning.

HIS WHITE SAMOYED,

Tanya, walks into the studio, and extends her paw in greeting. "What a lady!" he exclaims. "She always holds out her paw so politely." He pets the dog, and is soon joined by Sea C., a dark, friendly mutt who also seeks her master's attention.

Rauschenberg's love for his dogs is legendary. The street in front of his house is named for the late Laika. Because Laika was having puppies, he almost missed the Apollo 11 moon shot launching to which he had been invited as a documentary artist, an event that because of his passion for outer space exploration was a highlight of his life. When the fifteen-year-old blue-eyed husky, Star, had to be put to sleep, Rauschenberg was inconsolable.

"He's that passionate about all of life," says Walter Hopps, who organized Rauschenberg's Bicentennial retrospective. "He loves with such equal intensity: men, women, children, dogs, trees, rocks . . . all of life." Whether or not he *feels* more intensely than others, Rauschenberg is certainly extravagant in expressing his feelings. He sends gifts to friends on *his* birthday. His expansiveness, his

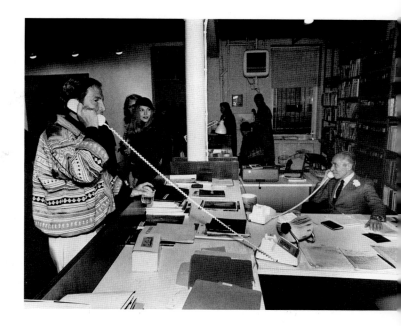

Rauschenberg and Leo Castelli (seated), his longtime art dealer and champion. Photograph by Michael L. Abramson/TIME magazine

sweetness and energy draw people to follow him, to collaborate, and to be part of his enterprise. He hugs, he kisses, he weeps, he dances, he yells, he apologizes, he holds the hands of the suffering.

"When my husband, Paul, was dying," recalls his eighty-seven-year-old Captiva neighbor, artist Oneita McCulloch, "he couldn't eat solid food. And so Bob would make soft things like lime custard and send them over every day."

AFTER ELEVEN in the evening, Rauschenberg finally stops work on the painting. It is now time for his one real meal of the day. The artist-turned-chef is at his "station" behind the chest-high bar in his kitchen.

Rauschenberg and Pottorf have teamed up to cook for the guests who have watched him paint. The artist's contribution is a mango pie made with fruit picked in his yard. Using Rauschenberg's fiery homemade barbecue sauce, Pottorf cooks chicken over charcoal on the small porch overlooking the Gulf. Everyone sits on the bar stools, relishing the food as well as Rauschenberg's stories, mostly humorous ones, about life as an artist. He talks about Elaine and Bill de Kooning's dramatic spats, Ben Shahn's volcanic temper, Jasper Johns's passion for poetry, and his own predicament in Moscow when he found that the audio tapes he used for the score of Trisha Brown's *Astral Convertible* had been stolen from the stage. Rauschenberg himself is quick to laugh at the human comedy in which he is an amused and fallible participant.

His home is as spare as his studio. The living room is bare of furniture except for a low white sofa built into a corner on the floor. The sofa is occupied now, as on most evenings, by Tanya and Sea C. There are always fresh flowers in his home and in his studio, but his surroundings are as austere as his "giving" side is flamboyant. On the wall tonight is one large new painting on metal and *High School Days*, a 1969 Jasper Johns lead relief of one black shoe with a small, round mirror in its toe.

His guest room door is a Cardbird like that in the Gemini G.E.L. exhibition at the National Gallery of Art, his perfect replica of cardboard boxes printed on both sides and built to be a door. His bed is on the floor, Japanese style. On the one chest of drawers is a photograph of his son, Christopher, in mime costume.

He lives simply, but well.

Rauschenberg usually sleeps until after noon. He drinks black coffee and watches the morning television news programs which have been taped for him, and then his favorite soap opera, "The Young and the Restless." In the afternoons, he enjoys the Florida sun, sometimes fishing, windsurfing (which he learned at fifty), or playing tennis, a sport he took up at sixty. He goes over decisions with his office manager Bradley Jeffries, and is on the telephone with Donald Saff, discussing the complex logistics of the next ROCI trip. He works on estate planning with his accountant, Rubin Gorewitz.

The latter task is one Rauschenberg approaches reluctantly. He does not want to go to Heaven, or anywhere else, after life. "I'd rather keep working in my studio," he explains. He tries to empty his mind of the past and to block his mind against the future, as he propels himself full tilt into the present. "I guess I'm like John Cage," he says. "John Cage, Morty Feldman, Christian Wolf, and Earle Brown [all musicians] were driving up to New London for some concert. And to get rid of the car boredom of just driving and driving, the question was asked, 'If you could choose a moment in history that you would like to live in, what would it be?' They all took their time thinking and giving their choices. Morty Feldman

ART CAR/BMW *1986. Decals affixed to an automobile. Collection BMW of North America, New York. Rauschenberg and Art Car beside his Florida jungle. Commissioned by BMW as part of an "art car project," the artist embellished the automobile with decals. Photograph by Terry Van Brunt*

picked some kind of beautiful Mozartian, baroque period. John was the last to answer, and he said in that soft high voice, 'I'd like the next five minutes.'"

Rauschenberg enjoys the moment. His days are filled with merriment of one kind or another. But he is a serious man, who perceives suffering and injustice as personal attacks. When the attacks are indeed personal, whether intended or not, he feels the wounds for years. This is evident, even though he tries to salve the hurt with humor through self-deprecating stories. Through humor, he also fights to retain his humility despite his own towering ego. He is beset with his own private demons which have led him to drink Jack Daniel's for more years than anyone can believe. After parties and openings, he worries whether he has disgraced himself. His friends are amazed that his body continues to function, but most drink with him and worry privately. His friends and staff are protective. He is so gentle, caring, brilliant, and funny that they feel for the tragic nature of his obsession. But function he does. For Rauschenberg, there is such joy in work that it supersedes everything else.

BEGINNING the big metal piece has thrown him into a week of all-night work frenzy. Finally, the "That's it" comes for the three-paneled painting. It looks nothing like the spare "early Marden" that lay on the table, nor even like the

painting with the rose, window, ram, wagon, and sunflower that emerged from Rauschenberg's first day's work. Now it is on the studio wall, dense with imagery and rippling with color.

The neon-orange rose, as big as Rauschenberg's head, has been over-screened in yellow, a sunny contrast to the dull gray metal background. Only the orange shadow remains. The horizontal red stripe across the top also remains. The image of the purplish Chilean lake bed has been screened over with the same image, in white but bigger. Only a ghost of violet remains. In the center panel on the stainless steel, another double-screen of a half wheel has been added.

Other new images have been piled on, including one of a statue. The final touch is another over-painting, a metallic silver brush stroke that makes the connection between the half wagon wheel with the spokes and the round-horned ram, which is still dark purple. While images are still of China and Chile, the international origins of the imagery have been subsumed by the composition itself. The arrangement has turned out to be almost gridlike, what John Cage would call a "Rauschenberg Mondrian." In this composition, the total effect of the vibration of color against metal is stately. The name of the picture: *Exotic Trail* (1988). "The title is always the last layer of color," says Rauschenberg. "We worked into the wee hours for several nights on that one," comments John Peet. "Yes, *we* did," jokes Rauschenberg.

His modus operandi is collaboration and Rauschenberg is always open to the fresh vision of the young artists who work as his assistants. "My eye gets so used to seeing things the same way, I can always learn from a new pair of eyes looking in a different way," he says.

Rauschenberg admires, but tries not to influence the work of his collaborators. Minimalists Marden and Dorothea Rockburne show no evidence that they were once his studio assistants; neither do Takahashi, Petersen, Pottorf, Voytek, or Nicholas Howey. These artists acknowledge how much they have learned about light, form, technique, and art history from working with Rauschenberg. He acts as mentor, encouraging them in their own pursuits, promoting their work, curating exhibitions for them, but never suggesting they follow his methods or styles. "That much I learned from Albers, too," he says with a wry grin.

Late at night at his beach house, with the big new picture finished, Rauschenberg is quiet and introspective. He talks about being southern—how it has given him a certain sensibility and a sense of place. He talks about visiting an astrologer, and about the good-luck amulets he always carries in his pockets, among them an arrowhead, a piece of quartz, a chunk of turquoise, even the pharaoh's eye given to him by the Aga Khan.

He talks about his continuing commitment to a useful collaboration between art and science to "integrate the creative mind with the new super technology." His anguish at the thought of nuclear war—of war of any kind—is countered by his fascination with and hopes for space exploration. Imagery of the planets, of the universe, pervades ¼ *Mile Piece*. He speaks passionately of space and space travel. "It's peaceful," he says. "One of the only mediums we have committed ourselves to that is peaceful. So many scientific advances here on earth come from explorations in outer space. I can't figure out why we can't build an obsession for science that is not based on *destruction*."

He has been leaning over the bar, reflecting. Suddenly, he stands. "I have a place where I go when I have to be absolutely alone, and surrounded by peaceful thoughts." This time he makes an exception and invites company.

It is 2:30 in the morning. He jumps into the car with one assistant and two guests, drives down the lane and across the road, takes down the "No Trespassing" chain and heads down a lane toward the bay. There, so far out in the

Rauschenberg in front of Fish House, Captiva, 1979. Photograph by Terry Van Brunt

water that it looks like a houseboat floating in the early morning blackness, is the modest white frame cottage with a tin roof, the Fish House. It is a simple house with one bedroom, the bed on the floor Japanese style. There is a central room with a natural wood table, a freestanding fireplace, and an adjoining kitchen. "The loft can also be used as a bedroom," he says. The house has a wraparound porch and a private deck. The Fish House, with its shiny pine floors and many-paned windows, is immaculate. "It is so *peaceful* here," says Rauschenberg, throwing his arms out wide and savoring the quiet. There is only the lapping of water.

He talks about the creative process. He is awed by it, this gift of his, and he doesn't know where it comes from, nor how. "It's like a crystal, clear and hard inside, and light hits it from somewhere—from where? Somewhere in outer space, maybe, that we haven't explored yet—and what comes out is just a reflection of that light, from that unknown source."

The stars are bright as crystals as he steps across the deck, back to land. Rauschenberg looks up at infinity. "Maybe it comes from out there," he says.

NOTES

Unless otherwise indicated, material about Robert Rauschenberg and his work and direct quotations from the artist were obtained from taped interviews conducted on February 26, 1982, February 21 and 26, 1988, March 8, 1989, Captiva, Florida; November 20 and 21, 1986, Tokyo; February 6, 1988, Havana, Cuba; and in notes on conversations from 1987 through 1989. For complete citations, see the Bibliography.

A GLOBAL PALETTE

Page 15 art critic Robert Hughes: Hughes, "The Arcadian as Utopian," *Time*, 24 January 1983, 74.

Page 16 "A picture is more": Quoted in Tomkins, *The Bride and the Bachelors*, 1965, 193–4.

Pages 15–19 Material on China: Fine, *Gemini G.E.L.: Art and Collaboration*, 1984, 104–125; *Gemini G.E.L.: 7 Characters* (catalogue), essay by Donald Saff, 1983; Stanley and Elyse Grinstein, interviews with author, Los Angeles, 1 July 1987; Chun-Wuei su Chien, telephone interview with author, Washington, D.C., 1 December 1987; Donald Saff, interviews with author, Washington, D.C., 14 January 1985 and New Orleans, 9 December 1987; China videotapes made by Terry Van Brunt, 1982.

Page 19 "There were moments": Quoted in Tono, interview with Rauschenberg in *After Pollock* (unpublished transcript in English), 1984.

Page 19 "Without curiosity": ROCI/Cuba forum for students and public (unpublished transcript), Museo Nacional de Bellas Artes, Havana, 6 February 1988.

Page 19 "I thought it would be terrible": ROCI/Japan press conference (unpublished transcript), Setagaya Art Museum, Tokyo, 21 November 1986.

Page 20 He explained that his initial impulse: Statement to United Nations (unpublished document), 14 December 1984.

Page 20 "His goal": "Conversations with Artists: Rauschenberg," Nan Rosenthal, Donald Saff, Ruth Fine, National Gallery of Art, Washington, D.C. (National Gallery of Art videotape), 6 January 1985.

Page 20 "had given up on the politicians": ROCI/Cuba student forum, 1988.

Page 20 He has described: Statement to United Nations, 1984.

Page 24 "If you work alone": Dialogue with Tahir Salakhov, First Secretary, Soviet Union of Artists, Central House of Culture, Tretyakov Museum of Art, Moscow (videotape by Van Brunt), 5 February 1989.

Page 25 "I want to make": ROCI/Japan press conference, 1986.

Page 25 "My pockets are empty": Dialogue with Seiji Oshima, director of Setagaya Art Museum, Tokyo, 23 November 1986.

Page 25 "By reflecting on society,": Jean-Louis Prat, interview with author, Saint-Paul-de-Vence, France, 7 July 1984.

Page 25 "instead of having a mid-life crisis": Rauschenberg, to Tono and Japanese students, Setagaya Art Museum, Tokyo, 21 November 1986.

Page 26 He ignored the intellectuals: ROCI/Japan press conference, 1986.

Page 26 To work with Chilean artists: Saff interview, 1987.

Page 26 "The situation was volatile": ROCI/Japan press conference, 1986.

Page 26 "Why not": Quoted in Lafourcade, *El Mercurio*, 28 October 1984, 1.

Page 26 "All of the art patrons": Mario Stein, interview with Karen Wilson, Santiago, 13 November 1986.

Page 27 Rauschenberg said he made: ROCI/Japan press conference, 1986.

Page 33 Known as Potter's Valley: Cort, *Shigaraki*, 1979, 6.

Page 33 "Shigaraki is a great place": ROCI/Japan press conference, 1986; Van Brunt, interview with author, New York, 20 May 1987.

Page 37 "To break down barriers": ROCI/Cuba student forum, 1988.

Page 37 On the night before: Rauschenberg and Saff, interview with author, Havana, 6 February 1988.

Page 40 At the Moscow opening: ROCI/USSR videotape by Van Brunt, 5 February 1989; also Donald Saff, Darryl Pottorf, Todd Simmons, interviews with author, March 1989.

Page 40 "The show is very important": Simmons, *Tampa Tribune*, 27 February 1989, A6.

Page 40 Macia Shashkino, Twentieth Century Coordinator: Shashkino, conversation with author, Washington, D.C., 10 May 1989.

Page 40 "Rauschenberg brought an impetus": Chun-Wuei su Chien, translator, "Fine Arts in China," 1985.

Page 41 Jack Cowart: Cowart, telephone interview with author, 20 March 1989.

Page 41 "In the ROCI project": Hughes, *Time*, January 1983, 74.

Page 41 "the function of art" ROCI/Japan press conference, 1986.

Page 41 "Bob once wanted": Leo Castelli, interview with author, New York, 22 April 1987.

WHISTLE STOP

Page 45 called "shotgun" houses: According to James Fisher, curator at the Modern Art Museum of Fort Worth, the diagram of the "shotgun house" in the painting comes from a history of Texas architecture, depicting "shotgun" and "dogtrot" houses built by homesteaders. Fischer, interview with author, Fort Worth, 6 November 1987.

Page 47 During Port Arthur's heyday: *The WPA Guide to Texas* (compiled by Workers of the Writer's Program of the Works Projects Administration, 1940), Texas Monthly Press, 1986 (reprint), 314.

Page 49 "Gulf States was": Rufus Mier, interview with author, Port Arthur, 11 November 1987.

Page 49 "He was very businesslike": Leonard Gaspard, interview with author, Port Arthur, 11 November 1987.

Page 49 "Art was not": Dora Rauschenberg, conversation with author, New York, 21 January 1987.

Page 50 When he was about ten: Tomkins, 1980, 14.

Page 52 In the same spirit: Barbara Rose, *Rauschenberg*, 1987, 10.

Page 52 "He was a handsome boy": Mary Nell Dore, interview with author, Port Arthur, 11 November 1987.

Page 52 "He was a *definite* leader": Mary Evelyn Dunn Hayes, interview with author, Port Arthur, 11 November 1987.

Page 55 One day in anatomy class: Tomkins, 1980, 17; Rose, 1987, 13. Yevgeny Yevtushenko used this incident as the basis for his 1989 essay, "Rauschenberg and the Princess/Frog," in the ROCI/USSR catalogue.

Page 55 "It's a certain uninhibited": Jane Livingston, interview with author, Washington, D.C., 10 August 1988.

Page 55 "Maybe that's why": Lin, "The Boy from Port Arthur," *Art & Antiques*, February 1986, 60.

Page 55 "Having grown up": Lin, *Art & Antiques*, February 1986, 60.

Page 61 Scarred by their experiences: Susan Weil, interview with author, 20 May 1987.

Page 61 "Picasso, Matisse, Brancusi": Sommer, *El Mercurio* (Chile), 21 July 1985, E1.

Page 61 "He took a bedspread": Weil interview, 1987.

Page 61 At the opera: June Colbert, interview with author, New York, 30 June 1988.

Page 61 "The paintings had": Weil interview, 1987.

Page 61 Rauschenberg had seen an article in *Time:* "The ideal training . . . would combine the kind of technical skill you learn at the Boston Museum School (how to paint what you see) with the more abstract approach (painting as a language of its own) that Black Mountain provides. And on top of that there should be courses having nothing to do with art, because to develop a fine artist you have to teach the whole man." *Time*, 16 August 1948, 44.

QUIET HOUSE

Page 65 It was founded by John Andrew Rice: Harris, *The Arts at Black Mountain College*, 1987, 2–7.

Page 66 the faculty included: Harris, 1987, 265–70.

Page 66 Albers had taught: *Josef Albers: A Retrospective* (catalogue), essay by Nicholas Fox Weber, Solomon R. Guggenheim Foundation, 1988, 28–29.

Page 66 From Johannes Itten: Duberman, *Black Mountain: An Exploration in Community*, 1972, 64; As did Moholy-Nagy: Goldstein, "Teaching Modernism," *Arts Magazine*, December 1979, 110.

Page 66 At Black Mountain, Albers: *Time*, 16 August 1948, 44.

Page 66 "He was a strange man": Weil interview, 1987.

Page 66 "to open eyes": *Albers: A Retrospective* (catalogue), 1988, 31.

Page 66 Rauschenberg often states: Kostelanetz, "A Conversation with Rauschenberg," *Partisan Review*, Winter 1968, 97.

Page 66 Years later Rauschenberg: Tomkins, 1965, 198–199.

Page 67 "I was too messy": Quoted in Kostelanetz, Winter 1968, 92.

Page 67 Albers, however, noted: Harris, 1987, 126.

Page 67 "*Werklehre* is a forming": Harris, 1987, 17.

Page 67 a centaur-like "unicorn": Pictured in Harris, 1987, 126.

Page 67 ("The Supine Dome"): Harris, 1987, 151.

Page 67 "We chose him because he fit": Weil interview, 1987.

Page 69 "What was to go on the canvas": Rosenberg, "American Action Painters," *Art News*, December 1952, 22.

Page 69 To their surprise: *Life*, 9 April 1951, 22–24.

Page 69 One of these works: Tomkins, 1980, 55.

Page 70 One trip to the zoo: Weil interview, 1987.

Page 70 Later, it became: Tomkins, 1980, 308.

Page 70 The painting, "by their son": fragment of 1954 newspaper clipping as part of collage, *Untitled* (1955), Los Angeles, Museum of Contemporary Art.

Page 70 He also gave: Feinstein, "The Unknown Early Robert Rauschenberg," *Arts Magazine*, January 1985, 126.

Page 70 "I could see": Quoted in Tomkins, 1980, 62.

Page 70 Preston wrote that his pictures: Preston, *The New York Times*, 18 May 1951, 25.

Page 70 Dorothy Seckler wrote: Seckler, "Reviews and Previews," *Art News*, May 1951, 59.

Page 71 Aaron Siskind's photographs: Feinstein, *Arts Magazine*, January 1985, 126–31.

Page 71 It was the first time: Tomkins, "A Good Eye and a Good Ear," *The New Yorker*, May 1980, 40–72.

Page 71 Later, using Cage's apartment: John Cage, interview with author, New York, 20 June 1987.

Page 71 He was painting: Rose, 1987, 37.

Page 71 In August, Rauschenberg: Weil, telephone interview with author, November 1989.

Page 74 Henri Cartier-Bresson: Harris, 1987, 168.

Page 74 The two were rivals: Duberman, 1972, 346; also Harris, 1987, 217.

Page 74 "I never went": Weil interview, 1989.

Page 75 Rauschenberg's antics: Duberman, 1972, 346.

Page 75 "The first thing I remember": Merce Cunningham, interview with author, New York, 29 September 1987.

Page 75 "Bob was very handsome": Dorothea Rockburne, interview with author, New York, 4 June 1987.

Page 76 "I'd always thought": Quoted in Tomkins, 1980, 71.

Page 76 Rauschenberg said he was seeking: Rose, 1987, 45.

Page 76 It was a seminal event: Duberman, 1972, 352–58; Harris, 1987, 226–28; Tomkins, 1980, 74.

Page 76 "They are airports for lights": Cage, "On Robert Rauschenberg . . . ," *Metro 2*, 1959/1960, 43.

Page 76 For four minutes: Tomkins, 1980, 71.

Page 76 "No value judgments are possible": Francine du Plessix Gray, notes on Cage lecture, in Duberman, 1972, 349.

Page 76 "He came into Black Mountain": Cage interview, 1987.

Page 78 "Dear Betty": Archives of American Art, Department of Twentieth Century Painting and Sculpture, Washington, D.C., Accession #87–037.

Page 78 But Rauschenberg: Tomkins, 1980, 77.

Page 78 Susan's parents: Weil interview, November 1989.

Page 78 Their plan: Rose, 1987, 36.

Page 79 "It solved the packing problem": *Robert Rauschenberg* (catalogue), National Collection of Fine Arts (NCFA), 1976, 33. Also, "What is the nature of Art when it reaches the Sea?" John Cage asked whimsically in "On Robert Rauschenberg, Artist, and His Work," *Metro 2*, 1959/1960, 37.

Page 79 Twombly divided his time: Tomkins, 1980, 84–85.

Page 79 Susan would bring Christopher: Weil interview, 1987.

Page 79 "For Rauschenberg": Kaprow, "Experimental Art," *Art News*, March 1966, 78.

Page 79 Others found: Chandler, "The Colors of Monochrome," *artscanada*, October/November 1971, 26.

Page 79 De Kooning thought Rauschenberg: Tono, interview with author, Tokyo, 23 November 1986 [quoting from his interview with De Kooning, in *Chatting with Artists*, 1962].

Page 79 Barnett Newman said: Rosenberg, *The De-Definition of Art*, 1972, 91.

Page 79 In *Arts and Architecture:* Fitzsimmons, *Arts and Architecture*, October 1953, 33–34.

Page 82 In *The Art Digest:* Crehan, "The See Change," *Art Digest*, September 1953, 25.

Page 82 Yet Dore Ashton: Ashton, "57th Street," *Art Digest*, September 1953, 21.

Page 82 "We were all poor": Cage interview, 1987.

Page 82 Kline teased Barnett Newman: Tono, *After Pollock*, 1984. (Transcript in English, from original taped recording of interview.)

Page 82 "monochrome no-image": *Robert Rauschenberg* (catalogue), NCFA, 1976, 75.

Page 82 Red was the "most difficult": Rose, 1987, 53.

Page 83 "I began using newsprint": "Robert Rauschenberg . . . ," *Print*, January/February 1959, 31.

Page 83 The critical views ranged: O'Hara, "Reviews and Previews," *Art News*, January 1955, 47; Preston, *The New York Times*, 3 January 1955.

Page 83 The show's main effect: Tomkins, 1980, 107–8.

Page 83 "They were very beautiful": Ileana Sonnabend, interview with author, New York, 23 April 1987.

Page 83 His point, Rauschenberg said: Tuchman, ed., *A Report on the Art and Technology Program of the Los Angeles County Museum of Art: 1967–1971*, 1971, 286.

Page 83 there was no way of predicting: O'Hara, *Art News*, January 1955, 47; also Tomkins, 1965, 88.

THE MAN IN THE WHITE SHOES

Page 85 *Newsweek* said it: *Newsweek*, 31 March 1958, 94.

Page 85 "I think of *Bed*": Quoted in Tomkins, 1980, 137.

Page 87 "Bob Rauschenberg painted himself": Richard Koshalek, interview with author, Los Angeles, 1 July 1987.

Page 87 "flatbed picture plane": Steinberg's description refers to a horizontal surface—like that of a flatbed printing press—on which the artist fills his picture plane by looking *down*, rather than at a wall. Steinberg, "Reflections on the State of Criticism," *Artforum*, March 1972, 49.

Page 89 Johns chose a single theme: Crichton, *Jasper Johns*, 1977, 63.

Page 89 "Bob was the first person": Quoted in Tomkins, 1980, 111.

Page 89 Rauschenberg said that they gave: Tomkins, 1965, 13.

Page 89 Matson was Dora Rauschenberg's: Tomkins, 1980, 114.

Page 89 "They were deeply involved:" Tomkins, 1980, 119.

Page 89 Rauschenberg said, "It would be hard": Rauschenberg, *Autobiography* (lithograph, Broadside Art, Inc.), 1968.

Page 89 Cage recalled the friendship: Cage interview, 1987.

Page 89 "We called Bob and Jasper": Cage interview, 1987.

Page 89 Rauschenberg wrote, "Painting relates": *Sixteen Americans* (catalogue), 1959, 59.

Page 89 Art, said Cage: Tomkins, 1980, 69–70.

Page 90 The influential critics: Rosenberg, *Art News*, December 1952, 22–23.

Page 90 Thomas Hess, the editor: Hess, *Willem De Kooning*, 1968.

Page 90 He had come to dislike: Seckler, *Art in America*, May/June 1966, 76, 81.

Page 90 By the mid to late fifties: Said Reinhardt, "Square black paintings are the last paintings that anyone can paint." Lippard, "The Silent Art," *Art in America*, 1967, 58–63.

Page 90 a sad cup of coffee: The phrase is from Allan Ginsberg's poem *Howl*, published in 1955.

Page 90 As Robert Hughes interpreted it: Hughes, *The Shock of the New*, 1981, 335.

Page 90 "Goats are the oldest metaphors": Hughes, 1981, 335.

Page 90 "A stuffed goat is special": Kostelanetz, Winter 1968, 97.

Page 91 "It marks the end": Roy Lichtenstein, interview with author, New York, 3 November 1988.

Page 91 According to John Cage: Cage, *Metro 2*, May 1961, 41.

Page 91 "A pair of socks": *Robert Rauschenberg* (catalogue), NCFA, 1976, 7.

Page 91 "What is extraordinary": Quoted in Kostelanetz, *Master Minds*, 1967, 266.

Page 91 He studied the colors: "Is Today's Artist with or Against the Past?" *Art News*, Summer 1958, 46.

Page 91 Duchamp, whom he admired: Rose, 1987, 57.

Page 91 "I felt like he made it all": Dorothy Gees Seckler, transcript of interview with Rauschenberg (unpublished document), Archives of American Art, 1966.

Page 98 "I saw evidence": Tomkins, 1980, 142.

Page 98 The Rauschenberg show in March: Tomkins, 1980, 144–45.

Page 98 "pursued their careers as rivals": Castelli interview, 1987.

Page 98 Castelli later recalled: Castelli interview, 1987.

Page 98 Rauschenberg, she felt, combined: Sonnabend interview, 1987.

Page 98 He knew he could do abstract work: Rose, 1987, 100.

Page 98 he worked with Michael Sonnabend: Ileana Sonnabend interview, 1987.

Page 99 "He attacks the problems": Ashton, "Rauschenberg's Illustrations . . . ," *Arts and Architecture*, February 1961, 4.

Page 99 "The drawings are transcendent": William Lieberman, interview with author, New York, 22 January 1987.

Page 99 John Canaday called them: Canaday, *The New York Times*, 19 December 1964, C27.

Page 99 Roberta Smith in *The New York Times:* Smith, *The New York Times*, 31 October 1986, sec. 3, 26.

Page 99 Rauschenberg has often said: Kostelanetz, 1967, 251; Tomkins, 1980, 199.

Page 99 "I was bombarded with TV sets": Hughes, 1981, 345.

Page 103 Rauschenberg and his friend Andy Warhol: Rose, 1987, 78.

Page 103 As Lawrence Alloway explained: Alloway, "Rauschenberg's Graphics," *Art and Artists*, September 1970, 18–21.

Page 103 "extremely random order": Rauschenberg, *Location*, 1963, 28.

Page 103 In his spacious new loft: Tomkins, 1980, 201.

Page 103 Brian O'Doherty: O'Doherty, *The New York Times*, 28 April 1963, 13.

Page 103 Max Kozloff: Kozloff, "Art," *The Nation*, 7 December 1963, 402.

Page 103 O'Doherty wrote that: O'Doherty, *American Masters*, 1974, 248.

Page 103 As one viewer told the *Times:* O'Doherty, 1974, 248.

Page 108 He had, wrote Dorothy Seckler: Seckler, "The Artist Speaks," *Art in America*, May/June 1966, 74.

Page 108 As one cultural historian wrote: Kostelanetz, 1967, 258.

Page 108 "The way [Rauschenberg]": O'Doherty, 1974, 246–47.

Page 108 "fondness for iconoclastic": Kostelanetz, 1967, 269.

Page 108 Rauschenberg himself ascribed: Rose, 1987, 36.

Page 108 Yet his work: Hughes, 1981, 333.

Page 108 Andy Warhol said that: Tomkins, 1981, 215.

Page 108 "The Coke bottles": Lichtenstein interview, 1988.

Page 110 "most important American artist": Mullins, *Telegraph* (London), 9 February 1964, 7.

Page 110 "The most enjoyable show": *The Observer* (London), Weekend Review, 23 February 1964, 21.

MINUTIAE

Page 113 Although a dance critic: Tomkins, 1980, 104.

Page 113 "Few artistic alliances": Davis, *National Observer*, 26 June 1967, 20.

Page 115 "I felt more at home": Tomkins, 1980, 104.

Page 115 For example, in *Summerspace: Rauschenberg/Performance, 1954–1984* (catalogue), essay by Nina Sundell, 1984, 7.

Page 115 Rauschenberg joked: Quoted in Kostelantz, 1967, 253.

Page 115 "Well, if you have a chair": Cunningham interview, 1987.

Page 117 According to Cunningham: Cunningham interview, 1987.

Page 117 Rauschenberg's dramatic lighting: Jowitt, *The Village Voice*, 17 January 1977, 48.

Page 117 "Following a performance": Bland, *The Observer*, Weekend Review, 2 August 1964, 20.

Page 117 Clive Barnes: Barnes, *The New York Times*, 3 August 1964, 15.

Page 117 The causes of the disagreement: Cage interview, 1987.

Page 117 While still traveling abroad: Kostelanetz, 1967, 251.

Page 118 Tudor played a John Cage: *Rauschenberg/Performance*, 1984, 8.

Page 119 Rauschenberg disliked the term: Abeel, "Daedalus at the Rollerdrome," *Saturday Review*, 28 August 1965, 51.

Page 119 The audience, which included: Wulp, "Happening," *Esquire*, November 1963, 184.

Page 119 Jill Johnston: Johnston, "Reviews and Previews," *Art News*, Summer 1962, 53.

Page 119 Merce Cunningham, who directed: Wulp, November 1963, 184.

Page 119 Others, such as Trisha Brown: *Rauschenberg/Performance*, 1984, 9.

Page 123 Steve Paxton said the Judson group: *Rauschenberg/Performance*, 1984, 9.

Page 123 "We were out to radicalize": Deborah Hay, telephone interview with author, 23 August 1988.

Page 123 "The soaring motion": *Rauschenberg/Performance*, 1984, 9.

Page 123 Erica Abeel wrote: Abeel, *Saturday Review*, 28 August 1965, 51–53.

Page 123 According to dancer Deborah Hay: Hay interview, 1988.

Page 123 *Spring Training* (1965): Novick, "Happenings in New York," *Studio International*, September 1966, 154–59.

Page 125 Walter Terry: Terry, *New York Herald Tribune*, 11 January 1966.

Page 125 According to Trisha Brown: Trisha Brown, interview with author, New York, 26 April 1987.

Page 125 "lumbering across the stage": Brown interview, 1987.

Page 125 "Art is about taking risks": Steinbrink, *The New York Times*, 3 April 1983, 62.

Page 125 "I'd rather make a new piece": Moyano, "POP," *Washington Post Potomac Magazine*, 5 June 1966, 30.

Page 127 If audiences were bored: Kostelanetz, 1967, 265.

Page 127 "It is not like any lighting": Cunningham interview, 1987.

Page 127 "I like the *liveness* of theater": Kostelanetz, *Partisan Review*, Winter 1968, 99.

Page 127 "In a single piece by Yvonne Rainer": Kostelanetz, *Partisan Review*, Winter 1968, 102.

Page 127 "All of a sudden, from a mob": Henry Hopkins, interview with author, Los Angeles, 30 October 1987.

Page 127 "Perhaps more than any other artist": Apple, "Long Beach," *Artweek*, 7 September 1985, 5.

Page 127 *New York Times* art critic: O'Doherty, 1974, 249.

Page 127 "It seems that in theater": Rose, 1987, 85.

SOUNDINGS

Page 129 In the second scene of *Open Score: Rauschenberg/Performance*, 1984, 22.

Page 129 "Tennis is movement": Rauschenberg, "9 Evenings: Theatre and Engineering" program notes, (unpublished document), October 1966, 13–23.

Page 129 An infrared television system: Bryant, *Bell Telephone Laboratory Reporter*, November/December 1966, 14.

Page 129 *Hommage à New-York*: Tomkins, 1980, 163–64.

Page 134 For Rauschenberg, however: Davis, *Art and the Future*, 1973, 144.

Page 134 Problems of the environment: Tuchman, ed., 1971, 284–86.

Page 134 Both Rauschenberg and Klüver: Billy Klüver, interview with author, New Jersey, 26 August 1988.

Page 134 Kurt Schwitters: Wooster, "Art Sounds," *Art in America*, February 1982, 118.

Page 134 To show the possibilities: Lieberman, *The New York Times*, 11 October 1967. sec. L, 49.

Page 134 "Five pieces in the round": Solomon, *Oracle* (unpublished document), Castelli Gallery (12 May–21 June), 1965.

Page 134 At the Stedelijk Museum: Swenson, "Rauschenberg Paints a Picture," *Art News*, April 1963, 44–47.

Page 135 Back in New York: Klüver interview, 1988.

Page 135 Writing in *Arts Magazine:* Berkson, "In the Galleries," *Arts Magazine*, September/October 1965, 62.

Page 135 Alan Solomon said that *Oracle:* Solomon, *Oracle* (unpublished document), 1965.

Page 135 Harold Rosenberg wrote: Rosenberg, 1972, 166.

Page 135 During E.A.T.'s first year: Klüver interview, 1989.

Page 135 Technological innovation would shape: Lieberman, *The New York Times*, 11 October 1967, L 49.

Page 135 He had in mind a work: Kostelanetz, 1967, 255.

Page 136 Andrew Forge approvingly compared: Alloway, "Technology and Art Schools," *Studio International*, April 1968, 186.

Page 136 Writing in *The New York Times:* Glueck, *The New York Times*, 24 October 1968, 94.

Page 136 In an interview: Rose, 1987, 100.

Page 136 Gregory Battcock of *Arts Magazine:* Battcock, "Rauschenberg's New Clocks," *Arts Magazine,* May 1969, 16.

Page 136 *Los Angeles Times* art critic: Wilson, *Los Angeles Times,* 19 May 1969, sec. IV, 11.

Page 138 He now wanted to design: Tuchman, ed., 1971, 285.

Page 138 "I called it my 'blowing fuses' period": Quoted in Rose, 1987, 65.

Page 138 "It *is* primitive": Quoted in Tuchman, ed., 1971, 282, 287.

Page 138 "That was not what anybody had in mind": Livingston interview, 1988.

Page 138 A number of art critics: Rosenberg, 1972, 166.

Page 138 "It's hard for me not to build": Quoted in Tuchman, ed., 1971, 286.

Page 139 "I'm talking about conscience": Quoted in Davis, 1973, 144.

Page 139 The failure, he felt: Davis, 1973, 144.

Page 139 "We wrote in our first newsletter": Klüver, telephone interview with author, 6 August 1989.

Page 139 "It was a catalyst": Ted Victoria, interview with author, New York, 27 March 1987.

VEILS

Page 143 "the second half of the twentieth century": Mitgang, "Tatyana Grosman," *ARTnews,* March 1974, 31.

Page 143 Tanya Grosman was the daughter: Tomkins, *The Scene: Reports on Post-Modern Art,* 1970, 75.

Page 143 "I didn't know modern art": Quoted in Sparks, *Universal Limited Art Editions,* 1989, 219.

Page 143 One way that Rauschenberg: O'Doherty, 1974, 256.

Page 145 "It's such a paradox": Quoted in Tomkins, 1970, 78.

Page 145 "The image that is made": *Robert Rauschenberg in Black and White* (catalogue), introduction by Thomas H. Garber, 1969 [unpaginated].

Page 145 "This time we print it": Quoted in de la Falaise McKendry, "Robert Rauschenberg Talks . . . ," *Interview,* May 1976, 34.

Page 147 She admired his work: Goldston interview, 1988.

Page 147 "For every artist": Quoted in Sparks, 1989, 219.

Page 147 Goldston was also from the South: Goldston interview, 1988.

Page 147 "We photosensitized the stone": Quoted in Rose, 1987, 78.

Page 147 Using that process: Goldston, telephone interview with author, 9 March 1989.

Page 147 Mrs. Grosman, who needed: Goldston interview, 1988.

Page 148 "The series is an investigation": Ginsburg, "Rauschenberg's Dialogue," *Print Collector's Newsletter,* January/February 1976, 152–55.

Page 148 Mrs. Grosman was astonished: Tomkins, 1970, 79.

Page 148 It began in 1972: de la Falaise McKendry, May 1976, 34.

Page 148 "The effect was a *Last Year at Marienbad*": Towle, "Two Collaborations," *Print Collector's Newsletter,* May/June 1979, 37–41.

Page 148 Their heads are on the pillow: Towle, May/June 1979, 37–41.

Page 148 Interviewed the following year: Goldston interview, 1988.

Page 152 Rauschenberg's collaborative innovations: Goldston interview, 1988.

Page 152 Previously, a lithograph: Keith Brintzenhofe, telephone interview with author, November 1989.

Page 152 Rauschenberg has said that his lithographs: *Robert Rauschenberg in Black and White* (catalogue), 1969.

Page 153 *Booster* (1967) "virtually redefined": Fine, 1984, 48.

Page 153 "And the doctor": Sidney Felsen, interview with author, Los Angeles, 1 July 1987.

Page 153 "Every day was like a party": Stanley Grinstein interview, 1987.

Page 153 "What's really nice": Perry, "A Conversation . . . ," *artmagazine* (Canada), November/December 1978, 34.

Page 153 "Rauschenberg is the ultimate": Timothy Isham, interview with author, Los Angeles, 30 October 1987.

Page 155 Printed in three sections: *Robert Rauschenberg* (catalogue), NCFA, 1976, 175

Page 155 it contains poems from: *Robert Rauschenberg* (catalogue), NCFA, 1976, 162.

Page 159 Weil recalled the relaxed atmosphere: Weil interview, 1987.

Page 159 In 1971: *Prints from the Untitled Press, Captiva, Florida* (catalogue), essays by Jack Cowart and James Elliott, 1973, 62–63.

Page 159 A New York artist: Saff interview, 1985.

Page 162 "By folding fabric": *Graphicstudio U.S.F.: An Experiment in Art and Education* (catalogue), interview with Donald Saff, 1978, 23.

Page 162 "I read the word in Dante": Quoted in Diamonstein, *Inside New York's Art World*, 1979, 311.

Page 162 "These shimmering": Pieszak, "Robert Rauschenberg . . . ," *New Art Examiner*, January 1978, 3.

Page 162 "The first ones [1974]": Quoted in Perry, *artmagazine*, November/December 1978, 34.

Page 165 "It took six months": Felsen interview, 1987.

Page 165 "Decidedly brilliant visual poetry": Dreiss, "Robert Rauschenberg," *Arts Magazine*, February 1975, 16.

Page 165 "Breathtaking": Bourdon, *The Village Voice*, 23 December 1974, 108.

Page 165 "Some magic inhabits there": *Robert Rauschenberg: Work From Four Series: A Sesquicentennial Exhibition* (catalogue), 1987, 11.

Page 165 Ruth Fine of the National: Fine, telephone interview with author, 15 August 1989.

SIGNS

Page 169 In 1965 *Life:* "A Modern Inferno," *Life*, 17 December 1965, 46–49.

Page 172 "To do a needed work": "Robert Rauschenberg, Notes on Painting, October 31–November 23, 1963," printed in English. Tono, 1984, 291.

Page 172 "celebrating a murder": Rose, 1987, 74.

Page 172 "I was privileged to share": *Robert Rauschenberg* (catalogue), NCFA, 1976, 45.

Page 172 He said of his contribution: Rose, 1987, 76.

Page 173 "I've been working my ass off": Quoted in Cannell, "Corporate Culture," *Manhattan, Inc.*, July 1987, 106.

Page 173 "He was known as one": Lichtenstein interview, 1988.

Page 173 "Sure you do," Gorewitz told him: Rubin Gorewitz, interview with author, New York, 23 April 1987.

Page 173 "It was a very moving": Theodore Kheel, telephone interview with author, 27 July 1989.

Page 176 "Rauschenberg and others": Ashton, "Response to Crisis . . . ," *Art in America*, January/February 1969, 24.

Page 176 In Chicago: Tomkins, 1980, 286.

Page 176 In 1970, sculptor Mark di Suvero: Ashton, *Art in America*, January/February 1969, 27.

Page 176 Artists belonging to: Tomkins, 1980, 286.

Page 176 "Those paintings were about looking": Quoted in Tuchman, ed., 1971, 286.

Page 176 "The incredibly bright lights": Quoted in Tomkins, 1980, 288.

Page 178 *Sky Garden* (1969) and *Waves* (1969): *Robert Rauschenberg* (catalogue), NCFA, 1976, 159.

Page 178 "*Sky Garden* was so long": Isham interview, 1987.

Page 178 He saw the successful space mission: *Robert Rauschenberg* (catalogue), NCFA, 1976, 17.

Page 178 "How wonderfully [Rauschenberg]": Canaday, *The New York Times*, 10 July 1970, 16.

Page 180 Lawrence Alloway credited Rauschenberg: *Robert Rauschenberg* (catalogue), NCFA, Alloway essay, 1976, 17.

Page 180 In his book: Alloway, *Topics in American Art*, 1975, 134–35.

Page 180 "There was such an abundance": Quoted in Rose, 1987, 86–87.

Page 182 In a catalogue accompanying *Currents: Robert Rauschenberg: Prints 1948/1970* (catalogue), essay by Edward A. Foster, 1970.

Page 182 Rauschenberg had drawn into himself: *Robert Rauschenberg* (catalogue), NCFA, 1976, 17.

Page 182 "I want to shake people awake": Kotz, "Robert Rauschenberg's State . . . ," *ARTnews*, February 1983, 54–61.

Page 182 Writing in *Newsweek:* Davis, "Strong Currents," *Newsweek*, 27 July 1970, 69.

Page 182 John Gruen, in *New York:* Gruen, "Galleries & Museums," *New York*, 29 June 1970, 57.

Page 182 Reviewing *Currents:* Plagens, *Los Angeles Art Examiner*, 9 October 1970, 86–88.

Page 182 John Canaday of *The New York Times:* Canaday, *The New York Times*, 10 July 1970, 16.

Page 182 Rauschenberg wrote that *Signs: Robert Rauschenberg: Werke 1950–1980* (catalogue), 1980, 97.

CARDBOARDS

Page 185 In the catalogue: *Cardboards* (unpublished document), Castelli Gallery, October 1971.

Page 185 shells "ought to stay on the beach": Rauschenberg, Symposium on the New American Paperworks Exhibition (transcript, unpublished document), University of Maryland, September 1986.

Page 187 In the view of: *Rauschenberg at Graphicstudio* (catalogue), 1974 [unpaginated].

Page 187 David Shirey of *The New York Times*: Shirey, *The New York Times*, 23 October 1971.

Page 187 As the Cardboards: Typified by comments made by a docent at Marion Koogler McNay Art Museum, San Antonio, opening for *Robert Rauschenberg, Work From Four Series: A Sesquicentennial Exhibition*, 13 April 1986; Chinese art professors at ROCI/China opening, 18 November 1985; and others, in published reviews and remarks to author.

Page 187 "Each label, each piece of tape": Isham interview, 1987.

Page 187 Isham has said that: Isham interview, 1987.

Page 187 According to Isham: In December 1989, di Suvero said he did not remember the incident but that "it could have happened."

Page 187 "As offset-photo lithographs": Pincus-Witten, "Robert Rauschenberg: Cardbirds and Cardboards," *Artforum*, December/January 1972, 79–83.

Page 187 But according to Ruth Fine: Fine, 1984, 109.

Page 189 The result of this: Kelder, "Made in Graphicstudio," *Art in America*, March/April 1973, 85.

Page 189 Eaker and printer Julio Juristo: Donald Saff, lecture [transcript, unpublished document], University of New Orleans, 10 December 1987.

Page 189 The ceramic that resulted: Rauschenberg, ROCI/Japan press conference, 1986.

Page 189 When this piece was finished: Saff, New Orleans lecture, [transcript], 1987.

Page 189 "Works in his Tampa Clay Piece": Larson, "Words in Print," *Print Collector's Newsletter*, July/August 1974, 53–56.

Page 189 On approaching Venice: Robert Petersen, telephone interview with author, 23 August 1989.

Page 193 At the start: Young, "Pages and Fuses . . . ," *Print Collector's Newsletter*, May/June 1974, 25–30.

Page 193 Working with owner: Young, May/June 1974; Fine, 1984.

Page 193 "very bad yogurt": Young, May/June 1974, 27.

Page 193 Writing in the: Young, May/June 1974, 30.

Page 193 And Ruth Fine: Fine, 1984, 111.

Page 194 He jokingly complained: Tono (transcript in English), 1984.

Page 195 He told Fischer: *Rauschenberg in Israel* (catalogue), text by Yona Fischer, 1975.

Page 195 At a discussion: Meeting with Israeli students, The Israel Museum, Jerusalem, (transcript of discussion, unpublished document), 29 May 1974.

Page 195 If life in Israel: Tono (transcript in English), 1984.

Page 203 It seemed a paradise: Rosamund Felsen, quoted in Fine, 1984.

Page 203 As he described the scene: Tono (transcript), 1984.

Page 206 They looked, as Rauschenberg noted: Fine, 1984, 115–16.

Page 206 "a beautiful look—very primitive": Quoted in Tono (transcript), 1984.

Page 206 "For the first time, I wasn't embarrassed": Quoted in Tono (transcript), 1984.

Page 206 In India: Diamonstein, *Inside New York's Art World*, 1979, 311.

Page 206 "He was very excited": Christopher Rauschenberg, interview with author, New York, July 1987.

Page 207 "The Jammers construction is so simple": Quoted in Perry, *artmagazine*, November/December 1978, 35.

Page 207 "large, beautiful pieces": Perry, "Artistry Blowing in the Wind," *The Province*, 8 September 1976, 27.

Page 207 "The Jammers . . . set up": *Robert Rauschenberg* (catalogue), NCFA, 1976, 20, 22.

Page 207 "I think if there is any idea": Quoted in Perry, *artmagazine*, November/December 1978, pp. 31–35.

SPREADS

Page 209 "We are pleased": *Robert Rauschenberg* (catalogue), NCFA, 1976, foreword.

Page 209 "Rural opulence": *Robert Rauschenberg* (catalogue), NCFA, 1976, 149.

Page 209 At first, Rauschenberg: Richard Koshalek, interview with author, Los Angeles, 1 July 1987.

Page 209 Buried in the iconography: Walter Hopps, interview with author, Houston, 9 November 1987.

Page 209 In *ARTnews*, Benjamin Forgey: Forgey, "An Artist for All Decades," *ARTnews*, January 1977, 35–36.

Page 210 "I think the reason": Koshalek interview, 1987.

Page 210 "The program should celebrate": Hopps interview, 1987.

Page 210 "There's an extraordinary flow": Hopps interview, 1987.

Page 210 "It was like an Indian tribe": Hopps interview, 1987.

Page 211 "This show strongly suggests": Forgey, *ARTnews*, January 1977, 35–36.

Page 211 In *Newsweek*, Douglas Davis: Davis, "Artist of Everything," *Newsweek*, 25 October 1976, 99.

Page 211 John Russell said: Russell, *The New York Times*, 25 March 1977, C1.

Page 211 In the article: Hughes, *Time*, 29 November 1976, 54–62.

Page 211 A major dissent: Rosenberg, "The Art World: Souvenirs of an Avant-Garde," *The New Yorker*, 16 May 1977, 124.

Page 211 Rauschenberg said that the retrospective: Glueck, *The New York Times*, 25 March 1977, C19.

Page 211 After the austerity: Dorsey, *The Baltimore Sun*, 19 October 1980, D1.

Page 214 One of the conscious echoes: Lewis, "Suddenly, Old Masters," *Washington Post Magazine*, 25 February 1979, 21.

Page 214 "In recent years": Zimmer, "Robert Rauschenberg," *Arts Magazine*, September 1977, 33.

Page 214 In reviewing several: Glueck, *The New York Times*, 26 January 1979.

Page 214 For Roger Cranshaw: Cranshaw, "Rereading Rauschenberg," *Artscribe*, June 1981, 8.

Page 215 "my present to me": Quoted in Diamonstein, 1979, 314.

Page 215 The compositions became: Cage interview, 1987.

Page 215 "For many years to come": Hopps interview, 1987.

Page 215 He received $200,000: Richard, *The Washington Post*, 4 October 1980, F9.

Page 218 The Kabal series is: *Robert Rauschenberg, Work from Four Series: A Sesquicentennial Exhibition* (catalogue), essay by Cathcart, 1985.

Page 218 As he told art critic Yoshiaki Tono: Tono (transcript), 1984.

Page 218 Publicons deal symbolically: Fine, 1984, 119.

Page 230 "I became addicted": Rauschenberg, *Rauschenberg Photographs*, interview with Alain Sayag, 1981.

Page 230 "Most days Terry and I": Rauschenberg, 1981.

Page 232 "The photographs of *In + Out City Limits*": Rauschenberg, 1981.

Page 232 Writing in *Art Week:* Johnstone, "Ambiguous Images of the City," *Artweek*, January 1982.

Page 232 Andy Grundberg: Grundberg, "Another Side of Rauschenberg," *The New York Times Magazine*, 18 October 1981, 46.

SALVAGE

Page 237 Rauschenberg and Brown: Kisselgoff, *The New York Times*, 23 October 1983, 62.

Page 237 Rauschenberg liked the chance: Black, "Robert Rauschenberg," *Splash*, September 1984, 25.

Page 237 "Let's see if": Videotape of preliminary stages *Set and Reset*, Terry Van Brunt, 1983.

Page 241 In *American Masters*: O'Doherty, 1974, 253–54.

Page 241 "The hounds drew closer": O'Doherty, 1974, 254.

Page 241 "mere shadows": Tennant, "Robert Rauschenberg . . . ," *ARTnews*, April 1986, 141–42; Marcus, "The Found . . . ," *Art Week*, 15 February 1986, 1.

Page 241 Visiting with Calvin Tomkins: Tomkins, 1980, 301.

Page 241 "The most astonishing single fact": *Robert Rauschenberg: Peintures Récentes* (catalogue), essay by Nan Rosenthal, Fondation Maeght, 1984, 21.

Page 242 The large canvases: *Robert Rauschenberg: Peintures Récentes* (catalogue), 1984, 12–13.

Page 242 A vision of mortality: *Robert Rauschenberg: Peintures Récentes* (catalogue), 1984, 16–19.

Page 242 "All the great artists": Prat interview, 1984.

Page 243 "Texas white trash": Lin, "The Boy From Port Arthur," *Art and Antiques*, February 1986, 58–61.

Page 243 "the state's most famous artist": *Robert Rauschenberg, Work From Four Series* (catalogue), 1985.

Page 246 "My mother says": Remarks made at opening of Sesquicentennial Exhibition, Houston, 21 December 1985.

Page 246 It happened in 1977: Anne Livet, Bill McKay, to author at Houston, 21 December 1985.

Page 246 "It's a time of glut": Quoted in Bashaw, *Fort Myers News-Press*, 26 March 1986, D1, D9.

Page 247 "I think of the Gluts series": Quoted in Rose, 1987, 90.

Page 251 John Russell cited elements: Russell, *The New York Times*, 28 July 1989, C22.

Page 251 "Curiosity is the main energy": Black, *Splash*, September 1984, 25.

THE BIG PICTURE

Page 255 in 1961, Rauschenberg said: Parinaud, "Un 'Misfit' . . . ," *Les Arts et Spectat*, 10 May 1961. [From transcript of interview, in English, Archives of American Art]

Page 255 "If I could write": Kotz, *ARTnews*, February 1983, 54.

Page 255 "It had no conceptual": Story, *USA Today*, 26 January 1987, D4.

Page 255 *Miami Herald* art critic: Kohen, *Miami Herald*, 27 May 1984, L1.

Page 258 According to William Lieberman: William Lieberman, statement to author, New York, 23 January 1987.

Page 258 In the Metropolitan Museum: Lieberman, "Metropolitan Museum of Art Bulletin," press release (unpublished document), January 1987.

Page 258 "It reflects my travels": Story, *USA Today*, 27 January 1987, D4.

Page 258 (This is a joke): Kohen, *Miami Herald*, 27 May 1984, L1.

Page 258 Forms interact: Castelli interview, 1987.

Page 259 John Russell: Russell, *The New York Times*, 15 February 1987, H33.

Page 259 "If Picasso": Rosenthal, interview with Robert Rauschenberg, "Conversations with Artists: Rauschenberg," National Gallery of Art, Washington, D.C. (videotape), 6 January 1985.

Page 259 "Rauschenberg is the artist": Steinberg, "Reflections on the State of Criticism," *Artforum*, March 1972, 49.

Page 259 "Among artists": Lichtenstein interview, 1988.

Page 262 According to Castelli: Castelli interview, 1987.

Page 263 "When I first": Dora Rauschenberg, conversation with author, Metropolitan Museum of Art, 21 January 1987.

CAPTIVA

Page 265 "Every time I came": Quoted in Hutchinson, "The World According to Rauschenberg," *Marquee*, May 1984, 21.

Page 269 "He's that passionate": Hopps interview, 1988.

Page 270 "When my husband, Paul,": Oneita McCulloch, interview with author, Captiva, Florida, 1 March 1988.

Page 272 "Rauschenberg Mondrian": Cage interview, 1987.

CHRONOLOGY

1925	Born October 22 in Port Arthur, Texas, to Dora and Ernest Rauschenberg.
1943	Enters University of Texas, Austin, to study pharmacy.
1943	Drafted into United States Navy. Serves as neuropsychiatric technician in Navy Hospital Corps, San Diego.
1945	Honorably discharged from U.S. Navy.
1946	Works at Ballerina Bathing Suit factory, Los Angeles.
1947	Enters Kansas City Art Institute on G.I. Bill. Changes name from Milton to Bob on arrival in Kansas City.
1948	March–October: Studies at the Académie Julian, Paris. October 1948–June 1949: Attends Black Mountain College, North Carolina.
1949	September: Attends Art Students League, New York, through 1952.
1950	June: Marries Susan Weil, Outer Island, Connecticut. Makes White Paintings.
1951	July 16: Birth of son, Christopher, in New York. Attends summer and fall sessions, Black Mountain College. Makes White Paintings; Black Paintings. First one-man exhibition at Betty Parsons Gallery, New York. Spring: Included in Ninth Street Gallery, New York, "First Artists' Annual" exhibition.
1952	Attends summer session, Black Mountain College. Participates in *Theater Piece #1* by John Cage, known as the first Happening. October: Divorced from Susan Weil. Fall: Travels to Europe with Cy Twombly.
1953	Moves into studio loft on Fulton Street, lower Manhattan. Designs costumes for *Septet*, Merce Cunningham Dance Company. Makes Red Paintings.
1954	Meets fellow artist Jasper Johns. Designs first stage set, *Minutiae*, for Merce Cunningham Dance Company. Major solo exhibition of Red Paintings, Egan Gallery, New York. Makes *Charlene*.
1955	January: Moves from Fulton Street to studio on Pearl Street. Supports himself by preparing window displays with Jasper Johns for Tiffany & Co. and Bonwit Teller. Designs costumes for three Paul Taylor dance performances. Makes *Bed*; *Rebus*; *Untitled* [Man in the White Shoes].
1956	Designs sets and costumes for *Nocturnes*, Merce Cunningham Dance Company. Makes *Small Rebus*.
1957	Creates set for *Tower*, Paul Taylor Dance Company. Makes *Factum I, Factum II*.
1958	Moves to Front Street studio. Makes sets and costumes for *Summerspace* and *Antic Meet*, Merce Cunningham Dance Company. Makes *Coca Cola Plan, Curfew*. Solo exhibition, at Leo Castelli Gallery, New York, which begins the continuing relationship with the gallery.
1959	Albright-Knox Art Gallery, Buffalo, acquires *Painting with Red Letter S* (1957), the first museum purchase of a Rauschenberg painting. Designs costumes for *Rune*, Merce Cunningham Dance Company. Begins work on series of drawings based on the thirty-four cantos of Dante's *Inferno*; completed 1960.
1960	Meets Marcel Duchamp. Begins involvement with Judson Church Dance Theater. Moves from Front Street to studio on Broadway. Creates sets and costumes for *Aeon*, Merce Cunningham Dance Company.
1961	Becomes lighting director and stage manager of Merce Cunningham Dance Company, New York. Participates in *Homage to David Tudor*, American Embassy, Paris. Makes *First Landing Jump; First Time Painting; Reservoir*.
1962	Makes first lithograph, *Abby's Bird*, at Universal Limited Art Editions (ULAE). Performs in *Construction of Boston*, Maidman Playhouse, New York. Designs sets and costumes for Paul Taylor's *Tracer*. Begins *Barge*, silkscreen paintings.
1963	April: Creates, choreographs, and performs in *Pelican*, POP Festival, Washington, D.C. Creates sets and costumes for *Story*, Merce Cunningham Dance Company. Major retrospective exhibition at The Jewish Museum, New York. Wins first prize with *Accident* at "Fifth International Exhibition of Prints," Ljubljana, Yugoslavia.

1964 Creates and performs in *Elgin Tie*, Judson Theater group, Moderna Museet, Stockholm; *Shot Put*, Sur + Theater, Stage '73, New York.
Travels with Merce Cunningham Dance Company as lighting, set, and costume designer, and stage manager during world tour.
Makes *Retroactive I, II*.
Wins Grand Prize of $3,200 for painting at the Thirty-Second Venice Biennale.

1965 Moves into former orphanage on Lafayette Street, New York, for studio and living quarters.
May 1–26: Performs *Pelican*, creates and performs in *Spring Training*, First New York Theater Rally.
November: Creates and performs in *Map Room [I]*, Goddard College, Plainfield, Vermont.
December: *Map Room II* premieres in "Film-Makers Cinematheque," New York.
Makes *Oracle*.

1966 With research scientist Billy Klüver, Robert Whitman, and Fred Waldhauer, cofounds Experiments in Art and Technology (E.A.T.).
April 26: Creates and performs in *Linoleum*, NOW Festival, Washington, D.C.
October 14–23: Participates in organizing "9 Evenings: Theatre & Engineering," 69th Regiment Armory, New York; creates and performs in *Open Score*.

1967 Begins relationship with Gemini G.E.L. in Los Angeles.
Creates and performs in *Urban Round*, New York.
Makes "Booster and 7 Studies" at Gemini G.E.L. Continues technological explorations with E.A.T.

1968 Makes *Soundings; Solstice*.

1969 Makes Stoned Moon lithographs at Gemini G.E.L.

1970 Establishes permanent residence and studio on Captiva Island, Florida.
Founds Change, Inc., in New York, a nonprofit organization to provide emergency aid to artists.
Makes Currents.

1971 April: Establishes Untitled Press, Inc. at Captiva with Robert Petersen.
Makes Cardboards and Cardbirds.

1972 Begins working with Graphicstudio U.S.F., University of South Florida, Tampa.
Makes Venetian series; Tampa Clay Pieces.

1973 Makes Pages and Fuses at Moulin à Papier Richard de Bas in Ambert, France.
Begins Hoarfrosts; makes Scriptures; Made-in-Israel works.

1975 Travels to Ahmedabad, India, to make art with paper at Gandhi Ashram.
Begins Jammers.

1976 First living visual artist to be featured on the cover of *Time* magazine, November 29 issue.
Makes *Rodeo Palace*. Begins Spreads series (continues through 1981).
Major retrospective exhibition at National Collection of Fine Arts, Washington, D.C. Retrospective tours throughout United States during 1977.

1977 Designs sets and costumes for *Travelogue*, Merce Cunningham Dance Company.
Makes Chow Bags series. Begins Scales (continues through 1980).

1978 Begins serving as Chairman, Trisha Brown Company.

1979 Designs sets and costumes for *Glacial Decoy*, Trisha Brown Company.

1980 Subject of book, *Off the Wall: Robert Rauschenberg and the Art World of Our Time*, by Calvin Tomkins.
Makes Cloisters; Signals.

1981 Begins work on *The ¼ Mile or 2 Furlong Piece*.
Makes Arcanum; In + Out City Limits (photographs); Photems; Kabal American Zephyr.

1982 Travels to Jingxian, China, to work at Xuan Paper Mill.
Works in ceramics at Otsuka Chemical Company, Shigaraki, Japan.
Makes *Chinese Summerhall*; Japanese Clay Pieces; Bifocal series.

1983 Makes art in Thailand and Sri Lanka.
Creates sets and costumes for *Set and Reset*, Trisha Brown Company.
Begins Salvage (continues through 1985).

1984 December 13: Announces Rauschenberg Overseas Culture Interchange project and tour at the United Nations, New York.
Travels to Mexico and Chile, collecting images for ROCI.
Makes Sling Shots Lit.

1985 Makes ROCI/Chile; ROCI/Venezuela artworks.
Begins ROCI exhibitions in twelve countries, which continues 1985–1990.

1986 Makes Gluts; Shiners; ¼ *Mile Piece;* ROCI/Japan artworks.

1987 January 1: ¼ *Mile Piece* opens at Metropolitan Museum of Art, New York.
Makes Passes; Tibetan Locks; Keys.

1988 Makes Bleachers; Urban Bourbons; ROCI/Cuba artworks.

1989 Creates set and lighting for *Astral Convertible*, Trisha Brown Company.
Makes ROCI/USSR; ROCI/East Berlin; ROCI/Malaysia artworks.

SELECTED AWARDS AND HONORS

1960 Prize of $3000, Society for Contemporary American Art Annual Exhibition XX and 20th Anniversary Exhibition, Art Institute of Chicago, for *Inlet* (1959).

1962 Ohara Museum Prize, Third International Biennial Exhibition of Prints, National Museum of Modern Art, Tokyo.

1963 First prize, Fifth International Exhibition of Prints, Gallery of Modern Art, Ljubljana, Yugoslavia.

1964 Grand Prize, 32nd International Venice Biennial Exhibition of Art, Italy.

1965 William A. Clarke gold medal for *Axle* [1964], The 29th Biennial Exhibition of Contemporary American Painting, Corcoran Gallery of Art, Washington, D.C.

1966 Norman Wait Harris Silver Medal and Prize, for *Oracle*, Art Institute of Chicago, 68th American Exhibition.

1967 Honorary degree, Doctor of Humane Letters, Grinnell College, Iowa.

1976 The Logan Award, Art Institute of Chicago. Honorary Doctorate in Fine Arts, University of South Florida, Tampa.

1977 Mayor's Award of Honor in Arts and Culture, Mayor's Commission for Cultural Affairs, New York.

1978 Creative Arts Medal in Painting, Brandeis University, Massachusetts. Elected member of the American Academy of Arts and Sciences.

1979 Grand Prix d'Honneur: International Exhibition of Graphic Art, Ljubljana, Yugoslavia. Special Award, Eighth Graphic Arts Biennial, Krakow, Poland. Gold Medal for Graphics, Oslo, Norway.

1980 Elected foreign member of the Royal Academy of Fine Arts, Stockholm.

1981 Named Officier, Ordre des Arts et Lettres, Ministry of Culture and Communication, France. Designated Fellow, Rhode Island School of Design.

1982 Skowhegan Medal for Painting, Skowhegan College, Maine.

1983 Bronze Award: Laureate of the International Print Biennial, Special Exhibition, from the City of Ljubljana, Yugoslavia.

1984 Grammy Award, National Academy of Recording Artists and Sciences for Best Album Package, for *Speaking in Tongues*, The Talking Heads. Honorary Doctorate in Fine Arts, New York University. Jerusalem Prize for Arts and Letters, Friends of the Bezatel Academy of Jerusalem, Philadelphia chapter.

1985 Andres Bello Medal for outstanding achievement in the fields of culture and education, presented on behalf of Venezuela by President Jaime Lusinchi. Certificate of Merit from Ministry of Culture, Beijing, People's Republic of China, for contribution to cultural exchange through ROCI/China.

1986 Golden Plate Award, 25th Anniversary Salute to Excellence, the American Academy of Achievement. Award for Excellence in International Cultural Interchange, World Print Council, presented at New American Paperworks Conference in College Park, Maryland.

1987 3rd annual award: to visual artist for use of photography in mixed media, International Center of Photography.

1989 The Algur H. Meadows Award for Excellence in the Arts presented by the Meadows School of the Arts, Southern Methodist University, Dallas, Texas. Florida Prize: to a Florida resident who excels in the visual and performing arts, presented by Florida Governor Bob Martinez.

SELECTED MUSEUM COLLECTIONS

Academy of Fine Arts, Honolulu
Albright-Knox Art Gallery, Buffalo, New York
Allen Memorial Art Museum, Oberlin College, Ohio
Art Gallery of Ontario, Toronto
Art Institute of Chicago
Australian National Gallery, Canberra
Baltimore Museum of Art
Centre National d'Art et Culture Georges Pompidou, Paris
Centro Cultural Arte Contemporaneo, Mexico City
Chrysler Museum, Norfolk, Virginia
Cleveland Museum of Art
Dallas Museum of Art
Des Moines Art Center
Detroit Institute of Art
Fort Worth Art Museum
Hara Museum of Contemporary Art, Tokyo
High Museum, Atlanta
Hirshhorn Museum and Sculpture Garden, Smithsonian Institution, Washington, D.C.
Hunter Museum of Art, Chattanooga, Tennessee
Israel Museum, Jerusalem
John and Mable Ringling Museum of Art, Sarasota, Florida
J. P. Speed Art Museum, Louisville, Kentucky
Kaiser Wilhelm Museum, Krefeld, West Germany
Kunstmuseum, Basel
Kunsthaus, Zurich
Kunstsammlung Nordrhein-Westfalen, Düsseldorf
Los Angeles County Museum of Art
Louisiana Museum of Modern Art, Humlebaek, Denmark
Ludwig Museum, Cologne
Menil Collection, Houston
The Metropolitan Museum of Art, New York
Minneapolis Institute of Art
Moderna Museet, Stockholm
Montreal Museum of Fine Art
Musée Cantonal, Lausanne
Museo de Arte Contemporaneo de Caracas
Museo Nacional de Bellas Artes, Santiago
Museo Nacional de Bellas Artes, Havana
Museum für Moderne Kunst, Frankfurt
Museum of Contemporary Art, Los Angeles
Museum of Fine Arts, Houston
Museum Folkwang, Essen, West Germany
Museum of Modern Art, New York
National Art Gallery, Beijing
National Gallery of Art, Washington, D.C.
National Museum of American Art, Washington, D.C.
National Museum of Art, Osaka, Japan
Nelson-Atkins Museum of Art, Kansas City
Neue Pinakothek Museum, Munich
New England Center for Contemporary Art, Brooklyn, Connecticut
New Orleans Museum of Art
New York University Art Collection
Norton Simon Museum, Pasadena, California
Philadelphia Museum of Art
Rose Art Museum, Brandeis University, Waltham, Massachusetts
Sammlung Ludwig, Neue Galerie Der Stadt, Aachen, West Germany
San Francisco Museum of Modern Art
Setagaya Art Museum, Tokyo
Sogetsu Art Museum, Tokyo
Staatsgalerie, Stuttgart
Stedelijk Museum, Amsterdam
The Solomon R. Guggenheim Museum, New York
The Tate Gallery, London
The University of North Carolina Museum of Art, Raleigh
Tretyakov Gallery, Moscow
Vancouver Art Gallery, Vancouver
Wadsworth Atheneum, Hartford, Connecticut
Walker Art Center, Minneapolis
Weatherspoon Gallery, University of North Carolina, Greensboro
White Museum of Art, Cornell University, Ithaca, New York
Whitney Museum of American Art, New York

SELECTED SOLO EXHIBITIONS

1951 Betty Parsons Gallery, New York, May 14–June 2, first one–man exhibition of seventeen paintings.

1953 Galleria dell'Obelisco, Rome, opened March 3, "Scatole e Feticci Personali." Traveled to Galleria d'Arte Contemporanea, Florence, opened March 14.
Stable Gallery, New York, September 15–October 3.

1954 Egan Gallery, New York, December 1954–January 1955, "Red Paintings."

1958 Leo Castelli Gallery, New York, March 4–29 (and annually thereafter), Combines.

1959 Galleria La Tartaruga, Rome, opened May 30.
Galerie 22, Düsseldorf.

1960 Galerie 22, Düsseldorf, April 22–May 30.

1961 Galerie Daniel Cordier, Paris, April.
Galleria dell'Ariete, Milan, October.

1962 Dwan Gallery, Los Angeles, March 4–31.

1963 Galerie Sonnabend, Paris, February 1–16 and February 20–March 9, consecutive exhibitions: "Première Exposition" and "Seconde Exposition" (and regularly thereafter through 1980).
Dartmouth College, Hanover, N.H., February 3–28.
The Jewish Museum, New York, March 31–May 12, retrospective of works from 1949–62.

1964 Whitechapel Gallery, London, February, "Robert Rauschenberg, Paintings, Drawings and Combines, 1949–1964."
Galerie Sonnabend, Paris, May.
Arte Moderna, Turin, June.
Museum Haus Lange, Krefeld, West Germany, September 12–October 18, paintings.

1965 Amerika Haus, West Berlin, January 8–February 4.
Sperone Gallery, Turin, April 22–30.
Moderna Museet, Stockholm, drawings for Dante's *Inferno*. Traveled to Stedelijk Museum, Amsterdam, May 28–June 28.
Walker Art Center, Minneapolis, May 3–June 6, "Rauschenberg, Paintings 1953–1964."
The Museum of Modern Art, New York, December 21–May 6, 1966, drawings for Dante's *Inferno*.

1966 Whitechapel Gallery, London, drawings for Dante's *Inferno*. Organized under auspices of the International Council of the Museum of Modern Art. Traveled to American Embassy, London; Hatton Gallery, University of Newcastle–upon–Tyne; Ashmolian Museum, Oxford; The Arts Capital Gallery, Cambridge.

1967 Leo Castelli Gallery, New York, May 13–June 10, "Revolvers."
Douglas Gallery, Vancouver, B.C., July 5–31, "Booster and 7 Studies."

1968 Stedelijk Museum, Amsterdam, February 23–April 7, "Soundings." Traveled to Kolnischer Kunstverein, Cologne, April 19–May 26; Musée d'Art Moderne de la Ville de Paris, June 7–July 14.
Peale Galleries of Pennsylvania Academy of the Fine Arts, Philadelphia, March 7–April 14, paintings.
The Museum of Modern Art, New York, October 22–January 26, 1969, "Soundings."

1969 Fort Worth Art Center, January 5–February 2, first American showing of *Solstice*.
Ace Gallery, Venice, Calif., April 26–May 17, "Carnal Clocks."
Museum Boymans–Van Beuningen, Rotterdam, February 8–March 6, "Drawings."
Newport Harbor Art Museum, Balboa, Calif., December 10–January 18, 1970, "Rauschenberg in Black and White: Paintings 1962–63, Lithographs 1962–67." Traveled to Phoenix Art Museum, Ariz., February 3–March 15; University of New Mexico, Albuquerque, April 6–May 3; Seattle Art Museum, Wash., May 22–June 21, 1970.

1970 Institute of Contemporary Art, Philadelphia, April 1–May 10, "Rauschenberg: Graphic Art." Traveled to Art Gallery, State University of New York, Albany, July 1–August 14; Marion Koogler McNay Art Institute, San Antonio, August 30–October 4; The Museum of Contemporary Art, Chicago, October 31–December 31.
Dayton's Gallery 12, Minneapolis, April 4–May 2, "Currents." Traveled to Castelli Graphics, New York, June 5–7; Automation House, New York, April 4–June 28.
Pasadena Art Museum, Calif., July 7–September 6, Stoned Moon series.
The New York Cultural Center, Summer, Currents and graphics.
Minneapolis Institute of Arts, August 10–September 27, "Robert Rauschenberg: Prints 1948/1970."
Kunstverein, Hannover, West Germany, August 29–September 27, graphics. Traveled to Fort Worth Art Center, September 29–October 25; Kunstmuseum, Basel, Switzerland, October 30–December 6.
Visual Arts Museum, School of Visual Arts, New York, November 17–December 16, drawings. Traveled to The Art Institute of Chicago, January 4–29, 1971; Dayton's Gallery 12, Minneapolis, May 1971.

1971 Dayton's Gallery 12, Minneapolis, June, Cardboards and Cardbirds.

1972 Multicenter Grafica, Milan, opened April 27, Stoned Moon and Currents.
Galerie Burén, Stockholm.

EXHIBITIONS

1973 Mitchell Gallery, Southern Illinois University, Carbondale, January 7–26, "Robert Rauschenberg: Prints."
 The Mayor Gallery, London, April 18–May 12, drawings.
 Jack Glenn Gallery, San Diego, Summer.

1974 University of South Florida, Tampa, January 11–February 15, "Rauschenberg at Graphicstudio."
 Galerie Sonnabend, Geneva, April.
 Israel Museum, Jerusalem, "Rauschenberg in Israel," May.
 Jared Sable Gallery, Toronto, Canada, September, "Tablet Series."
 Los Angeles County Museum of Art, October 22–January 26, 1975, "Pages and Fuses."
 Lucio Amelio Modern Art Agency, Naples, Italy, November.
 Museum Haus Lange, Krefeld, West Germany, December 1–January 19, 1975.
 Leo Castelli and Sonnabend Galleries, New York, December 7–28, first exhibition of Hoarfrosts.
 Galerie Mikro, West Berlin, Germany.

1975 Margo Leavin Gallery, Los Angeles, January, Hoarfrost Editions.
 Visual Arts Museum, School of Visual Arts, New York, February 24–April 2, "Robert Rauschenberg: Drawings."
 Museo d'Arte Moderna Ca'Pesaro, Venice, September 6–October 6, "Rauschenberg." Traveled to Galleria Civica d'Arte Moderna, Ferrara, January 18, 1976–March 7, 1976; Forte di Belvedere, Florence, September 11, 1976–October 19, 1976.
 Galerie Tavit, Munich, October 3–31.
 Visual Arts Museum, School of Visual Arts, New York, October 6–31, "Robert Rauschenberg: Twenty–Six Years of Printmaking."

1976 Galerie H. M., Brussels, January 28–March 10, "Rauschenberg Hoarfrost."
 Galerie D, Brussels, opened January 28, "Tampa Drawings."
 Alberta College of Art, Calgary, Canada, October 12–November 7, "Rauschenberg: Glass Handle."
 National Collection of Fine Arts, Washington, D.C., October 29–January 2, 1977, major retrospective to commemorate the Bicentennial. The Smithsonian–sponsored retrospective traveled to The Museum of Modern Art, New York, March 25–May 17; San Francisco Museum of Modern Art, June 24–August 21; Albright–Knox Art Gallery, Buffalo, N.Y., September 27–October 30; The Art Institute of Chicago, December 3–January 15, 1978.
 Galerie de Gestlo, Hamburg, Germany.
 Galleriet Lund, Sweden, "Bones and Unions."
 United States Information Agency, Washington, D.C., prints, traveling exhibitions 1977 through 1979.

1977 Linda Farris Gallery, Seattle, September 5–30, Hoarfrosts and Jammers.
 Janie C. Lee Gallery, Houston, October 29–November.
 Ace Gallery, Venice, Calif., November 20–December 14, "New Paintings: Spreads and Scales."
 Galerie Rudolf Zwirner, Cologne.
 John Berggruen Gallery, San Francisco, prints.

1978 The Mayor Gallery, London, June 28–August 11, "Robert Rauschenberg: An Exhibition of Recent Work" [Spreads and Scales].
 Vancouver Art Gallery, September 8–October 29, Spreads and Scales.
 Denise Rene/Hans Meyer, Düsseldorf, "Robert Rauschenberg."
 Fort Worth Art Museum, *Whistle Stop* [Spread], commissioned by museum.

1979 Richard Gray Gallery, Chicago, January 19–March 10, "New Works" [Spreads and Scales]. Spreads and Scales were also exhibited at Akron Art Institute, Ohio, February 3–March 18; Ace Gallery, Venice, Calif., February 16–March 24; Richard Hines Gallery, Seattle, February 19–March 24; Gloria Luria Gallery, Bay Harbor Islands, Fla., February 24–March 19; Portland Art Center, Oreg., April 2–30.
 Kunsthalle Tubingen, West Germany, May 4–June 24, "Robert Rauschenberg: Drawings." Traveled to Kunstmuseum Hannover mit Sammlung Sprengel, West Germany, August 19–September 23.
 The Center for Music, Drama and Art, Lake Placid, N.Y., June 28–July 15, "Hiccups."
 Musée de Toulon, France, July 14–September 23.
 Art in Progress, Cologne, West Germany.
 Institute for Contemporary Art, Richmond, Va., "Rauschenberg: Prints/Multiples."

1980 Gallery of Fine Art, Edison Community College, Fort Myers, Fla., February 3–27, Spreads and Scales.
 University Gallery of Fine Art, Ohio State University, Columbus, February 14–March 16.
 Visual Arts Museum, School of Visual Arts, New York, March 11–28, "Variable Editions."
 Staatliche Kunsthalle, West Berlin, March 23–May 4, "Rauschenberg: Werke 1950–1980" [retrospective]. Traveled to Kunsthalle, Düsseldorf, June 6–July 13; Louisiana Museum, Humlebaek, Denmark, September 20–November 23; Städtisches Galerie im Städel, Frankfurt, December 4–January 18, 1981; Städtisches Galerie im Lenbachhaus, Munich, February 4–April 5; Tate Gallery, London, April 29–June 14, 1981.
 Anniston Museum of Natural History, Ala., June 6–September 6.
 Cranbrook Academy of Art, Bloomfield Hills, Mich., September 14–October 26, Spreads and Scales.
 Children's Hospital, Washington, D.C., October 3, dedication of commissioned work, *Periwinkle Shaft*.
 Baltimore Museum of Art, October 5–November 30, "Robert Rauschenberg: 1970–1980."
 Galleriet Lund, Sweden, November 29–December 21, Rookery Mounds, Hoarfrosts, Unions, Cardboards.
 Conejo Valley Art Museum, Thousand Oaks, Calif., drawings for Dante's *Inferno*.

1981 The New Gallery of Contemporary Art, Cleveland, Ohio, January 6–February 21, "Robert Rauschenberg: Recent Works: Spreads, Drawings, Etchings, Photographs."

Galerie Watari, Tokyo, January 16–February 10, photographs.
Colorado State University, Fort Collins, March 3–April 4, "Rauschenberg in the Rockies," prints from U.L.A.E. and Gemini G.E.L. Traveled to Boise Gallery of Art, Ida., April 11–May 10; Aspen Center for the Visual Arts, May 29–July 15; Colorado Springs Fine Arts Center, August 15–October 4; Northern Arizona University Art Gallery, Flagstaff, October 8–November 6; University of Southern Colorado, Pueblo, February 3–28, 1982; University of Wyoming, Laramie, March 14–April 11; The Walter Phillips Gallery, The Banff Centre School of Fine Arts, Alberta, Canada, May 9–June 2; Arvada Center for the Arts and Humanities, Colo., June 25–July 29; New Mexico Museum of Fine Arts, Santa Fe, August 13–September 26; Laguna Gloria Art Museum, Austin, October 29–December 12, 1982.
Musée National d'Art Moderne, Centre Georges Pompidou, April 15–May 27, photographs. Traveled to Musée Cantini, Marseille, November 15–December 15; Musée des Beaux-arts, St. Etienne, January 6, 1982–February 28; Moderna Museet, Stockholm, March 15–April 30; Aarhus Kunstmuseum, May 22–June 15, 1982.
Styria Gallery, New York, May 14–June 27, "Arcanum I–XIII."
Institute of Contemporary Art, Boston, September 15–November 1, Photems.
The Mayor Gallery, London, October 12–November 14, drawings.
Gibbes Art Gallery, Charleston, S.C., October 27–November 29, "In + Out City Limits: Charleston"; Magnuson–Lee Gallery, Boston, October 20–December 14, "In + Out City Limits: Boston"; Grimaldis Gallery, Baltimore, November 5–29, "In + Out City Limits: Baltimore"; Rosamund Felsen Gallery, Los Angeles, December 31–January 23, 1982, "In + Out City Limits: Los Angeles."

1982 Gallery of Fine Art, Edison Community College, Fort Myers, Fla., February 6–26, "The 1st Footage of the ¼ Mile or 2 Furlong Piece."
Hara Museum of Contemporary Art, Tokyo, February 19–March 31.
Long Beach Museum of Art, Calif., July 4–August 29.
Flow Ace Gallery, Paris, October 23–November 27.
Van Straaten Gallery, Chicago, November 5–December 10.
The Museum of Modern Art, New York, December 2–February 1, 1983, "Rauschenberg in China."

1983 Louisiana Museum of Modern Art, Humlebaek, Denmark, opened February 3, photographs. Traveled to Tranegaar–den, Copenhagen; Esbjerg and Henie–Onstad Museum, Oslo.
Flow Ace Gallery, Los Angeles, March 16–April 9, "Robert Rauschenberg: A Selection of Work from the Last Decade."
Jingxian, Anhui Province, People's Republic of China, June–July, 7 Characters.
Gallery of Fine Art, Edison Community College, Fort Myers, Fla., July 22–September 9, "The Second Footage of the ¼ Mile or 2 Furlong Piece."
Galleria di Franca Mancini, Pesaro, Italy, August 11–September 30, "Rauschenberg/Performances: 1954–1979." Expanded version (1954–1983) traveled to Arthur A. Houghton Jr. Gallery, The Cooper Union for the Advancement of Science and Art, New York, December 7–22; Contemporary Arts Museum, Houston, May 12, 1984–June 24; Cleveland Center for Contemporary Art, September 7–October 8; North Carolina Museum of Art, Raleigh, December 18–February 17, 1985; Norton Gallery and School of Art, West Palm Beach, Fla., March 9–April 23; The University Museum, California State University, Long Beach, Calif., July 15–September 1985.
The Maryland Institute, Baltimore, October 12–November 13, "Images from China" [7 Characters].
Australian National Gallery, Canberra, December 5–January 31, 1984.

1984 Port Arthur Public Library, Texas, February 4–19, "Robert Rauschenberg Exhibition."
Heland Thordén Wetterling Galleries, Stockholm, March 15–April 23.
Galerie Beyeler, Basel, Switzerland, March–May, retrospective.
Center for the Fine Arts, Miami, May 5–July 2, "First 400 Feet, ¼ Mile Piece."
Fondation Maeght, St.-Paul-de-Vence, France, May 12–June 30, "Robert Rauschenberg: Recent Paintings" [Salvage].

1985 Fundación Juan March, Madrid, February–March, retrospective. Traveled to Fundación Joan Miró, Barcelona, March 28–May 19.
John and Mable Ringling Museum of Art, Sarasota, Fla., March 21–May 19, "Robert Rauschenberg: Works from the Salvage Series."
Museo Rufino Tamayo, Mexico City, April 17–June 23, "ROCI Mexico," inaugural exhibition of "Rauschenberg Overseas Culture Interchange."
Museo Nacional de Bellas Artes, Santiago, July 17–August 18, "ROCI Chile."
Museo de Arte Contemporaneo de Caracas, September 12–October 27, "ROCI Venezuela."
National Art Gallery, Beijing, November 18–December 5, "ROCI China."
Tibet Exhibition Hall, Lhasa, People's Republic of China, December 2–23, "ROCI Tibet."
Contemporary Arts Museum, Houston, "Robert Rauschenberg—Work from Four Series: A Sesquicentennial Exhibition," December 21–March 16, 1986. Traveled to Marion Koogler McNay Art Museum, San Antonio, April 13–June 8; Dallas Museum of Art, December 21–February 8, 1987; Art Museum of South Texas, Corpus Christi, March 11–June 5, 1987.

1986 Espace Niçois d'Art et de Culture, Nice, March 21–May 11, works on paper.
Visual Arts Museum, School of Visual Arts, New York, October 20–November 17, photographs and Photems.
Setagaya Museum of Art, Tokyo, November 20–December 23, "ROCI Japan."
Sogetsu Kaikan, Tokyo, December 1–6, "Interlink Festival."
Dallas Museum of Art, December 21–March 15, 1987, "Prints from Dallas and Fort Worth Collections."

1987 Heland Thordén Wetterling Galleries, Stockholm, March 5–April 1, Paintings on Copper and Stainless Steel.
 Kaj Forsblom Gallery, Helsinki, March 7–April 5.
 Blum Helman Gallery, New York, March 11–April 4, works on paper.
 Galerie Denise Rene Hans Meyer, Düsseldorf, April 21–June 10.
 Lucio Amelio, Naples, April 24–May 30, Neapolitan Gluts.
 Texas Gallery, Houston, opened November 10, Summer Gluts.
 Waddington Galleries, London, November 26–December 23, Gluts.
 Blue Sky Gallery, Portland, Oreg., December 3–January 3, 1988.

1988 Pace/MacGill Gallery, New York, January 21–March 5.
 Museo Nacional de Bellas Artes, Castillo de la Fuerza and Casa de las Americas (Galleria Haydee Santa Maria), Havana, February 10–April 3, "ROCI Cuba."
 Galerie Alfred Kren, Cologne, February 27–March 30, Currents.
 Knoedler Gallery, New York, May 14–June 2, drawings, (and exhibitions regularly thereafter).
 Galerie Isy Brachot, Brussels, May 18–September 3, Gluts.
 Galerie Jamileh Weber, Zurich, September 15–October 29, paintings and Gluts.
 BMW Showroom, West Berlin, September 22–October 16, Beamer series.

1989 U.L.A.E. Gallery, New York, January 13–February 28, "Soviet/American Array."
 Central House of Culture, Tretyakov Gallery, Moscow, February 2–March 5, "ROCI USSR."
 Fabian Carlsson Gallery, London, March 1–25.
 Ivory/Kimpton Gallery, San Francisco, April 6–29, "Rauschenberg Revisited: The Hoarfrost Editions, 1974."
 Akira Ikeda Gallery, Tokyo, May 9–31, "New Paintings."
 Ace Contemporary Exhibitions, Los Angeles, June, "Rauschenberg: A Selection of Paintings and Sculpture."
 Schwartz Cierlak Gallery, Santa Monica, Calif., June 16–July 16, "Rauschenberg: Prints 1965–1982."
 Fred Hoffman Gallery, Santa Monica, Calif., and Manny Silverman Gallery, Los Angeles, September 15–October 14, "Robert Rauschenberg, the Gemini Works: 1967–1988."
 Meadows Museum, Southern Methodist University, Dallas, November 4–25, "A Tribute to Rauschenberg: Works from Dallas Collections."
 Galerie Jamileh Weber, Zurich, opened November 24, "Robert Rauschenberg."
 M. Knoedler + Co., New York, November, "Robert Rauschenberg Works."

1990 Lorence/Monk Gallery, New York, January 6–28, "Rauschenberg Prints."
 Lang & O'Hara, New York, February 1–March 3, "Robert Rauschenberg: Paintings 1962–1980." Traveled to Runkel-Hue-Williams Ltd., London, May 3–June 7.
 Altes Museum (Neue Berliner Galerie Im Alten Museum), East Berlin, March 9–April 1, "ROCI Berlin."
 Balai Seni Lukis Negara National Art Gallery, Malaysia, May 24–June 24, "ROCI Malaysia."
 The Menil Collection, Houston, October, "Rauschenberg: The Early Works."
 Whitney Museum of American Art, New York, December 7, 1990–March 17, 1991, "Robert Rauschenberg: The Silk Screen Paintings, 1962–1964."

SELECTED GROUP EXHIBITIONS

1951 Ninth Street Gallery, New York, Spring, "First Artists' Annual" exhibition [later known as "The Ninth Street Show"].

1953 Stable Gallery, New York, "Artists' Annual." (Exhibited there also in 1954, 1955, and 1956.)

1957 The Jewish Museum, New York, March 10–April 28, "Artists of the New York School: Second Generation."

1958 Contemporary Arts Museum, Houston, February 27–April 6, "Collage International, from Picasso to the Present."
 Carnegie Institute, Pittsburgh, December 5–February 8, 1959, "The 1958 Pittsburgh International Exhibition of Contemporary Painting and Sculpture."
 Alan Gallery, New York, December 29–January 24, 1959, "Beyond Painting: An Exhibition of Collages and Constructions." Newport, R.I., Summer, "The Newport Jazz Festival Exhibition."

1959 Time–Life Building, New York, January 12–30, "Art and the Found Object." Traveled with The American Federation of Arts traveling exhibition, 1959–60.
 Leo Castelli Gallery, New York, April, "Three" [Rauschenberg, Bluhm, and Dubuffet].
 Museum Friedericianum, Kassel, West Germany, July 11–October 11, "Documenta II: Kunst nach 1945."
 Museu de Arte Moderna, Brazil, September 21–December 2, "V Bienal do São Paulo."
 Musée d'art Moderne de la Ville de Paris, October 2–25, "Première Biennale de Paris: manifestation biennale et internationale des jeunes artistes."
 The Museum of Modern Art, New York, December 16–February 14, 1960, "Sixteen Americans."

1960 Columbus College of Fine Arts, Ohio, March, "Some Younger Americans."
 The Art Institute of Chicago, May 17–June 18, "Society for Contemporary Art Annual Exhibition XX and 20th Anniversary Exhibit."
 Des Moines Art Center, Iowa, "Six Decades of American Painting."

1961 Stedelijk Museum, Amsterdam, opened March, "Motion in Art."
 Galerie Iris Clert, Paris, "Les 41 présentent Iris Clert," opened May 15.
 The Museum of Modern Art, New York, October 2–November 12, "Art of Assemblage." Traveled to
 Dallas Museum for Contemporary Art, January 9, 1962–February 11; San Francisco Museum of Art,
 March 5–April 15, 1962.
 Guggenheim Museum, New York, October 13–December 31, "American Abstract Expressionists and
 Imagists."
 Carnegie Institute, Pittsburgh, October 27–January 7, 1962, "1961 Pittsburgh International Exhibition
 of Contemporary Painting and Sculpture."
 Whitney Museum of American Art, New York, December, "Annual Exhibition: Contemporary American
 Painting."
 International Council of The Museum of Modern Art, New York, "Abstract Drawings and Watercolors:
 USA." Traveled through Latin America, 1961–1963.

1962 Moderna Museet, Stockholm, March 17–May 6, "4 Amerikanare." Traveled to Stedelijk Museum, Am-
 sterdam, May–June; Kunsthalle Bern, Switzerland, July–August.
 World's Fair, Seattle, April 21–October 21, "Art Since 1950, American and International."
 Milwaukee Art Center, Wis., September 20–October 21, "Art: USA: NOW (S.C. Johnson & Son Collec-
 tion)." Traveled through Europe 1963–1965.
 Stedelijk Museum, Amsterdam, September, "Dylaby (Dynamisch Labyrint)."
 Dwan Gallery, Los Angeles, November 15–December 18, "My Country 'Tis of Thee."
 National Museum of Modern Art, Tokyo, "Third International Biennial Exhibition of Prints."

1963 The Art Institute of Chicago, January 11–February 10, "66th American Annual Exhibition."
 Guggenheim Museum, New York, March 14–June 12, "Six Painters and the Object."
 Washington Gallery of Modern Art, Washington, D.C., April 18–June 2, "The Popular Image."
 Institute of Contemporary Arts, London, October 24–November 23, "The Popular Image."
 Whitney Museum of American Art, New York, December 11–February 2, 1964, "Annual Exhibition of
 Painting."
 Gallery of Modern Art, Ljubljana, Yugoslavia, "Fifth International Exhibition of Prints."

1964 New School Art Center, New York, March 3–April 4, "The American Conscience."
 Venice, Italy, June 2–October 18, "32nd International Venice Biennial Exhibition of Art."
 Whitney Museum of American Art, New York, June 24–September 23, "Between the Fairs: 25 Years of
 American Art, 1939–1964."
 Galleria dell'Ariete, Milan, June, "Quattro Americani."
 Rose Art Museum, Waltham, Mass., October 5–November 2, "The Painter and the Photograph." Orga-
 nized by the University of New Mexico, Albuquerque. Traveled to Museum of Art, Indiana University,
 Bloomington, November 15–December 20; The Art Gallery, State University of Iowa, Iowa City,
 January 3, 1965–February 10; Isaac Delgado Museum of Art, New Orleans, February 28–March 22;
 University of New Mexico, Albuquerque, April 1–May 7; Santa Barbara Museum of Art, Calif., May 19–
 June 21.

1965 Palais des Beaux-Arts, Brussels, February 5–March 1, "Pop Art, Nouveau Realism."
 Corcoran Gallery of Art, Washington, D.C., February 26–April 18, "The 29th Biennial Exhibition of
 Contemporary American Painting."
 Whitney Museum of American Art, New York, April 28–June 6, "A Decade of American Drawings, 1955–
 1965."

1966 Museum of Fine Arts, Richmond, Va., May 16–June 12, "American Painting, 1966."
 National Museum of Modern Art, Tokyo, October 15–November 17, "Two Decades of American Paint-
 ing." Organized under the auspices of the International Council of The Museum of Modern Art. Traveled
 to National Museum of Modern Art, Kyoto; Lalit Kala Academy, New Delhi; National Museum of
 Victoria, Melbourne; Art Gallery of New South Wales, Sydney, closed August 20, 1967.
 The Museum of Modern Art, New York, November–January 1967, "Art in the Mirror." Traveled through
 the U.S. for one year.
 William Rockhill Nelson Gallery of Art, Kansas City, Mo., "Sound, Light, Silence."

1967 Finch College Museum of Art, N.Y., opened March 9, "Art in Process: The Visual Development of a
 Collage." Traveled under the auspices of the American Federation of Arts.
 Los Angeles County Museum of Art, April 28–June 25, "American Sculpture of the Sixties." Traveled to
 Philadelphia Museum of Art, September 18–October 19.
 Expo '67, U.S. Pavilion, Montreal, April 28–October 27, "American Painting Now." Traveled to Hor-
 ticultural Hall, Boston, December 15–January 10, 1968.
 9th São Paulo Biennial of the Museum of Modern Art, Brazil, September 22–January 8, 1968, "Environ-
 ment USA: 1957–1967." Traveled to Brandeis University, Waltham, Mass., February 19, 1968–March 23.

1968 The Museum of Modern Art, New York, March 27–June 9, "Dada, Surrealism, and Their Heritage."
 Traveled to Los Angeles County Museum of Art, July 16–September 8; The Art Institute of Chicago,
 October 19–December 8.
 Fondation Maeght, St.-Paul-de-Vence, France, April 13–June 30, "L'Art Vivant 1965–68."
 The Museum of Modern Art, New York, November 25–February 9, 1969, "The Machine As Seen at the
 End of the Machine Age." Traveled to the University of St. Thomas, Houston, March 25–May 10; San
 Francisco Museum of Art, June 23–August 24, 1969.
 Museum of Modern Art, Belgrade, December 30–February 2, 1969, "The New Vein: The Human Figure,
 1963–1968." Organized by the National Collection of Fine Arts International Art Program, Washington,

D.C. Traveled to Kolnischer Kunstverein, Cologne, February 23–March 23; Staatliche Kunsthalle, Baden–Baden, West Germany, April 11–May 15; Musée d'Art et d'Histoire, Geneva, July 11–September 4; Palais des Beaux-Arts, Brussels, October 21–November 16; Museum des 20. Jahrhunderts, Vienna, November 28–December 28; Galleria D'Arte Moderna, Padiglione d'Arte Contemporanea, Milan, January 22, 1970–February 21.
Denver Art Museum, Colo., "An American Report on the Sixties."

1969 Sala Dalles, Bucharest, January 17–February 2, "The Disappearance and Reappearance of the Image: American Painting Since 1945." Organized by the National Collection of Fine Arts International Art Program, Washington, D.C. Traveled to Muzeul Banatului, Timisoara, Rumania, February 14–March 1; Galerie de Arte, Cluj, Rumania, March 14–April 2; Slovak National Gallery, Bratislava, Czechoslovakia, April 14–June 15; Wallenstein Palace, Prague, July 1–August 15; Palais des Beaux-Arts, Brussels, October 21–November 16.
Neue National Galerie, Berlin, March 1–April 14, "Sammlung 1968 Karl Stroher." Traveled to Städtische Kunsthalle, Düsseldorf, April 25–June 17; Kunsthalle Bern, Switzerland, July 12–September 28.
Irvine Art Gallery, University of California at Irvine, March 18–April 27, "New York: The Second Breakthrough, 1959–1964."
The Hayward Gallery, London, July–August, "Pop Art."
The Metropolitan Museum of Art, New York, October 18–December 8, "Prints by Five New York Painters."
The Metropolitan Museum of Art, New York, October 18–February 8, 1970, "New York Painting and Sculpture: 1940–1970."
Pasadena Art Museum, Calif., November 24–January 11, 1970, "Painting in New York: 1944–1969."

1970 The Expo Museum of Fine Arts, Osaka, March 15–September 13, "Expo '70" [American Pavilion].
Fondation Maeght, St.-Paul-de-Vence, France, July 16–September 30, "L'Art Vivant aux Etats-Unis."
Institute of Contemporary Art, Philadelphia, November 14–December 22, "Against Order: Chance and Art."
Museum Haus Lange, Krefeld, West Germany, "Moon Shot Series: Prints."

1971 Contemporary Arts Center, Cincinnati, January–February, "Duchamp, Johns, Rauschenberg, Cage."
Los Angeles County Museum of Art, May 11–August 29, "Art and Technology."
Palais des Beaux-Arts, Brussels, "Métamorphose de l'Objet."
Musée du Louvre, Paris, "Le Bain Turc d'Ingres."

1972 The Art Institute of Chicago, June 24–August 20, "Seventieth American Exhibition."
High Museum, Atlanta, "The Modern Image."

1973 The New York Cultural Center, New York, January 19–March 11, "3D Into 2D: Drawing for Sculpture." Traveled to The Vancouver Art Gallery; The National Gallery of Canada, Ottawa; Allen Memorial Art Museum, Oberlin, Ohio; University of California, Santa Barbara.
Des Moines Art Center, Iowa, March 6–April 22, "25 Years of American Painting 1948–1973."
Wadsworth Atheneum, Hartford, Conn., October 17–November 18, "Prints from the Untitled Press, Captiva, Florida." Traveled through the U.S.
Moderna Museet, Stockholm, October 27–December 2, "New York Collection for Stockholm."
Parcheggio di Villa Borghese, Rome, November–February 1974, "Contemporanea."

1974 The Art Institute of Chicago, March 23–May 5, "Idea and Image in Recent Art."
Whitney Museum of American Art, New York, April 6–June 16, "American Pop Art." Traveled to Utah Museum of Fine Arts, Salt Lake City; Wadsworth Atheneum, Hartford, Conn.
Leo Castelli Gallery, New York, May 4–25, "Cy Twombly and Robert Rauschenberg."
The Museum of Modern Art, New York, September 25–November 25, "Works from Change, Inc."
Dallas Museum of Fine Arts, November 20–December 29, "Poets of the Cities: New York and San Francisco, 1950–1965." Traveled to San Francisco Museum of Art, January 31, 1975–March 23; Wadsworth Atheneum, Hartford, Conn., April 23–June 1, 1975.

1975 Los Angeles County Museum of Art, April 8–June 29, "A Decade of Collecting."
Worcester Art Museum, Mass., October 20–November 30, "American Art Since 1945." Organized by The Museum of Modern Art, New York. Traveled through the U.S.
Visual Arts Museum, School of Visual Arts, New York, November, "Formative Years: Early Works by Prominent New York Artists."
Westbroadway Gallery, New York, "Artists' Rights."

1976 Guggenheim Museum, New York, January 23–March 23, "Twentieth Century American Drawings: Three Avant-Garde Generations." Traveled to Staatliche Kunsthalle, Baden-Baden, West Germany, May 27–July 11; Bremen Kunsthalle, West Germany, July 18–August 29.
Fort Worth Art Museum, January 25–April 11, "The Great American Rodeo." Traveled to Colorado Springs Fine Arts Center, August 1–29; Witte Memorial Museum, San Antonio, February 5, 1977–April 3, 1977.
Albright–Knox Art Gallery, Buffalo, N.Y., March 6–April 11, "Heritage and Horizon: American Painting 1776–1976." Traveled to The Detroit Institute of Arts, May 5–June 13; The Toledo Museum of Art, Ohio, July 4–August 15; The Cleveland Museum of Art, September 8–October 10.
Whitney Museum of American Art, New York, March 16–September 26, "200 Years of American Sculpture."
Galerie Beyeler, Basel, Switzerland, June–September, "Autres Dimensions: Collages, Assemblages, Reliefs."

The Minneapolis Institute of Arts, September 2–October 24, "American Master Drawings and Water-colors." Organized by the American Federation of Arts. Traveled to Whitney Museum of American Art, New York, November 23–January 23, 1977; The California Palace of the Legion of Honor, San Francisco, February 19–April 17, 1977.

Galerie Beyeler, Basel, Switzerland, October–December, "America-America."

The Mayor Gallery, London, November 10–December 17, "USA*USA."

1977 Whitney Museum of American Art, New York, January 29–October 23, "Permanent Collection: 30 Years of American Art 1945–1975."

Jacksonville Art Museum, Fla., January 28–March 27, "The Florida Connection" [Rauschenberg and James Rosenquist].

New Orleans Museum of Art, La., January 28–March 27, "Five from Louisiana."

Newport Art Museum, R.I., February 13–March 27, "Two Decades of Exploration: Homage to Leo Castelli on the Occasion of his Twentieth Anniversary."

Philadelphia College of Art, October 30–December 17, "Artists' Sets and Costumes."

Musée National d'Art Moderne, Paris, "Paris–New York."

1978 Whitney Museum of American Art, New York, July 19–September 24, "Art about Art." Traveled to North Carolina Museum of Art, Raleigh, October 15–November 26; Frederick S. Wight Art Gallery, University of California, Los Angeles, December 17–February 11, 1979; Portland Art Museum, Oreg., March 6–April 15, 1979.

The Neuberger Museum, State University of New York, Purchase, September 24–November 26, "The Sense of Self: From Self-Portrait to Autobiography." Organized by Independent Curators Inc., N.Y. Traveled to the New Gallery of Contemporary Art, Cleveland, January 13, 1979–February 3; University of North Dakota Art Gallery, Grand Forks, February 13–March 8; Alberta College of Art Gallery, Calgary, November 21–December 19; Tangeman Fine Art Gallery, University of Cincinnati, February 11, 1980–March 8; The Allen Memorial Art Museum, Oberlin College, Ohio, April 1–May 4, 1980.

Albright-Knox Art Gallery, Buffalo, N.Y., December 8–January 14, 1979, "American Painting of the 1970s." Traveled to Newport Harbor Art Museum, Newport Beach, Calif., February 3–March 18; The Oakland Museum, Calif., April 10–May 20; Cincinnati Art Museum, July 6–August 26; Art Museum of South Texas, Corpus Christi, September 9–October 21; Krannert Art Museum, University of Illinois, Champaign, November 11–January 2, 1980.

Smithsonian Institution Traveling Exhibition, Washington, D.C., "Paper as Medium." Traveled through 1980.

1979 Guggenheim Museum, New York, January 18–February 25, "Art in America after World War II."

Everson Museum of Art of Syracuse and Onondaga County, N.Y., May 5–September 23, "A Century of Ceramics in the United States 1878–1978." Traveled to Renwick Gallery of the National Collection of Fine Arts, Smithsonian Institution, Washington, D.C., November 9–January 27, 1980; Cooper-Hewitt Museum, N.Y., February 26–May 25; Flint Institute of Art, Mich., June 15–August 31; The De Cordova Museum, Lincoln, Mass., September 28–November 23; The Philbrook Art Center, Tulsa, Okla., December 15–January 25, 1981; The Chicago Public Library Cultural Center, February 23–April 12; Allentown Art Museum, Pa., May 3–July 26; The Toledo Museum of Art, Ohio, September 13–October 18, 1981.

Centre National d'Art et de Culture Georges Pompidou, Paris, October 10–November 12, "Autour Merce Cunningham."

San Antonio Museum of Art, November 26–January 14, 1980, "Twentieth Century Drawings from the Whitney Museum of American Art." Organized by the Whitney Museum of American Art. Traveled to University of Iowa Museum of Art, Iowa City, February 8, 1980–March 23; Frederick S. Wight Art Gallery, University of California, Los Angeles, April 6–May 4; Minnesota Museum of Art, St. Paul, June 18–July 25; J. B. Speed Art Museum, Louisville, Ky., October 6–November 17; Loch Haven Art Center, Orlando, Fla., January 3, 1981–February 15, 1981.

1980 Grand Palais, Paris, March 13–April 13, "91ème Exposition Société des Artistes Indepéndents."

Hirshhorn Museum and Sculpture Garden, Smithsonian Institution, Washington, D.C., May 22–September 21, "The Fifties: Aspects of Painting in New York."

Whitney Museum of American Art, New York, June 3–August 31, "50th Anniversary Gifts and Promised Gifts."

Kunsthaus, Zurich, August 22–November 2, "Reliefs."

The Brooklyn Museum, New York, November 22–January 18, 1981, "American Drawing in Black and White."

Walker Art Center, Minneapolis, December 7–January 18, 1981, "Artist and Printer: Six American Print Studios."

The Tate Gallery, London, "Recent Acquisitions."

1981 The Mayor Gallery, London, March 2–30, "Major Paintings and Sculptures."

National Gallery of Art, Washington, D.C., March 22–July 19, "Contemporary American Prints and Drawings 1940–1980."

Guggenheim Museum, New York, April, "Contemporary Americans: Museum Collections and Recent Acquisitions."

Städtisches Kunsthalle, Düsseldorf, October 16–December 6, "Black."

Rheinisches Landsmuseum, Bonn, "The Portrait in Photography."

1982 The Museum of Modern Art, New York, March 1–16, "A Century of Modern Drawing."

Nationalgalerie Berlin, March 10–April 12, "Sammlung Dr. Erich Marx: Beuys, Rauschenberg, Twombly, Warhol." Traveled to Städtisches Museum Abteiberg, Mönchengladbach, West Germany.

National Gallery of Art, Washington, D.C., May 30–September 8, "20th Century Masters: The Thyssen-Bornemisza Collection." Organized by the International Exhibitions Foundation, Washington, D.C. Traveled to Wadsworth Atheneum, Hartford, Conn., October 1–November 28; The Toledo Museum of Art, Ohio, December 17–February 20, 1983; Seattle Art Museum, March 15–May 15; San Francisco Museum of Modern Art, June 2–July 31; The Metropolitan Museum of Art, New York, August 30–November 27; Phoenix Art Museum, January 6, 1984–March 2, 1984.

Stedelijk Museum, Amsterdam, April 9–July 11, "'60–'80 attitudes/concepts/images: A Selection from Twenty Years of Visual Arts."

Whitney Museum of American Art, Downtown Branch, New York, August 30–September 28, "U.L.A.E.: A Tribute to Tatyana Grosman."

Guggenheim Museum, New York, July 1–August 29, "The New York School: Four Decades."

Ethniki Pinaakothiki and Alexandre Soutzos Museum, Athens, September 20–November 7, "American Paintings 1900–1982."

Institute of Contemporary Arts, Boston, November 9–January 8, 1983, "Art & Dance: Images from the Modern Dialogue 1890–1980." Traveled to The Toledo Museum of Art, Ohio, March 6–April 24; The Neuberger Museum, State University of New York, Purchase, June 25–September 25, 1983.

John Hansard Gallery, University of Southampton, England, November, "Painter as Photographer." Traveled to Wolverhampton Art Gallery, The Museum of Modern Art, Oxford; The Royal Albert Memorial Museum, Exeter; Camden Arts Centre, Camden; Windsor Festival, Windsor Castle; National Museum of Photography, Film and TV, Bradford, England, through 1983.

1983 Arles, France, July, "Fourteenth Photographic Gathering at Arles."

The Museum of Modern Art, New York, October 26–January 3, 1984, "The Modern Drawing: One Hundred Works on Paper in the Museum of Modern Art."

Guggenheim Museum, New York, November 8–27, "Trends in Post-War American and European Art."

The Museum of Contemporary Art, Los Angeles, November 23–February 19, 1984, "The First Show: Painting and Sculpture from Eight Collections."

Fondation Nationale des Arts Graphiques et Plastiques, Paris, opened November 22, "Art Contre/Against Apartheid."

National Museum of Art, Osaka, Japan, "Modern Nude Painting 1880–1980."

1984 Castelli Graphics, New York, March 10–31, "Fifteenth Anniversary Exhibition."

Janie C. Lee Gallery, Houston, March–April, "Master Drawings."

Galerie Biedermann, Munich, opened April 12, "American Drawings."

Brooke Alexander, Inc., New York, April 24–May 19, "Icons of the '60s."

Stedelijk Museum, Amsterdam, "Summer Exhibition/20 Years of Collecting."

Galerie Beyeler, Basel, Switzerland, June 2–September 30, "Sculpture in the 20th Century."

Los Angeles County Museum of Art, June 7–October 7, "Olympian Gestures."

Philippe Bonnafont Gallery, San Francisco, July 11–August 11, "The Artist and the Theater."

Museum of Contemporary Art, Los Angeles, July 21–January 6, 1985, "Automobile and Culture." Traveled to Detroit Institute for the Arts, June 9–September 9, 1985 as "Automobile and Culture: Detroit Style."

Whitney Museum of American Art, New York, September 19–December 2, "BLAM! The Explosion of Pop, Minimalism and Performance, 1958–1964."

Fay Gold Gallery, Atlanta, October 26–November 28, "Rauschenberg and Dine."

Marisa del Re Gallery, Inc., New York, November 7–December 1, "Masters of the Sixties: From New Realism to Pop Art."

National Gallery of Art, Washington, D.C., November 18–February 24, 1985, "Gemini G.E.L.: Art and Collaboration." Traveled to Los Angeles County Museum of Art, November 1, 1985.

1985 Greenville County Museum of Art, S.C., January 14–March 10, "Twentieth Century American Printmakers: Selections from the Permanent Collection of the Whitney Museum of American Art." Traveled to Joseph and Margaret Muscarelle Museum of Art, College of William and Mary, Williamsburg, Va., April 1–June 4; Hunter Museum of Art, Chattanooga, Tenn., June 17–August 18; Sunrise Museum, Charleston, W. Va., August 31–November 3; Cranbrook Academy of Art Museum, Bloomfield Hills, Mich., November 17–January 26, 1986; Fred L. Emerson Gallery, Hamilton College, Clinton, N.Y., February 10–April 6; Huntsville Museum of Art, Huntsville, Ala., April 28–June 22, 1986.

The Art Museum, Princeton University, N.J., February 3–June 9, "Selections from the Ileana and Michael Sonnabend Collection: Works from the 1950s and 1960s." Traveled to the Archer M. Huntington Art Gallery, The University of Texas at Austin, September 8–October 27; Walker Art Center, Minneapolis, November 23–March 9, 1986.

Nelson-Atkins Museum of Art, Kansas City, Mo., April 20–May 26, "The Kansas City Art Institute's First Century."

Guggenheim Museum, June 28–September 3, "Painterly Visions, 1940–1984."

1986 Pennsylvania Academy of the Fine Arts, Philadelphia, January 24–April 13, "American Graphic Arts: Watercolors, Drawings and Prints."

Seattle Art Museum, opened February 20, "Treasures from the National Museum of American Art." Traveled to Minneapolis Institute of Arts; Cleveland Museum of Art; Amon Carter Museum, Fort Worth; High Museum, Atlanta; National Museum of American Art (Smithsonian Institution), Washington, D.C., closed May 1987.

Städtische Galerie im Lenbachhaus, Munich, July 16–November 2, "Hommage à Beuys."

The National Gallery of Art, Washington, D.C., August, "Seven American Masters."

Sogetsu Art Museum, Tokyo, October 13–March 28, 1987, "Contemporary Art Exhibition."

Museum of Contemporary Art, Los Angeles, opened December 2, "Individuals: A Selected History of Contemporary Art, 1945–1986."
Museum of Fine Arts, Santa Fe, N.M., December 19–March 22, 1987, "Poetics of Space: Contemporary Photographic Works."

1987 The John and Mable Ringling Museum of Art, Sarasota, Fla., March 7–May 31, "This Is Not a Photograph: Twenty Years of Large-Scale Photography, 1966–1986." Traveled to Akron Art Museum, Ohio; The Chrysler Museum, Norfolk, Va.
The Edith C. Blum Art Institute, Bard College, Annandale-on-Hudson, New York, April 11–July 5, "The Arts at Black Mountain College, 1933–1957." Traveled to North Carolina Museum of Art, Raleigh, July 18–October 4; Grey Art Gallery, New York University, October 25–December 19.
Los Angeles County Museum of Art, opened April 22, "Avant-Garde in the Eighties."
National Gallery of Art, Washington, D.C., May 21–September 7, "20th Century Drawings from the Whitney Museum of American Art." Traveled to The Cleveland Museum of Art, September 30–November 8; Achenbach Foundation, California Palace of the Legion of Honor, San Francisco, March 5, 1988–June 5; Arkansas Arts Center, Little Rock, June 30–August 28; Whitney Museum of American Art, Stamford, Conn., November 17–January 25, 1989.
Los Angeles County Museum of Art, June 4–August 30, "Photography and Art: Interaction Since 1946." Traveled to Museum of Art, Fort Lauderdale, Fla., October 15–January 24, 1988; Queens Museum, Flushing, N.Y., February 13, 1988–April 3, 1988; Des Moines Art Center, Iowa, May 6, 1988–June 26, 1988.
Thomas Amman Fine Art, Zurich, June 17–September 18, "Impressionist and 20th Century Masters."
Centro Cultural Arte Contemporaneo, Mexico City, June 25–October 18, "Leo Castelli y sus Artistas."
Padiglione d'Arte Contemporanea, Milan, September 23–November 2, "From American Pop Art to the New Figurative Painting."
Galerie Daniel Templon, Paris, October 23–November 25, "Hommage à Leo Castelli."
Moderna Museet, Stockholm, October 24–January 10, 1988, "Implosion."

1988 Ludwig Museum, Cologne, January 14–March 6, "Marcel Duchamp and the Avant Garde Since 1950."
Whitney Museum of American Art, Stamford, Conn., February 5–April 6, "American Print Renaissance 1958–1988."
Galerie Kaj Forsblom, Helsinki, March 12–May 21, "Celebrating Leo Castelli and Pop Art."
Guggenheim Museum, New York, March 29–May 22, "Aspects of Collage, Assemblage and the Found Object in 20th Century Art."
Kolnischer Kunstverein, Cologne, April 21–May 29, "The International Art Show for the End of World Hunger" (and tour).
The Marion Koogler McNay Art Museum, San Antonio, July 1–31, "The McNay and the Texas Artists."
Musée St. Pierre, Lyon, October 5–December 5, "La Couleur Seule, l'expérience du monochrome."
Guggenheim Museum, New York, December 8–January 22, 1989, "Viewpoints: Postwar Painting and Sculpture from the Guggenheim Museum Collection and Major Loans."
Polaroid Gallery, Cologne, "Selections 4" (from the International Polaroid Collection). Traveled to Musée de L'Elysée, Lausanne, Switzerland; Victoria and Albert Museum, London; The Kunsthalle, Hamburg; Museo de Arte Contemporaneo de Caracas, Venezuela; and other Latin American countries.

1989 National Gallery of Art, Washington, D.C., opened January 17, "Twentieth Century Art: Selections for the Tenth Anniversary of the East Building."
The Brooklyn Museum, N.Y., March–June, Prints and Drawings Gallery.
Whitney Museum of American Art, Stamford, Conn., April 7–June 14, "The 'Junk Aesthetic': Assemblage of the 1950s and Early 1960s."
Museum Ludwig, Cologne, April 8–June 28, "Bilderstreit."
The Mayor Gallery, London, April 16–May 17, "A Tribute to Leo Castelli."
Helsinki Art Hall, Helsinki, May 16–July 30, "Modern Masters '89."
Centro de Arte Reina Sofia, Madrid, May 24–July 25, "Collection Beyeler."
Duson Gallery, Seoul, Korea, June 23–July 12, "Five Great American Artists: Warhol, Lichtenstein, Rauschenberg, Rosenquist, Stella."
Gagosian Gallery, New York, Summer, "Summer Show: Major Paintings."
Nelson-Atkins Museum of Art, Kansas City, Mo., July 22–September 3, "Art by Choice: Fortuitous Impressions."
Akira Ikeda Gallery, Nagoya, Japan, September 4–30, "Frank Stella, Robert Rauschenberg."
Whitney Museum of American Art, New York, November 9–February 18, 1990, "Image World."
Fabian Carlsson Gallery, London, December 15–February 6, 1990, "American Masters."
San Jose Museum of Art, San Jose, Calif., December 16–February 1990, "Jasper Johns and Robert Rauschenberg: Selections from the Anderson Collection."

1990 Pratt Manhattan Gallery, New York, January 13–February 28, "Prints of the Eighties." Traveled to the Rubelle & Norman Schafler Gallery, Pratt Institute, Brooklyn, March 2–30; Guild Hall, East Hampton, N.Y., June 16–July 29.
Lorence/Monk Gallery, New York, February 3–24, "The Indomitable Spirit Portfolio," sponsored by Photographers + Friends United Against AIDS. Traveled to Pace/MacGill Gallery, New York, February 22–March 24; Fraenkel Gallery, New York, March 14–April 14; Blum Helman Gallery, Los Angeles; A Gallery for Fine Photography, New Orleans; and Rhona Hoffman Gallery, Chicago.
The International Center of Photography Midtown, New York, February 9–April 7, 1990, "The Indomitable Spirit," sponsored by Photographers + Friends United Against AIDS. Traveled to The Los Angeles Municipal Art Gallery, May 13–June 17.

BOOKS

Albers, Josef. *Interaction of Color*. New Haven: Yale University Press, 1971.

Alloway, Lawrence. *Topics in American Art Since 1945*. New York: W.W. Norton, 1975.

————. *The Venice Biennale 1895–1968: From Salon to Goldfish Bowl*. Greenwich, Conn.: New York Graphic Society, Ltd., 1968.

Amaya, Mario. *Pop Art and After*. New York: Viking Press, 1965.

Ashton, Dore. *American Art Since 1945*. New York: Oxford University Press, 1982.

————. *The New York School: A Cultural Reckoning*. New York: Viking Press, 1972.

————. *Rauschenberg: XXXIV Drawings for Dante's Inferno*. New York: Harry N. Abrams, 1969.

————. *The Unknown Shore: A View of Contemporary Art*. Boston: Little, Brown and Company, Atlantic Monthly Press, 1962.

Baigell, Matthew. *A History of American Painting*. New York: Praeger Publishers, 1971.

Battcock, Gregory, ed. *Minimal Art*. New York: E.P. Dutton & Co., 1968.

————. *The New Art: A Critical Anthology*. New York: E.P. Dutton & Co., 1966.

Becker, Jurgen, and Wolf Vostell. *Happenings, Fluxus, Pop Art, Nouveau Realisme*. Hamburg, Germany: Rowohlt Paperback Sonderband, 1965.

Blesh, Rudi, and Harriet Janis. *Collage: Personalities, Concepts, Techniques*. Philadelphia: Chilton Book Company, 1962.

Buettner, Stewart. *American Art Theory: 1945–1970*. Ann Arbor, Michigan: University Microfilms International, 1981.

Burnham, Jack. *Beyond Modern Sculpture: The Effects of Science and Technology on the Sculpture of This Century*. New York: George Braziller, 1973.

Cage, John. *Silence: Lectures and Writings*. Middletown, Conn.: Wesleyan University Press, 1961.

Calas, Nicolas. *Art in the Age of Risk and Other Essays*. New York: E.P. Dutton & Co., 1968.

Castleman, Riva. *Modern Art in Prints*. New York: The Museum of Modern Art, 1973.

Coke, Van Deren. *The Painter and the Photograph*. Albuquerque: University of New Mexico Press, 1964.

Compton, Michael. *Pop Art*. New York: Hamlyn Publishing Group, 1970.

Cort, Louise Allison. *Shigaraki, Potters' Valley*. Tokyo: Kodansha International Ltd., 1979.

Crichton, Michael. *Jasper Johns*. New York: Harry N. Abrams, 1977.

Davis, Douglas. *Art and the Future: A History/Prophecy of the Collaboration Between Science, Technology and Art*. New York: Praeger Publishers, 1973.

————. *ArtCulture: Essays on the Post-Modern*. New York: Harper & Row, Publishers, Icon Editions, 1977. Introduction by Irving Sandler.

D'Harnoncourt, Anne, and Kynaston McShine. *Marcel Duchamp*. New York: The Museum of Modern Art, 1973.

Diamonstein, Barbaralee. *Inside New York's Art World*. New York: Rizzoli, 1979.

Dienst, Rolf-Gunter. *Pop-Art. Eine Kritische Information*. Wiesbaden, West Germany: Limes Verlag, 1965.

Duberman, Martin. *Black Mountain: An Exploration in Community*. New York: E.P. Dutton, Inc., 1972.

Elsen, Albert E. *Purposes of Art*. New York: Holt, Rinehart and Winston, 1962.

Fine, Ruth E. *Gemini G.E.L.: Art and Collaboration*. New York: Abbeville Press, 1984. Published on the occasion of the exhibition *Gemini G.E.L.: Art and Collaboration* at the National Gallery of Art, 18 November 1984–24 February 1985.

Forge, Andrew. *Rauschenberg*. New York: Harry N. Abrams, 1972.

Forge, Andrew. *Rauschenberg*. New York: Harry N. Abrams, 1969.

Friedman, B. H. *School of New York: Some Younger Artists*. New York: Grove Press, 1959.

Greenberg, Clement. *Art and Culture: Critical Essays*. Boston: Beacon Press, 1961.

Hansen, Alfred E. *A Primer of Happenings & Time/Space Art*. New York: Something Else Press, 1965.

Harris, Mary Emma. *The Arts at Black Mountain College*. Cambridge, Massachusetts: The MIT Press, 1987.

SELECTED BIBLIOGRAPHY

Hayes, Bartlett. *American Drawings.* New York: Shorewood Press, 1965.

Heller, Jules. *Printmaking Today.* New York: Holt, Rinehart and Winston, 1972.

Henri, Adrian. *Total Art: Environments, Happenings, and Performances.* New York: Praeger Publishers, 1974.

Hughes, Robert. *The Shock of the New.* New York: Alfred A. Knopf, 1981.

Hunter, Sam, and John Jacobus. *American Art Since 1900.* New York: Harry N. Abrams, 1970.

Johnson, Ellen H. *Modern Art and the Object: A Century of Changing Attitudes.* London: Thames and Hudson, 1976.

Johnston, Jill. *Paper Daughter: Autobiography in Search of a Father.* vol. II. New York: Alfred A. Knopf, 1985.

Kaprow, Allan. *Assemblage, Environments & Happenings.* New York: Harry N. Abrams, 1966.

Kirby, Michael. *Happenings.* New York: E.P. Dutton & Co., 1965.

Klosty, James, ed. *Merce Cunningham.* New York: E.P. Dutton & Co., 1975.

Kostelanetz, Richard. *Master Minds: Portraits of Contemporary American Artists and Intellectuals.* Toronto: The Macmillan Company, Collier-Macmillan Canada Ltd., 1967.

————. *The Theatre of Mixed Means.* New York: Dial Press Inc., 1968.

————, ed. *The New American Arts.* New York: Horizon Press, 1965.

Kozloff, Max. *Renderings: Critical Essays on a Century of Modern Art.* New York: Simon and Schuster, 1968.

Kramer, Hilton. *The Age of the Avant-Garde: An Art Chronicle of 1956–1972.* New York: Farrar, Straus & Giroux, 1973.

Lippard, Lucy. *Pop Art.* New York: Frederick A. Praeger Publishers, 1966.

Lucie-Smith, Edward. *Late Modern, the Visual Arts Since 1945.* New York: Frederick A. Praeger Publishers, 1969.

McCoubrey, John W. *American Painting 1900–1970.* New York: Time-Life Books, 1970.

Meyers, David. *School of New York.* New York: Evergreen Gallery Book Number 12, 1959.

Nordness, Lee, ed. *Art: USA: Now.* New York: Viking Press, 1963.

O'Doherty, Brian. *American Masters: The Voice and the Myth.* New York: Random House, 1974.

————. *Object and Idea: An Art Critic's Journal 1961–1967.* New York: Simon and Schuster, 1967.

Pellegrini, Aldo. *New Tendencies in Art.* Translated by Robin Carson. New York: Crown Publishers, 1966.

Popper, Frank. *Art-Action and Participation.* New York: New York University Press, 1975.

Rauschenberg, Robert. *Photographs.* London: Thames and Hudson, 1981.

————. *Photos In + Out City Limits: Boston.* New York: Untitled Press (Universal Limited Art Editions), 1981. Introduction by Clifford Ackley.

————. *Photos In + Out City Limits: New York C.* New York: Untitled Press (Universal Limited Art Editions), 1981.

————. *Rauschenberg Photographs.* New York: Pantheon Books, 1981. Foreword by Pontus Hulten and Robert Rauschenberg. Interview with Alain Sayag.

Richardson, Tony and Nikos Stangos, eds. *Concepts of Modern Art.* New York: Harper & Row Publishers, Icon Editions, 1974.

Rose, Barbara. *American Art Since 1900: A Critical History.* New York: Frederick A. Praeger Publishers. [Revised edition London: Thames and Hudson, 1975]

————. *American Painting: The 20th Century.* Switzerland: Skira, 1970.

————. *Rauschenberg.* New York: Vintage Books, 1987.

————. *Readings in American Art.* New York: Frederick A. Praeger Publishers, 1968.

Rosenberg, Harold. *The Anxious Object: Art Today and Its Audience.* New York: New American Library, 1964.

————. *Art on the Edge: Creators and Situations.* New York: Macmillan Publishing Co., 1975.

————. *Artworks and Packages.* New York: Horizon Press, 1969.

————. *The De-Definition of Art: Action Art to Pop to Earthworks.* New York: Horizon Press, 1972.

Rubin, William S. *Dada and Surrealist Art.* New York: Harry N. Abrams, 1968.

Russell, John. *The Meanings of Modern Art*. New York, Museum of Modern Art: Harper & Row, 1981.

Russell, John, and Suzi Gablik. *Pop Art Redefined*. New York: Frederick A. Praeger Publishers, 1969.

Sandler, Irving H. *The New York School: The Painters and Sculptors of the Fifties*. New York: Harper & Row Publishers, Icon Editions, 1978.

Scarf, Aaron. *Art and Photography*. Baltimore: Penguin Books, 1974.

Solomon, Alan R. *New York: The New Art Scene*. New York: Holt, Rinehart and Winston, 1967.

Stein, Harvey. *Artists Observed*. New York: Harry N. Abrams, 1986. Preface by Cornell Capa. Essay by Elaine A. King.

Steinberg, Leo. *Other Criteria*. New York: Oxford University Press, 1972.

Sundell, Nina. *The Robert and Jane Meyerhoff Collection: 1958–1979*. Published by Jane B. Meyerhoff, 1980.

Tomkins, Calvin. *The Bride and the Bachelors: Five Masters of the Avant-Garde*. New York: Viking Press, 1965.

———. *Off the Wall: Robert Rauschenberg and the Art World of Our Time*. Garden City, N.Y.: Doubleday & Co., 1980. [softcover edition, New York: Penguin Books, 1980]

———. *Post- to Neo-: The Art World of the 1980s*. New York: Henry Holt and Company, 1988.

———. *The Scene: Reports on Post-Modern Art*. New York: Viking Press, 1976.

Tono, Yoshiaki. *After Pollock*. (Japanese) Tokyo: Bijutsu Shuppan-sha, 1984.

———. *Chatting with Artists*. (Japanese) Tokyo: Iwanami Shoten, 1984.

Tuchman, Maurice. *A Report on the Art and Technology Program of the Los Angeles County Museum of Art: 1967–1971*. Los Angeles: Los Angeles County Museum of Art, 1971. Introduction by Maurice Tuchman. Essay by Jane Livingston.

Weil, Susan. *Bird Songs Heartbeats: More Days Here & There*. Ahus, Sweden: NYA Civiltryckeriet, Kristianstad, 1980.

Weller, Allen S. *The Joys and Sorrows of Recent American Art*. Urbana, Illinois: University of Illinois Press, 1968.

Wescher, Herta. *Collage*. New York: Harry N. Abrams, 1968.

Wolfe, Tom. *The Painted Word*. New York: Bantam Books, 1975.

CATALOGUES

36th Biennial Exhibition of Contemporary American Painting: de Kooning, Johns, Kelly, Lichenstein, Rauschenberg. Washington, D.C.: Corcoran Gallery of Art, 1979. Essay by Jane Livingston.

Josef Albers: A Retrospective. New York: Solomon R. Guggenheim Foundation, 1988. Preface by Diane Waldman. Essays by Nicholas Fox Weber, Mary Emma Harris, Charles E. Rickart, Neal Benezra.

Art of Assemblage. New York: The Museum of Modern Art, 1961. Essay by William C. Seitz.

Artists' Sets and Costumes. Philadelphia: Philadelphia College of Art, 1977. Essays by Janet Kardon and Don McDonagh.

Dylaby (Dynamisch Labryrint). Amsterdam: Stedelijk Museum, 1962.

Gemini: 7 Characters: Rauschenberg. Jinxgian, China. Essay by Donald Saff. Gemini G.E.L., Los Angeles, 1983.

Graphicstudio U.S.F.: An Experiment in Art and Education. Foreword by Michael Botwinick; text by Gene Baro; interview with Donald Saff. Brooklyn: The Brooklyn Museum, 1978.

The Great American Rodeo. Fort Worth, Texas: Fort Worth Art Museum, 1976. Introduction by Richard Koshalek; essay by Jay Belloli.

Miller, Dorothy C., ed. *Sixteen Americans*. New York: The Museum of Modern Art, distributed by Doubleday & Company, Inc., Garden City, New York, 1959.

New American Paperworks. Organized by Jane M. Farmer for The World Print Council, San Francisco, California, 1982.

New York: The Second Breakthrough, 1959–1964. Irvine, California: University of California at Irvine Art Gallery, 1969. Essay by Alan R. Solomon.

The Panza Collection. Los Angeles: The Museum of Contemporary Art, 1985. Edited by Julia Brown. Introduction by Richard Koshalek; interview with Dr. Giuseppe Panza di Biumo by Kerry Brougher.

Prints from the Untitled Press, Captiva, Florida. Hartford, Connecticut: Wadsworth Atheneum, 1973. Essays by Jack Cowart and James Elliott.

Rauschenberg. Paris: Galerie Ileana Sonnabend, 1963. Essays by Lawrence Alloway, John Cage, Françoise Choay, Gillo Dorfles, Alain Jouffroy, André Parinaud, Michel Ragon.

Rauschenberg: Currents. Minneapolis: Dayton's Gallery 12, 1970.

Rauschenberg: Graphic Art. Philadelphia: Institute of Contemporary Art, 1970. Introduction by Lawrence Alloway.

Rauschenberg at Graphicstudio. Tampa, Florida: University of South Florida Library Gallery, 1974. Introduction by Willard McCracken; acknowledgments by Donald Saff.

Rauschenberg in Israel. Jerusalem: The Israel Museum, 1975. Text by Yona Fischer.

Rauschenberg in the Rockies. Fort Collins, Colorado: Colorado State University, 1981. Foreword by Peter A. Jacobs; essay by Ron G. Williams.

Rauschenberg/Performance, 1954–1984. Organized by Nina Sundell and the Cleveland Center for Contemporary Art, 1984. Introduction by Marjorie Talalay; essay by Nina Sundell.

Rauschenberg: The White and Black Paintings: 1949–1952. New York: Larry Gagosian Gallery, 1986. Introduction by Roberta Bernstein.

Rauschenberg's Pages and Fuses. Los Angeles: Los Angeles County Museum of Art, 1975. Introduction by Joseph E. Young.

Robert Rauschenberg. New York: The Jewish Museum, 1963. Essay by Alan R. Solomon.

Robert Rauschenberg. Amsterdam: Stedelijk Museum, 1968. Foreword by Edy de Wilde; essay by Andrew Forge.

Robert Rauschenberg. Hannover, Germany: Kunstverein Hannover, 1970. Essays by Manfred de la Motte, Willoughby Sharp, William S. Lieberman, John Ciardi, Lucy Lippard, Lawrence Alloway, Douglas M. Davis, Paul Wember.

Robert Rauschenberg. Ferrara, Italy: Galleria Civica d'Arte Moderna, Palazzo dei Diamanti, 1976. Essays by Paola Serra Zanetti, Daniel Abadie, David Bourdon.

Robert Rauschenberg. Washington, D.C.: Smithsonian Institution, National Collection of Fine Arts, 1976. Organized by Walter Hopps; foreword by Joshua C. Taylor; essay by Lawrence Alloway.

Robert Rauschenberg Drawings 1958–1968. New York: Acquavella Contemporary Art, Inc., 1986. Essay by Lawrence Alloway.

Robert Rauschenberg in Black and White: Paintings 1962–1963, Lithographs 1962–1967. Balboa, California: Newport Harbor Art Museum, 1969. Introduction by Thomas H. Garber.

Robert Rauschenberg: Paintings 1953–1964. Minneapolis: Walker Art Center, 1965. Acknowledgments and essay by Dean Swanson.

Robert Rauschenberg: Paintings, Drawings and Combines, 1949–1964. London: Whitechapel Art Gallery, 1964. Essays by Henry Geldzahler, John Cage, Max Kozloff.

Robert Rauschenberg: Peintures Récentes. St.-Paul-de-Vence, France: Fondation Maeght, 1984. Introduction by Jean-Louis Prat; essay by Nan Rosenthal.

Robert Rauschenberg: Prints 1948/1970. Minneapolis: The Minneapolis Institute of Arts, 1970. Introduction by Edward A. Foster.

Robert Rauschenberg (Retrospective). London: The Tate Gallery, 1981. Foreword and introduction by Alan Bowness.

Robert Rauschenberg: Selections. Fort Worth, Texas: Fort Worth Art Center Museum, 1969. Introduction by Henry T. Hopkins.

Robert Rauschenberg: Werke 1950–1980. Berlin: Staatliche Kunsthalle Berlin, 1980. Introduction by Dieter Ruckhaberle; essays by Lawrence Alloway, Gotz Adriani, Douglas Davis, William S. Lieberman.

Robert Rauschenberg, Work From Four Series: A Sesquicentennial Exhibition. Houston, Texas: Contemporary Arts Museum, 1985. Exhibition organized by Linda L. Cathcart and Marti Mayo. Essay by Donald Barthelme.

Robert Rauschenberg: Works from the Salvage Series. Sarasota, Florida: The John and Mable Ringling Museum of Art, 1985. Introduction, essay, and organized by Mark Ormond.

ROCI/Berlin: Altes Museum (Neue Berliner Galerie Im Alten Museum), East Berlin, GDR, 1990. Essay by Heiner Müller.

ROCI/Chile. Santiago: Museo Nacional de Bellas Artes, 1985. Essay by José Donoso.

ROCI/China. Beijing: National Art Gallery, 1985. Essay by Wu Zuang.

ROCI/Cuba. Havana: Casa de las Americas (Galleria Haydee Santa Maria), 1988. Essay by Roberto Fernandez Retamar.

ROCI/Japan. Tokyo: Setagaya Art Museum, 1986. Essay by Yoshiaki Tono.

ROCI/Mexico. Mexico City: Museo Rufino Tamayo, 1985. Essay by Octavio Paz.

ROCI/Tibet. Lhasa: Tibet Exhibition Hall, 1985. Essays by Laba Pingcuo and Wangqing Pingcuo.

ROCI/U.S.S.R. Moscow: Central House of Culture, Tretyakov Gallery, 1989. Essay by Yevgeny Yevtushenko.

ROCI/Venezuela. Caracas: Museo de Arte Contemporaneo de Caracas, 1985. Essay by Arturo Uslar-Pietre.

Six Painters and the Object. New York: The Solomon R. Guggenheim Museum, 1963. Essay by Lawrence Alloway.

Willem de Kooning. New York: Museum of Modern Art, 1968. Essay by Thomas B. Hess.

DISSERTATION

Bolmeier, Jane. "Response and Documentation: Aesthetic Inquiry Relevant to Selected Works of Robert Rauschenberg." Doctorate of Fine Arts, New York University, 1984. Copyright Jane Bolmeier. University Microfilms International.

MAGAZINES

Abeel, Erica. "Daedalus at the Rollerdrome." *Saturday Review*, 28 August 1965, pp. 51–53.

Alloway, Lawrence. "Assembling a World Between Art and Life." *Second Coming*, 1, June 1962, pp. 50–52.

———. "Rauschenberg's Graphics." *Art and Artists*, 5, September 1970, pp. 18–21.

———. "Technology and Art Schools." *Studio International*, 175, April 1968, pp. 184–86.

———. "The World is a Painting: Rauschenberg." *Vogue*, 15 October 1965, 100, pp. 154–56.

Antin, David. "Art and the Corporations." *ARTnews*, 70, September 1971, p. 22.

Apple, Jacki. "Long Beach: Revisiting a Frontier." *Artweek*, 7 September 1985, p. 5.

Ashbery, John. "Five Shows Out of the Ordinary: Robert Rauschenberg." *Art News*, 57, March 1958, pp. 40, 56.

Ashton, Dore. "The Collaboration Wheel: A Comment on Robert Rauschenberg's Comment on Dante." *Arts and Architecture*, 80, December 1963, pp. 10–11.

———. "57th Street: Robert Rauschenberg." *Art Digest*, 27, September 1953, p. 21.

———. "Object Versus Illusion." *Studio International*, 167, January 1964, pp. 41–43.

———. "Protest: Politics and Painters." *Art Voices*, Summer 1966, pp. 20–29.

———. "Rauschenberg's Illustrations for Dante's *Inferno*." *Arts and Architecture*, 78, February 1961, pp. 4–5.

———. "Rauschenberg's Thirty-Four Illustrations for Dante's Inferno." *Metro* (Italy), 2, May 1961, pp. 53–61.

———. "Response to Crisis in American Art." *Art in America*, 57, January/February 1969, pp. 24–35.

Balladore, Sandy. "The Mid-Seventies Rauschenberg For the Joy of It." *Artweek*, 11 September 1976, p. 1.

Baro, Gene. "The Venice Biennale." *Arts Magazine*, 38, September 1964, pp. 32–37.

Battcock, Gregory. "Rauschenberg's New Clocks." *Arts Magazine*, 43, May 1969, p. 16.

Bell, Jane. "Robert Rauschenberg: Leo Castelli, Sonnabend, The Exhibition Space." *ARTnews*, April 1983, p. 149.

Berkson, William. "In the Galleries: Robert Rauschenberg." *Arts Magazine*, 39, September/October 1965, p. 62.

Bernstein, Roberta. "Robert Rauschenberg's *Rebus*." *Arts Magazine*, vol. 52, pt. 5, January 1978, pp. 138–41.

Bisdorf, Dell. "The Rauschenberg Roadshow Comes to China." *China Reconstructs*, March 1986, p. 57.

Black, L.D. "Rauschenberg's ROCI." *Splash*, February 1988.

———. "Robert Rauschenberg." *Splash*, 1984, pp. 24–28.

Bochner, Mel. "The Serial Attitude." *Artforum*, 6, December 1967, pp. 28–33.

Bongard, Willi. "When Rauschenberg Won the Biennale." *Studio International* (U.K.), 175, June 1968, pp. 288–89.

Brach, Paul. "Rauschenberg." *Scrap*, 2, 23 December 1960.

Bryant, Gloria. "The Switched-on Theatre." *Bell Telephone Laboratory Reporter*, November/December 1966, pp. 12–17.

Burnside, Madeleine. "Robert Rauschenberg (Castelli Graphics)." *Arts Magazine*, September 1979, p. 37.

Burstein, Patricia. "In His Art and Life, Robert Rauschenberg Is A Man Who Steers His Own Daring Course." *People*, 19 May 1980, pp. 99–104.

Cage, John. "On Robert Rauschenberg, Artist, and His Work." *Metro 2* (Italy), May 1961, pp. 36–51.

Calas, Nicolas. "ContiNuance: On the Possibilities of a New Kind of Symbolism in Recent American Painting and What Such Symbols Could Possibly Mean." *Art News*, 57, February 1959, pp. 36–39.

Campbell, Lawrence. "Reviews and Previews: Rauschenberg and Twombly." *Art News*, September 1953, p. 48.

"Carnival in Venice." *Newsweek*, 6 July 1964, pp. 73–74.

Castle, Frederick C. "Threat Art." *Art News*, 67, October 1968, pp. 54–55.

Chandler, John Noel. "The Colors of Monochrome: An Introduction to the Seduction of Reduction." *Artscanada*, 28, October/November 1971, pp. 18–31.

Chien, Chun-Wuei, trans. Reviews from *Fine Arts in China*, vol. 22, 21 December 1985. Essays by Kong Chang-an, Yao Qing-zhang, Li Jia-tun, Yu Feng, Yuan Xiaojin, Zhao Jian-hai, Zhu Ye, Zheng Sheng-tian. Published in Beijing by Chinese Art Institute.

Choay, Françoise. "Dada, Neo-Dada, et Rauschenberg." *Art International*, 5, 20 October 1961, pp. 82–84.

Coates, Robert M. "The Art Galleries." *The New Yorker*, 9 April 1960, pp. 158–59.

Cohen, Ronny H. "The Medium Isn't the Message." *ARTnews*, October 1985, pp. 74–81.

Cole, Mary [M.C.]. "Fifty-Seventh Street in Review: Bob Rauschenberg." *Art Digest*, 25, 1 June 1951, p. 18.

Constable, Rosalind. "Europe Explodes as American Takes Prize: Art Pops In." *Life*, 10 July 1964, pp. 65–68.

Cranshaw, Roger and Adrian Lewis. "Rereading Rauschenberg." *Artscribe* (U.K.), 29, June 1981, pp. 44–51.

Crehan, Hubert. "The See Change: Raw Duck." *Art Digest*, 27, September 1953, pp. 21, 25.

Davis, Douglas. "Artist of Everything." *Newsweek*, 17 October 1976, pp. 94–99.

———. "Rauschenberg's Recent Graphics." *Art in America*, 57, July/August 1969, pp. 90–95.

———. "Strong Currents." *Newsweek*, 27 July 1970, p. 69.

de Ak, Edit. "Robert Rauschenberg and Cy Twombly at Castelli Downtown." *Art in America*, July/August 1974, p. 86.

de la Falaise, Maxime. "Rauschenberg à Washington et à New York." *XXe Siècle* (France), vol. 39, December 1977, pp. 28–34.

Domingo, Willis. "In the Galleries: Robert Rauschenberg." *Arts Magazine*, 46, December/January 1972, p. 60.

Dorfles, Gillo. "Rauschenberg, or Obsolescence Defeated." *Metro 2*, May 1961, pp. 32–35.

Dreiss, Joseph. "Robert Rauschenberg." *Arts Magazine*, 49, February 1975, p. 16.

"The Emperor's Combine." *Time*, 18 April 1960, p. 92.

Evaul, William H. "Printmaking Ensuite with Rauschenberg, Rockburne, and Lewitt." *Print Review*, 14, 1981, pp. 70–73.

Feinstein, Roni. "The Early Work of Robert Rauschenberg: The White Paintings, the Black Paintings, and the Elemental Sculpture." *Arts Magazine*, 61, September 1986, pp. 28–37.

———. "The Unknown Early Robert Rauschenberg: The Betty Parsons Exhibition of 1951." *Arts Magazine*, 59, January 1985, pp. 126–31.

Fischer, Yona. "Robert Rauschenberg in Israel." *Ariel* (Israel), 37, 1974, pp. 34–47.

Fitzsimmons, James. "Art." *Arts and Architecture*, 70, October 1953, pp. 33–34.

Fondiller, Harvey. "A painter as photographer: the constructs of Robert Rauschenberg." *Popular Photography*, December 1981, pp. 50–51.

Forge, Andrew. "Cross Currents." *Studio International*, 175, April 1968, p. 191.

———. "Robert Rauschenberg." *New Statesman*, 67, 21 February 1964, pp. 304–5.

Forgey, Benjamin. "An all-star quintet from the 1960's, Now 'old masters.'" *Smithsonian*, February 1979, pp. 80–87.

———. "An Artist for All Decades." *ARTnews*, 76, January 1977, pp. 35–36.

Foster, Hal. "The Problem of Pluralism." *Art in America*, 70, January 1982, pp. 9–15.

Gablik, Suzi. "Light Conversation." *ARTnews*, 67, November 1968, pp. 58–60.

———. "Meta-Trompe-L'oeil." *ARTnews*, 64, March 1965, pp. 46–49.

Geldzahler, Henry. "Robert Rauschenberg." *Art International*, 7, 25 September 1963, pp. 62–67.

Gibson, Eric. "New York Letter: Robert Rauschenberg." *Art International*, 23, April 1979, pp. 44–51.

Ginsburg, Susan. "Rauschenberg's Dialogue." *Print Collector's Newsletter*, 6, January/February 1976, pp. 152–55.

Goldman, Judith. "New Editions: Robert Rauschenberg." *ARTnews*, 74, March 1975, pp. 59–60.

Goldstein, Carl. "Teaching Modernism: What Albers Learned in the Bauhaus and Taught to Rauschenberg, Noland, and Hesse." *Arts Magazine*, 54, December 1979, pp. 108–16.

Graham, Marna C. "A Restless, Inquiring Eye." *Artweek*, 15 October 1983, pp. 11–12.

Gray, Cleve. "Tatyana Grosman's Workshop." *Art in America*, 53, December/January 1965–66, pp. 83–85.

Greenberg, Clement. "After Abstract Expressionism." *Art International*, 6, October 1962, pp. 24–32.

Gruen, John. "Galleries & Museums." *New York*, 29 June 1970, p. 57.

———. "Robert Rauschenberg: An Audience of One." *ARTnews*, 76, February 1977, pp. 44–48.

Grundberg, Andy. "Another Side of Rauschenberg." *The New York Times Magazine*, 18 October 1981, pp. 43–47, 113–15.

Hahn, Otto. "L'enfant terrible de New York." *L'Express*, 20 October 1968, p. 114.

Hassinger, Peter. "Rauschenberg in San Francisco." *California*, July 1977, pp. 72–75.

Henry, Gerrit. "Personal Retrenchment." *Art and Artists*, 6, February 1972, pp. 42–45.

Herrera, Hayden. "Cy Twombly, Robert Rauschenberg." *ARTnews*, 73, October 1974, p. 110.

———. "Rauschenberg's *Scroll*." *Connoisseur*, 213, January 1983, pp. 57–61.

Hess, Thomas B. "Collage as an Historical Method." *ARTnews*, 60, November 1961, pp. 31–33.

———. "Rauschenberg: Choose a Chance." *New York*, 9 September 1974, pp. 60–61.

———. "Replenishing Rauschenberg." *New York*, 16 May 1977, p. 78.

———. "Younger Artists and the Unforgivable Crime." *ARTnews*, 56, April 1957, pp. 46–49.

"How Important is the Surface to Design? Robert Rauschenberg—An Artist Explains." *Print*, 13, January/February 1959, p. 31.

Hughes, Robert. "The Arcadian as Utopian: Rauschenberg's Rhapsodic Energies Fill Four Manhattan Shows." *Time*, 24 January 1983, pp. 74–77.

———. "Enfant Terrible at 50." *Time*, 27 January 1975, pp. 60–61.

———. "The Most Living Artist." *Time*, 29 November 1976, pp. 54–62.

———. "The Revival of Prints." *Time*, 18 January 1971, pp. 56–57.

Hunter, Sam. "Artist, Tramp (Robert Rauschenberg's Cultural Exchange: A Traveling International Art Project)." *Elle*, March 1989, pp. 48–56.

Hutchinson, Bill. "The World According to Rauschenberg: Clear Skies, Sunny and Warm." *Marquee*, May 1984, pp. 16–22.

"Is today's artist with or without the past: Rauschenberg." [by J.S.]. *ARTnews*, 57, Summer 1958, p. 46.

Ives, Colta. "Razorback Country." *ARTnews*, 81, September 1982, pp. 62–63.

Johnson, Ellen H. "Is Beauty Dead?" *Allen Memorial Bulletin*, 20, Winter 1963, pp. 59–62. Review of "Three Young Americans."

———. "The Image Duplicators—Lichtenstein, Rauschenberg and Warhol." *Canadian Art*, 23 January 1966, pp. 12–19.

Johnston, Jill. "Robert Rauschenberg." *ARTnews*, 59, January 1961, pp. 12–13.

———. "Robert Rauschenberg, Jean Tinguely, Niki de Saint Phalle." *ARTnews*, 61, Summer 1962, pp. 53–54.

Johnstone, Mark. "Ambiguous Images of the City." *Artweek*, 16 January 1982.

Jouffroy, Alain. "Rauschenberg et la liberté d'indifférence." *XXe Siècle* (France), 40, June 1973, pp. 125–31.

———. "Rauschenberg ou le déclic mental." *Aujourd'hui*, 7, September 1962, pp. 22–23.

———. "R. Rauschenberg." *L'Oeil* (France), 113, May 1964, pp. 28–35, 68.

Judd, Donald. "Robert Rauschenberg." *Arts Magazine*, 7, May/June 1963, pp. 103–4.

———. "Robert Rauschenberg." *Arts Magazine*, 36, January 1962, pp. 39–40.

Kaprow, Allan. "Experimental Art." *ARTnews*, 65, March 1966, pp. 60–63.

Karshan, Donald H. "Robert Rauschenberg." *Art in America*, 58, November/December 1970, pp. 48–49.

Kelder, Diane. "Made in Graphicstudio." *Art in America*, 61, March–April 1973, pp. 84–85.

Kelly, Edward T. "Neo-Dada: A Critique of Pop Art." *Art Journal*, XXIII, 3, April 1964, pp. 192–201.

Klüver, Billy. "Theater and Engineering: An Experiment: Notes by an Engineer." *Artforum*, 5, February 1967, pp. 31–33.

Kostelanetz, Richard. "The Artist as Playwright and Engineer." *The New York Times Magazine*, 9 October 1966.

———. "A Conversation with Robert Rauschenberg." *Partisan Review*, 35, Winter 1968, pp. 92–102.

Kotz, Mary Lynn. "Robert Rauschenberg's Overseas Culture Interchange." *USIA Trends*, vol. 12, 1986, pp. 17–28.

———. "Robert Rauschenberg's State of the Universe Message." *ARTnews*, 82, February 1983, pp. 54–61.

Kozloff, Max. "American Painting During the Cold War." *Artforum*, 11, May 1973, pp. 43–54.

———. "Art." *The Nation*, 7 December 1963, p. 402.

———. "Art and the New York Avant-Garde." *Partisan Review*, 31, Fall 1964, pp. 535–54.

———. "The Division and Mockery of the Self." *Studio International*, 179, January 1970, pp. 9–15.

———. "The Impact of De Kooning." *Arts Yearbook*, vol. 7, 1964, pp. 77–88.

———. "The Many Colorations of Black and White." *Artforum*, 2, February 1964, pp. 22–25.

Kramer, Hilton. "Month in Review." *Arts Magazine*, 33, February 1959, pp. 48–51.

Krauss, Rosalind. "Rauschenberg and the Materialized Image." *Artforum*, 13, December 1974, pp. 36–43.

Lampert, Catherine. "Review: Robert Rauschenberg at the Mayor Gallery." *Studio International*, 185, June 1973, pp. 293–94.

Larson, Kay. "Rauschenberg's Renaissance." *New York*, 27 December 1982, p. 50.

Larson, Philip. "Words in Print." *The Print Collector's Newsletter*, 5, July/August 1974, pp. 53–56.

Lerman, Leo. "The New Old Masters." *Mademoiselle*, February 1965, pp. 120–23.

Levine, Neil A. "Robert Rauschenberg." *ARTnews*, 64, September 1965, p. 11.

Lewis, Jo Ann. "Suddenly, Old Masters." *Washington Post Magazine*, 25 February 1979, pp. 20–24.

Lin, Wendy. "The Boy From Port Arthur." *Art and Antiques*, February 1986, pp. 58–61.

Lippard, Lucy R. "The Silent Art." *Art in America*, 55, January/February 1967, pp. 58–63.

Lord, J. Barry. "Pop Art in Canada." *Artforum*, 2, March 1964, pp. 28–31.

Marano, Lizbeth. "Robert Rauschenberg at Castelli Greene Street and Sonnabend." *Art in America*, 71, April 1983, pp. 182–83.

Marcus, Stanley. "The Found, the Recycled, the Metamorphosized." *Artweek*, 15 February 1986, p. 1.

McKendry, Maxime de la Falaise. "Robert Rauschenberg Talks to Maxime de la Falaise McKendry." *Interview*, 6, May 1976, pp. 34–36.

Mellers, Wilfrid. "Tranquillity." *New Statesman*, 31 July 1964, p. 160.

Melville, Robert. "Fear of the Banal." *Architectural Review*, April 1964, pp. 291–93.

Mitgang, Herbert. "Tatyana Grosman: The Inner Light of 5 Skidmore Place." *ARTnews*, 73, March 1974, pp. 29–32.

"A Modern Inferno." *Life*, 17 December 1965, pp. 46–49.

Moorman, Margaret. "Rocky Road to Peace and Understanding." *ARTnews*, 84, February 1985, p. 11.

"More Dangerous Than Generals." The 'Vasari' Diary, *ARTnews*, February 1978, pp. 22, 24.

"Most Happy Fella." *Time*, 18 September 1964, pp. 84–87.

Murphy, Anne. "Dancing with Art: Why Choreographers Like Collaborating with Artists." *Theatre Crafts*, 18, April 1984, pp. 30–35, 71–72.

Mussman, Toby. "A Comment on Literalness: Should the Picture Plane be Abolished." *Arts Magazine*, 42, February 1968, pp. 14–17.

Newman, Michael. "Rauschenberg Re-evaluated." *Art Monthly* (U.K.), 47, June 1981, pp. 7–10.

Novick, Elizabeth. "Happenings in New York." *Studio International*, 172, September 1966, pp. 154–59.

O'Doherty, Brian. "Rauschenberg and the Vernacular Glance." *Art in America*, 61, September/October 1973, pp. 82–87.

Oeri, Georgine. "The Object of Art." *Quadrum*, 16, 1964, pp. 4–26.

O'Hara, Frank [F.O'H.] "Reviews and Previews: Bob Rauschenberg." *ARTnews*, 53, January 1955, p. 47.

Ohff, Heinz. "The Collection of Dr. Erich Marx: Beuys, Rauschenberg, Twombly, Warhol." *Das Kunstwerk* (Germany), 35, June 1982, pp. 77–78.

Ossa, Nena. "Sobre el Viajero Mundo de Rauschenberg." *La Nacion* (Santiago, Chile), 17 July 1985.

Owens, Craig. "The Pro-scenic Event." *Art in America*, 69, December 1981, pp. 128–33.

Padawar, Martha. "Rauschenberg Criticism, 1950–1970." *Bulletin of Bibliography and Magazine Notes*, 30, April/June 1973, pp. 61–67.

Paltridge, Blair. "Souvenirs of Travel." *Artweek*, vol. 15, pt. 9, 3 March 1984, p. 4.

Parinaud, Andre. "Un'intervista con Rauschenberg." *Le Arti*, nos. 1–2, 19, January/February 1969, pp. 25–26.

———. "Un 'misfit' de la peinture newyorkaise se confesse." *Les Arts et Spectat*, 82, 10 May 1961. Translation, National Museum of American Art.

Perreault, John. "Rauschenberg: The World Is His Studio." *Geo*, November 1983, pp. 64–77.

Perrone, Jeff. "Robert Rauschenberg." *Artforum*, 15, February 1977, pp. 24–31.

Perry, Arthur. "A Conversation between Robert Rauschenberg and Arthur Perry." *artmagazine* (Canada), 10, 41, November/December 1978, pp. 31–35.

Peters, Ben. "Rauschenberg: Blueprint Photographer." *Photo Arts*, August 1952, pp. 216–21.

Pieszak, Devonna. "Robert Rauschenberg: From Port Arthur to Captiva." *New Art Examiner*, 5, January 1978, p. 3.

Pincus-Witten, Robert. "New York: Robert Rauschenberg." *Artforum*, 7, December 1968, p. 55.

———. "Robert Rauschenberg: Cardbirds and Cardboards." *Artforum*, 10, December/January 1972, pp. 79–83.

Plagens, Peter. "Los Angeles: Robert Rauschenberg." *Los Angeles Art Examiner*, 9 October 1970, pp. 86–88.

"Pop Goes the Biennale." *Time*, 5 July 1964, p. 54.

"Process: Artistic Forms." *Art Voices*, Fall 1966, pp. 39–40.

"A Quartet of Spectaculars 2: Rauschenberg, The World Is a Painting." *Horizon*, May 1977, p. 16.

Ratcliff, Carter. "Mostly Monochrome." *Art in America*, 69, April 1981, pp. 111–31.

———. "New York." *Art International*, 21, May/June 1977, pp. 60–63.

"Rauschenberg." *The New Yorker*, 23 May 1977, pp. 30–31.

Rauschenberg, Robert. "Notes on Stoned Moon." *Studio International*, 178, December 1969, pp. 246–47.

———. "Oyvind Fahlstrom." *Art & Literature*, 3, 1964.

———. "Random Order." *Location*, 1, Spring 1963, pp. 27–31.

Restany, Pierre. "The New Realism." *Art in America*, 51, 1, February 1963, pp. 103–4.

Rips, Geoffrey. "Notes on a Native Son." *Texas Observer*, 30 May 1986, pp. 16–17.

"Robert Rauschenberg Ceramics." *Ceramics Monthly*, May 1983, pp. 39–41.

Roberts, Keith. "Current and Forthcoming Exhibitions: London." *Burlington Magazine*, 106, March 1964, pp. 137–38.

Rohter, Larry. "A Brush With the Master." *Newsweek*, 2 August 1982, p. 40.

Rose, Barbara. "Dada Then and Now." *Art International*, 7, 25 January 1963, pp. 23–28.

———. "Rauschenberg: The Artist as Witness." *Vogue*, February 1977, p. 174.

———. "The Second Generation: Academy and Breakthrough." *Artforum*, 4, September 1965, pp. 53–63.

Rosenberg, Harold. "The American Action Painters." *ARTnews*, 51, December 1952, pp. 22–23.

———. "Souvenirs of an Avant-Garde." *The New Yorker*, 16 May 1977, pp. 123–28.

Rosenblatt, Leon. "Robert Rauschenberg in Captiva." (Special Rauschenberg Edition) *Printable News*, December 1980, pp. 1–9.

Rosenblum, Robert [R.R.]. "In the Galleries: Robert Rauschenberg." *Arts Magazine*, 32, March 1958, p. 61.

Rowes, Barbara. "Painter Robert Rauschenberg Takes a Trip to China and Pops Back with New Shows and New Vitality." *People*, 24 January 1983, pp. 82–83.

Rubin, William. "Younger American Painters." *Art International*, 4, January 1960, pp. 24–31.

Russell, John. "Persistent Pop." *The New York Times Magazine*, 21 July 1974, pp. 6–34.

Saff, Donald J. "Graphicstudio, U.S.F." *Art Journal*, 34, Fall 1974, pp. 10–18.

Sandler, Irving H. "Ash Can Revisited, a New York Letter." *Art International*, 8, 25 October 1960, pp. 28–30.

Sawin, Martha. "In the Galleries: Robert Rauschenberg." *Arts Magazine*, 35, January 1961, p. 56.

Schuyler, James. "Reviews and Previews: Three (Castelli)." *ARTnews*, 58, April 1959, p. 13.

Seckler, Dorothy Gees. "The Artist Speaks: Robert Rauschenberg." *Art in America*, 54, May/June 1966, pp. 73–84.

———. "Robert Rauschenberg (Parsons)". *ARTnews*, 50, May 1951, p. 59.

Seitz, William C. "Assemblage: Problems and Issues." *Art International*, 6, February 1962, pp. 26–36.

Shaw, John. "Robert Rauschenberg and the Profit Motif." *Antique Collector* (U.K.), 52, November 1981, p. 118.

Shewey, Don. "We Collaborated by Postcards." *Theatre Crafts*, April 1984, pp. 36–39.

Silverthorne, Jeanne. "Robert Rauschenberg: Castelli Gallery, Sonnabend Gallery, Museum of Modern Art," *Artforum*, 21, April 1983, pp. 75–76.

Smith, Philip. "To and About Robert Rauschenberg." *Arts Magazine*, 51, March 1977, pp. 120–21.

Solomon, Alan. "American Art Between Two Biennales." *Metro* 11, June 1966, pp. 24–35.

———. "The New American Art." *Art International*, 8 March 1964, pp. 50–55.

"Speaking of Pictures." *Life*, 9 April 1951, pp. 22–24.

Steinberg, Leo. "Contemporary Group at Stable Gallery." *Arts Magazine*, 30, January 1956, pp. 46–48.

———. "Reflections on the State of Criticism." *Artforum*, 10, March 1972, pp. 37–49.

Stitleman, Paul. "Galleries: Robert Rauschenberg." *Arts Magazine*, 47, February 1973, pp. 68–69.

Stuckey, Charles F. "Reading Rauschenberg." *Art in America*, 65, March/April 1977, pp. 74–84.

Swenson, Gene R. "Rauschenberg Paints a Picture." *ARTnews*, 62, April 1963, pp. 44–47.

Tennant, Donna. Review of Exhibition: "Robert Rauschenberg, Work from Four Series: A Sesquicentennial Exhibition, Contemporary Arts Museum, Houston." *ARTnews*, 85, April 1986, pp. 141–42.

Thomsen, Barbara. "Robert Rauschenberg at Castelli." *Art in America*, 61, September/October 1973, pp. 112–14.

"Through the Ages, the Inferno." *Life*, 17 December 1965, pp. 38–50.

Tomkins, Calvin. "The Big Show in Venice." *Harper's Magazine*, April 1965, pp. 96–104.

———. "A Good Eye and a Good Ear." *The New Yorker*, 26 May 1980, pp. 40–72.

———. "The Man Who Created the Most Public Work or Private Art in History." *Miami Herald Tropic Magazine*, 30 December 1979, pp. 21–22.

———. "Profile: Moving Out." *The New Yorker*, 29 February 1964.

"Tomorrow's Artist." *Time*, 16 August 1948, pp. 43–44.

Towle, Tony. "Rauschenberg: Two Collaborations-Robbe-Grillet and Voznesensky." *Print Collector's Newsletter*, 10, May/June 1979, pp. 37–41.

"Trend to the 'Anti-Art.'" *Newsweek*, 31 March 1958, p. 94.

Tully, Judd. "Paper Chase." *Portfolio*, May/June 1983, pp. 78–85.

Tuten, Frederic. "In the Galleries: Robert Rauschenberg: Revolvers and Lithographs." *Arts Magazine*, 41, Summer 1967, p. 55.

Vann, Philip. "Visual Arts at the American Festival." *Contemporary Review*, 247, September 1985, pp. 155–59.

Vinklers, Bitite. "Why Not Dante?" *Art International*, Summer 1968, pp. 99–106.

Wallach, Amei. "Rauschenberg Goes to Moscow." *Art in America*, March 1989, pp. 21–22.

Wallis, Nevile. "Art of the Possible." *Spectator*, 212, 14 February 1964, p. 214.

Welish, Marjorie. "Texas, Japan, Etc.: Robert Rauschenberg's Sense of Place." *Arts Magazine*, 60, March 1986, pp. 52–54.

Whittet, G. S. "Interesting, But It Isn't Art." *Studio International* (U.K.), 167, April 1964, pp. 158–61.

Wooster, Ann-Sargent. "Art Sounds." *Art in America*, 70, February 1982, pp. 116–25.

Wortz, Melinda. "Rauschenberg's 'Hoarfrost' Series." *ARTnews*, 16 November 1974.

———. "Rauschenberg's Bones and Unions." *Artweek*, 18 October 1975, p. 2.

Wulp, John. "Happening." *Esquire*, November 1963, pp. 134–38, 184–87.

Young, Joseph E. "New Editions: Robert Rauschenberg." *ARTnews*, 73, March 1974, pp. 48–49.

———. "*Pages and Fuses:* An Extended View of Robert Rauschenberg." *Print Collector's Newsletter*, 5, May/June 1974, pp. 25–30.

Zimmer, William. "Robert Rauschenberg." *Arts Magazine*, September 1977, p. 33.

NEWSPAPERS

"Rauschenberg: New Pace-Setter in Art." *Observer* (London), 23 February 1964, p. 21. [Review]

"The Exhilarating Art of Robert Rauschenberg." *Times* (London), 8 February 1964. [Review]

Aarons, Leroy F. "New Theater's 'Happening' Amuses, Angers Audience." *Washington Post*, 27 April 1966, sec. B, p. 2.

Ahlander, Leslie Judd. "Pop Art Festival Hailed." *Washington Post*, 26 May 1963, sec. G, p. 10.

Asbury, Edith Evans. "Artists 'Bank' to Aid Health Costs." *The New York Times*, 2 October 1977, p. 48.

Ashbery, John. "Venice Biennale Center of Controversy." *New York Herald Tribune* (Paris), 23 June 1964, p. 5. [Review]

Ashton, Dore. "Art: Collages Are Shown in Exhibition." *The New York Times*, 1 January 1959, p. 29. [Review]

———. "Art: Derivation of Dada." *The New York Times*, 30 March 1960, p. 42. [Review]

Barnes, Clive. "Dance or Something at the Armory." *The New York Times*, 16 October 1966, p. 88. [Review]

———. "U.S. Dancers Win Hearts in London." *The New York Times*, 3 August 1964, p. 15.

Baro, Gene. "The Canal Goes 'Pop'." *New York Herald Tribune*, 28 June 1964, sec. 2, p. 24. [Review]

Bashaw, Maureen. "Artist Spills His 'Gluts'." *Fort Myers News Press*, March 1987, sec. D, p. 1, 9.

Battiata, Mary. "Rauschenberg, the Art Explorer: The Avant-Garde Master's Plan a Worldwide Creation." *Washington Post*, 1 June 1985, sec. D, p. 1.

Beckett, Henry. "Pop Artist Displays An X-Ray Vision." *New York Post*, 23 January 1968.

Bland, Alexander. "The Future Bursts In." *Observer Weekend Review* (London), 2 August 1964, p. 20. [Review]

Bongartz, Ray. "Writers, Composers and Actors Collect Royalties—Why Not Artists." *The New York Times*, 2 February 1975.

Bourdon, David. "Art: Rauschenberg's Hoarfrost Causes Shivers of Delight." *The Village Voice*, 23 December 1974, p. 108. [Review]

———. "Rauschenberg: Oracle." *The Village Voice*, 27 May 1965, p. 7. [Review]

Brenson, Michael. "Art People: Rauschenberg Giant Photo." *The New York Times*, 29 October 1982. [Review]

Brett, Guy. "Rauschenberg in Retrospect." *Guardian* (U.K.), 11 February 1964, p. 7. [Review]

Burrows, Carlyle. "Art Review: New Shows Strong in Experiment." *New York Herald Tribune*, 20 September 1953, sec. 4, p. 10. [Review]

Canaday, John. "End Papers." *The New York Times*, 19 December 1964, sec. L, p. 27. [Review]

———. "Rauschenberg Art: Chance to Catch Up." *The New York Times*, 10 July 1970, p. 16. [Review]

Charlton, Linda. "Bill Would Let Artists Deduct Gifts of Their Works." *The New York Times*, 23 June 1976, p. 50.

Corbino, Marcia. "ZAP! Robert Rauschenberg as Art World Superman." *Sarasota Journal*, 22 October 1974, sec. A, p. 12.

Cutler, Carol. "Art in Paris: Documenting an Unacceptable Culture." *International Herald Tribune* (Paris), 15 October 1968, p. 6. [Review]

Davis, Douglas M. "The Enigmatic Mr. Rauschenberg." *National Observer*, 10 October 1966, pp. 1, 17. [Review]

———. "The Expanding Arts: A Revolt Against Logic Leads to the Absurd." *National Observer*, 26 December 1966, p. 18.

———. "Rhythmic or Not, the Art Is in Activity." *National Observer*, 26 June 1967, p. 20.

Donohoe, Victoria. "Rauschenberg: Art Made from Everyday Things." *Philadelphia Inquirer*, 5 December 1976, p. 11 H. [Review]

Dorsey, John. "Rauschenberg: An Appraisal." *Baltimore Sun*, 19 October 1980, sec. D, p. 1. [Review]

Everingham, Carol J. "Promoting World Peace Through Art." *Houston Post*, 23 December 1985, sec. C, p. 4.

Forgey, Benjamin. "He's Pushing Equal Rights for Artists." *Washington Star*, 5 November 1976, p. A1.

———. "Rauschenberg: Making Up for Lost Prints." *Washington Star*, 7 November 1976, sec. G, p. 24–25. [Review]

———. "A Traffic-Stopping Art Work by Rauschenberg for Kids." *Washington Star*, 4 October 1980, sec. C, p. 1. [Review]

Genauer, Emily. "Literal Image of Inferno." *New York Herald Tribune*, 11 December 1960, p. 23. [Review]

———. "Rauschenberg's Drawings for Dante's Inferno." *New York Herald Tribune*, 25 December 1965, p. 7. [Review]

———. " 'The 10 Greatest'—It Says Here." *New York Herald Tribune*, 25 July 1965, pp. 26–27.

Glueck, Grace. "Art Notes." *The New York Times*, 26 January 1979, sec. C, p. 14.

———. "Art People." *The New York Times*, 25 March 1977, sec. 3, p. 19.

———. "Art People." *The New York Times*, 2 July 1976, sec. 3, p. 21.

———. "Art: Rauschenberg 'Soundings' Involves Viewers at the Modern." *The New York Times*, 25 October 1968, sec. C, p. 42. [Review]

Goddard, Dan R. "But . . . he's from Port Arthur." *Sunday Express-News* (San Antonio), 13 April 1986, sec. H, p. 7. [Review]

Gosling, Nigel. "A Jackdaw of Genius." *Observer* (London), 9 February 1964, p. 23. [Review]

Graham-Dixon, Andrew. "Glut Reaction." *Independent* (London), 11 December 1987. [Review]

Gruen, John. "On Art." *Soho Weekly News*, 12 December 1974, p. 18.

———. "Painter Dancing in the Dark." *New York Herald Tribune*, 2 January 1966, p. 22.

Harmel, Mark. "Rauschenberg." *Sanibel-Captiva Islander*, 15 April 1980, sec. B, pp. 1–4.

Holland, Edward. "Rauschenberg's 'Peace Mission'" (Associated Press). *Austin American-Statesman*, 11 October 1985, sec. F, p. 3.

Howard, Pamela. "A Glimpse into the Now." *Washington Daily News*, 9 March 1966, p. 3.

Isenberg, Barbara. "A One-Man Crusade for Artists' Rights." *Los Angeles Times* (*Calendar*), 23 May 1976, p. 1.

Johnson, Lincoln F. "Rauschenberg: 'Great Show, Great Artist'". *Baltimore Sun*, 11 November 1976, sec. B, pp. 1, 3. [Review]

Johnson, Patricia C. "Modern Master Shows Awesome Power in Contemporary Arts Museum Exhibit." *Houston Chronicle*, 28 December 1985, p. 1. [Review]

Johnston, Jill. "The Artist in a Coca-Cola World." *The Village Voice*, 31 January 1963, p. 7. [Review]

———. "Three Theatre Events." *The Village Voice*, 23 December 1965, pp. 11, 25–26. [Review]

Jowitt, Deborah. "Zen and the Art of Dance." *The Village Voice*, 17 January 1977, p. 48.

Joyner, Brooks. "Glass Handle: Very Significant Exhibition." *Albertan* (Canada), 23 October 1976, p. 9. [Review]

Kisselgoff, Anna. "Dance: Premiere of 'Set and Reset.'" *The New York Times*, 23 October 1983, p. 62. [Review]

———. "The Sounds of a Brave New World." *The New York Times*, 16 March 1989, p. 15. [Review, Dance]

Kohen, Helen L. " '1/4 Mile' Makes Art an Experience." *Miami Herald*, 27 May 1984, sec. L, p. 1. [Review]

————. "Stat Art: Rauschenberg Rises to the Challenge of New Creative Process." *Miami Herald*, 23 December 1979, sec. L, pp. 1, 3.

————. "To Cuba, with Art." *Miami Herald*, 21 February 1988, sec. K, p. 1, 2.

Kotz, Mary Lynn. "Rauschenberg's Tour de Force." *The New York Times*, 3 May 1987, pp. 30, 33.

Kramer, Hilton. "Art: Over 53 Feet of Wall Decoration." *The New York Times*, 23 January 1968, p. 28. [Review]

Krasnow, Iris. "Rauschenberg." *Houston Post*, 16 December 1984, sec. F, p. 9.

Kutner, Janet. "Rauschenberg on the Road." *Dallas Morning News*, 18 January 1987, sec. C, pp. 1, 6, 7.

Lafourcade, Enrique. "Rauschenberg en Chile," *El Mercurio* (Santiago), 28 October 1984, sec. E, p. 1.

Lieberman, Henry R. "Art and Science Proclaim Alliance in Avant-Garde Loft." *The New York Times*, 11 October 1967, p. 49.

Lowndes, Joan. "Art: Rauschenberg." *Vancouver Sun*, 3 September 1976, p. 35A.

Lucie-Smith, Edward. "Three Illustrators of Dante." *Times* (London), 11 February 1964, p. 13. [Review]

McGill, Douglas C. "Rauschenberg's 'Rocky' Starting Next April." *The New York Times*, 28 December 1984, sec. 3, p. 32.

McGrath, Kristin. "Rauschenberg Work: 54-foot-long chronicle of now." *Minneapolis Star*, 4 April 1970, sec. A, p. 12. [Review]

Martin, Judith. "Aid for Artists?" *Washington Post*, 23 June 1976, sec. B, p. 3.

Meiss, Stella J. "All-American Artist." *New Haven Register*, 28 November 1976, p. 1D, 4D.

Michel, Jacques. "Le monde illogique de Rauschenberg." *Le Monde* (Paris), 17 October 1968, p. 17.

Mullins, Edwin. "Not Just a Joker." *Telegraph* (London), 9 February 1964.

Nemy, Enid. "Artists' Families Needing Aid Get It from Rauschenberg's Group." *The New York Times*, 25 September 1974, p. 46.

O'Doherty, Brian. "Robert Rauschenberg-One Man Show." *The New York Times*, 28 April 1963, sec. X, p. 13. [Review]

Paz, Octavio. "Un Viento Llamado Bob Rauschenberg." *El Mercurio* (Santiago), 14 July 1985, sec. E, p. 1.

Perreault, John. "For Rauschenberg, An Overdue Celebration." *The Village Voice*, 19 April 1973, p. 34.

————. "No Boundaries." *The Village Voice*, 16 March 1967, pp. 10–11. [Review]

Perry, Art. "Artistry Blowing in the Wind." *Province* (Canada), 8 September 1977, p. 27.

Preston, Stuart. "Divisions of Today." *The New York Times*, 19 December 1954, sec. 2, p. 12. [Review]

————. [SP]. "Varied Art Shown in Galleries Here." *The New York Times*, 18 May 1951, p. 25. [Review]

Reif, Rita. "Auction Reveals Dispute by Artist and an Ex-backer." *The New York Times*, 6 November 1986.

Richard, Paul. "Apollo 11 as an Art Form." *Washington Post*, 30 October 1970, sec. B, p. 1. [Review]

————. "The Art of Healing: Robert Rauschenberg's Mural for Sick Children." *Washington Post*, 4 October 1980, sec. F, p. 1.

————. "Corcoran's Biennial. . . Focusing on Five." *Washington Post*, 18 February 1979, sec. K, pp. 1, 3.

————. " 'Goofy, Grand' Rauschenberg." *Washington Post*, 30 October 1976, sec. B, p. 1. [Review]

Russell, John. "An Art School That Also Taught Life." *The New York Times*, 19 March 1989, p. 33.

————. "Art: At Artists Space, 3 Survivors of 1930's." *The New York Times*, 2 May 1986, sec. 3, p. 28. [Review]

————. "Art That Sings." *The New York Times*, 25 March 1977, sec. C, p. 1, 19. [Review]

————. "One and a Half Decades of Whitney Acquisitions." *The New York Times*, 28 July 1989, sec. C., p. 22.

————. "Rauschenberg and Johns: Mr. Outside and Mr. Inside." *The New York Times*, 15 February 1987, sec. H, pp. 33, 34.

————. "Robert Rauschenberg." *The New York Times*, 14 December 1974, pp. 18, 22.

Sandler, Irving. "In the Art Galleries." *New York Post*, 14 April 1963. [Review]

————. "Rauschenberg and Johns: Anti-Art?" *The New York Times*, 10 May 1970, sec. D, p. 21. [Review]

Schjeldahl, Peter. "Rauschenberg Just Won't Be Boxed In." *The New York Times*, 31 October 1971, sec. D, p. 21. [Review]

Shirey, David L. "Rauschenberg Turning to Cardboards." *The New York Times*, 23 October 1971, p. 23. [Review]

Silcox, David. "Rauschenberg Lights Fire with Inferno Art." *Globe and Mail* (Toronto), 27 February 1965. [Review]

Simmons, Todd. "Color U.S. Art Exhibit in Moscow a Major Success." *Tampa Tribune*, 3 February 1989.

———. "Soviet Artists Fight for Freedom." *Tampa Tribune*, 27 February 1989, pp. 1A, 8A.

Smith, Griffin. "Rauschenberg's Graphics Splendid." *Miami Herald*, 20 January 1974, sec. G, p. 8.

Smith, Roberta. "Art: Drawings by Robert Rauschenberg, 1958–1968." *The New York Times*, 31 October 1986, sec. 3, p. 26. [Review]

Sommer, Waldemar. "Rauschenberg, el Gozo Creador." *El Mercurio* (Santiago), 21 July 1985, sec. E, p. 1.

Steele, Mike. "Rauschenberg—The Artist Is Daring." *Minneapolis Tribune*, 30 August 1970, sec. E, p. 6. [Review]

Steinbrink, Mark. "Why Artists Design for Paul Taylor." *The New York Times*, 3 April 1983, sec. 1, p. 62.

Story, Richard David. "Robert Rauschenberg: The Unstoppable Artist Pours Hard Work and Wild Humor into his Pop-Cultural Canvases." *USA Today*, 26 January 1987, sec. D, p. 4.

Terry, Walter. "The Avant-Garde Dance Becomes Non-Dance With Rauschenberg." *New York Herald Tribune*, 11 January 1966, p. 10.

Wilson, William. " 'Rauschenberg Black and White' at Newport Harbor." *Los Angeles Times*, 28 December 1969, p. 38. [Review]

———. "Rauschenberg's Super-Earthy Things." *Los Angeles Times*, 19 May 1969, sec. IV, p. 11. [Review]

INDEX

108; dichotomy in, 55, 76, 98, 271; exuberance of, 20, 55, 89; generosity of, 173, 180, 243; gregariousness of, 16, 52, 55, 89, 108, 127, 262; humility of, 52, 259, 271; humor and playfulness of, 52, 67, 75, 82, 127, 246, 270, 271; nonconformist, 55, 74; open-mindedness of, 129; optimism of, 20, 169, 172; self-confidence of, 66, 271; shyness of, 52, 55, 127, 136

pets of: from childhood, 50, 52, 90; dogs, 108, 123, 152, 165, 176, 242, 268, 269, 270; turtle (Rocky), 20, 125, 262

Photem series, 233; *234*

photographs by, 71, 79, 210; *23, 79, 87;* of American cities, 230, 232–33, 247; *231;* for assemblages, 233; in black-and-white, 69–70, 78, 79, 230, 237, 247; at Black Mountain College, 65, 74, 79, 230; *64;* Bleachers series, 247; books published of, 230, 232; as collage elements in the work of, 79, 87, 136; in costume design, 237, 238; to document the work of, 73; *73;* double-exposure, 78; *78;* erotic, 136; in the etchings, 227, 230, 233; exhibitions of, 23, 230, 232; in Italy, 78; *78;* of Johns, 91; *91;* in the lithographs of, 147, 227, 230, 233; Polaroid, 103, 247; for ROCI projects, 15, 22, 23, 25, 26, 27, 33, 37, 237, 241, 267, 268; *14, 27;* as serious medium for, 74, 230, 247; in set design, 230, 238; silkscreened for the paintings, of, 23, 27, 37, 103, 237, 241, 242, 247, 265, 266–68; silkscreened on ceramic tiles, 33

photographs of, *24, 36, 48, 49, 52, 56, 70, 75, 76, 78, 87, 90, 94, 98, 109, 115, 118, 119, 121–25, 127, 128, 138–139, 148, 152, 165, 172, 178, 199, 203, 211, 220–21, 223, 232, 233, 254, 266–69, 273*

photogravures by, 251, 253; *253*

physical appearance of, 16, 18, 52, 127

poetic and ephemeral quality of the work of, 98

political activism of, 20, 25, 41, 169, 172–73, 176, 180, 185, 210, 222, 223

political philosophy of, 20, 41, 56, 169, 182, 272

political views and convictions, reflected in the work of, 56, 134, 138–39,

165, 169, 170, 172, 173, 176, 180, 182, 185, 194, 222, 223

in Port Arthur, Texas, 60, 182, 243; *see also* childhood of; adolescent and teenage years of

posters by, 172, 173, 176, 243; *177;* drawing for, *175*

prices for the work of, 25, 110, 117, 173, 187, 215, 251

printing presses owned by: Grasshopper, 162, 165, 214, 258; Little Janis, 182, 233

printmaking and, 16, 24, 117, 127, 165, 189, 193, 210, 267; cardboard prints, 187, 189; *186, 187;* etchings, 159, 230, 233; *226;* intaglio prints, 159, 161, 162, 165; *161;* lithographs, 20, 113, 139, 143, 145, 147–48, 152, 153, 155, 165, 176, 178, 180, 230, 233, 251; *142, 144, 149–151, 154, 156, 177, 179, 222, 227, 235;* screen-prints (silkscreen or serigraphy), 37, 155, 159, 180, 182; *39, 157, 158, 160, 168, 181*

prolific output of, 215, 247, 251, 259

Publicons, 218; *219*

Pyramid series, 195; *201*

Razorback Bunch series, 233

recollections of: by Cage, 76, 89, 117; by Leo Castelli, 41, 98; by Cunningham, 75, 127; by Henry Hopkins, 127; by Johns, 89; by Lichtenstein, 173; by Robert Petersen, 189; by Christopher Rauschenberg, 206; by Dora Rauschenberg, 49; by Dorothea Rockburne, 75; by Ileana Sonnabend, 98; by Susan Weil, 61, 69, 159

Red Paintings, 82–83, 113, 206, 210, 259; *63, 80*

relationship with Johns, 89, 98, 143

relationship with Ernest Rauschenberg, 50, 55, 66, 172

relationship with Susan Weil, 61, 67, 69–70, 74, 78, 79, 159

religion and, 41, 52, 55, 70

religious elements in the work of, 31, 70, 193, 218, 241, 242

reputation of, established, 110

reviews of the work of, 15, 40, 41, 70–71, 79, 82, 83, 85, 99, 103, 110, 117, 119, 123, 136, 162, 165, 178, 180, 182, 187, 189, 209, 211, 214–15, 232–33, 251, 255, 258, 259

Revolvers series, 136, 139, 253; *138–39, 141*

ROCI and, *see* Rauschenberg Overseas Culture

Interchange (ROCI)

Rookery Mounds series, 230; *227*

sales and collectors of the work of, 79, 99, 110, 117, 136, 138, 187

Salvage series, 237, 241–42, 247, 255; *51, 58, 236, 240*

Scales series, 210, 211, 214, 215, 216, 222; *216*

Scripture series, 195; *200*

sculpture by: assemblages and constructions, 85, 113, 131, 134, 135–36, 237; *3, 112, 131;* Bifocal series, 243, 244; *244;* ceramic, 33; *32;* Early Egyptian series, 194, 195; *197, 198;* fetish-boxes, 78–79, 210; Gluts, 246–47, 250; *248, 250–51;* of handmade paper, 193, 203; from the Kabal American Zephyr series, 246; *245;* light, as element in, 28, 117; Made in Israel series, 194–95; Publicons, 218; *219;* for ROCI projects, 28, 31; *28, 31, 42;* in the Scales series, 214, 216; sound, as element in, 83, 117; with technological elements, 117, 135–36, 137, 139, 141; *136–39, 141;* Venetian series, 189; *190–192*

sets designed by: at Black Mountain College, 67; for Trisha Brown Company, 22, 40, 226, 230, 237, 238; *238–39;* for Merce Cunningham Dance Company, 113, 115, 116, 117, 223; *112, 116–17;* for films, 60; for Paul Taylor, 115; for theater piece by, 127; *126*

7 Characters series, 18, 19, 25; *17*

Shiners series, 247, 249, 262, 265; *238–39, 249*

silkscreening in the work of, 23, 26, 27, 33, 37, 56, 136, 140, 141, 159, 165, 180, 193, 237, 241, 242, 247, 258, 265, 266–69, 272

silkscreen paintings by, 58, 99, 103, 107, 108, 110, 117, 127, 136, 143, 170, 172, 209, 210, 214; *59, 106, 110–11, 126, 171, 174*

Snowflake Crimes series, 233

social commentary in the work of, 41, 169, 176, 242, 246–47, 258

solitary work done by, 182, 185

solvent transfer (transfer-printing), in the work of, 98–99, 145, 146, 153, 159, 162, 165, 209, 214, 215, 220, 222, 244, 246, 258

space program: support for, 176, 178, 269, 272; work based on, 176, 178, 180; *179*

specialness of, as a child, 52, 55

spiritual context for the work of, 55, 70, 98, 195, 218, 242, 272–73

Spreads series, 45, 209, 210, 211, 214–15, 216, 218, 220, 222, 255, 258, 259; *44, 46, 208, 212–13, 217, 220–21*

as stage manager: for Merce Cunningham Dance Company, 113; for Judson Dance Theater, 119, 123

Stoned Moon series, 176, 178, 180; *179*

as storyteller, 55, 246, 270, 271

studio assistants: administrative, 173; in Captiva, Florida, 24, 265, 266–69; for drawings and works on paper, 194, 195; for exhibition installations, 210; Alex Hay, 115, 117; Nicholas Howey, 173, 272; importance to the work of, 272; Timothy Isham, 178, 187; Christine Kozlov, 195; Brice Marden, 127, 266, 272; John Peet, 267; Robert Petersen, 155, 180, 194, 195, 272; for photography, 230; Darryl Pottorf, 40, 247, 265, 266, 267, 272; for printmaking, 155, 162, 165, 178, 187; Christopher Rauschenberg, 210; in ROCI projects, 16, 18, 22, 23, 24, 33; Dorothea Rockburne, 75, 127, 272; Rodney "Tup" Schmidt, 265, 266; Hisachika Takahashi, 155, 194, 195, 267, 272; for theater pieces, 115, 117, 127; Mayo Thompson, 195; travels with, 194, 195, 206, 230; Terry Van Brunt, 16, 22, 23, 33, 230, 233; Lawrence Voytek, 247, 265, 272

studios and houses of: in Captiva, Florida, 24, 50, 155, 159, 162, 182, 185, 187, 194, 195, 207, 210, 214, 218, 230, 233, 241, 246, 259, 262, 265–69, 271–73; *24, 165, 220–21, 233, 266, 273;* in New York City: Broadway, 103, 123; *109;* East Eighty-seventh Street, 69; Front Street, 94, 143; *94;* Fulton Street, 52, 79, 87; Lafayette Street, 134, 180; 262; *232;* Pearl Street, 87, 91, 98; *90;* West Ninety-fifth Street, 69; Willett Street, 69

successes of, 103, 123, 210–11, 246, 259

Summer Rental series, 105

support for: from Cage, 74,

76, 89; from Johns, 89, 90; from Morris Kantor, 70; from Motherwell, 74; from Christopher Rauschenberg, 230; from Tworkov, 79, 83

support from, for Johns, 89

symbolism in the work of, 27, 54, 70, 99, 100, 218, 242

Tablets series, 195

Tampa Clay Pieces, 189; *189*

as teacher, at Black Mountain College, 65, 74

techniques of, 99, 210; for Cardbirds, 187; ceramic, 33, 34, 37, 189; collage, 83, 87; drawing, 194; etching, 159, 162; lithographic, 143, 145, 146, 147, 152, 153, 155, 178; for mud sculpture, 206; natural pigments made by, 26, 29; painting, 76, 83, 85, 89, 129, 162, 258–59, 265–69; papermaking, 193, 203, 206; photography, 247; printmaking, 165, 187, 251; silkscreen, 99, 103, 159, 265, 266–69; solvent transfer (transfer-printing), 98–99, 145, 159, 162, 165, 214; *see also* working methods of

technology: combined with art, in the work of, 33, 117, 129, 131, 133, 134–36, 137, 138–39, 140, 141, 148; views on the importance and benefits of, 134, 138–39, 176, 178, 272

Texas roots of: coming to terms with, 246; effect, on the life and work of, 55

theater, early love of, 52, 113

theater pieces by, 20, 24, 118–19, 121, 123, 124, 125, 127, 129; *118, 119, 121–25; see also* dance and theater, work in

travels: to Ambert, France, 193–94; to Amsterdam, 134; to Atlantic City, 230; to Baltimore, 230; to Berlin, 222; to Boston, 230, 232; to California, 56, 60, 215, 230; to Casablanca, 78; to Charleston, South Carolina, 230; to Cuba, 75, 98; with Merce Cunningham Dance Company, 115, 116, 117, 172; to Florence, 79; to India, 20, 203, 206–7; to Israel, 194–95, 199, 262; to Italy, 78, 79, 110, 117, 189, 194; to Japan, 116, 152; to Jerusalem, 194–95, 199; to Kansas City, 58, 60; to London, 115, 117; to Los Angeles, 215, 230; to Madrid, 139; to Malibu, Hawaii, 180; to Miami, 247; to Outer Island, Connecticut, 67, 69, 74; to

PHOTOGRAPH CREDITS

The author and publisher wish to thank the individuals, galleries, and institutions for permitting the reproduction of works in their collections. Photographs were generally supplied by the artist, Robert Rauschenberg. Where the attribution is not included in the caption, a listing follows below. All references are to page numbers.

Acquavella Contemporary Arts, Inc.: 146; Becker Graphics, Inc.: 54; Rudy Burckhardt: 62, 83, 95, 100, 101, 102, 114, 131, 141; Cameraphoto: 201; Leo Castelli Gallery, New York: 71, 84, 110–11, 111; Geoffrey Clements: 81; Giorgio Colombo: 177, 198, 200; Condit Studios: 225; Cunningham Dance Foundation, Inc.: 115 (right); Bevan Davies: 46, 160, 161, 168, 213, 216; D. James Dee: 77; Toni Dolinski: 113; P. Richard Eells: 68; eeva-inkeri: 234; Emil Fray: 10–11, 29, 42, 43 (left), 47, 51, 57, 229 (left), 236, 244, 256, 257, 260, 261; © Gemini, G.E.L., Los Angeles, California, 1990: 154, 179, 186, 187, 196, 202, 204, 227, 235; Hickey-Robertson, Houston: 74, 163; George Holzer: 3, 14, 31; Knoedler Gallery (photo: Ken Cohen): 212; Malcolm Lubliner: 187; Alex Mirzaoff: 224; Multiples, Inc., New York: 158; Gerard Murrell: 222; National Gallery of Art, Washington, D.C.: 112; Otsuka Ohmi Chemical Company: 32, 34–35; Douglas Parker: 80; Eric Pollitzer: 140, 164, 190, 191, 226; Pollitzer, Strong, Meyer: 71; Rheinisches Bildarchiv, Cologne: 130; Sogetsu Art Museum, Japan: 116; Sonnabend Gallery, New York: 96, 106, 132; Sotheby's, New York: 157; Glenn Steigelman: 21, 167, 184, 186, 188, 197, 205, 229 (right); Squidds & Nunns: 88, 95; University Art Museum, California State University, Long Beach: 124; Terry Van Brunt: 28, 30; Walker's, San Diego: 56; Dorothy Zeidman: 9, 84, 176, 181, 248 (top and bottom), 249, 250 (top and bottom), 253 (top), 264; Zindman/Fremont: 17, 228.